PERCEIVING THE ARTS

Sixth Edition

PERCEIVING THE ARTS

An Introduction
to the Humanities

Dennis J. Sporre

Elon College

Prentice Hall
Upper Saddle River, New Jersey 07458

Library of Congress Cataloging-in-Publication Data

SPORRE, DENNIS J.
 Perceiving the Arts: an introduction to the humanities / DENNIS
 J. SPORRE.—6th ed.
 p. cm.
 Includes bibliographical references and index.
 ISBN 0-13-022359-X
 1. Arts. 2. Perception. I. Title.
 NX620.S68 2000
 700'.1—dc21 99-30566

Editorial director: *Charlyce Jones Owen*
Publisher: *Bud Therien*
Assistant editor: *Marion Gottlieb*
Editorial/production supervision: *Edie Riker*
Buyer: *Lynn Pearlman*
Cover director: *Jayne Conte*
Marketing manager: *Sheryl Adams*

This book was set in 10/12 Goudy by East End Publishing Services, Inc.,
and was printed and bound by RR Donnelly & Sons Company. The cover was
printed by Phoenix Color Corp.

Printed in the United States of America

10 9 8 7 6 5 4 3 2 1

ISBN 0-13-022359-X

Prentice-Hall International (UK) Limited, *London*
Prentice-Hall of Australia Pty. Limited, *Sydney*
Prentice-Hall Canada Inc., *Toronto*
Prentice-Hall Hispanoamericana, S.A., *Mexico*
Prentice-Hall of India Private Limited, *New Delhi*
Prentice-Hall of Japan, Inc., *Tokyo*
Pearson Education Asia Pte. Ltd., *Singapore*
Editora Prentice-Hall do Brasil, Ltda., *Rio de Janeiro*

For my wife Hilda

Contents

The Performing Arts

The Environmental Arts

The Language Arts

Preface

Fundamentally, *Perceiving the Arts* has a very specific and limited purpose: to provide an introductory, technical, and respondent-related reference to the arts and literature. Its audience comprises individuals who have little or no knowledge of the arts, and it is designed to give those readers touchstones concerning what to look and listen for in works of art and literature. Such a purpose, attempted in such a short text, is challenging because most artistic terminology and concepts are complex. Many characteristics of the arts change (sometimes subtly and sometimes profoundly) as historical periods and styles change. Further, most artists do not paint, sculpt, compose, or write to neat, fixed formulas. For example, widely used terms like *symphony* have many subtle connotations and can be defined accurately only within specific historical contexts. Nonetheless, our understanding begins with generalities, and the treatment of definitions and concepts in this text remains at that basic and general level. When a course requires more detailed and sophisticated understanding than the basic definitions provided here, an instructor can easily add those layers.

The arts may be approached in a variety of ways. One of those deals with the questions of what we can see and hear in works of art and what we can read in literature. *Perceiving the Arts* takes that approach and relates the arts to the perceptual process. To do that, we adapt Harry Broudy's formulation of aesthetic response. That is, we can ask four questions about an art, an artwork, or a work of literature: (1) What is it? (a formal response); (2) How is it put together? (a technical response); (3) How does it appeal to the senses? (an experiential response); and (4) What does it mean? (a contextual and personal response). These questions constitute a consistent and workable means and comfortable springboard for getting into the arts at a basic level. However, like any categorical device, this one is not foolproof. People don't always agree on definitions of terms and concepts. Also, choices of what to include and exclude, and how best to illustrate, remain arbitrary.

Getting the most from an experience with the arts depends to a large degree on our skills of perception. Knowing what to see and what to hear in a poem, painting, play, building, or musical

composition is one step toward developing discriminating perception and toward making effective steps into getting the most from a relationship with the arts. Introducing the aesthetic experience through terminology may be arguable, but the approach gains credence from the College Board statement on "Academic Preparation for College" where use of "the appropriate vocabulary" is emphasized as fundamental. Vocabulary isolates for us characteristics of what to see and hear in individual works of art and helps us focus our perceptions and responses. Knowing the difference between polyphony and homophony, between a suite and a concerto, between prints and paintings, and between fiction and poetry is as important as knowing the difference between baroque and romantic, iconoclasm and cubism.

The arts are accessible to everyone. This text illustrates how much can be approached using the perceptual skills we have been developing since childhood. However, this step is only the beginning. I hope the understanding and confidence readers develop will make them want to make study and involvement with the arts a lifetime venture.

This book originated as a text for an interdisciplinary course in aesthetic perception. The text was designed as an information sourcebook and should be flexible enough to serve any course that examines more than one artistic discipline. Its information is basic and more easily presented in a text than in a lecture. Those whose background is expansive can read it rapidly, pausing to fill in the holes in their background. Students who have no or little experience with the arts can spend the necessary time memorizing. Thus classroom time can be utilized on expanded illustration, discussion, analysis, and experience of actual works. Readers' personal philosophy about the arts and literature should not be affected by this work. For example, when theories, philosophies, or definitions differ, we provide an overview. We might compare this text to a dictionary in a writing course.

This edition of *Perceiving the Arts* contains three important additions. First is a series of feature boxes entitled "Profile," which introduces the reader to an artist of significance in the discipline studied in that chapter. The second addition, likewise, is a series of feature boxes entitled "A Matter of Style." This series injects an artistic style into the text—again appropriate to the discipline in the particular chapter. This is not an attempt to transform *Perceiving the Arts* into a history. Only one or two styles appear in each chapter. Nonetheless, taken in sum, the boxes give a fair overview of the major artistic styles of history. Finally, in the chapter on music, illustrations are referenced to a music CD produced and available from Prentice Hall. Hopefully, each of these additions will enhance both the teaching and study of the text.

Finally, a word of explanation. When the first edition of *Perceiving the Arts* was published in 1978, the text for the chapter on film was written by Ellis Grove; the chapter on landscape architecture, by Donald Girouard. Both of these gentlemen were extremely patient in adapting their ideas to my organizational scheme. Six editions later, the material in those chapters remains basically true to their original concepts. I have, however, made many changes both in style and content. The addition of the feature boxes in this edition is one major example. Thus, whatever faults may now appear in these chapters belong to me. It goes without saying that I am extremely grateful to Ellis and Don, and to the late Warren Smith, who introduced the course for which this book was originally written. Also, I am fundamentally indebted to a host of editors at Prentice Hall who through the years have been very generous with their assistance and insights. Finally, I am grateful to my wife, Hilda, to whom this book is dedicated, for her patience, editorial and critical assistance, and love.

D.J.S.

What Are the Arts and How Do We Respond to and Evaluate Them?

We live in buildings and listen to music constantly. We hang pictures on our walls and react like personal friends to characters in television, film, and live dramas. We escape to parks, engross ourselves in novels, wonder about a statue in front of a public building, and dance the night away. All of these situations involve forms of art in which we engage and are engaged daily. Curiously, as close to us as they are, in many ways they remain mysterious. What are they? How are they put together? How do they stimulate us? What do they mean? In ten relatively short chapters, we will attempt to answer those and other questions about the arts. We begin with the questions What *are* the arts? and How do we respond to and evaluate them?

Humans are a creative species. Whether in science, politics, business, technology, or the arts, we depend on our creativity almost as much as anything else to meet the demands of daily life. Any story about the arts is a story about us: our perceptions of the world as we have come to see and respond to it and the ways we have communicated our understandings to each other since the Ice Age, more than 35,000 years ago (Fig. 1.1). At that time, we were already fully human. Since then, we have learned a great deal about our world and how it functions, and we have changed our patterns of existence. However, the fundamental characteristics that make us human—that is, our ability to intuit and to symbolize—have not changed. Art—the major remaining evidence of our earliest times—reflects these unchanging human characteristics in inescapable terms.

Our study will focus on vocabulary and perception, and we begin with an overview about art itself and its place in our world. This chapter provides a foundation. It is more conceptual than the remainder of the book, and the following questions can be used as a guide for reading this material:

- What is meant by the term *humanities?* How do the humanities differ from other ways of knowing?
- What is meant by the statement that the arts are *processes, products,* and *experiences?*

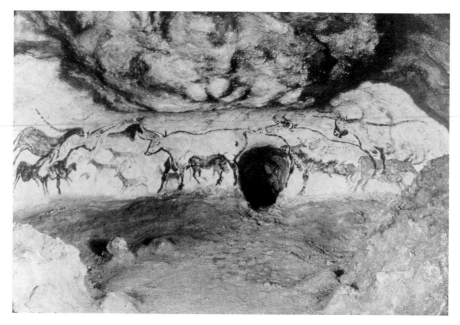

Figure 1.1 General view of cave chamber at Lascaux, France, from the early Stone Age (c. 15,000 B.C.) Archiv fur Kunst und Geschichte, Berlin.

- Why does a definition of a work of art imply non-restrictiveness, human enterprise, a medium of expression, and communication?
- What is a *symbol* and in what ways can it communicate?
- What are the major functions of art?
- How is it possible for a work of art to fulfill more than one function?
- How may religious ritual qualify as art?

THE HUMANITIES AND THE ARTS

The humanities, as opposed, for example, to the sciences, can very broadly be defined as those aspects of culture that look into the human spirit. But despite our desire to categorize, there really are few clear boundaries between the humanities and the sciences. The basic difference lies in the approach that separates investigation of the natural universe, technology, and social science from the sweeping search of the arts for human reality and truth.

Within the educational system, the humanities have traditionally included the fine arts, literature, philosophy, and, sometimes, history. These subjects are all oriented toward exploring what it is to be human, what human beings think and feel, what motivates their actions and shapes their thoughts. Many of the answers lie in the millions of artworks all round the globe, from the earliest sculpted fertility figures to the video art of today. These artifacts and images are themselves expressions of the humanities, not merely illustrations of past or present ways of life.

Artistic styles, schools, and conventions are the stuff of art history. But change in the arts differs from change in the sciences in one significant way: New technology usually displaces the old; new scientific theory explodes the old; but new art does not invalidate earlier human expression. Obviously, not all artistic styles

survive, but the art of Picasso cannot make the art of Rembrandt an idle curiosity of history the way the theories of Einstein did the theories of Newton.

Works of art also remain, in a curious way, always in the present. We react *now* to the sound of a symphony or to the color and composition of a painting. No doubt an historical perspective on the composer or painter and a knowledge of the circumstances in which the art was created enhance understanding and appreciation. But for most of us, today's reaction is most important.

The arts can be approached with all the subtlety we normally apply to human relationships. We learn very young that people cannot simply be categorized as "good" or "bad," as "friends," "acquaintances," or "enemies." We relate in complex ways. Some friendships are pleasant but superficial, some people are easy to work with, and others (but few) are lifelong companions. Similarly, when we have gone beyond textbook categories and learned this sort of sensitivity, we find that art, like friendship, has a major place in our growth and quality of life.

What is Art?

In a broad sense, the arts are *processes, products,* and *experiences* that communicate aspects of human living in a variety of ways, many of which do not use words. *Processes* are the creative actions, thoughts, materials, and techniques artists combine to create *products*—that is, artworks. *Experiences* are human interactions and responses that occur when people encounter an artist's vision in an artwork. These are a few of the characteristics that identify the arts—as opposed to science, technology, and social science—as vantage points we use to understand our attitudes, actions, and beliefs.

But what is art? Scholars, philosophers, and aestheticians have attempted to answer this question for centuries without yielding many ade-

quate results. The late pop artist Andy Warhol reportedly said, "Art is anything you can get away with" (Fig. 1.2). Perhaps we should be a little less cynical, and a little more specific. Instead of asking "What is art?" let us ask "What is a work of art?" *A work of art is one person's vision of human reality (emotions, ideas, values, religions, political beliefs, etc.), expressed in a particular medium and shared with others.* Now we can explore the terms of this definition.

Nonrestrictiveness

First, the definition is sufficiently nonrestrictive: An artwork is anything that attempts to communicate a vision of human reality through a means traditionally associated with the arts—for example, drawing, painting, printmaking, sculpture, as well as works of music, dance, literature, film, architecture, and theatre. If the originator *intends* it as a work of art, it is one. Whether it is good or bad, sophisticated or naive, profound or inconsequential, matters little. A child's drawing that expresses some feeling about mother, father, and home is as much an artwork as Michelangelo's Sistine Chapel frescoes. The music of the Grateful Dead and that by Mozart both qualify as artworks under our definition, even though the *qualities* we might ascribe to these artworks probably would be different. (We discuss *value judgments* later in this chapter.)

Human Enterprise

The second implication of our definition is that a work of art is a human enterprise: Whenever we experience a work of art, we are coming into contact with another human being. We experience human contact in works of art because artworks are intended to engage us and to initiate a desire to respond. In the theatre, for example, we are exposed to a variety of visual and aural stimuli that attempt to make us feel, think, or react in harmony with the goals of the artists.

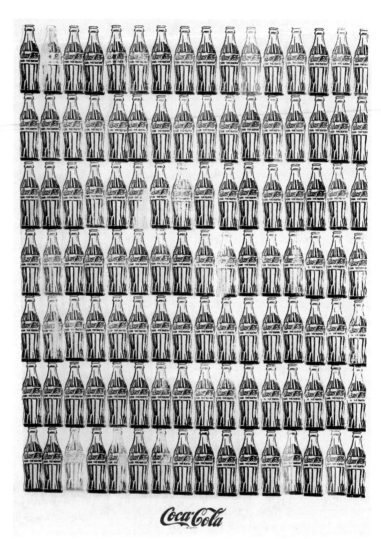

Figure 1.2 Andy Warhol, *Green Coca-Cola Bottles* (1962). Oil on canvas, 6'10" × 4'9". Collection of Whitney Museum of American Art, New York.Purchase, with funds from the Friends of the Whitney Museum of American Art. ©1998 The Andy Warhol Foundation for the Visual Arts/Artists Rights Society (ARS), New York

Medium of Expression

Although we can readily accept the traditional media—for example, painting, traditional sculpture, music using traditional instruments, theatre using a script and performed in an auditorium, and so on—sometimes when a medium of expression does not conform to our expectations or experiences, we might decide that the work is not art. For example, Figures 1.3A and B show one gigantic installation, in two parts, of blue and yellow umbrellas in Japan and the United States, respectively, created (and entirely financed) by the artists Christo and Jeanne-Claude. For them, this temporary work of art is an artwork. For other people, it most definitely was not. Even though the medium was unconventional and the work transitory, our definition

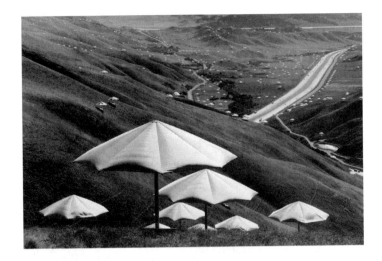

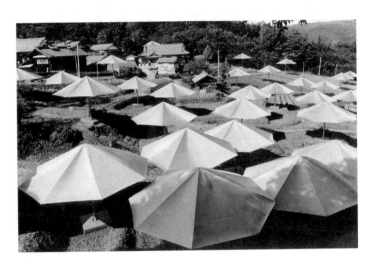

Figure 1.3 A and B Christo and Jeanne-Claude, *The Umbrellas, Japan-USA (1984–91).* (A) Valley north of Los Angeles, California, 1,760 yellow umbrellas; (B) Valley in prefecture of Ibaraki, Japan, 1,340 blue umbrellas. Combined length: 30 miles. © Christo, 1991. Photographs: Wolfgang Volz.

would allow the artwork because the *intent* of the work was clearly artistic.

Communication

Artworks involve communication and sharing. The common factor in all art is the humanizing experience. Artists need other people with whom they can share their perception of human reali-

ty. When artworks and humans interact, many possibilities exist. Interaction may be casual and fleeting, as in the first meeting of two people, when one or both are not at all interested in each other. Similarly, an artist may not have much to say, or may not say it very well. For example, a poorly written or produced play probably will not excite an audience. Similarly, if an audience member is self-absorbed, distracted, has

rigid preconceptions not met by the production, or is so preoccupied by what may have occurred outside the theatre that he or she finds it impossible to perceive what the production offers, then the artistic experience also fizzles. On the other hand, all conditions may be optimum, and a profoundly exciting and meaningful experience may occur: The play may treat a significant subject in a unique manner, the acting, directing, and design may be excellent, and the audience may be receptive. Or the interaction may fall somewhere between these two extremes. In any case, the experience is a human one, and that is fundamental to art.

In discussing art as communication, we need to note one important term: *symbol*. Symbols are things that *represent* something else. They often use a material object to suggest something less tangible or less obvious: a wedding ring, for example. Symbols differ from *signs*, which suggest a fact or condition. Signs are what they denote. Symbols carry deeper, wider, and richer meanings. Look at Figure 1.4. What do you see? You might identify this figure as a sign, which looks like a plus sign in arithmetic. But the figure might be a Greek cross, in which case it becomes a symbol because it suggests many images, meanings, and implications. Artworks use a variety of symbols to convey meaning. By using symbols, artworks can relay meanings that go well beyond the surface of the work and offer glimpses of human reality that cannot be sufficiently described in any other manner. Symbols make artworks into doorways through which we pass in order to experience, in limited time and space, more of the human condition.

The Functions of Art

Art can function in many ways: as enjoyment, political and social weapon, therapy, and artifact. One function is no more important than the others. Nor are they mutually exclusive; one artwork may fill many functions. Nor are the four functions just mentioned the only ones. Rather, they serve as indicators of how art has functioned in the past and can function in the present. Like the types and styles of art that have occurred through history, these four functions and others are options for artists and depend on what artists wish to do with their artworks.

Enjoyment

Plays, paintings, and concerts can provide escape from everyday cares, treat us to a pleasant time, and engage us in social occasions. Works of art that provide enjoyment may perform other functions as well. The same artworks we enjoy may also create insights into human experience. We can also glimpse the conditions of other cultures, and we can find healing therapy in enjoyment.

An artwork in which one individual finds only enjoyment may function as a profound social and personal comment to another. A Mozart symphony, for example, may relax us and allow us to escape our cares. It may also comment on the life of the composer and/or the conditions of eighteenth-century Austria. Grant Wood's *American Gothic* (Fig. 1.5) may amuse us, and/or provide a detailed commentary about nineteenth-century America, and/ or move us deeply. The result depends on the artist, the artwork, and us.

Figure 1.4 Greek cross?

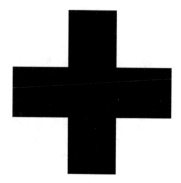

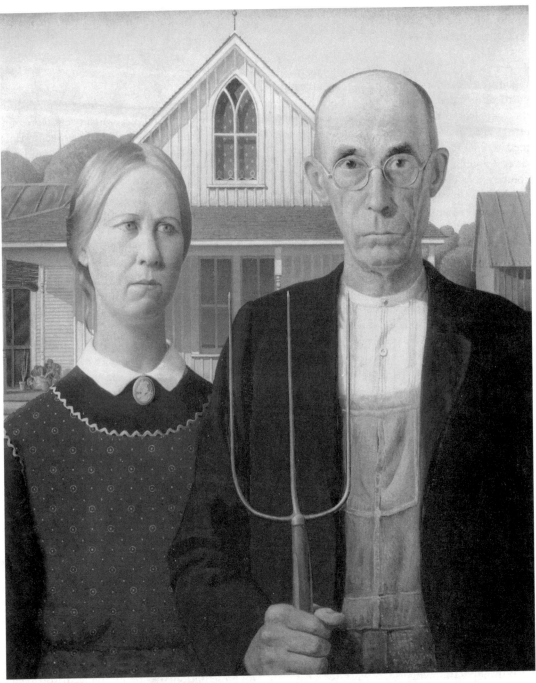

Figure 1.5 Grant Wood, American (1891-1942), *American Gothic* (1930). Oil on beaver board, 30" x 25". Friends of American Art Collection. Photograph © 1990. All rights reserved by The Art Institute of Chicago and VAGA, New York.

Political and Social Commentary

Art used to bring about political change or to modify the behavior of large groups of people has political or social functions. In ancient Rome, for example, the authorities used music and theatre to keep masses of unemployed people occupied in order to quell urban unrest. At the same time, Roman playwrights used plays to attack incompetent or corrupt officials. The Greek playwright Aristophanes used comedy in such plays as *The Birds* to attack the political ideas of the leaders of ancient Athenian society. In *Lysistrata*, he attacks war by creating a story in which all the women of Athens go on a sex strike until Athens is rid of war and warmongers.

In nineteenth-century Norway, playwright Henrik Ibsen used *An Enemy of the People* as a platform for airing the issue of whether a government should ignore pollution in order to maintain economic well-being. In the United States today, many artworks act as vehicles to advance social and political causes, or to sensitize viewers, listeners, or readers to particular cultural situations like racial prejudice and AIDS.

Therapy

In a therapeutic function, creating and experiencing works of art may provide therapy for individuals with a variety of illnesses, both physical and mental. Role playing, for example, is used frequently as a counseling tool in treating dysfunctional family situations. In this context, often called psychodrama, mentally ill patients act out their personal circumstances in order to find and cure the cause of their illness. The focus of this use of art as therapy is the individual. However, art in a much broader context acts as a healing agent for society's general illnesses as well. In hopes of saving us from disaster, artists use artworks to illustrate the failings and excesses of society. In another vein, the laughter caused by comedy releases endorphins, chemicals produced by the brain, which strengthen the immune system.

Artifact

Art also functions as an *artifact*: A product of a particular time and place, an artwork represents the ideas and technology of that specific time and place. Artworks often provide not only striking examples but occasionally the only tangible records of some peoples. Artifacts, like paintings, sculptures, poems, plays, and buildings, enhance our insights into many cultures, including our own. Consider, for example, the many revelations we find in a sophisticated work like the Igbo-Ukwu roped pot on a stand (Fig. 1.6). This ritual water pot from the village of Igbo-Ukwu in eastern Nigeria was cast using the *cire perdue* or "lost wax" process and is amazing in its virtuosity. It tells us much about the vision and technical accomplishment of this ninth- and tenth-century African society.

The Igbo-Ukwu pot suggests that when we examine art in the context of cultural artifact, one of the issues we face is the use of artworks in religious *ritual*. We could consider ritual as a separate function of art. However, we may not think of religious ritual as art at all, but in the context we have adopted for this text, ritual often meets our definition of human communication using an artistic medium. Music, for example, when part of a religious ceremony, meets the definition, and theatre—if seen as an occasion planned and intended for presentation—would include religious rituals as well as events that take place in theatres. Often, as a survey of art history would confirm, we cannot discern when ritual stops and secular production starts. For example, Ancient Greek tragedy seems clearly to have evolved from and maintained ritualistic practices. When ritual, planned and intended for presentation, uses traditionally artistic media like music, dance, and theatre, we can legitimately study ritual as art, and see it also as an artifact of its particular culture.

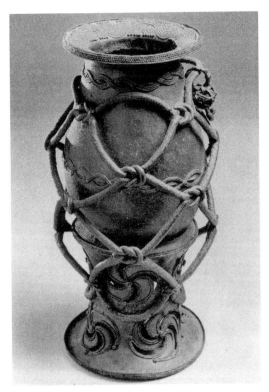

Figure 1.6 Roped pot on a stand, from Igbo-Ukwu (ninth or tenth century). Leaded bronze, height 12¹/₂". The National Museum, Lagos, Nigeria.

What Is Art Criticism?

One of the questions we all seem to ask about an artwork is, "Is it any good?" Whether rock music, a film, a play, a painting, or a classical symphony, judgments about the quality of a work often vary from one extreme to the other, ranging from "I liked it" and "interesting," to specific reasons why the artwork is thought to be effective or ineffective.

Because the word *criticism* implies many things to many people, we must first agree what it means—or what it does not. Criticism is not necessarily saying negative things about a work of art. All too often we think of critics as people who write or say essentially negative things, giv-

ing their opinions on the value of a play, a concert, or an exhibition. Personal judgment may result from criticism, but criticism implies more than passing judgment.

Criticism *should* be a detailed process of analysis to gain understanding and appreciation. Identifying the formal elements of an artwork—learning what to look for or listen to—is the first step. We describe an artwork by examining its many facets and then try to understand how they work together to create meaning or experience. We then try to state what that meaning or experience is. Only when the process is complete should the critic offer judgment.

The critic, however, also brings a set of standards developed essentially from personal experience. Applying these standards makes value judgment a tricky task. Our *knowledge* of an art form can be shallow. Our *perceptual skills* may be faulty, the range of our *experiences* may be limited. The application of standards may be especially difficult if we try to judge an artwork as good or bad based on preestablished criteria: If someone believes a plot is the most important element in a film or a play, then any film or play that does not depend heavily on a plot may be judged as faulty, despite other qualities it presents. Preestablished criteria often deny critical acclaim to new or experimental approaches in the arts.

History resounds with examples of new artistic attempts that received terrible receptions from so-called experts, whose ideas of what an artwork ought to be could not allow for experimentation or departures from accepted practice. In 1912, when Vaslav Nijinsky choreographed the ballet *Rite of Spring* to music by Igor Stravinsky, the unconventional music and choreography actually caused a riot: Audiences and critics could not tolerate that the ballet did not conform to accepted musical and ballet standards. Today, both the music and the choreography are considered masterpieces. Similarly, Samuel Beckett's *Waiting for Godot* (1953) (Fig. 1.7) does not have a plot, characters, or ideas

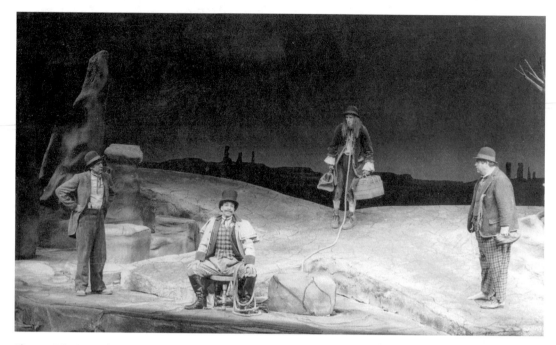

Figure 1.7 Samuel Beckett, *Waiting for Godot*, Utah Shakespearean Festival (1990). Director: Tom Marlens.

that are expressed in a conventional manner. In *Godot* two tramps wait beside the road by a withered tree for the arrival of someone named Godot. The tramps tell stories to each other, argue, eat some food, and are interrupted by a character named Pozzo leading a slave, Lucky, by a rope. After a brief conversation, Lucky and Pozzo leave. At the end of the first act, a boy enters to announce that Godot will not come today. In Act 2, much the same sequence of events occurs. Then, Lucky leads in a blind Pozzo. The tree has sprouted a few leaves. The play ends as the young boy returns to indicate Godot will not arrive that day either. If your standards require a successful play to have a carefully fashioned plot wrapped around fully developed characters and a clear message, then *Waiting for Godot* cannot possibly be a good play. Some people agree with such an assertion; others disagree vehemently. What, then, are we to

conclude? What if my criteria do not match yours? What if two experts disagree on the quality of a movie? Does that make any difference to our experience of it?

Value judgments are intensely personal, but some opinions are more informed than others and represent more authoritative judgment. However, sometimes even knowledgeable people disagree. Disagreements about quality, however, can enhance our experience of a work of art when they lead us to think about why the differences exist. In this way, we gain a deeper understanding of the artwork. Nonetheless, *criticism* can be exercised without involving any judgment. We can thoroughly dissect any work of art and describe what it comprises—for example, we can describe and analyze line, color, melody, harmony, texture, plot, character, and/or message. We can observe how all of these factors affect people and their responses. We can

spend a significant amount of time doing this and never pass a value judgment at all.

Does this discussion mean all artworks are equal in value? Not at all. It means that in order to understand what criticism involves, we must separate descriptive analysis, which can be satisfying in and of itself, from the act of passing value judgments. We may not like the work we have analyzed, but we may have understood something we did not understand before. Passing judgment may play no role whatsoever in our understanding of an artwork. But we are still involved in *criticism*.

As an exercise in understanding, criticism is necessary. We must investigate and describe. We must experience the need to know enough about the process, product, and experience of art if we are to have perceptions to share.

Now that we have examined briefly what criticism is and why we might do it, what criteria or approaches can we use?

Types of Criticism

In general, there are two types of criticism. If we examine a single artwork by itself, it is called *formal criticism*. If we examine the same work in the context of the events surrounding it or, perhaps, the circumstances of its creation, it is called *contextual criticism*.

Formal Criticism

In formal criticism, we are interested primarily in the artwork itself, applying no external conditions or information. We analyze the artwork just as we find it: If it is a painting, we look only within the frame; if it is a play, we analyze only what we see and hear. Formal criticism approaches the artwork as an entity within itself. As an example, consider this brief analysis of Molière's comedy *Tartuffe* (1664) (Fig. 1.8):

Figure 1.8 Jean-Baptiste Molière, *Tartuffe*. University of Arizona Theatre (1990). Director: Charles O'Connor.

Orgon, a rich bourgeois, has allowed a religious con man, Tartuffe, to gain complete control over him. Tartuffe has moved into Orgon's house, and tries to seduce Orgon's wife at the same time he is planning to marry Orgon's daughter. Tartuffe is unmasked, and Orgon orders him out. Tartuffe seeks his revenge by claiming title to Orgon's house and blackmailing him with some secret papers. At the very last instant, Tartuffe's plans are foiled by the intervention of the king, and the play ends happily.

We have just described a story. Were we to go one step further and analyze the plot, we would look, among other things, for points at which *crises* occur and cause important decisions to be made by the characters; we would also want to know how those decisions moved the play from one point to the next. In addition, we would try to locate the extreme crisis, the *climax*. Meanwhile, we would discover auxiliary parts of plot such as *reversals*—for example, when Tartuffe is discovered and the characters become aware of the true situation. Depending on how detailed our criticism were to become, we could work our way through each and every aspect of the plot. We might then devote some time to describing and analyzing the driving force—the *character*—of each person in the play and how the characters relate to each other. Has Molière created fully developed characters? Are they types or do they seem to behave more or less like real individuals? In examining the *thematic* elements of the play, we would no doubt conclude the play deals with religious hypocrisy and that Molière had a particular point of view on that subject.

In this formal approach, information about the playwright, previous performances, historic relationships, and so on, is irrelevant. Thus the formal approach helps us analyze how an artwork operates and helps us decide why the artwork produces the responses it does. We can apply this form of criticism to any work of art and come away with a variety of conclusions. Of course, knowledge about how artworks are put together, what they are, and how they stimulate the senses enhances the critical process. Knowing the basic elements that comprise formal and technical elements of the artwork (which are the subjects of the succeeding chapters of this book) gives us a ready outline on which to begin a formal analysis.

Contextual Criticism

The other general approach, contextual criticism, seeks meaning by adding to formal criticism an examination of related information outside the artwork, such as facts about the artist's life, his or her culture, social and political conditions and philosophies, public and critical responses to the work, and so on. These can all be researched and applied to the work in order to enhance perception and understanding. Contextual criticism views the artwork as an artifact generated from particular contextual needs, conditions, and/or attitudes. If we carry our criticism of *Tartuffe* in this direction, we would note that certain historical events help clarify the play. For example, the object of Molière's attention probably was the Company of the Holy Sacrament, a secret, conspiratorial, and influential religious society in France at the time. Like many fanatical religious sects—including those of our own time—the society sought to enforce its own view of morality by spying on the lives of others and seeking out heresies—in this case, in the Roman Catholic church. Its followers were religious fanatics, and they had considerable impact on the lives of the citizenry at large. If we were to follow this path of criticism, we would pursue any and all contextual matters that might illuminate or clarify what happens in the play. Contextual criticism may also employ the

same kind of internal examination followed in the formal approach.

Making Judgments

Now that we have defined criticism and noted two approaches we might take in pursuit of understanding and enjoying a work of art, we can move on to the final step: making value judgments.

There are several approaches to the act of judgment. Two characteristics, however, apply to all artworks: Artworks are *crafted* and they *communicate* something to us about our experiences as humans. Making a judgment about the quality of an artwork should address each of these characteristics.

Craftsmanship

Is the work well made? To make this judgment, we first need some understanding of the medium in which the artist works. For example, if the artist proposes to give us a realistic vision of a tree, does the artist's handling of the paint yield a tree that looks like a tree? Of course, if craftsmanship depended only on the ability to portray objects realistically, judgment would be quite simple. However, we must remember that judgments about the craftsmanship of an artwork require some knowledge about the techniques and styles of its medium. Although we may not yet be ready to make judgments about all of the aspects of craftsmanship in any art form, we can apply what we know. Good craftsmanship means the impact of the work will have clarity and not be confusing. It also means the work will hold our interest (given basic understanding and attention on our part). If the artwork does not appear coherent or interesting, we may wish to examine whether the fault lies in the artwork or in ourselves before rendering judgment. Beyond that, we are left to learn the lessons that the rest of this book seeks to teach. Each chapter will give us more tools to evaluate the craftsmanship of a work of art.

Communication

Evaluating what an artwork is trying to say offers more immediate opportunity for judgment and less need for expertise. Johann Wolfgang von Goethe, the nineteenth-century poet, novelist, and playwright, set out a basic, common-sense approach to evaluating communication. Because Goethe's approach provides an organized means for discovering an artwork's communication by progressing from analytical to judgmental functions, it is a helpful way to end our discussion on criticism. Goethe suggests that we approach the critical process by asking three questions: What is the artist trying to say? Does he or she succeed? Was the artwork worth the effort? These three questions focus on the artist's communication by making us identify first what was being attempted, and then on the artist's success in that attempt. The third question, whether or not the project was worth the effort, raises other issues, such as uniqueness or profundity. This question asks us to decide if the communication offered important or unique perceptions (as opposed to the trivial or inane). A well-crafted work of art that merely restates obvious insights about the human condition lacks quality in its communicative component. One that offers profound and unique insights exhibits quality.

We should think of the arts as we think of people. Adequate adjustment to the world cannot be made from social responses that simply divide the "good people" from the "bad people." We should be skeptical even of such categories as "the people I like" and "the people I don't like." If we do maintain such divisions, we find individuals constantly moving from one group to the other. Eventually we find human differences too subtle for easy classification, and the web of our relationships becomes too complex for analysis. We try to move toward more and more sensitive discrimination, so that there are those we can learn from, those we can work with, those good for an evening of light talk,

those we can depend on for a little affection, and so on—with perhaps those very few with whom we can sustain a deepening relationship for an entire lifetime. When we have learned this same sensitivity and adjustment to works of art—when we have gone beyond the easy categories of the textbooks and have learned to regard our art relationships as part of our own growth—then we shall have achieved a dimension in living that is as deep and as irreplaceable as friendship.

LIVING WITH THE ARTS

Because of unfamiliarity, many individuals are uncomfortable approaching the arts and literature. That unfamiliarity, perhaps, has been fostered by individuals, both within the disciplines and without, who try to make involvement in the arts and literature elitist, and art galleries, museums, concert halls, theatres, and opera houses open only to the knowledgeable and the sophisticated. Nothing could be further from actuality. The arts are elements of life with which we can and must deal and to which we must respond every day. We live with the arts because the principles of *aesthetics* permeate our existence. Specifically, the aesthetic experience is a way of knowing and communicating in and of itself, separate from other ways of knowing and communicating. It forms a significant part of our existence.

The arts play important roles in making the world around us more interesting and habitable place. Artistic ideas join with *conventions* to make everyday objects attractive and pleasurable to use. The term *convention* is one we use repeatedly in this text. A convention is a set of rules or mutually accepted conditions. For example, the standard connector on our electrical appliances is a convention. It is a practical convention to which those who have traveled abroad can testify. A more relevant example of a convention might be the keyboard and tuning of a piano. In any case, from these two examples

we understand clearly the role that conventions play in our lives.

Figure 1.9, a scale drawing of an eighteenth-century highboy, illustrates how art and convention combine in everyday items. The high chest was conceived to fill a practical purpose—to provide for storage of household objects in an easily accessible, yet hidden, place. However, while designing an object to accommodate that practical need, the cabinetmakers felt the

Figure 1.9 Scale drawing of an eighteenth-century highboy.

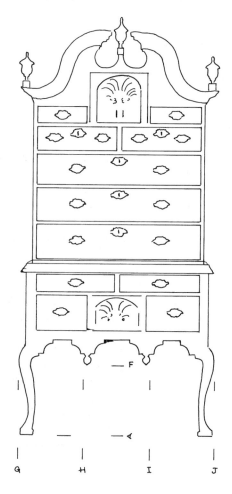

additional need to provide an interesting and attractive object. Our total experience of this piece of furniture can be enlightening and challenging if we perceive it with discrimination and imagination.

First of all, the design is controlled by a convention that dictates a consistent height for tables and desks. So the lower portion of the chest, from point A to point B, designs space within a height that will harmonize with other furniture in the room. If we look carefully, we also can see that the parts of the chest are designed with a sophisticated and interesting series of proportional and progressive relationships. The distance from A to B is twice the distance from A to D and is equal to the distance from B to C. The distances from A to F and C to E bear no recognizable relationship to the previous dimensions but are, however, equal to each other and to the distances from G to H, H to I, and I to J. In addition, the size of the drawers in the upper chest decreases at an even and proportional rate from bottom to top.

A further example might be the Volkswagen shown in Figure 1.10. Here repetition of form reflects a concern for unity, one of the fundamental characteristics of art. The design of the early Volkswagen used strong repetition of the oval.

We need only to look at the rear of the Bug to see variation on this theme as applied in the window, motor-compartment hood, tail-lights, fenders, and bumper. Later models of the Volkswagen differ from this version and reflect the intrusion of conventions, again, into the world of design. As safety standards called for larger bumpers, the oval design of the motor-compartment hood was flattened so a larger bumper could clear it. The rear window was enlarged and squared to accommodate the need for increased rear vision. The intrusion of these conventions changed the design of the Beetle by breaking down the strong unity of the original composition.

Finally, as Edwin J. Delattre states when he compares the purpose for studying technical subjects to the purpose for studying the humanities or the arts, "When a person studies the mechanics of internal combustion engines the intended result is that he should be better able to understand, design, build, or repair such engines, and sometimes he should be better able to find employment because of his skills, and thus better his life. . . . When a person studies the humanities [the arts] the intended result is that he should be better able to understand, design, build, or repair a life—for living is a vocation we have in common despite our differences."

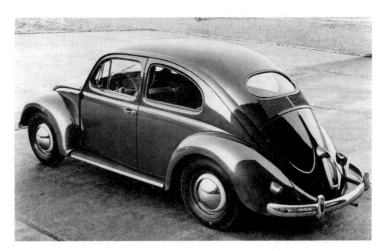

Figure 1.10 Volkswagen Beetle (1953). Courtesy of Volkswagen of America, Inc.

"The humanities provide us with opportunities to become more capable in thought, judgment, communication, appreciation, and action." Delattre goes on to say that these provisions enable us to think more rigorously and to imagine more abundantly. "These activities free us to possibilities that are new, at least to us, and they unbind us from portions of our ignorance about living well . . . Without exposure to the cultural . . . traditions that are our heritage, we are excluded from a common world that crosses generations."* The poet Archibald MacLeish is more succinct: "Without the Arts, how can the university teach the Truth?"

The information in this text helps us understand the elements that comprise works of art, which we can respond to and which make our experiences more rewarding.

AESTHETIC PERCEPTION AND RESPONSE

In this chapter we have examined the nature of the arts and a bit of their relationship to life. The question of how we go about approaching them, or how we study them, is another challenge. A myriad of methods is available, and so it remains to choose one and carry on from there. The purpose of this book is to provide a concentrated reference that covers all the arts. We assume those who are interested in such a work have had only limited exposure to the arts. So we have chosen a method of study that can act as a springboard into the arts and literature, as a point of departure from the realm of the familiar into the unknown. Inasmuch as we live in a world of facts and figures, weights and measures, it seems logical to begin our study by dealing with some concrete characteristics. In other words, from mostly an intellectual point of view, what can we see and what can we hear in the arts and literature?

*Edwin J. Delattre, "The Humanities Can Irrigate Deserts," *The Chronicle of Higher Education*, October 11, 1977, p. 32.

To put that question in different terms, how can we sharpen our aesthetic perception?

- First of all, we must identify those items that can be seen and heard in works of art and literature.
- Second, we must learn—just as we learn any subject—some of the terminology relating to those items.
- Third, we must understand why and how what we perceive relates to our response.

It is, after all, our response to an artwork that interests us. We can *perceive* an object. We *choose* to *respond* to it in aesthetic terms.

We need to employ a consistent method as we pass from one art discipline to another. We will ask three questions: (1) What is it? (2) How is it put together? (3) How does it stimulate our senses? We will study these questions in each of the art disciplines. As we will see, these are also the basic questions we can ask about individual artworks.

When we respond to the question *What is it?* we make a *formal* response. We recognize we are perceiving the two-dimensional space of a picture, the three-dimensional space of a sculpture or a piece of architecture, or perhaps time in sound, or time and space in dance. We also recognize the form of the item—for example, a still life, a human figure, a tragedy, a ballet, a concerto, a narrative film, a park, or a residence. The term *form* is a broad one: There are *art forms*, *forms* of arts, and *forms* in art.

When we respond to the question *How is it put together?* we respond to the technical elements of the artwork. We recognize and respond to, for instance, the fact that the picture has been done in oil, made by a printmaking technique, or created as a watercolor. We also recognize and respond to the elements that constitute the work, the items of composition—line, form or shape, mass, color, repetition, harmony—and the unity that results from all of these. What devices have been employed, and how does each part relate to the others to make a whole? A concerto is

composed of melody, harmony, timbre, tone, and more; a tragedy utilizes language, mise-en-scène, exposition, complication, denouement; a ballet has formalized movement, mise-en-scène, line, idea content, and so on.

Moving to the third question, we examine *how the work stimulates our senses*—and why. In other words, how do the particular formal and technical arrangements (whether conscious or unconscious on the part of the artist) elicit a sense response from us? Here we deal with physical and mental properties. For example, our response to sculpture can be physical. We can touch a piece of sculpture and sense its smoothness or its hardness. In contrast, we experience sense responses that are essentially mental. For example, upright triangles give us a sense of solidity. When we perceive the colors green and blue we call them "cool"; reds and yellows are "warm" colors. Pictures that are predominantly horizontal or composed of broad curves are said to be "soft" or placid. Angular, diagonal, or short, broken lines stimulate a sense of movement. Music that utilizes undulating melodic contours can be "smooth"; music that is highly consonant can be "warm" or "rich." These and other sense responses tend to universal; most individuals respond in similar fashion to them.

We also can ask a fourth question about a work of art: *What does the work mean?* We may answer that question in strictly personal terms, for example, a painting may remind us of some personal experience. However, we cannot dismiss the question *What does it mean?* as a reference to purely personal experience. Meaning in a work of art* implies much more. The ultimate response, meaning, and experience of an artwork goes beyond opinion to encompass an attempt to understand what the communicator may have had in mind. It is not sufficient, for example, merely to regard the disproportionate forms of a Mannerist painting as "strange." *Meaning* implies

*From here on, *art* and *artwork* can be assumed to include literary works as well.

an understanding of the discomforting circumstances of religion and society that existed during that period. When we understand that, we may understand *why* the paintings of that period appear as they do. We may also sympathize with the agonies of individuals trying to cope with their universe. As a result, the "strangeness" of the artwork may come to mean something entirely different to us personally. Sometimes meaning in an artwork can be enhanced by understanding cultural or historical contexts, including biography. Sometimes artworks spring from purely aesthetic necessity. Sometimes it is difficult to know which case applies or whether both cases apply.

In this book, we delve into only the first three questions (What is it? How is it put together? How does it stimulate our senses?) because the fourth involves a great deal more information than our space allows.

STYLE IN THE ARTS

A work of art or an art form is one person's vision of human reality expressed in a particular medium and shared with others. That summation indicates briefly what the aesthetic experience is about. The manner in which artists express themselves constitutes their *style*. Style is tantamount to the personality of an artwork. However, applying its connotations to a body of artworks calls for breadth and depth of knowledge. Style is that body of characteristics that identifies an artwork with an individual, a historical period, a school of artists, or a nation, for example, realism, expressionism, abstract, and so on. For an overview of some important styles, refer to the "A Matter of Style" boxes throughout the text. Applying the term means assimilating materials and drawing conclusions.

Therefore, determining the style of any artwork requires analysis of how the artist has arranged the characteristics applicable to his or her medium. If the usage is similar to others, we might conclude they exemplify the same style.

For example, Bach and Handel typify the *baroque* style in music; Haydn and Mozart, the *classical*. Listening to works by these composers quickly leads to the conclusion that the ornate melodic developments of Bach are like those of Handel, and quite different from the precise concern for structure and clearly articulated motifs of Mozart and Haydn. The precision and symmetry of the Parthenon compared with the ornate opulence of the Palace of Versailles suggest that in line and form the architects of these buildings treated their medium differently. Yet the design of the Parthenon is very much a visual companion, stylistically, of Mozart and Haydn; Versailles reflects an approach to design similar to that of Bach and Handel.

We can take our examination one step further and play a game of stylistic analysis with four paintings. The first three of these paintings were done by three different artists; the fourth, by one of those three. By stylistic analysis we will determine the painter of the fourth painting. Inasmuch as we have not yet dealt with definitions in composition, our analysis will be as nontechnical as possible. We use three characteristics only: *line, palette,* and *brush stroke.*

The first painting (Fig. 1.11) is Corot's *A View Near Volterra.* We can see that Corot has used

Figure 1.11 Jean-Baptiste-Camille Corot, French (1796–1875), *A View Near Volterra* (1838). Canvas, 27³/8" × 37¹/2". National Gallery of Art, Washington, D.C. Chester Dale Collection. (See also color insert Plate 6.)

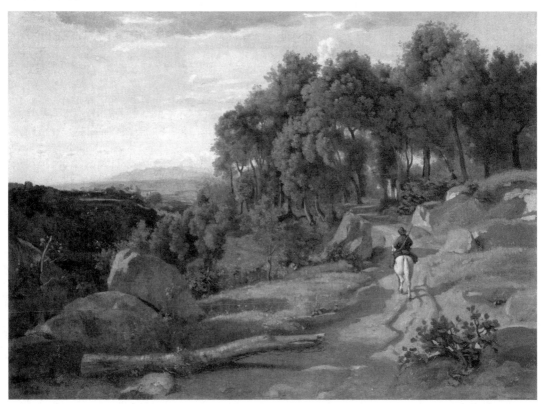

curvilinear line primarily, and that line (which creates the edges of the forms or shapes in the painting) is somewhat softened. That is, many of the forms—the rocks, trees, clouds, and so on—do not have crisp, clear edges. Color areas tend to blend with each other, giving the painting a softened, somewhat fuzzy or out-of-focus appearance. That comfortable effect is heightened by Corot's use of *palette*. Palette, as we note later, encompasses the total use of color and contrast. As with his use of line, Corot maintains a subtle value contrast—that is, a subtle relationship of dark and light. His movement from light to dark is gradual, and he avoids stark contrasts. He employs a limited range of colors, but does so without calling attention to their positioning. His *brush stroke* is somewhat apparent: If we look carefully, we can see brush marks, individual strokes where paint has been applied. Even though the objects in the painting are lifelike, Corot has not made any pretensions about the fact that his picture has been painted. We can tell the foliage was executed by stippling (by dabbing the brush to the canvas as you would dot an

"i" with a pencil). Likewise, we can see marks made by the brush throughout the painting. The overall effect of the painting is one of realism, but we can see in every area the spontaneity with which it was executed.

The second painting (Fig. 1.12) is Picasso's *Guernica*. We hardly need be an expert to tell that this painting is by a different painter—or certainly in a different style than the previous one. Picasso has joined curved lines and straight lines, placing them in such relationships that they create movement and dissonance. The edges of color areas and forms are sharp and distinct; nothing here is soft or fuzzy. Likewise, the value contrasts are stark and extreme. Areas of the highest value—that is, white—are forced against areas of the lowest value—black. In fact, the range of tonalities is far less broad than in the previous work. The mid or medium (gray) tones are there, but they play a minor role in the effect of the palette. In palette the work is limited to blacks, whites, and grays. The starkness of the work is also reinforced by brush stroke, which is noteworthy in its near *absence*

Figure 1.12 Pablo Picasso, *Guernica* (mural) (1937, May–early June). Oil on canvas, 11'6" × 25'8". Museo Nacional Centro de Arte Reina Sophia, Madrid. ©Estate of Pablo Picasso/Artists Rights Society (ARS), New York.

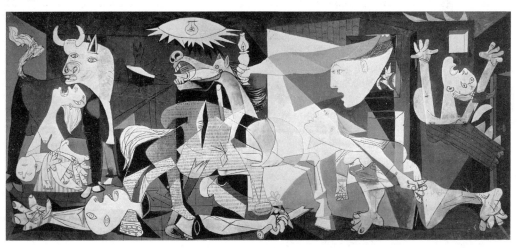

Pablo Picasso

Pablo Picasso (1881-1973) was born in Málaga, on the Mediterranean coast of Spain. He studied at the Academy of Fine Arts in Barcelona but having already mastered realistic technique, had little use for school. At 16 he had his own studio in Barcelona. In 1900 he first visited Paris, and in 1904 he settled there. His personal style began to form in the years from 1901 to 1904, a period often referred to as his blue period because of the pervasive blue tones he used in his paintings at that time. In 1905, as he became more successful, Picasso altered his palette, and the blue tones gave way to a terracotta color, a shade of deep pinkish red. At the same time his subject matter grew less melancholy and included dancers, acrobats, and harlequins. The paintings he did during the years between 1905 and 1907 are said to belong to his rose period.

Picasso played an important part in the sequence of different movements in the twentieth century. He said that to repeat oneself is to go against "the constant flight forward of the spirit." Primarily a painter, he also became a fine sculptor, engraver, and ceramist. In 1917 Picasso went to Rome to design costumes and scenery for Sergei Diaghilev's *Ballets Russes*. This work stimulated another departure in Picasso's work, and he began to paint the works now referred to as belonging to his classic period, which lasted from about 1918 until 1925.

At the same time he was working on designs for the ballet, Picasso also continued to develop the cubist technique (see Fig. 1.14 and Plate 5), making it less rigorous and austere.

His painting *Girl Before a Mirror* (Fig. 1.14 and Plate 5) gives us an opportunity to study his use of color in contrast to form. The painting depends greatly on form, and yet, if we compare Figure 1.14 with Plate 5, we understand how color gives meaning to this work. For example, Picasso chose red and green perhaps because they are complementary colors and perhaps, as art historian H. W. Janson suggests, because Picasso intended the green spot in the middle of the forehead of the mirror's image as a symbol of the girl's psyche, or inner self, which she confronts with apparent anguish.

Guernica (Figs. 1.12 and 2.26), his moving vision of the Spanish Civil War, also depends on curved forms. In this painting, however, the forms are intended to be fundamental because Picasso uses no color, only whites, grays, and black. *Guernica*, a huge painting, was Picasso's response to the 1937 bombing by the Fascist forces of the small Basque town of Guernica. In it distortions of form approach surrealism (see "A Matter of Style," page 48), but Picasso never called himself a surrealist. Picasso continued to work with incredible speed and versatility—as painter, ceramist, sculptor, designer, and graphic artist—into his nineties. The value of his estate was estimated at more than 500 million dollars when he died on April 8, 1973, in Mougins, France.

of effect. Tonal areas are flat, and few traces of brush exist.

The third painting (Fig. 1.13) is van Gogh's *The Starry Night*. Use of line is highly active although uniformly curvilinear. Forms and color areas have both hard and soft edges, and van Gogh, like Picasso, uses outlining to strengthen his images and reduce their reality. The overall effect of line is a sweeping and undulating movement, highly dynamic and yet far removed from the starkness of the Picasso. In contrast, van Gogh's curvilinearity and softened edges are quite different in effect from the relaxed quality of the Corot. Van Gogh's value contrasts are very broad, but moderate. He ranges from darks to lights, all virtually equal in importance.

Even when movement from one area to another is across a hard edge to a highly contrasting value, the result is moderate: not soft, not stark. It is, however, brush stroke that gives the painting its unique personality. We can see thousands of individual brush marks where the artist applied paint to canvas. The nervous, almost frenetic use of brush stroke makes the painting come alive.

Now that we have examined three paintings in different styles and by different artists, can you determine which of the three painted Figure 1.14? First, examine the use of line. Form and color edges are hard. Outlining is used. Curved and straight lines are *juxtaposed* against each other. The effect is active and stark. By

Figure 1.13 Vincent van Gogh, *The Starry Night* (1889). Oil on canvas, 29" × 36¼". ©Collection, The Museum of Modern Art, New York. Acquired through the Lillie P. Bliss Bequest.

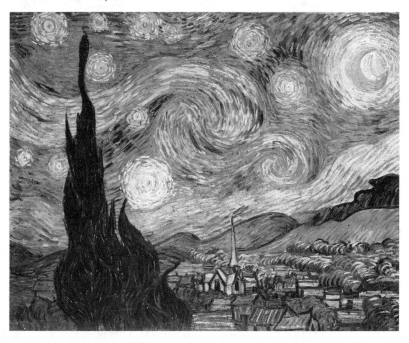

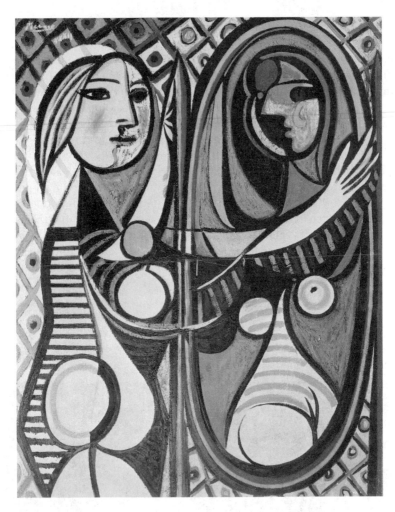

Figure 1.14 Exercise painting. See Plate 5 for identification.

comparison, use of line is not like Corot, a bit like van Gogh, and very much like Picasso. Next, examine palette. Darks and lights are used broadly. However, the principal utilization is of strong contrast—the darkest darks against the lightest lights. This is not like Corot, a bit like van Gogh, and most like Picasso. Finally, brush stroke is generally unobtrusive. Tonal areas mostly are flat. This is definitely not a van Gogh and probably not a Corot. Three votes out of three go to Picasso, and the style is so distinctive you probably had no difficulty deciding, even without the analysis. However, could you have been so certain if asked whether Picasso painted Figure 1.15? A work by another cubist painter would pose even greater difficulty. So some differences in style are obvious; some are unclear. Distinguishing the work of one artist from another who

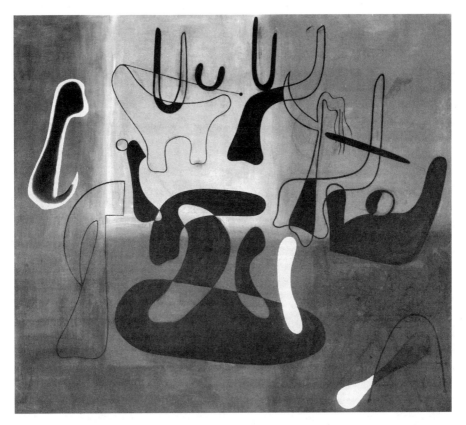

Figure 1.15 Joan Miro, *Painting*, 1933, oil on canvas, 68¹/₂" × 65¹/₄" (174 × 196.2 cm). The Museum of Modern Art, New York. Loula D. Lasker Bequest (by exchange). © 1998 Artists Rights Society (ARS), New York/ADAGP, Paris.

designs in a similar fashion becomes even more challenging. However, the analytical process we just completed is indicative of how we can approach artworks to determine *how* they exemplify a given style, or what style they reflect.

We recognize differences in style sometimes without thinking much about it. Our experience or formal training need not be extensive to recognize that the buildings in Figure 1.16 and 1.18 reflect different cultural circumstances. The

Russian Orthodox Church in Figure 1.16 (see also color insert Plate 1) is distinguishable by its characteristic domes and by the icons that decorate its walls (Fig. 1.17). In the same sense, the tomb in Figure 1.18 is typically Moslem, identifiable by its arch.

The decorative embellishment (Fig. 1.19), in contrast to the icons of the Orthodox church, reflects the prohibition of the Islamic faith of depicting human form in architectural decoration.

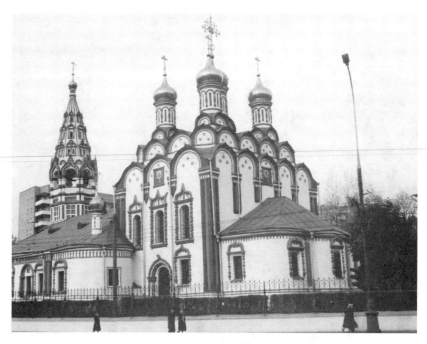

Figure 1.16 The Church of Nikolai Khamovnik (1679–1682). Moscow, Russia. (See also color insert Plate 1.)

Figure 1.17 Detail, front portal, The Church of Nikolai Khamovnik (1679–1682). Moscow, Russia.

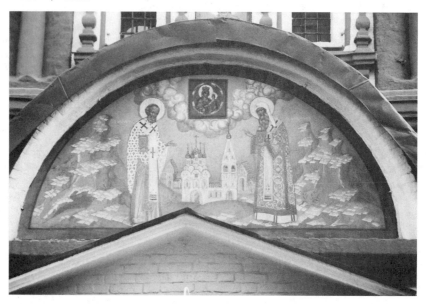

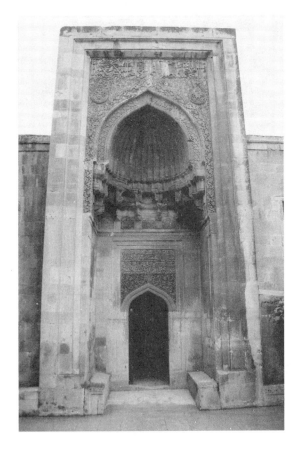

Figure 1.18 Tomb of the Shirvanshah (fifteenth century A.D.). Baku, Azerbaijan.

Figure 1.19 Detail, entrance portal, Tomb of the Shirvanshah (fifteenth century A.D.). Baku, Azerbaijan.

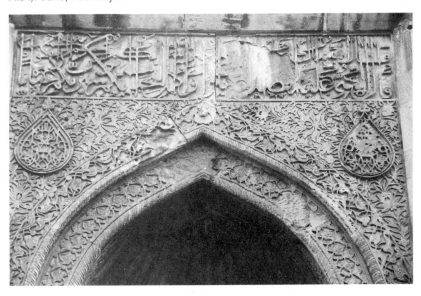

Pictures

Painting, Printmaking, and Photography

Pictures of family, friends, rock and sports stars, copies of artistic masterpieces, and original paintings and prints adorn our personal spaces. Dorm rooms, bedrooms, living rooms, and other places where we live seem coldly empty and depersonalized without pictures of some kind in them. Pictures have always been important to us. People who lived in caves 20,000 years ago drew pictures on their walls. In this chapter we'll learn about the many ways pictures can be made and how artists use two-dimensional qualities to speak to us.

What is it?

Paintings, photographs, and prints are pictures, differing primarily in the technique of their execution. They are two dimensional, and their subject might be a landscape, seascape, portrait, religious picture, nonobjective (nonrepresentational) or abstract picture, still life, or something else. So, at first encounter, our response is a simple and straightforward matter of observing subject matter.

How is it put together?

Medium

Our technical level of response is more complex. First of all, our response to how a work is put together is to the medium used by the artist to execute the work.

Paintings and Drawings

Paintings and drawings are executed through use of oils, watercolors, tempera, acrylics, fresco, gouache, ink, pastels, and pencils, to name just a few. An artist may combine these media and may use some others. Each medium has its own characteristics and to a great extent dictates what the artist can or cannot achieve as an end result.

OILS are perhaps the most popular of the painting media, and have been since their development near the beginning of the fifteenth century. Their popularity stems principally from the great variety of opportunity they give the painter. Oils offer a wide range of color possibilities; because they dry slowly, they can be reworked; they present many options for textural manipulation; and they are durable. If we compare two oils, van Gogh's *The Starry Night* (Fig. 2.1) and Giovanni Vanni's *Holy Family with Saint John* (see color insert Plate 2), the medium shows its importance to the final effect of the works. Vanni creates light and shade in the baroque tradition, and his chiaroscuro (pronounced key·ahr´·ūh·skū´·rō) depends on the capacity of the medium to blend smoothly among color areas. Van Gogh, in contrast, requires a medium that will stand up to form obvious brush strokes. Vanni demands the paint to be flesh and cloth. Van

Gogh demands the paint to be paint and to be stars and sky, but also to call attention to itself.

WATERCOLOR is a broad category that includes any color medium that uses water as a thinner. However, the term has traditionally referred to a transparent paint usually applied to paper. Because watercolors are transparent, artists must be very careful to control them. If one area of color overlaps another, the overlap will show as a third area combining the previous hues. But their transparency gives watercolors a delicacy that cannot be produced in any other medium.

TEMPERA is an opaque watercolor medium whose use spans recorded history. It was employed by the ancient Egyptians and is still used today. Tempera refers to ground pigments and their color binders such as gum or glue, but is best known as its egg tempera form. It is a fast-drying

Figure 2.1 Vincent van Gogh, *The Starry Night* (1889). Oil on canvas, 29" × 36¼". Collection, The Museum of Modern Art, New York. Acquired through the Lillie P. Bliss Bequest.

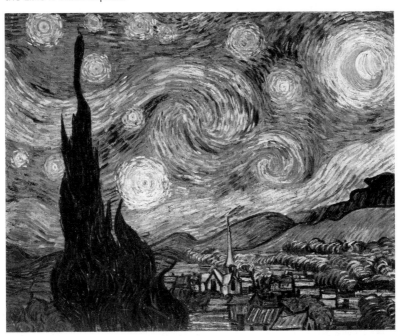

medium that virtually eliminates brush strokes and gives extremely sharp and precise detail. Colors in tempera paintings appear almost gemlike in their clarity and brilliance.

ACRYLICS, in contrast with tempera, are modern synthetic products. Most acrylics are water soluble (that is, they dissolve in water), and the binding agent for the pigment is an acrylic polymer. Acrylics are flexible media offering artists a wide range of possibilities in both color and technique. An acrylic paint can be either opaque or transparent, depending on dilution. It is fast drying, thin, and resistant to cracking under temperature and humidity extremes. It is perhaps less permanent than some other media but adheres to a wider variety of surfaces. It will not darken or yellow with age, as will oil.

FRESCO is a wall-painting *technique* in which pigments suspended in water are applied to fresh wet plaster. Michelangelo's Sistine Chapel frescoes are the best known examples of this technique. Because the end result becomes part of the plaster wall rather than being painted on it, fresco provides a long-lasting work. However, it is an extremely difficult process, and once the pigments are applied, no changes can be made without replastering the entire section of the wall.

GOUACHE is a watercolor medium in which gum is added to ground opaque colors mixed with water. Transparent watercolors can be made into gouache by adding Chinese white to them, a special white, opaque, water-soluble paint. The final product, in contrast to watercolor, is opaque.

INK as a painting medium has many of the same characteristics as transparent watercolor. It is difficult to control, yet its effects are nearly impossible to achieve in any other medium. Because it must be worked quickly and freely, it has a spontaneous and appealing quality (see Fig. 2.2).

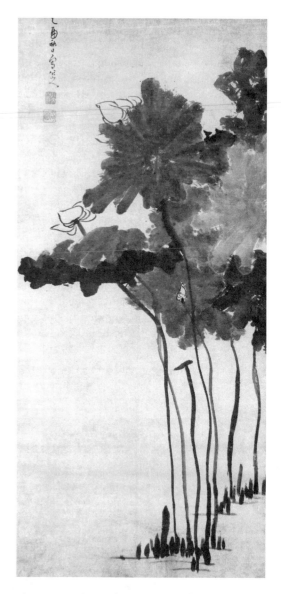

Figure 2.2 Chu Ta (Pa-ta-shan-jen), *Lotus* (1705). Brush and ink, 61½" × 28". Palmer Museum of Art, The Pennsylvania State University.

DRAWING MEDIA such as ink, when applied with a pen (as opposed to a brush), pastels (crayon or chalk), and pencils all create their effect through buildup of line. Each has its

own characteristics, but all are relatively inflexible in their handling of color and color areas (see Fig. 2.8).

Prints

Prints fall generally into three main categories based essentially on the nature of the printing surface. First is *relief printing* such as woodcut, wood engraving, linoleum cut, and collograph. Second is *intaglio*, including etching, aquatint, drypoint, and again, collograph. Third is the *planographic process*, which includes lithography and serigraphy (silkscreen) and other forms of stenciling. In addition, other combinations and somewhat amorphous processes such as mono-printing also are used by printmakers.

To begin with, however, we need to ask, What is a print? A print is a hand-produced picture that has been transferred from a printing surface to a piece of paper. The artist personally prepares the printing surface and directs the printing process. The uniqueness and value of a print reside in the fact that the block or surface from which the print is made usually is destroyed after making the desired number of prints. In contrast, a reproduction is not an original. It is a *copy* of an original painting or other artwork, reproduced usually by a photographic process. As a copy, the reproduction does not bear the handiwork of an artist. In purchasing prints we must be sure we are buying an actual print (which has value as an artwork) and not a reproduction (which lacks such value) disguised by obscure or misleading advertising.

Note that every print has a number. On some prints the number may appear as a fraction—for example, 36/100. The denominator indicates how many prints were produced from the plate or block. This number is called the *issued number*, or *edition number*. The numerator indicates where in the series the individual print was produced. A single number such as 500 (also called an issue number), simply indicates the total number of prints in the series. Printmakers are beginning to eliminate the former kind of numbering because

of the misconception that the relationship of the numerator to the issue total has a bearing on a print's value. The numerator is an item of curiosity only; it has nothing to do with a print's value, monetarily or qualitatively. The issue number does have some value in comparing, for example, an issue of 25 with one of 500, and usually is reflected in the price of a print. However, the edition number is not the sole factor in determining the value of a print. The quality of the print and the reputation of the artist are more important considerations.

RELIEF PRINTING. In relief printing, the image is transferred to the paper by cutting away non-image areas and inking the surface that remains. Therefore, the image protrudes, in relief, from the block or plate and produces a picture that is reversed from the image carved by the artist. This reversal is a characteristic of all printmaking media. *Woodcuts* and *wood engravings* are two popular techniques. A woodcut, one of the oldest techniques, is cut into the plank of the grain; a wood engraving is cut into the butt of the grain (Fig. 2.3). Figure 2.4 illustrates the linear essence of the woodcut and shows the precision and delicacy possible in this medium in the hands of a master. *Collograph* is a

Figure 2.3 Wood plank and butt.

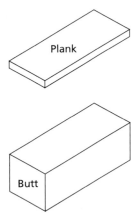

Plank

Butt

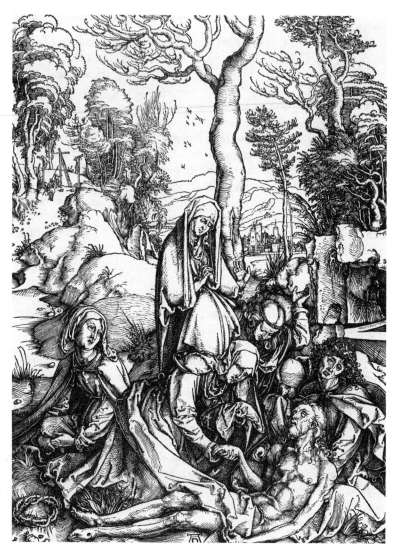

Figure 2.4 Albrecht Dürer, German (1471–1528), *Lamentation* (c. 1497–1500). Woodcut, 15½" × 11¼". Gift of the Friends of the Palmer Museum of Art. Palmer Museum of Art, The Pennsylvania State University.

printmaking process in which assorted objects are glued to a board or plate. A collograph represents relief printing when the raised surfaces are inked and printed. When the recessed areas are inked and printed, the collograph becomes an intaglio work.

INTAGLIO. The intaglio process is the opposite of relief printing. The ink is transferred to the paper not from raised areas but rather from grooves cut into a metal plate. *Line engraving, etching, drypoint,* and *aquatint* are some of the methods of intaglio.

Line Engraving involves cutting grooves into the metal plate with special sharp tools. It requires great muscular control because the pressure must be continuous and constant if the grooves are to produce the desired image. The print resulting from the line-engraving process

is very sharp and precise. This form of intaglio is the most difficult and demanding.

Etchings are less demanding. In this process the artist removes the surface of the plate by exposing it to an acid bath. First the plate is covered with a thin waxlike substance called a *ground*. Then the artist scratches away the ground to produce the desired lines. The plate is then immersed in the acid, which burns away the exposed areas of the plate. The longer a plate is left in the acid, the deeper the resulting etches will be; the deeper the etch, the darker the final image. So artists wishing to produce lines or areas of differing darkness must cover those lines that they do not desire to be more deeply cut before further immersions in the acid. They

can accomplish this task easily. The desired number of repetitions of the process yields a plate producing a print with the desired differences in light and dark lines. All the details of Figure 2.5 consist of individual lines, either single or in combination. The lighter lines required less time in the acid than the darker ones. Because of the precision and clarity of the lines, it would be difficult to determine, without knowing in advance, whether this print is an etching or an engraving. Drypoint, in contrast, produces lines with less sharp edges.

Drypoint is a technique in which the surface of the metal plate is scratched with a needle. Unlike line engraving, which results in a clean, sharp line, drypoint technique leaves a ridge on

Figure 2.5 Daniel Hopfer, *Ceiling Ornament*. Etching, 10" × 8³/4". Palmer Museum of Art, The Pennsylvania State University.

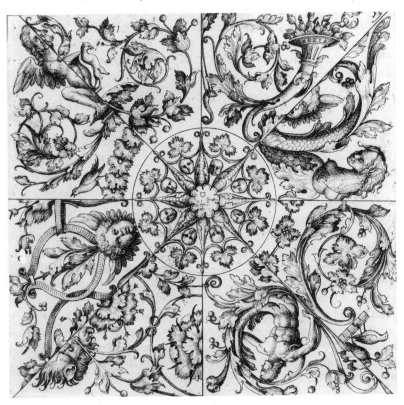

either side of the groove, resulting in a somewhat fuzzy line.

Aquatint. The intaglio methods noted thus far consist of various means of cutting lines into a metal plate. On occasion, however, an artist may wish to create large areas of subdued tonality. Such shadowlike areas cannot be produced effectively with lines. Therefore, the artist dusts the plate with a resin substance. The plate is then heated, which affixes the resin, and put into the acid bath. The result yields a plate with a rough surface texture, like sandpaper, and a print whose tonal areas reflect that texture.

Once the plate is prepared, whether by line engraving, etching, aquatint, drypoint, or a combination of methods, the artist is ready for the printing process. The plate is placed in a press and a special dampened paper is laid over it. Padding is placed on the paper and then a roller is passed over, forcing the plate and the paper together with great pressure. The ink, which has been carefully applied to the plate and left only in the grooves, transfers as the paper is forced into the grooves by the roller of the press. Even if no ink had been applied to the plate, the paper would still receive an image. This *embossing* effect marks an intaglio process; the three-dimensional *platemark* is very obvious.

PLANOGRAPHIC PROCESSES. In a planographic process, the artist prints from a plane surface (neither relief nor intaglio). *Lithography* (the term's literal meaning is "stone writing") rests on the principle that water and grease do not mix. To create a lithograph, artists begin with a stone, usually limestone, and grind one side until absolutely smooth. They then draw an image on the stone with a greasy substance. Artists can vary the darkness of the final image by the amount of grease they use: The more grease applied, the darker the image. After artists have drawn the image, they treat the stone with gum arabic and nitric acid and then rinse it with water. This bath fixes the greasy areas to the surface of the stone. The next step seems baffling. When the artist rinses the stone and fans it dry, the surface is clean! However, the water, gum, and acid have impressed the grease on the stone, and when the stone is wetted it absorbs water (limestone being porous) only in those areas that were not previously greased. Finally, a grease-based ink is applied to the stone. It, in turn, will not adhere to the water-soaked areas. As a result the stone, with ink adhering only to the areas on which the artist has drawn, can be placed in a press and the image transferred to the waiting paper. In Figures 2.6 and 2.7 we can see the characteristic most attributable to the medium of lithography—a crayon-drawing appearance. Because the lithographer usually draws with a crayonlike material on the stone, the final print has exactly that quality. Compare these prints with Figure 2.8, a pastel drawing, and the point is clear.

The *serigraphic* process (serigraphy) or silk-screening is the most common of the stenciling processes. Silkscreens are made from a wooden frame covered with a finely meshed silk fabric. The nonimage areas are blocked out with a glue mixture painted directly on the silk fabric or blocked out by a cut paper stencil. The stencil is placed in the frame and ink applied. By means of a rubber instrument called a squeegee, the ink is forced through the openings of the stencil, through the screen, and onto the paper below. This technique allows the printmaker to achieve large, flat, uniform color areas. We can see this smooth uniformity of color areas in Figure 2.9. Here the artist, through successive applications of ink, has built up a complex composition with highly verisimilar (lifelike) detail.

Looking over Figures 2.4 through 2.9, we see how the images of the various prints reflect recognizable differences in technique. Again, it is not always possible to discern the technique used in executing a print, and some prints reflect a combination of techniques. However, in seeking the method of execution, we add another layer of potential response to a work.

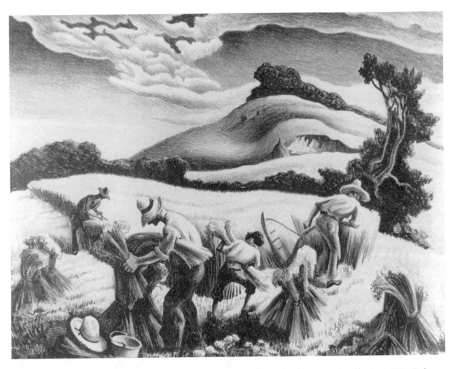

Figure 2.6 Thomas Hart Benton, *Cradling Wheat* (1938). Lithograph, 9^{1}/$_{2}$" × 12". Palmer Museum of Art, The Pennsylvania State University. Gift of Carolyn Wose Hull.

Figure 2.7 Charles Sheeler, *Delmonico Building* (1926). Lithograph, 10" × 7^{1}/$_{8}$". Palmer Museum of Art, The Pennsylvania State University.

Figure 2.8 Hobson Pittman,
Violets No. 1 (1971).
Pastel, 9¹/₂" x 10¹/₄".
Palmer Museum of Art,
The Pennsylvania
State University.

Figure 2.9 Nancy McIntyre
(American), *Barbershop Mirror*
(1976). Serigraph, 26¹/₂" X 19".
Palmer Museum of Art,
The Pennsylvania
State University.

Photography

In some cases photography is not really an art at all; it is merely a matter of personal record executed with equipment of varying degrees of expense and sophistication (see Fig. 2.10). Certainly photography as a matter of pictorial record, or even as *photojournalism*, may lack the qualities we believe requisite to art. A photograph of a baseball player sliding into second base or of Aunt Mabel cooking hamburgers at the family reunion may trigger expressive responses for us, but it is doubtful the photographers had aesthetic communication or particular design in mind when they snapped the shutter. But a carefully composed and sensitively designed and executed photograph can contain every attribute of human expression possible in any art form.

Ansel Adams saw the photographer as an interpretive artist; he likened a photographic negative to a musical score, and the print to a performance (see Fig. 2.11). In other words, despite all the choices the artist may make in committing an image to film, they are only the beginning of the artistic process. The photographer still has the choice of *size, texture,* and *value contrast,* or *tonality.* A photo of the grain of a piece of wood for example, has an enormous range of aesthetic possibilities depending on how the artist employs and combines these three elements.

Consequently, the question "Is it art?" may have a cogent application to photography. However, the quality of our aesthetic repayment from the photographic experience is higher if we view photography in the same vein as we do the other arts—as a visualization expressed through a technique and resulting in an aesthetic response or communication.

Composition

Our discussions of how any artwork is put together eventually result in a discussion of how it is composed. The elements and principles of *composition* are basic to all the arts, and we return to them time and time again as we proceed.

Figure 2.10 The single-lens reflex (SLR) camera.

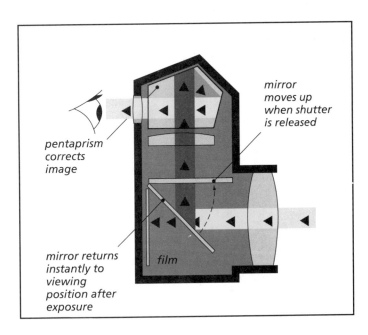

Figure 2.11 Ansel Adams, *Moon and Half Dome,* Yosemite National Park, California (1960). © The Ansel Adams Publishing Rights Trust.

Elements

LINE. The basic building block of a visual design is line. To most of us a line is a thin mark such as this: ————. We find that denotation in art as well. In color insert Plate 3 we find amorphous shapes. Some of these shapes are like cartoon figures; that is, they are identifiable from the background because of their *outline*. In these instances line identifies form and illustrates the first sentence of this paragraph. However, the other shapes in Plate 3 also exemplify line. If we put our finger on the edge of these shapes, we have identified a second aspect of line: the boundary between areas of color and between shapes or forms. (We noted this use of line in our discussion of style in Chapter 1.) There is one further aspect of line, which is implied rather than physical. The three rectangles in Figure 2.12 create a horizontal line that extends across the design. There is no physical line between the tops of the forms, but their spatial arrangement creates one by implication. A similar use of line occurs in Figure 2.1, where we

Figure 2.12 Outline and implied line.

can see a definite linear movement from the upper left border through a series of swirls to the right border. That line is quite clear, although it is composed not of a form edge or outline but of a carefully developed relationship of numerous color areas. This treatment of line is also seen in Figure 2.13, although here it is much more subtle and sophisticated. By dripping paint onto his canvas (a task not as easily executed or accidental as it might appear), the artist was able to subordinate form, in the sense of recognizable and distinct areas, and thereby *focal areas*, to a dynamic network of complex lines. The effect of this technique of execution has a very strong relationship to the actual force and speed with which the pigment was applied.

An artist uses line to control our vision, to create unity and emotional value, and ultimately to develop meaning. In pursuing those ends, and by employing the three aspects of line noted earlier, the artist finds that line has two characteristics: It is *curved* or it is *straight*.

Whether expressed as an outline, as an area edge, or by implication, and whether simple or in combination, a line is some derivative of the characteristics of straightness or curvedness. Some people speculate whether line can also be thick or thin. Certainly that quality is helpful in describing some works of art. Those who deny that quality, however, have a point difficult to refute in asking, If line can be thick or thin, at what point does it cease to be a line and become a form?

FORM. Form and line are closely related both in definition and in effect. Form is the *shape* of an object within the composition, and *shape* often is used as a synonym for form. Literally, form is that space described by line. A building is a form. So is a tree. We perceive them as buildings or trees, and we also perceive their individual details because of the line by which they are composed; form cannot be separated from line in two-dimensional design.

Figure 2.13 Jackson Pollock, *One (Number 31, 1950)* (1950). Oil and enamel on unprimed canvas, 8' 10" × 17' 5⅝". The Museum of Modern Art, New York. The Sidney and Harriet Janis Collection Fund (by exchange). ©1998 Pollock-Krasner Foundation/Artists Rights Society (ARS), New York.

COLOR. Color characteristics differ depending on whether we are discussing color in light or color in pigment. For example, in light the primary hues (those hues that cannot be achieved by mixing other hues) are red, *green*, and blue; in pigment they are red, *yellow*, and blue. If we mix equal proportions of yellow and blue pigments we have green. Because green can be achieved by mixing, it cannot be a primary—in pigment. However, no matter how hard we try, we cannot mix any hues that will achieve green light. Inasmuch as our response to artworks most often deals with colored pigment, the discussion that follows concerns color in pigment. We do not discuss color in light.

Hue. Hue is the spectrum notation of color; a hue is a specific pure color with a measurable wavelength. The visible range of the color spectrum extends from violet on one end to red on the other. The color spectrum consists of three primary hues, blue, yellow, and red and three additional, secondary, hues that are direct derivatives of them: green, orange, and violet. These six hues are the basic hues of the spectrum, and each has a specific, measurable wavelength (Fig. 2.14). In all there are (depending on which the-

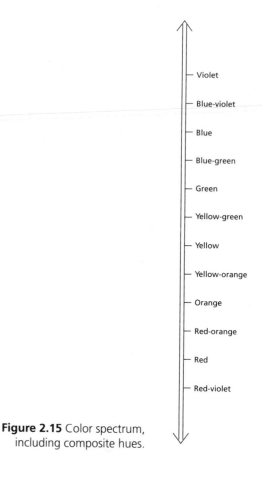

Figure 2.15 Color spectrum, including composite hues.

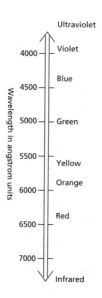

Figure 2.14
Basic color spectrum.

ory one follows) from ten to twenty-four perceivably different hues, including these six. These perceptible hues are the composite hues of the color spectrum.

For the sake of clarity and illustration, let us assume twelve basic hues. Arranged in a series, they would look like Figure 2.15. However, because combinations of these hues are possible beyond the straight-line configuration of the spectrum, it is helpful to visualize color by turning the color spectrum into a color wheel (Fig. 2.16; see also color insert Plate 4). With this visualization we now can discuss what an artist can do to and with color. First, an artist can take the primary hues of the spectrum, mix them two at a time in varying proportions, and create the other hues of the spectrum. For example, red and

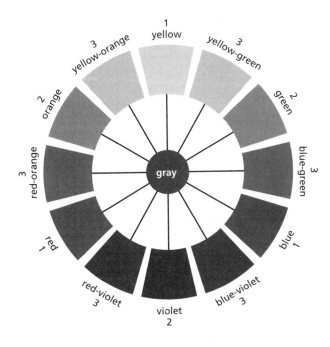

Figure 2.16 Color wheel.
(See also color insert Plate 4.)

Figure 2.17
Value scale.

White

High light

Light

Medium light

Medium (gray)

High dark

Dark

Low Dark

Black

yellow in equal proportions make orange, a *secondary hue*. Varying the proportions—adding more red or more yellow—makes yellow-orange or red-orange, which are *tertiary hues*. Yellow and blue make green, and also blue-green and yellow-green, red and blue gives us violet, blue-violet, and red-violet. Hues directly opposite each other on the color wheel are *complementary*. When they are mixed together in equal proportions, they produce gray (see **Intensity**).

Value. In discussing photography, we noted in passing the concept of value contrast—the relationship of blacks to whites and grays. The range of possibilities from black to white forms the *value scale*, which has black at one end, white at the other, and medium gray in the middle. The perceivable tones between black and white are designated light or dark (Fig. 2.17).

The application of the effects of value on color is treated in different ways by different sources. However, it appears most helpful if we approach the subject less from a theoretical

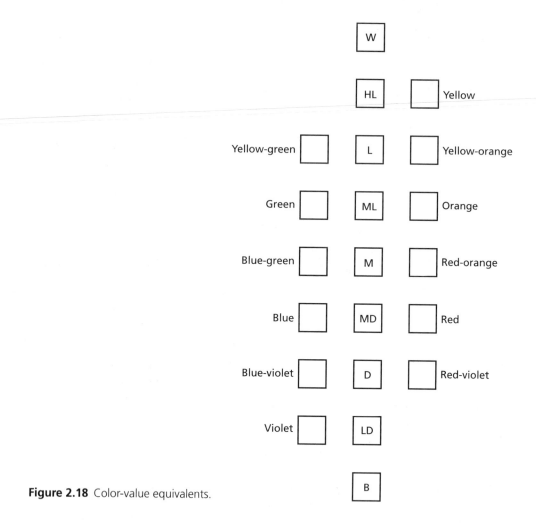

Figure 2.18 Color-value equivalents.

point of view and more from a practical one. That is, what can painters do to color in order to create a painting that gives the effect they desire? As we indicated, they may mix primaries to create secondary and tertiary hues. Every hue has its own value; that is, in its pure state each hue falls somewhere on the value scale in Figure 2.18.

A broad range of color possibilities exists between high-light gray and pure white or between a pure hue and white, which does not fall on the traditional value scale. That range of possibilities is described by the term *saturation*. A saturated hue is a pure hue. An unsaturated hue is a hue to which some quantity of white alone has been added. Unsaturated hues, such as pink, are known as *tints*. What is not entirely clear is whether saturation is part of or separate from value—that is, whether the two terms should be considered as separate properties of color change or whether value includes saturation. More on this momentarily.

We can easily see that some colors are brighter than others. As we noted, the perceivable

difference in brightness between primary yellow and primary blue is due to their difference in value. However, it is possible to have a *bright* yellow and a *dull* yellow. The difference in brightness between the two may be a matter of value, as we just observed—a pure yellow versus a grayed yellow. It also may be a matter of surface *brilliance*, or reflectance, a factor of considerable importance to all visual artists. A highly reflective surface creates a brighter color, and therefore a different response from the observer, than does a surface of lesser reflection, although all other color factors may be the same. This is the difference among high gloss, semigloss, and flat paints, for example. Probably surface reflectance is more a property of texture than of color. However, the term *brilliance* is often used to describe not only surface gloss but also characteristics synonymous with value. Some sources also use brilliance as a synonym for saturation; still others use saturation as a synonym for an additional color-change possibility, *intensity*.

Intensity. Intensity is the degree of purity of a hue. It also is sometimes called *chroma*. Returning to the color wheel (Fig. 2.16), we note that movement around the wheel creates a change in hue. Movement *across* the wheel creates a change in intensity. If we add green to red we alter its intensity. When, as in this case, hues are directly opposite each other on the color wheel such mixing has the practical effect of *graying* the original hue. Therefore, because graying a hue is a *value* change, one occasionally finds intensity and value used interchangeably. Some sources use the terms independently but state that changing a color's value *automatically* changes its intensity. Let's think about the implications of these concepts. There is a difference between graying a hue by using its complement and graying a hue by adding black (or gray derived from black and white). A gray derived from complementaries, because it *has color*, is far livelier than a gray derived from black and white, which are not colors.

The composite, or overall, use of color by an artist is termed *palette*. An artist's palette can be broad, restricted, or somewhere in between, depending on whether the artist has utilized the full range of the color spectrum and/or whether he or she explores the full range of *tonalities*—brights and dulls, lights and darks.

MASS (SPACE). Only three-dimensional objects have mass, that is, take up space and have density. However, two-dimensional objects give the illusion of mass, *relative* only to the other objects in the picture.

TEXTURE. The texture of a picture is its apparent roughness or smoothness. Texture ranges from the smoothness of a glossy photo to the three-dimensionality of *impasto*, a painting technique in which pigment is applied thickly with a palette knife to raise areas from the canvas. The texture of a picture may be anywhere within these two extremes. Texture may be illusory in that the surface of a picture may be absolutely flat but the image gives the impression of three-dimensionality. So the term can be applied to the pictorial arts either literally or figuratively.

Principles

REPETITION. Probably the essence of any design is repetition: how the basic elements in the picture are repeated or alternated. In discussing repetition let's consider three terms: *rhythm*, *harmony*, and *variation*.

Rhythm is the ordered recurrence of elements in a composition. Recurrence may be regular or irregular. If the relationships among elements are equal, the rhythm is regular (Fig. 2.12). If not, the rhythm is irregular. However, we must examine the composition as a whole to discern if patterns of relationships exist and whether or not the *patterns* are regular, as they are in Figure 2.19.

Figure 2.19 Repetition of patterns.

Harmony is the logic of the repetition. Harmonious relationships are those whose components appear to join naturally and comfortably. If an artist employs forms, colors, or other elements that appear incongruous, illogical, or out of sync, then we would use a musical term and say the resulting picture is dissonant; its constituents simply do not go together in the way our cultural conditioning would describe as natural. We do need to understand here, nevertheless that ideas and ideals relative to harmonious relationships in color or other elements often reflect cultural conditioning or arbitrary understandings (conventions).

Variation is the relationship of repeated items to each other; it is similar to theme and variation in music. How does an artist take a basic element in the composition and use it again with slight or major changes? The artist of color insert Plate 5 has taken two geometric forms, the diamond and the oval, and created a complex painting via repetition. The diamond with a circle at its center is repeated over and over to form the background. Variation occurs in the color given to these shapes. Similarly, the oval of the mirror is repeated with variations in the composition of the girl. The circular motif also is repeated throughout the painting, with variations in color and size—similar to the repetition and variation in the design of the Volkswagen noted in Figure 1.10.

BALANCE. The concept of balance is very important. It is not difficult to look at a composition and almost intuitively respond that it does or does not appear balanced. Most individuals have this second sense. Determining, *how* artists achieve balance in their pictures is an important aspect of our own response to pictures.

Symmetry. The most mechanical method of achieving balance is *symmetry*, or specifically, bilateral symmetry, the balancing of like forms, mass, and colors on opposite sides of the vertical axis of a picture. Symmetry is so precise that we can measure it. Pictures employing absolute symmetry tend to be stable, stolid, and without much sense of motion. Many works approach symmetry, but retreat from placing mirror images on opposite sides of the centerline, as do Figures 2.12, 2.20, and 2.21, all of which are symmetrical.

Asymmetrical Balance, sometimes referred to as psychological balance, is achieved by careful placement of unlike items (Fig. 2.22). It might seem that asymmetrical balance is a matter of opinion. However, intrinsic response to what is balanced or unbalanced is relatively uniform among individuals, regardless of their aesthetic training. Every painting illustrated in this chapter is asymmetrical. Often color is used to balance

Figure 2.20 Closed composition (composition kept within the frame).

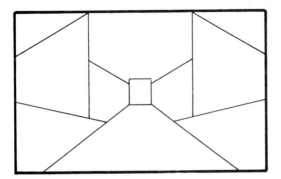

Figure 2.21 Open composition (composition allowed to escape the frame).

UNITY. With a few exceptions, we can say that artists strive for a sense of self-contained completeness in their artworks. Thus an important characteristic in a work of art is the means by which *unity* is achieved. All the elements of composition work together toward meaning. Often compositional elements are juxtaposed in unusual or uncustomary fashion to achieve a particular effect. Nonetheless, that effect usually comprises a conscious attempt at maintaining or completing a unified statement, that is, a total picture. Critical analysis of the elements of a painting should lead us to a judgment about whether the total statement comprises a unified one.

With regard to unity, we also must consider whether or not the artist allows the composition to *escape the frame*. People occasionally speak of *closed composition*, or composition in which use

line and form. Because some hues, such as yellow, have great eye attraction, they can balance tremendous mass and activity on one side of a painting, by being placed on the other side.

Figure 2.22 St. Mark and St. Luke from the Gospel Book of Godescale, 781–3. Vellum, 12¼" × 8¼". Bibliothèque Nationale de France—Paris.

Beverly Buchanan
Contemporary Voice

Beverly Buchanan's (b. 1940) work explores the medium of pastel oilsticks, and central to her work are the makeshift shacks that dot the Southern landscape near her home in Athens, Georgia. "Beginning in the early 1980s, Buchanan started photographing these shacks, an enterprise she has carried on ever since. 'At some point,' she says, 'I had to realize that for me the structure was related to the people who built it. I would look at shacks and the ones that attracted me always had something a little different or odd about them. This evolved into my having to deal with [the fact that] I'm making portraits of a family or person.'

"Buchanan soon began to make drawings and sculptural models of the shacks. Each of these models tells a story . . . for instance . . .

Some of Richard's friends had already moved north, to freedom, when he got on the bus to New York. Richard had been 'free' for fifteen years and homeless now for seven. . . . After eight years as a fore-man, he was 'let go.' He never imagined it would be so hard and cruel to look for something else. Selling his blood barely fed him. At night, dreams took him back to a childhood of good food, hard work, and his Grandmother's yard of flowers and pinestraw and wood. Late one night, his cardboard house collapsed during a heaving rain. Looking down at a soggy heap, he heard a voice, like thunder, roar this message through his brains, RICHARD GO HOME!

"Buchanan's sculpture does not represent the collapsed cardboard house in the North, but Richard's new home in the South. It is not just a ramshackle symbol of poverty. Rather, in its improvisational design, in its builder's determination to use whatever materials are available, to make something of nothing, as it were, the shack is a testament to the energy and spirit of its creator. More than just testifying to Richard's will to survive, his shack underscores his creative and aesthetic genius.

"Buchanan's oilstick drawings such as *Monroe County House with Yellow Datura* (Figure 2.23) are embodiments of this same energy and spirit. In their use of expressive line and color, they are almost abstract, especially in the fields of color that surround the shacks. Their distinctive scribble-like marks are based on the handwriting of Walter Buchanan, Beverly Buchanan's great-uncle and the man who raised her. Late in his life he suffered a series of strokes, and before he died he started writing letters to family members that he considered very important. 'Some of the words were legible,' Buchanan explains, 'and some were in this kind of script that I later tried to imitate. . . . What I thought about in his scribbling was an interior image. It took me a long time to absorb that. . . . And I can also see the relation of his markings to sea grasses, the tall grasses, the marsh grasses that I paint.' The pastel oilstick is the perfect tool for this line, the seemingly untutored rawness of its application mirroring the haphazard construction of the shacks. An it results in images of great beauty, as beautiful as the shacks themselves."

Henry M. Sayre, *A World of Art,* 2nd edition (Upper Saddle River, NJ: Prentice Hall, Inc., 1997), pp. 184-185.

Figure 2.23 Beverly Buchanan, *Monroe County House with Yellow Datura*, 1994. Oil pastel on paper, 60" x 79" Photo by Adam Reich. Collection Dr. Harold Steinbaum. Courtesy Steinbaum Krauss Gallery, New York.

Figure 2.24 Hung Liu, *Three Fujins*, 1995. Oil on canvas, bird cages, 96" x 126" x 12". Private collection, Washington, D.C. Courtesy Steinbaum Krauss Gallery, New York. Photograph by Ben Blackwell.

PROFILE

Hung Liu
Contemporary Voice

Hung Liu (b. 1948) lived in China until 1984. "Beginning in 1966, during Mao's Cultural Revolution, she worked for four years as a peasant in the fields. Successfully 'reeducated' by the working class, she returned to Beijing where she studied, and later taught, painting of a strict Russian Social Realist style—propaganda portraits of Mao's new society. In 1980, she applied for a passport to study painting in the United States, and in 1984 her request was granted. An extraordinarily independent spirit, raised and educated in a society that values social conformity above individual identity, Liu depends as a painter on the interplay between unity and variety, not only as a principle of design but as the very subject of her art.

"During the Cultural Revolution, Liu had begun photographing peasant families, not for herself, but as a gift for the villagers. She has painted from photographs ever since, particularly archival photographs that she has discovered on research trips back to China in both 1991 and 1993. 'I am not copying photographs,' she explains. 'I release information from them. There's a tiny bit of information there—the photograph was taken in a very short moment, maybe 1/100 or 1/50 of a second—and I look for clues. The clues give me an excuse to do things.' In other words, for Liu to paint from a photograph is to liberate something locked inside it." For example, the disfigured feet, the result of traditional Chinese footbinding, of an aristocratic Chinese woman. "Unable to walk, even upper-class women were forced into prostitution after Mao's Revolution confiscated their material possessions and left them without servants to transport them.

"*Three Fujins* [Figure 2.24] . . . is also a depiction of women bound by the system in which they live. These are the concubines of the famous 'last prince,' Yi Huan of the Qing Dynasty, which was overthrown in 1911. Projecting in front of each concubine is an actual birdcage, purchased by Liu in San Francisco's Chinatown, symbolizing the women's spiritual captivity. But even the excessively unified formality of their pose—its perfect balance, its repetitious rhythms—belies their submission to the rule of tyrannical social forces. The unified composition of the photography upon which this painting is based, the sense that these women have given up themselves—and made themselves up—in order to fit into their proscribed roles, Liu sees as symbolizing 'relationships of power, and I want to dissolve them in my paintings.'

"Speaking specifically about *Three Fujins*, Liu explains how that dissolution takes place: 'Contrast is very important. If you don't have contrast, everything just cancels each other thing out. So I draw, very carefully, and then I let the paint drip—two kinds of contrasting line.' One is controlled, the line representing power, and the other is free, liberated. It introduces the necessary variety into the composition. 'Linseed oil is very thick,' Liu goes on, 'it drips very slowly, sometimes overnight. You don't know when you leave what's going to be there in the morning. You hope for the best. You plant your seed. You work hard. But for the harvest, you have to wait.' The drip, she says, gives her 'a sense of liberation, of freedom from what I've been painting. . . . It's part of me.'"

Henry M. Sayre, *A World of Art*, 2nd edition (Upper Saddle River, NJ: Prentice Hall, Inc., 1997), pp. 164-165.

of line and form always directs the eye into the painting (Fig. 2.20), as unified, and *open composition*, in which the eye is led or allowed to wander off the canvas, or *escape the frame* (Fig. 2.21), as disunified. Such is not the case. Keeping the artwork within the frame is a stylistic device that has an important bearing on the artwork's meaning. For example, painting in the classical style is predominantly kept within the frame. This illustrates a concern for the self-containment of the artwork and for precise structuring. Anti-classical design, in contrast, often forces the eye to escape the frame, suggesting perhaps a universe outside or the individual's place within an overwhelming cosmos. So unity can be achieved by keeping the composition closed, but it is not necessarily lacking when the opposite state exists.

FOCAL AREA. When we look at a picture for the first time, our eye moves around it, pausing briefly at those areas that seem of greatest visual appeal. These are *focal areas*. A painting may have a single focal area to which our eye is drawn immediately and from which it will stray only with conscious effort. Or it may have an infinite number of focal points. We describe a picture of the latter type as "busy"; that is, the eye bounces at will from one point to another on the picture, without much attraction at all.

Focal areas are achieved in a number of ways—through confluence of line, by encirclement, (Fig. 2.25) or by color, to name just a few. To draw attention to a particular point in the picture the artist may make all lines lead to that point. He or she may place the focal object or area in the center of a ring of objects, or may give the object a color that demands our attention more than the other colors in the picture. Again, for example, bright yellows attract our eye more readily than dark blues. Artists use focal areas, of whatever number or variety, as controls over what we see and when we see it when we look at a picture.

Other Factors

Perspective

Perspective is a tool artists use to indicate spatial relationships of objects in a picture. It is based on the perceptual phenomenon that causes objects farther away from us to appear smaller. If we examine a painting that has some degree of verisimilitude, we can identify, through perspective, the spatial relationship between the objects in the foreground and the objects in the background. We also can discern whether that relationship is rational—that is, whether or not the relationships of the objects appear as we see them in life. For example, paintings executed prior to the Italian Renaissance (when mechanical procedures for rendering perspective were developed) look rather strange because although background objects are painted smaller than foreground objects the positioning does not appear rational. So their composition strikes us as being rather primitive.

LINEAR PERSPECTIVE. Two types of perspective may be used. The first, *linear* perspective, is characterized by the phenomenon of standing on railroad tracks and watching the two rails apparently come together at the horizon. It uses *line* to achieve the sense of distance. In color insert Plate 6, the road recedes from foreground to background and becomes narrower as it does so. We perceive that recession, which denotes distance, through the artist's use of line.

AERIAL PERSPECTIVE indicates distance through the use of light and atmosphere. For example, mountains in the background of a picture are made to appear distant by being painted in less detail; they are hazy. In the upper left of Plate 2 a castle appears at a great distance. We know it is distant because it is smaller and, more important, because it is indistinct. The same applies to the mountains in Plate 6.

Surrealism in Painting

As the work of psychoanalyst Sigmund Freud (1856-1939) became popular, artists became fascinated by the subconscious mind. By 1942 a surrealist manifesto stated some specific connections between the subconscious mind and painting. Surrealist works were thought to be created by "pure psychic automatism." Its advocates saw surrealism as a way to discover the basic realities of psychic life by automatic associations. Supposedly, a dream could be transferred directly from the unconscious mind of the painter to canvas without control or conscious interruption.

Surrealists resisted the rationalist trend of post-World War I art and architecture. The style itself was the creation of a French writer, André Breton (1896-1966), who was involved in the Dada movement (an anti-art art movement) after World War I (1914-17). Breton had grown tired of the playful nonsense of Dada and wanted to turn Dada's desire to free human behavior toward something more programmatic. In 1924 he published his "Manifesto of Surrealism," in which he outlined his own opinion of Sigmund Freud's view of the human psyche as a battleground between rational and civilized forces of the conscious and the irrational, instinctual urges of the unconscious.

Breton argued that the way to achieve happiness was in freeing the individual to express personal desires, as opposed to restraining desires through the repressive forces of reason. His aim, and that of those who subscribed to his views, was to assist individuals in developing techniques for liberating the individual unconscious. These techniques included dream analysis, free association, automatic writing, word games, and hypnotic trances, all of which would lead to discovery of a larger reality, or "surreality," that existed beyond limited rational understanding of what was real.

One of the artists subscribing to such a viewpoint was Spanish painter and printmaker Salvador Dali (DAH-lee; 1904-89). His famous work *The Persistence of Memory* (Plate 8) has become nearly a cliché for the surrealist style. Dali called works such as *The Persistence of Memory* "hand-colored photographs of the subconscious," and the almost photographic detail of his work, coupled with the nightmarish relationships of the objects pictured, has a forceful impact. The whole idea of time is destroyed in these "soft watches" (as they were called by those who first saw this work) hanging limply and crawling with ants. And yet the images are strangely fascinating, perhaps in the way we are fascinated by the world of our dreams.

Another Spanish artist associated with the Surrealists was Joan Miró (HOH-ahn mee-ROH; 1893-1983). His work *Painting* (Plate 3), is based partly on collages created from illustrations of machine tools in catalogues. Miró developed such works by drawing a series of lines without considering what they might be or become. Such a technique is called *automatism* or automatic writing. Then he consciously reworked the images into whatever his imagination suggested.

Figure 2.25 St. Mark from the Gospel Book of St. Medard of Soissons, France (early ninth century). Paint on vellum, 14³/8" × 10¹/4". Bibliothèque Nationale de France—Paris.

Another treatment of aerial perspective can be seen in the painting *Buddhist Retreat by Stream and Mountains*, attributed to the Chinese artist Juran (Fig. 2.26). This hanging scroll illustrates a device fairly common in Chinese paintings with a vertical format. The artist divides the picture into two basic units, foreground and background. The foreground of the painting consists of details reaching back toward the middle ground. At that point a division occurs, so the background and the foreground are separated by an openness in what might have been a deep middle ground. The foreground represents the nearby, and its rich detail causes us to pause and ponder on numerous elements, including the artist's use of brush stroke in creating foliage, rocks, and water. Then there is

a break, and the background appears to loom up or be suspended, almost as if it were a separate entity. Although the foreground gives us a sense of dimension—of space receding from the front plane of the painting—the background seems flat, a factor that serves to enhance further the sense of height of the mountains.

Subject Matter

We can regard treatment of subject matter as ranging from verisimilitude, or representationalism, to nonobjectivity (Fig. 2.27). We use this continuum again in later chapters, substituting the term *theatricality* for nonobjectivity. Between the two ends of this continuum are many of the isms we all are familiar with in the

Figure 2.26 *Buddhist Retreat by Stream and Mountains.* Hanging scroll, ink on silk, height 185.4 cm. Attributed to Juran, Chinese, active c. A.D. 960–80, northern Song dynasty. The Cleveland Museum of Art. Gift of Katherine Holden Thayer.

Figure 2.27 Subject-matter continuum.

art world: realism, impressionism, expressionism, cubism, fauvism, and so forth. Each suggests a particular method of treatment of subject matter.

Chiaroscuro

Chiaroscuro (sometimes called *modeling*), whose meaning in Italian is "light and shade," is the device used by artists to make their forms appear *plastic*, that is, three dimensional. The problem of making two-dimensional objects appear three dimensional rests heavily on an artist's ability to render highlight and shadow effectively. Without them all forms are two dimensional in appearance.

Use of chiaroscuro gives a picture much of its character. For example, the dynamic and dramatic treatment of light and shade in color insert Plate 7 gives this painting a quality quite different from what would have resulted had the artist chosen to give full, flat, front light to the face. The highlights, falling as they do, create not only a dramatic effect but also a compositional triangle extending from shoulder to cheek, down to the hand, and then across the sleeve and back to the shoulder. Consider the substantial change in character of Plate 2 had highlight and shadow been executed in a different manner. Finally, the treatment of chiaroscuro in a highly verisimilar fashion in color insert Plate 8 helps give that painting its strangely real yet dreamlike appearance.

In contrast, works that do not employ chiaroscuro have a two-dimensional quality. This can be seen to a large extent in Figure 2.1 and also in Plate 5 and Figure 2.28.

How does it stimulate the senses?

We do not touch pictures, and so we cannot feel their roughness or their smoothness, their coolness or their warmth. We cannot hear pictures and we cannot smell them. So, when we conclude that a picture affects our senses in a particular way, we are responding in terms of visual stimuli that are transposed into mental images of our sense of touch, taste, sound, and so forth.

Contrasts

The colors of an artist's palette are referred to as warm or cool depending on which end of the color spectrum they fall. Reds, oranges, and yellows are said to be warm colors. Those are the colors of the sun and therefore call to mind our primary source of heat. So they carry strong implications of warmth. Colors falling on the opposite end of the spectrum—blues and greens—are cool colors because they imply shade, or lack of light and warmth. As we will notice frequently, this is a stimulation that is mental but has a physical basis. Tonality and color contrast also affect our senses. The stark value contrasts of Figure 2.28 contribute significantly to the harsh and dynamic qualities of the work. The colorlessness of this monochromatic black, white, and gray work completes its horrifying comment on the tragic bombing of the Spanish city of Guernica. In the opposite vein, the soft, yet dramatic, tonal contrasts of Plate 7 and the strong warmth and soft texture of the red hat bring us a completely different set of stimuli.

Many of the sense-affecting stimuli work in concert and cannot be separated from each other. We already have noted some of the effects of chiaroscuro, but one more will serve well. One of the most interesting effects to observe in a picture is the treatment of flesh. Some flesh is treated harshly and appears like stone. Other flesh appears soft and true to life. Our response to whatever treatment has been given is very tactile—we want to touch, or we believe we know what we would feel if we touched. Chiaroscuro is essential in an artist's achieving those effects. Harsh shadows and strong contrasts create one set of responses; diffused shadows and subdued contrasts create another.

Figure 2.28 Pablo Picasso, *Guernica* (mural) (1937, May–early June). Oil on canvas, 11'6" × 25'8". Museo Nacional Centro de Arte Reina Sophia, Madrid. ©Estate of Pablo Picasso/Artists Rights Society (ARS), New York.

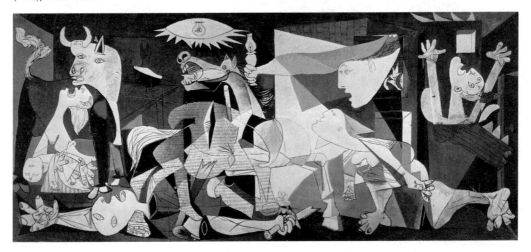

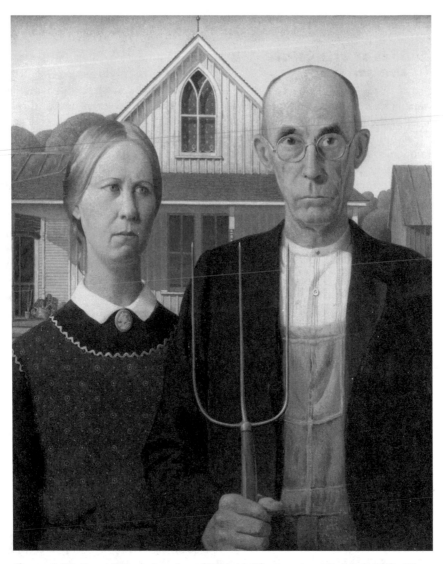

Figure 2.29 Grant Wood, American (1891-1942), *American Gothic* (1930). Oil on beaver board, 30" x 25". Friends of American Art Collection. Photograph © 1990. All rights reserved by The Art Institute of Chicago and VAGA, New York.

Rubens's *Assumption of the Virgin* (color insert Plate 9) presents us with softly modeled flesh whose warmth and softness come from color and chiaroscuro. Highlight and shadow function to create softness, and predominantly red hues warm the composition; our sensual response is heightened dramatically.

Dynamics

Although pictures are motionless, they can effectively stimulate a sense of movement and activity. They also can create a sense of stable solidity. An artist stimulates these sensations by using certain conventional devices. Composition

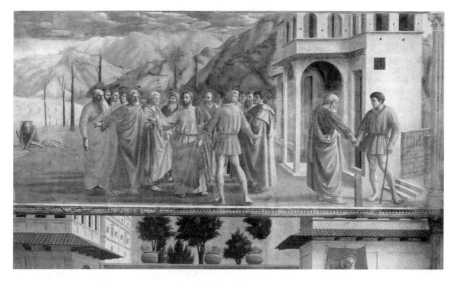

Figure 2.30 Masaccio, *Tribute Money* (c. 1427). Santa Maria del Carmine, Florence. Courtesy of Heaton-Sessions, Stone Ridge, New York. Scala/Art Resource.

that is principally vertical can express, for example, a sense of dignity and grandeur (color insert Plate 10) and Figure 2.29. A picture that is horizontal can elicit a sense of stability and placidity (Fig. 2.30). The triangle is a most interesting form in engineering because of its structural qualities. It is also interesting in art because of its psychological qualities. If we place a triangle so its base forms the bottom of a picture, we create a definite sense of solidarity and immovability (Fig. 2.31). If that triangle were a pyramid sitting on a level plane, a great deal of effort would be required to tip it over. If we invert the triangle so it balances on its apex, a sensation of extreme instability results (Fig. 2.32). Although we can feel clearly the sensations stimulated by these rather simple geometric forms, we should not conclude that geometric forms used as compositional devices are either explicit or limited in communication. Nonverbal communication

Figure 2.31 Upright-triangular composition.

Figure 2.32 Inverted-triangular composition.

Renaissance Painting

The Renaissance of the early fifteenth century was explicitly seen by its leaders as a rebirth of people's understanding of themselves as social and creative beings. Florence, the crucible of the Renaissance in Italy, was called the "New Athens," and it was here that the fine arts, or "liberal arts," were first redefined as art, in contrast to their status as crafts in the Middle Ages. Now accepted among the intellectual disciplines, the arts became an essential part of learning and literary culture. Artists, architects, composers, and writers gained confidence from their new status and from the technical mastery they were achieving.

Tommaso di Giovanni, better known as Masaccio (mah-ZAH-coh or mah-ZAHT-choh, 1401-29) represents, in a single genius, the onset of an entirely new Renaissance manner of expression in painting. The hallmark of Masaccio's invention and development of a "new" style lies in the way he employs deep space and rational foreshortening or perspective in his figures.

Masaccio's works have a gravity and monumentality that make them larger than life. The use of deep perspective, plasticity, and modeling to create dramatic contrasts gives solidity to the figures and unifies the paintings. Atmospheric perspective enhances the deep spatial naturalism. Figures are strong, detailed, and very human. At the same time, the composition carefully subordinates the parts of the painting to the whole. In Masaccio's genius and innovation, whose characteristics we have just described, there emerges an entirely new approach and mature handling of space that brought the Renaissance to painting.

We can see this new approach at work in Masaccio's *The Tribute Money* (Fig. 2.30). The radical change from the painting style of the Middle Ages is apparent when we compare *The Tribute Money* with the works of Figures 2.24 and 2.25. The setting of *The Tribute Money* makes full use of the new discovery of linear perspective, as the rounded figures move freely in unencumbered deep space. The painting employs *continuous narration*, where a series of events unfolds across a single picture. Here Masaccio depicts a New Testament story from Matthew (17:24-27). Weight and volume are depicted in an entirely new way. Each figure stands in classical *contrapposto* stance, where the accurate rendering of the feet and the anatomically correct weight distribution make these the first painted figures to seem to stand solidly on the ground. Masaccio establishes a consistent light source to create verisimilar modeling. In addition, the figures form a circular and three-dimensional grouping rather than a flat line across the surface of the work. Even the halos overlap at odd angles. The single vanishing point, by which the linear perspective is controlled, sits at the head of Christ.

Masaccio also has rediscovered aerial perspective, in which distance is indicated through diminution of light and blurring of outlines. Masaccio's technique brought a new genius to which later titans like Michelangelo would return for inspiration. Masaccio's singular genius marks the onset and character of the Renaissance.

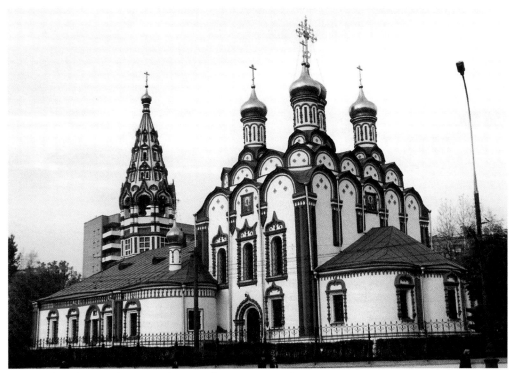

Plate 1 The Church of Nikolai Khamovnik (1679–1682). Moscow, Russia.

Plate 3 Joan Miró, *Painting* (1933). Oil on canvas, 68½″ × 77¼″. The Museum of Modern Art, New York. Loula D. Lasker Bequest (by exchange).

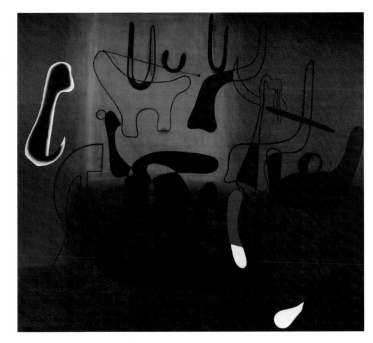

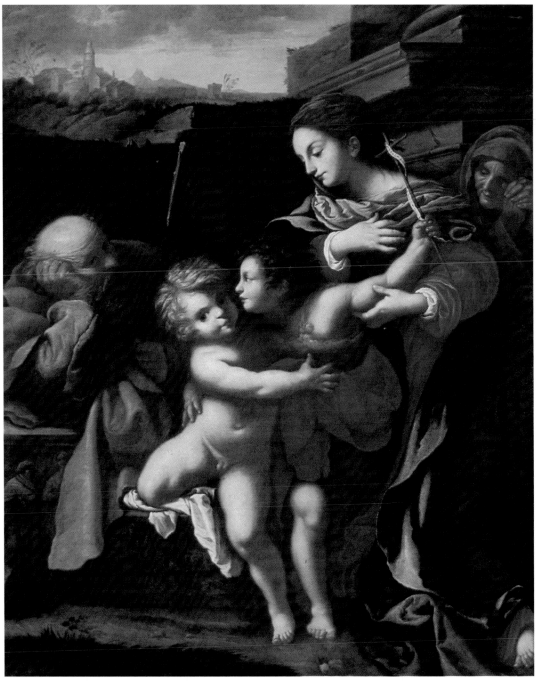

Plate 2 Giovanni Battista Vanni, *Holy Family with St. John*. Oil on canvas, 70″ × 58″. Palmer Museum of Art, The Pennsylvania State University.

Plate 4 Color wheel.

Plate 5 Pablo Picasso, *Girl Before a Mirror* (Boisgeloup, March 1932). Oil on canvas, 64″ × 51¼″. Collection, The Museum of Modern Art, New York. Gift of Mrs. Simon Guggenheim. Photograph © 1996, The Museum of Modern Art, New York.

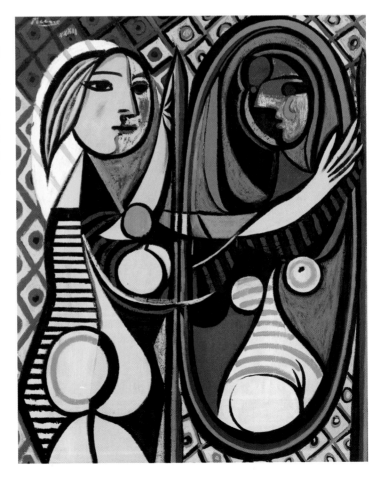

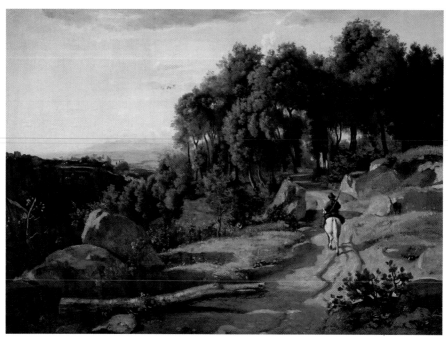

Plate 6 Jean-Baptiste-Camille Corot (French, 1796–1875), *A View Near Volterra* (1838). Canvas/oil on canvas, 27³/₈″ × 37¹/₂″. National Gallery of Art, Washington, D.C. Chester Dale Collection. Photo by Richard Carafelli.

Plate 7 Jan Vermeer (Dutch, 1632–1675), *The Girl with a Red Hat* (c. 1660). Oil on panel, unframed: 9 × 7¹/₁₆″; framed: 17¹/₂″ × 15¹/₂″ × 3¹/₄″. National Gallery of Art, Washington, D.C. Andrew W. Mellon Collection. Photo by Richard Carafelli.

Figure 2.33 Curved line.

Figure 2.34 Broken line.

in the arts is not that simple. Nonetheless, the basic compositional devices do influence our response and impact on our perceptions.

The use of line also affects sense response. Figure 2.33 illustrates how this use of curved line can elicit a sense of relaxation. The broken line

in Figure 2.34, in contrast, creates a more dynamic and violent sensation. We can also feel that the upright triangle in Figure 2.31, although solid and stable, is more dynamic than the horizontals of Figure 2.30 because it uses stronger diagonal line, which tends to stimulate a sense of

Figure 2.35 Piet Mondrian, *Composition in White, Black, and Red* (1936). Oil on canvas, 40¹/₄"× 41". Collection, The Museum of Modern Art, New York. Gift of the Advisory Committee.

movement. Precision of linear execution also can create sharply defined forms or soft, fuzzy images. Piet Mondrian (Fig. 2.35) finds in straight lines and right angles the basic principles of life itself. Vertical lines signify vitality and life; horizontal lines signify tranquillity and death. The intersection of vertical and horizontal line represents life's tensions.

Trompe l'oeil

Trompe l'oeil (pronounced trawmp LOY), or "trick the eye," gives the artist a varied set of stimuli by which to affect our sensory response. Occasionally this device forms the core of a painting; at other times it is used to enhance a work's appeal. For example, all objects drawn with parallel sides recede to the same vanishing point. Some artists make subtle changes in the placement of the vanishing point, with the effect that the picture, while appearing verisimilar, gives the impression of rotating forward at the top. Its kinesthetic appeal is thereby much more dynamic.

Juxtaposition

We can also receive sense stimuli from the results of juxtaposing curved and straight lines, which results in linear dissonance or consonance.

Figure 2.36 Juxtaposition.

Figure 2.36 illustrates the juxtaposing of inharmonious forms, which creates instability. Careful use of this device can stimulate some very interesting and specific sense responses, as the artist has done in Plate 5.

Objectivity

Subject matter, which involves any or all of the characteristics we have discussed, is a powerful device for effecting both sensory responses and more intense, subjective responses. The use of verisimilitude or nonobjectivity is a noticeable stimulant of individual response. It would seem logical for individuals to respond intellectually to nonobjective pictures because the subject matter should be neutral, with no inherent expressive stimuli. However, the opposite tends to occur. When asked whether they feel more comfortable with the treatment of subject matter in Plate 2 or that in Figure 2.13, most individuals choose the former.

Does an explicit appeal cause a more profound response? Or does the stimulation provided by the unfamiliar cause us to think more deeply and respond more fully because our imagination is left free to wander? The answers to these questions are worth considering as we perceive artworks, many of whose keys to response are not immediately obvious.

CHRONOLOGY OF SELECTED WORKS FOR ADDITIONAL STUDY

c. 24,000 B.C.–c. 300 A.D.

Cave paintings from Lascaux and Altamira
Ancient Egyptian tomb paintings
Archaic and classical Greek vase paintings
Roman wall paintings

c. 300–c. 1400

Byzantine mosaics
Romanesque manuscript illumination
Gothic Style

Manuscript illustration
Cimabue: *Madonna Enthroned*
Giotto: *The Lamentation*
Lorenzetti: *The Birth of the Virgin*

c. 1400–1570

Flanders
Jan van Eyck: *The Arnolfini Marriage*
Roger van der Weyden: *The Descent from the Cross*
Italian Renaissance
Botticelli: *Spring*
Masaccio: *The Tribute Money*
Reformation
Dürer: *The Four Horsemen of the Apocalypse*
High Renaissance
Leonardo da Vinci: *The Last Supper; Mona Lisa*
Michelangelo: Sistine Chapel frescoes
Raphael: *Madonna of the Chair*
Mannerism
Bronzino: *Portrait of a Young Man*
Parmigianino: *The Madonna with the Long Neck*

c. 1570–c. 1700

Baroque
Caravaggio: *Death of the Virgin*
Rubens: *Assumption of the Virgin*
Poussin: *Funeral of Phocian*
Rembrandt: *The Night Watch*
van Ruysdael: *The Jewish Cemetary*
Vermeer: *The Girl in the Red Hat*

c. 1700–1900

Rococo
Watteau: *Embarkation for Cythera*
Fragonard: *The Swing*
Social Criticism
Hogarth: *The Rake's Progress*
Portraiture
Gainsborough: *The Honorable Francis Duncombe*

Neoclassicism
David: *The Oath of the Horatii*
Romanticism
Goya: *Executions of the Third of May, 1808*
Géricault: *The Raft of the "Medusa"*
Delacroix: *Massacre at Chios*
Realism
Courbet: *The Stonebreakers*
Manet: *Luncheon on the Grass*
Romantic Naturalism
Corot: *A View Near Volterra*
Impressionism
Monet: *The River*
Renoir: *Luncheon of the Boating Party*
Degas: *Dancers Practicing at the Bar*
Post-Impressionism
Seurat: *Sunday Afternoon on the Island of the Grande-Jatte*
van Gogh: *Church at Auvers*
Cézanne: *Mont Sainte-Victoire Seen from Bibemus Quarry*
Gaughin: *Vision After the Sermon*

c. 1900–2000

Fauvism
Matisse: *The Blue Nude-Souvenir of Biskra*
Expressionism
Beckman: *Christ and the Woman Taken in Adultery*
Cubism
Picasso: *Les Demoiselles d'Avignon*
Abstraction
Mondrian: *Composition in White, Black, and Red*
Surrealism
Dali: *The Persistence of Memory*
Abstract Expressionism
Dekooning: *Excavation*
Pollock: *Number 1*
Pop Art
Lichtenstein: *Whaam!*

Sculpture

Sculpture, in contrast to pictures, seems less personal and more public. In fact, we are likely to find works of sculpture mostly in public spaces. Outside city halls and in parks and corporate office buildings we find statues of local dignitaries and constructions of wood, stone, and metal that appear to represent nothing at all. We might even wonder why our tax dollars were spent to buy them. Today, as throughout history, sculpture (and other forms of art) are often the subject of public pride and controversy. Because of its permanence, sculpture often represents the only artifact of entire civilizations. In this chapter we'll not only see how sculpture is made and how it works, but our examples will reveal ideas of artists from ancient history, contemporary times, and many cultures.

What is it?

Sculpture is a three-dimensional art. It may take the form of whatever it seeks to represent, from pure, or nonobjective form, to lifelike depiction of people or any other entity. Sometimes sculpture, because of its three-dimensionality, comes very close to reality in its depiction. Duane Hanson and John DeAndrea, for example, use plastics to render the human form so realistically that the viewer must approach the artwork and examine it closely to determine it is not a real person.

How is it put together?

Dimensionality

Sculpture may be *full round, relief,* or *linear.* Full round works are freestanding and fully three dimensional (Fig. 3.1). A work that can be viewed from only one side—that is, one that projects from a background—is said to be *in relief* (Fig. 3.2). A work utilizing narrow, elongated materials is called *linear* (Fig. 3.14). A sculptor's choice of full round, relief, or linearity as a mode of expression dictates to a large extent what he or she can and cannot do, both aesthetically and practically.

Painters, printmakers, and photographers have virtually unlimited choice of subject matter and compositional arrangements. Full round sculptures dealing with such subjects as clouds, oceans, and panoramic landscapes are problematic for the sculptor. Because sculpture occupies real space, the use of perspective, for example, to increase spatial relationships poses obvious problems. In addition, because full round sculpture is freestanding and three dimensional, sculptors must concern themselves with the practicalities of engineering and gravity. For example, they cannot create a work with great mass at the top unless they can find a way (within the bounds of acceptable composition) to keep the statue from falling over. In numerous full round works, sculptors use small animals, branches, tree stumps, rocks, and other devices as additional support to give practical stability to a work.

Relief

Sculptors who create works in relief do not have quite so many restrictions because their work is attached to a background. Clouds, seas, and perspective landscapes are within relief sculptors' reach because their work needs only to be viewed from one side. Relief sculpture, then, is three dimensional. However, because it protrudes from a background, it maintains a two-dimensional quality, as compared to full round sculpture.

Linear

The third category of sculpture, *linear sculpture*, emphasizes construction with thin, elongated items such as wire or neon tubing. Artworks using linear materials and occupying three-dimensional space will occasionally puzzle us as we consider or try to decide whether they are really linear or full round. Here again, absolute definition is less important than the process of analysis and aesthetic experience and response.

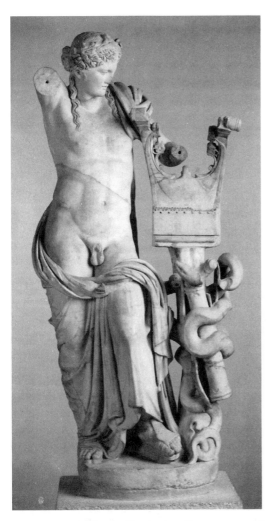

Figure 3.1 Apollo playing the lyre (Roman copy of a Greek statue), from the Temple of Apollo at Cyrene (first century A.D.). Marble, over life size. ©The British Museum, London.

Full Round

Sculptural works that explore full three-dimensionality and intend viewing from any angle are called *full round*. Some subjects and styles pose certain constraints in this regard, however.

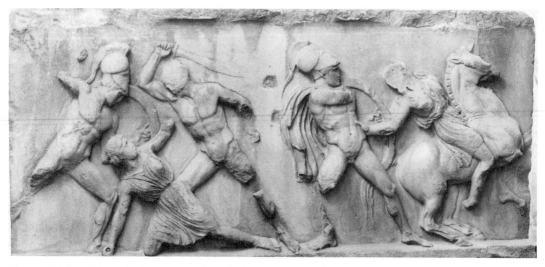

Figure 3.2 East Frieze, *Halicarnassus*. The British Museum, London.

Methods of Execution

In general, we may say that sculpture is execut-ed using additive, subtractive, substitute, or ma-nipulative techniques, or any combination of these. A fifth category, called *found sculpture*, may or may not be considered a method of execution, as we see later.

Subtraction

Carved works are said to be *subtractive*. That is, the sculptor begins with a large block, usual-ly wood or stone, and cuts away (subtracts) the unwanted material. In previous eras, and to some extent today, sculptors have had to work with whatever materials were at hand. Wood carvings emanated from forested regions, soapstone carv-ings came from the Eskimos, and great works of marble came from the regions surrounding the quarries of the Mediterranean. Anything that can yield to the carver's tools can be formed into a work of sculpture. However, stone, with its promise of immortality, has proven to be the most popular material.

Three types of rock hold potential for the carver. *Igneous* rock, of which granite is an ex-ample, is very hard and potentially long lasting. However, it is difficult to carve and therefore not popular. *Sedimentary* rock such as limestone is relatively long lasting, easy to carve, and pol-ishable. Beautifully smooth and lustrous surfaces are possible with sedimentary rock. *Metamor-phic* rock, including marble, seem to be the sculptor's ideal. It is long lasting, a pleasure to carve, and exists in a broad range of colors. Whatever the artist's choice, one requirement must be met: The material to be carved, whether wood, stone, or a bar of soap, must be free of flaws.

A sculptor who sets about to carve a work does not begin simply by imagining a *Samson Slaying a Philistine* (Fig. 3.3) and then attacking the stone. He or she first creates a model, usual-ly smaller than the intended sculpture. The model is made of clay, plaster, wax, or some other material and completed in precise detail—a miniature of the final product.

Once the likeness of the model has been en-larged and transferred, the artist begins to rough

purpose. Then, using a different set of carving tools, she carefully takes the material down to the precise detail. Finishing work and polishing follow.

Addition

In contrast with carving from a large block of material, the sculptor using an additive process starts with raw material and *adds* element to element until the work is finished. The term *built sculpture* often is used to describe works executed in an additive technique. The materials employed in this process can be plastics, metals such as aluminum or steel, terracottas (clay), epoxy resins, or wood. Many times materials are combined (Fig. 3.4). It is not uncommon for sculptors to combine constructional methods as well. For example, built sections of metal or plastic may be combined with carved sections of stone.

Substitution

Any material that can be transformed from a plastic, molten, or fluid state into a solid state can be molded or *cast* into a work of sculpture. The creation of a piece of cast sculpture always involves the use of a mold. First, the artist creates an identically sized model of the intended sculpture. This is called a *positive*. He or she then covers the positive with a material, such as plaster of paris, that when hardened and removed will retain the surface configurations of the positive. This form is called a *negative* and becomes the mold for the actual sculpture. The molten or fluid material is poured into the negative and allowed to solidify. When the mold is removed, the work of sculpture emerges. Surface polishing, if desired, brings the work to its final form. Figures 3.5, 3.6, and color insert Plate 11 all show the degrees of complexity and variety achievable through casting.

Very often sculpture is cast so it is hollow. This method, of course, is less expensive because it

Figure 3.3 Giambologna, *Samson Slaying a Philistine* (c. 1562). Courtesy of The Board of Trustees of The Victoria and Albert Museum, London.

out the actual image ("knocking away the waste material," as Michelangelo put it). In this step of the sculpting process, the artist carves to within 2 or 3 inches of what is to be the finished area, using specific tools designed for the

Figure 3.4 Bakota ancestor figure from Gabon, late nineteenth century. French Congo. Ancestral figure of wood. Overlaid with copper and brass. Given by H. G. Beasley, Esq., 1924. The British Museum, London.

requires less material. It also results in a work less prone to crack, since it is less susceptible to expansion and contraction resulting from changes in temperature. Finally, hollow sculpture is, naturally, lighter and thus more easily shipped and handled.

Manipulation

In this technique, materials such as clay are shaped by skilled use of the hands. A term of similar meaning is *modeling*. The difference between this technique and addition is clear when we

Figure 3.5 Ronald J. Bennet, *Landscape* #3 (1969). Cast bronze, 8" high × 10" wide × 7" deep. Palmer Museum of Art, The Pennsylvania State University. Gift of the Class of 1975.

watch an artist take a single lump of clay and skillfully transform it, as it turns on a potter's wheel, into a final shape.

Found

This category of sculpture is exactly what its name implies. Often natural objects, whether shaped by human hands or otherwise, are discovered that for some reason have taken on char-acteristics which stimulate aesthetic responses. They become *objets d'art* not because an artist put them together (although an artist may combine found objects to create a work), but because an artist chose to take them from their original surroundings and hold them up to the rest of us as vehicles for aesthetic communication. In other words, an artist decided that such an object said something aesthetically and *chose* to present it in that vein.

Figure 3.6 Henry Moore, *Two Large Forms* (1969). The Serpentine, Hyde Park, London. (See also color insert Plate 11.)

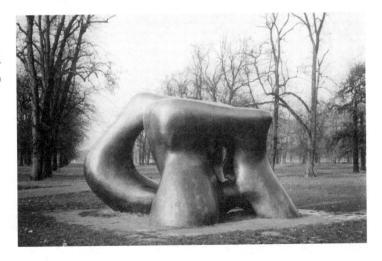

Some may have concern about such a category, however, because it removes *techne*, or *skill*, from the artistic process. As a result, objects such as driftwood and interesting rocks can assume perhaps an unwarranted place as art products or objects. This is a touchy area. However, if a found object is altered in some way to produce an artwork, then the process would probably fall under one of our previously noted methods, and the product could be termed an artwork in the fullest sense of the word.

Ephemeral

Ephemeral art has many different expressions and includes the works of the conceptualists, who insist art is an activity of change, disorientation, and violent lack of cohesion. Designed to be transitory, ephemeral art makes its statement and then, eventually, ceases to exist. Undoubtedly the largest work of sculpture ever designed was based on that concept. Christo and Jeanne-Claude's *Running Fence* (Fig. 3.7) was an event and a process, as well as a sculptural work. At the end of a two-week viewing period, *Running Fence, Sonoma and Marin Counties, California (1972–76)* was removed entirely and materials were recycled.

Composition

Composition in sculpture comprises the same elements and principles as composition in the pictorial arts: mass, line, form, balance, repetition, color, proportion, and unity. Sculptors' uses of these elements are significantly different, however, because they work in three dimensions.

Figure 3.7 Christo and Jeanne-Claude, *Running Fence, Sonoma and Marin Counties, California* (1972–76). Woven nylon fabric and steel cables, height 18', length 24¹/₂ miles. © Christo, 1976. Photograph: Wolfgang Volz.

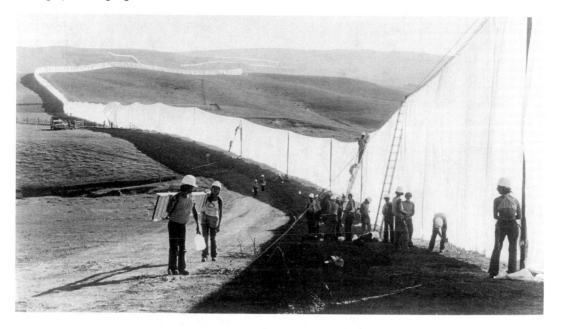

Elements

MASS (SPACE). Unlike a picture, a sculpture has literal mass. It takes up three-dimensional *space*, and its materials have *density*. Mass in pictures is *relative* mass: The mass of forms in a picture has application principally in *relation* to other forms within the same picture. In sculpture, however, mass is literal and consists of actual volume and density. So the mass of a sculpture that is 20 feet high, 8 feet wide, and 6 feet deep and made of balsa wood would seem less than a sculpture 10 feet high, 4 feet wide, and 3 feet deep and made of lead. Space and density must both be considered. What if the material of a statue is disguised to look and feel like a different material? We discuss this question later in the chapter, when we look at how a sculpture affects our senses.

LINE AND FORM. As we stated in Chapter 2, line and form are highly related. We can separate them (with some difficulty) when we discuss pictures because in two dimensions an artist uses line to define form. In painting, line is a construction tool. Without using line, artists cannot reveal their forms, and when we analyze a painting, line is perhaps more important to us than the actual form it reveals. Notwithstanding, in sculpture the case is nearly reversed. It is the form that draws our interest, and when we discuss line in sculpture, we do so in terms of how it is revealed in form.

When we view a sculpture, its elements direct our eye from one point to another, just as focal points do, via line and color, in a picture. In some works the eye is directed through the piece and then off into space. Such sculptures have an *open* form. In Figure 3.11 the eye is directed outward from the work in the same fashion as composition that escapes the frame in painting. If, however, the eye is directed continually back into the form, we say the form is *closed*. If we allow our eye to follow the linear detail of Figure 3.8, we find we are continually led back into the work. This is similar to composition kept within the frame in painting and to closed forms in music, which we discuss in Chapter 4. Often it is difficult to fit a work precisely into one or the other of these categories. For example, in Figure 3.3 there are elements of closed composition and, as indicated by the fabric flying to the left, open composition as well.

Obviously, not all sculptures are completely solid; they may have openings. We call any such holes in a sculpture *negative space*, and we can discuss this characteristic in terms of its role in the overall composition. In some works negative space is inconsequential; in others it is quite significant. It is up to us to decide which, and to determine how negative space contributes to the overall piece. In figure 3.6 and Plate 11 negative space plays a significant role. In the former it might be argued that negative space is as instrumental to the overall concept of the work as is the metal form. In Figure 3.1, in contrast, negative space is clearly incidental.

COLOR. Perhaps color does not seem particularly important when we relate it to sculpture. We tend to see ancient sculpture as white and modern sculpture as natural wood or rusty iron. Nevertheless, color is as important to the sculptor as it is to the painter. In some cases the material itself may be chosen because of its color; in others, the sculpture may be painted. The lifelike sculptures of Duane Hanson depend on color for their effect. They are so lifelike that we easily could confuse them with real people. Finally, still other materials may be chosen or treated so that nature will provide the final color through oxidation or weathering.

TEXTURE. Texture, the roughness or smoothness of a surface, is a tangible characteristic of sculpture. Sculpture is unique in that we can perceive its texture through our sense of touch. Even when we cannot touch a

Figure 3.8 Michelangelo, *David* (1501-1504) Marble, 13'5". Academy, Florence. Alinari-Art Reference Bureau/Art Resource.

Michelangelo

Michelangelo (1475-1564) was a sculptor, painter, and architect and perhaps the greatest artist in a time of greatness. He lived during the Italian Renaissance, a period known for its creative activity, and his contemporaries included Leonardo da Vinci and Raphael. In art, the age's great achievement, Michelangelo led all others. Michelangelo had a remarkable ability to concentrate his thoughts and energy. Often while working he would eat only a little bread, would sleep on the floor or on a cot beside his unfinished painting or statue, and continue to wear the same clothes until his work was finished.

His birthplace, Caprese, Italy, was a tiny village that belonged to the nearby city-state of Florence. He attended school in Florence, but his mind was on art, not on his studies. Even as a young child he was fascinated by painters and sculptors at work.

Without his father's knowledge or permission, Michelangelo went to work under Bertoldo, a talented sculptor working for Lorenzo di Medici (Lorenzo the Magnificent). One day Lorenzo himself saw the boy carving a marble faun's head. Lorenzo liked it so much that he took Michelangelo to live with him in his palace and treated the boy like a son.

Lorenzo died in 1492, and Florence changed almost overnight. Fra Girolao Savonarola, a Dominican monk, rose to power and held all the people under the spell of his sermons. Michelangelo feared Savonarola's influence and decided to leave Florence.

In 1496 Michelangelo was in Rome for the first time. There he was commissioned to carve a Pietà, a marble group showing the Virgin Mary supporting the dead Christ on her knees. This superb sculpture, known as the *Madonna della Pietà*, won him wide fame. One of the few works signed by Michelangelo, it now stands in St. Peter's Basilica in Rome.

When he was 26, Michelangelo returned to Florence. He was given an 18-foot (5.5-meter) marble block that another sculptor had already started to carve. The block was nearly ruined. Michelangelo worked on it for more than two years. Out of its huge mass, and in spite of the difficulties caused by the first sculptor's work, he carved his youthful, courageous *David* (Fig. 3.8).

Between 1508 and 1512 Michelangelo painted the vaulted ceiling of the Sistine Chapel in Rome with hundreds of giant figures that made up his vision of the world's creation. Painting and sculpture, however, did not absorb all Michelangelo's genius. When Florence was in danger of attack, he superintended its fortification. He also wrote many sonnets. In his last years he designed the dome of St. Peter's Basilica in Rome, which has been called the finest architectural achievement of the Italian Renaissance. Michelangelo worked with many of the leaders of his time: the popes and the rulers of the Italian city-states. He knew and competed with Leonardo da Vinci and Raphael. He died on Feb. 18, 1564, at the age of 89, and was buried in the church of Santa Croce in Florence.

High Renaissance Sculpture

The high point of the Renaissance came in the early sixteenth century as papal authority was re-established, and artists were called to Rome. The importance of this brief period, occurring from approximately 1508–1527 in Rome, and exemplified by Michaelangelo, Leonardo da Vinci, and Raphael, has led scholars to call it the High Renaissance. Undoubtedly, it would be inaccurate to call the High Renaissance a "style" as the term is known. Nevertheless, the arts of the period were significantly different from the arts of the earlier Renaissance. In particular, the High Renaissance championed a new concept—the concept of genius—and it can be argued that everything done in the visual arts in Italy between 1495 and 1520 was subordinate to the overwhelming genius of two men: Leondardo da Vinci and Michelangelo Buonarotti. In fact, such was the achievement of these two that many have argued that the High Renaissance in visual art was not a culmination of early Renaissance style but a new kind of art entirely.

By the end of the quattrocento (the fourteen hundreds) the courts of the Italian princes had come to find the arts of the early Renaissance vulgar and naive. They demanded a more aristocratic, elegant, dignified, and lofty art, which accounts, at least in part, for the new "style."

High Renaissance style sought a universal ideal achieved through universal themes. Stunning renditions of anatomy and tricks of perspective were no longer sufficient. Thus, figures became types again, rather than individuals—god-like beings in the Greek classical tradition. This human-centered attitude also included a certain artificiality and emotionalism that reflected the conflicts of the times.

There is no better example of High Renaissance sculpture than Michelangelo's *David* (Fig. 3.8). Towering some 18 feet (5.5 meters) above the floor, this nude champion exudes a pent-up energy as the body seems to exist merely as an earthly prison for the soul. The upper body moves in opposition to the lower. The viewer's eye is led downward by the right arm. The entire figure seeks to break free from its confinement through thrust and counter-thrust.

Much of the effect of *David*—the bulging muscles, exaggerated rib cage, heavy hair, undercut eyes, and frowning brow—may be due to the fact that these features were intended to be read from a distance. The work was originally meant to be placed high above the ground on a buttress for Florence Cathedral (*duomo*). Instead, the city leaders, believing it to be too magnificent to be placed so high, put it in front of the Palazzo Vecchio (the Town Hall). It also had to be protected from the rain, since the soft marble rapidly began to deteriorate.

Inspired by the Hellenistic sculptures he had seen in Rome, Michelangelo set out in pursuit of an emotion-charged heroic ideal. The scale, musculature, emotion, and stunning beauty and power of those works became a part of Michelangelo's High Renaissance style.

work of sculpture, we can perceive and respond to texture, which can be both physical and suggested. Sculptors go to great lengths to achieve the texture they desire for their works. In fact, much of a sculptor's technical mastery manifests itself in that final ability to impart a surface to the work. We examine texture more fully in our discussion of sense responses.

Principles

PROPORTION. Proportion is the relative relationship of shapes to one another. Just as we have a seemingly innate sense of balance, so we have a feeling of proportion. That feeling tells us that each form in the sculpture is in proper relationship to the others. However, as any student of art history will tell us, proportion—or the ideal of relationships—has varied from one civilization or culture to another. For example, such a seemingly obviously proportioned entity as the human body has varied greatly in its proportions as sculptors over the centuries have depicted it. Study the differences in proportion in the human body among Michelangelo's *David* (Fig. 3.8), the Chartres' *Saints* (Fig. 3.9), an ancient Greek *Kouros* figure (Fig. 3.10), and Giacometti's *Man Pointing* (Fig. 3.11). Each depicts the human form, but with differing proportions. This difference in proportion helps transmit the message the artist wishes to communicate about his or her subject matter.

REPETITION. Rhythm, harmony, and variation constitute repetition in sculpture, as they did in the pictorial arts. In sculpture, though, we must look more carefully and closely to determine how the artist has employed these elements because these characteristics occur more subtly. If we reduce a sculpture to its components of line and form, we begin to see how (as in music) rhythmic patterns—regular and irregular—occur. In Figure 3.2, for example,

a regular rhythmic pattern is established in space as the eye moves from figure to figure and from leg to leg of the figures. We also can see whether the components are consonant or dissonant. For instance, in Figure 3.2 a sense of dynamics, that is, action or movement, is created by the dissonance that results from juxtaposing the strong triangles of the stances and groupings with the *biomorphic* lines of the human body. Unity of the curves in Figure 3.13, in contrast, provides us with a consonant series of relationships. Finally, we can see how line and form are used in theme and variation. We noted the repetition of triangles in Figure 3.2. In contrast, the sculptor of Figure 3.12 varies his motif, the oval, as the eye moves from the child's face to the upper arm, the hand, and finally the cat's face.

Other Factors

Articulation

Important also in viewing sculpture is noting the manner by which we move from one element to the next. That manner of movement is called *articulation*, and it applies to sculpture, painting, photography, and all the other arts. As an example, let us step outside the arts to consider human speech. Sentences, phrases, and individual words are nothing more than sound syllables (vowels) articulated (that is, joined together) by consonants. We understand what someone says because that individual articulates as he or she speaks. Let us put the five vowel sounds side by side: Eh—EE—Ah—O—OO. As yet we do not have a sentence. Articulate those vowels with consonants, and we have meaning: "Say, she must go too." The nature of an artwork depends on how the artist has repeated, varied, harmonized, and related its parts and how he or she has articulated the movement from one part to another—that is, how the sculptor indicates where one stops and the other begins.

Figure 3.9 Jamb Statues, West Portal, Chartres Cathedral (begun 1145). Lauros-Giraudon/Art Resource, N.Y.

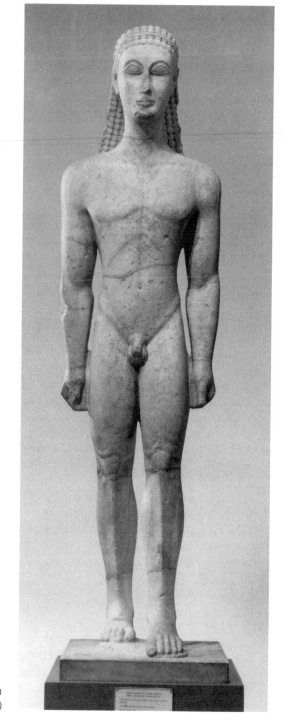

Figure 3.10 *Kouros* figure. The Metropolitan Museum of Art, Fletcher Fund, 1932. (32.11.1)

Gothic Sculpture

The sculptures of Figure 3.9 represent the Gothic style, and, as the illustration clearly shows, they stand attached to a background. They are *relief* sculptures, emerging from a carved section of the jamb surrounding a portal of a structure we more readily recognize as representing Gothic style, that is, a cathedral (see Figs. 9.27 and 9.29).Gothic style took many forms, but in the cathedral it achieved a synthesis of intellect, spirituality, and engineering, perfectly expressing the medieval mind from which it sprang. Gothic style was widespread in Europe, but like the other arts, it was not uniform in application nor in date. Initially a very local style on the Île de France (pronounced eel duh FRAHNS) in the late twelfth century, it spread outward to the rest of Europe. It had died as a style in some places before it was adopted in others.

Gothic sculpture reveals the changes in attitude of the period. It portrays serenity, idealism, and simple naturalism. Gothic sculpture has a human quality. In Gothic sculpture life seems to be more valuable than it had been in the immediately preceding time. The vale of tears, death, and damnation that often can be found in the sculpture of the Romanesque period of the Middle Ages, which occurred just prior to the Gothic Age, are replaced by conceptions of Christ as a benevolent teacher and of God as awesome in his beauty rather than in his vengeance. There is a new order, symmetry, and clarity. Visual images carry over a distance with greater distinctness. The figures of Gothic sculpture are less entrapped in their material and, as time passed, stood more and more away from their backgrounds.

During the Gothic Age of the twelfth and thirteenth centuries, schools of sculpture developed throughout France. Thus, although individual stone carvers worked alone, their links with a particular school gave their works the character of that school. The work from Reims, for example, had an almost classical quality; that from Paris was dogmatic and intellectual, perhaps reflecting the role of Paris as a university city. As time went on, sculpture became more naturalistic. Spiritual meaning was sacrificed to everyday appeal, and sculpture increasingly reflected secular interests, both middle class and aristocratic.

Compositional unity also changed over time. Early Gothic sculpture was subordinate to the overall design of the building, as occurs in the Chartres sculptures, created in 1145 (Fig. 3.9). Later work began to claim attention on its own.

The sculpture of Figure 3.9 reflects the early part of Gothic style. These figures are attenuated. That is, the forms of the humans are slender and the proportions are lengthened to display a heightened sense of relaxed serenity, idealism, and simple naturalism. They are an integral part of the portal columns, but they also emerge from them, each in its own space. Each figure has a particular human dignity despite its idealization. Cloth drapes easily over the bodies. Detail is somewhat formal and shallow, but a figure emerges beneath the fabric; fabric is no longer mere surface decoration.

Figure 3.11 Alberto Giacometti,
Man Pointing (1947).
Bronze, 6'-8$^1/_2$" high.
Collection, The Museum of
Modern Art, New York. Gift of
Mrs. John D. Rockefeller 3d.

Figure 3.12 William Zorach, *Child with Cat* (1926). Bronze, 17¹/₂" × 10" × 7¹/₂".Palmer Museum of Art, The Pennsylvania State University.

Figure 3.13 *Tree Spirit* (*Bracket Figure*), central India (first century A.D.). ©The British Museum, London.

Focal Area (Emphasis)

Sculptors, like painters or any other visual artists, must concern themselves with drawing our eye to those areas of their work that are central to what they wish to communicate. They also must provide the means by which our eye can move around the work. However, their task is much more complicated because they deal in three dimensions and they have little control over the direction from which we will first perceive the piece; the entire 360-degree view contributes to the total message communicated by the work.

Converging lines, encirclement, and color all work for sculptors as they do for painters. The encircling line of the tree and body parts in Figure 3.13 causes us, however we proceed to scan the work, to focus ultimately on the torso of this fertility figure.

One further device is available—movement, and sculptors have the option of placing moving objects in their work. Such an object immediately becomes a focal point of the sculpture. A mobile (Fig. 3.14) presents many ephemeral patterns of focus as it turns at the whim of the breezes.

How does it stimulate the senses?

Touch

We can touch sculpture and feel its roughness or its smoothness, its coolness or perhaps its warmth. Even if we are prohibited by museum regulation from touching a sculpture, we can see the surface texture and translate the image into an imaginary tactile sensation. Any work of sculpture cries out to be touched.

Temperature and Age

Color in sculpture stimulates our response by utilizing the same universal symbols as it does in paintings, photographs, and prints. Reds, oranges, and yellows stimulate sensations of warmth; blues

Figure 3.14 Alexander Calder, *Spring Blossoms* (1965). Painted metal and heavy wire, extends 52" × 102". Palmer Museum of Art, The Pennsylvania State University. Gift of the Class of 1965. ©1998 Estate of Alexander Calder/Artists Rights Society (ARS), N.Y.

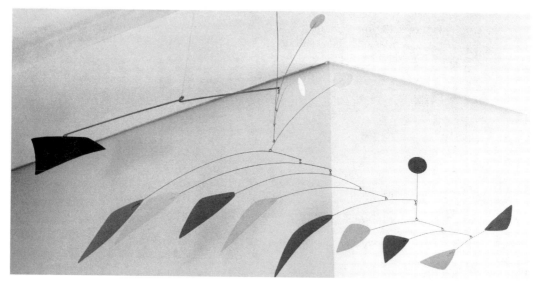

and greens, sensations of coolness. In sculpture, color can result from the conscious choice of the artist, either in the selection of material or in the selection of the pigment with which the material is painted. Or, as we indicated earlier, color may result from the artist's choice to let nature color the work through wind, water, sun, and so forth.

This weathering effect, of course, creates very interesting patterns, but in addition it gives the sculpture the attribute not only of space but also of time, because the work obviously will change as nature works her wonders. A copper sculpture early in its existence will be a different work, a different set of stimuli, than it will be in five, ten, or twenty years. This is not accidental; Artists choose copper, knowing what weathering will do to it. They obviously cannot predict the exact nature of the weathering or the exact hues of the sculpture at any given time in the future, but such predictability is irrelevant.

Our response to a work of art may in fact be shaped by the effects of age. Ancient objects possess a great deal of charm and character. A wooden icon like Figure 3.15 might have greater emotional impact because of the effects of age on its surfaces.

Figure 3.15 *Gero Crucifix* (c. 975–1000 A.D.). Oak, 6' 2". Cologne Cathedral. Courtesy of Heaton Sessions, Stone Ridge, New York. Rheinisches Bildarchiv photo.

Figure 3.16 Egyptian statuary. Sculpture made of red granite. The Metropolitan Museum of Art, New York. Gift of Edward S. Harkness, 1914 (14.7.15)

Dynamics

Line, form, and juxtaposition create dynamics in works of sculpture. The activity of a sculpture tends to be heightened because of its three-dimensionality. In addition, we experience a certain sense of dynamics as we move around the work. Although we are moving and not the sculpture, we perceive and respond to what seems to be movement in the work itself.

Size

Because sculpture has mass—that is, takes up space and has density—our senses respond to the weight and/or scale of a work. Egyptian sculpture, which is solid, stable, and oversized (see Fig. 3.16), has mass and proportion as well as line and form that make it appear heavier than a non-Egyptian work of basically the same size and material, such as in Figure 3.3. Moreover, the very same treatment of texture, verisimilitude, and subject would elicit a completely different sense response if the work were 3 feet tall than if it were 30 feet tall.

Early in the chapter we mentioned the possibility of an artist's *disguising the material* from which the work is made. Marble polished to appear like skin or wood polished to look like fabric can change the appearance of the mass of a sculpture and significantly affect our response to it.

We also must consider the purpose of disguising material. For example, does the detailing of the sculpture reflect a formal concern for design, or does it reflect a concern for greater verisimilitude? Examine the cloth represented in Figures 3.1 and 3.13. In both cases the sculptor has disguised the material by making stone appear to be cloth. In Figure 3.1 the cloth is detailed to reflect reality. It drapes as real cloth would drape, and as a result its effect in the composition depends on the subtlety of line characteristic of draped cloth. However, in Figure 3.13 the sculptor has depicted cloth in such

a way that its effect in the design is not dependent on how cloth drapes, but rather on the decorative function of line as the sculptor wishes to use it. Real cloth cannot drape as the sculptor has depicted it. Nor, probably, did the sculptor care. His main concern here was for decoration, for using line (that looks like cloth) to emphasize the rhythm of the work. When sculpture de-emphasizes lifelikeness in order to draw attention to the substance from which it is made, we call it *glyptic*. Glyptic sculpture emphasizes the material from which the work is created and usually retains the fundamental geometric qualities of that material.

Lighting and Environment

One final factor that significantly influences our sense response to a sculpture, a factor we very often do not consider and is outside the control of the artist unless he or she personally supervises every exhibition in which the work is displayed, is that of *lighting and environment*. As we note in the chapter on theatre, light plays a seminal role in our perception of and thereby our response to three-dimensional objects. The direction and number of sources of light striking a three-dimensional work can change the entire composition of that work. Whether the work is displayed outdoors or indoors, the method of lighting affects the overall presentation of the work. Diffuse room lighting allows us to see all aspects of a sculpture without external influence. However, if the work is placed in a darkened room and illuminated from particular directions by spotlights, it becomes much more dramatic and our response is affected accordingly.

Where and how a work is exhibited also contributes to our response. A sculpture can create a far different response if placed in a carefully designed environment that screens our vision from distracting or competing visual stimuli than if exhibited among other works amid the bustle of a public park, for instance.

CHRONOLOGY OF SELECTED WORKS FOR ADDITIONAL STUDY

c. 4000 B.C.–c. 300 A.D.

Ancient Egypt
 Tomb and temple sculptures
Classical Greece
 Polycleitus: *Lance Bearer*
 Myron: *Discus Thrower*
 Praxitiles: *Cnidian Aphrodite*
Hellenistic Greece
 Winged Victory of Samothrace
 Laocoön Group

c. 400–c. 1400

Romanesque
 Bronze doors of Hildesheim Cathedral
 Last Judgment tympanum, Autun Cathedral
Gothic
 sculptures of Chartres Cathedral

c. 1400–c. 1570

Renaissance
 Donatello: *David*
High Renaissance
 Michelangelo: *David*
Mannerism
 da Bologna: *Mercury*

c. 1570–c. 1700

Baroque
 Bernini: *Ecstacy of St. Theresa*

c. 1700–c. 1900

Neoclassicism
 Maillot: *Night*
Eclecticism
 Rodin: *Balzac*

c. 1900–c. 2000

Cubism
 Picasso: *Mandolin and Clarinet*
 Lipchitz: *Man with a Guitar*

Futurism
 Boccioni: *Unique Forms of Continuity in Space*
Postwar Classicism
 Henry Moore: *Reclining Figure*
Abstract Expressionism
 David Smith: *Tank Totem IV*
Abstraction
 Giacometti: *Man Pointing*
 Calder: *7 Red, 7 Black, 1 White*

Primary Structures
 Nevelson: *America-Dawn*
Installations
 Pfaff: *Dragons*
Video Art
 Paik: *TV Bra for Living Sculpture*

Music

We all have favorite forms of music. They might be tejano, reggae, rock, rhythm and blues, rap, gospel, or classical. Occasionally we are surprised to find that our favorite tune or musical form was once something else: a rock tune that first was an operatic aria, or an ethnic style that combines styles from other ethnic traditions. Whatever the case, music is music. It comprises rhythms and melodies that differ only in the ways they are put together. In this chapter we'll concentrate first on some classical forms, but after that we'll discuss qualities that apply to all music, whether classical or popular.

Music often has been described as the purest of the art forms because it is free from the physical restrictions of space that apply to the other arts. However, the freedom enjoyed by the composer becomes a constraint for us listeners because music is an art that places significant responsibility on us. That responsibility is especially critical in trying to learn and apply musical terminology, because we have only a fleeting moment to capture many of the characteristics of music. A painting or a sculpture stands still for us; it does not change or disappear, despite the length of time it takes us to find or apply some new characteristic. Such is not the case with music.

We live in a society that is very aural in its perceptions, but these perceptions usually do not require any kind of active listening. An excellent example is the Muzak we hear in many stores, restaurants, office buildings, and on telephone "hold," which is intended solely as a soothing background designed *not* to attract attention. We hear music constantly on the radio, the television, and in the movies, but nearly always in a peripheral role. Because we are not expected to pay attention to it, we do not. Therefore, we hardly ever undertake the kind of practice we need to be attentive to music and to perceive it in detail. However, like any skill, the ability to hear perceptively is enhanced through repetition and training. If we have had limited

experience in responding to music, we will find challenge in the concert hall hearing what there is to hear in a piece of music that passes in just a few seconds.

What is it?

At a formal level, our experience of a musical work begins with its type, or form. As is the case with theatre genres, the basic form of a musical composition shapes our initial encounter by providing us with some specific parameters for understanding. Unlike our experience in the theatre, we are likely to find an identification of the musical composition, by type, in the concert program. Here are a few of the more common forms we are likely to encounter. Because many musical forms are period- or style-specific—that is, they grew out of a specific stylistic tradition, some of our descriptions may include brief historical references.

Art Song

An art song is a setting of a poem for solo voice and piano. Typically, it adapts the poem's mood and imagery into music. Art song is a distinctive form of music which grew out of the Romantic style of the nineteenth century. That is to say, it has an emotional tendency, and its themes often encompass lost love, nature, legend, and the far away and long ago. In this type of composition, the accompaniment is an important part of the composer's interpretation and acts as an equal partner with the voice. In this form, important words are emphasized by stressed tones or melodic climaxes. (Listen to Schubert's "The Erlking," CD track 14)

Cantata

A cantata is usually a choral work with one or more soloists and an instrumental ensemble. Written in several movements, it is typified by the church cantata of the Lutheran church of the baroque period (1600-1750) and often includes chorales and organ accompaniment. The word cantata originally meant a piece that was sung—in contrast to a sonata (see below), which was played. The Lutheran church cantata (exemplified by those of Johann Sebastian Bach) uses a religious text either original or drawn from the Bible or familiar hymns (chorales). In essence, it served as a sermon in music, drawn from the lectionary (prescribed Bible readings for the day and on which the sermon is based). A typical cantata might last twenty-five minutes and include several different movements—choruses, recitatives, arias, and duets. (Listen to Bach's "Cantata No. 80," final chorale, CD track 9)

Concert Overture

A concert overture is an independent composition for orchestra. It contains one movement, composed in sonata form (see Sonata). The concert overture is modeled after the opera overture, similarly a one-movement work, that establishes the mood of an opera. Unlike the opera overture, the concert overture is not intended as the introduction to anything. It stands on its own as an independent composition.

Concerto

A *solo* concerto is an extended composition for an instrumental soloist and orchestra. Reaching its zenith during the classical period of the eighteenth century, it typically contains three movements, in which the first is fast, the second, slow, and the third, fast. Concertos join a soloist's virtuosity and interpretive skills with the wide-ranging dynamics and tonal colors of an orchestra. The concerto provides, thus, a dramatic contrast of musical ideas and sound in which the soloist is the star. Typically, concertos present great challenge to the soloist and great reward to the

STYLE

Musical Classicism

In 1785 Michel Paul de Chabanon (pronounced shahb-ah-NOHN) wrote: "Today there is but one music in all of Europe." What he meant was that music at the time was being composed to appeal not only to the aristocracy but to the middle classes as well. Egalitarian tendencies and the popular ideas of the era had influenced artists, who now sought larger audiences. Eighteenth-century *rationalism* saw excessive complexity and ornamentation (both characteristics of the anti-classical art of the previous century, called *Baroque*) as not appealing to a wide audience on its own terms. Those tendencies prompted a move toward order, simplicity, and careful attention to form. We call this style in music *classical* (the term was not applied until the nineteenth century), rather than neoclassical or classical revival, because although the other arts such as architecture, for example, returned, more or less, to Greek and Roman prototypes, music had no known classical antecedents to revive. Music thus turned to classical ideals, though not to classical models.

The classical style in music had, among others, five basic characteristics. The first of these is variety and contrast in *mood*. In contrast to the previous, baroque style (for example, that of Johann Sebastian Bach) which usually dealt with a single emotion, classical pieces typically explore contrasts between moods. There may be contrasting moods within movements and within themes, as well. Changes in mood may be gradual or sudden; they are, however, as one might expect of a style called "classical," well controlled, unified, and logical.

A second characteristic of classical style in music is flexibility of *rhythm*. Classical music explores a wide variety of rhythms, utilizing unexpected pauses, syncopation, and frequent changes from long to shorter notes. As in mood, changes in rhythm may be sudden or gradual. A third characteristic of classical style in music is a predominantly homophonic *texture*. Nonetheless, texture also is flexible, with sudden and gradual shifts from one texture to another.

A fourth characteristic is memorable *melody*. The themes of classical music tend to be very tuneful and often have a folk or popular flavor. Classical melodies tend toward balance and symmetry, again what one would expect of "classical" works as we have seen them since the ancient Greeks. Frequently classical themes have two phrases of equal length. The second phrase often begins like the first but ends more decisively.

A fifth characteristic of classical style is gradual changes in *dynamics*, in contrast to baroque music, which employs sudden changes in dynamics (*step dynamics*). One of the consequences of this direction in musical composition was the replacement of the harpsichord with the piano, which was more capable of handling the subtlety of classical dynamic patterns.

The two predominant composers of the classical style were Wolfgang Amadeus Mozart and Franz Josef Haydn.

listener, who can delight in the soloist's meeting of the technical and interpretive challenges of the work. Nonetheless, the concerto is a balanced work in which the orchestra and soloist act as partners. The interplay between orchestra and soloist provides the listener with fertile ground for involvement and discernment. Concertos can last from 20 to 45 minutes. Typically, during the first movement, and sometimes the third, of a classical concerto, the soloist has an unaccompanied showpiece called a cadenza.

Common to the late baroque period (1600-1750), the *concerto grosso* is a composition for several instrumental soloists and small orchestra. In the baroque style contrast between loud and soft sounds and between large and small groups of performers was typical. In a concerto grosso, a small group of soloists (two to four) contrasts a larger group called the *tutti* which consists of eight to twenty players. Most often a concerto grosso contains three movements contrasting in tempo and character. The first movement is fast; the second, slow; and the third, fast. The opening movement, usually bold, explores the contrasts between tutti and soloists. The slow movement is more lyrical, quiet, and intimate. The final movement is lively, lighthearted, and sometimes dancelike. (Listen to Vivaldi's "Spring" from the *Four Seasons*—first movement, CD track 11.)

Fugue

The fugue is a polyphonic (two or more melodic lines of relatively equal importance performed at the same time) composition based on one main theme, or subject. It can be written for a group of instruments or voices or for a single instrument like an organ or harpsichord. Throughout the composition, different melodic lines, called "voices," imitate the subject. The top melodic line is the soprano and the bottom line, the bass. A fugue usually includes three, four, or five voices. The composer's exploration of the subject typically

passes through different keys and combines with different melodic and rhythmic ideas. Fugal form is extremely flexible: the only constant feature is the beginning in which a single, unaccompanied voice states the theme. The listener's task, then, is to remember that subject and follow it through the various manipulations that follow.

Mass

The mass is a sacred choral composition consisting of five sections: Kyrie, Gloria, Credo, Sanctus, and Agnus Dei. These also form the parts of the mass ordinary—that is, the Roman Catholic church texts that remain the same from day to day throughout most of the year. The Kyrie text implores, "Lord, have mercy upon us. Christ, have mercy upon us. Lord, have mercy upon us." The Gloria text begins, "Glory be to God on High, and on earth peace, good will towards men." The Credo states the creed: "We believe in one God, the Father, the Almighty, maker of heaven and earth," and so on. Sanctus confirms, "Holy, holy, holy, holy, Lord God of Hosts. Heaven and earth are full of thy glory. Glory be to thee, O Lord Most High." The Agnus Dei (Lamb of God) implores "O Lamb of God, that takest away the sins of the world, have mercy upon us. O Lamb of God, that takest away the sins of the world, have mercy upon us. O Lamb of God, that takest away the sins of the world, grant us thy peace." (Listen to Palestrina's "Kyrie" from the *Pope Marcellus Mass*, CD track 7.) The *requiem mass*, which often comprises a musical program, is a special mass for the dead.

Motet

A motet is a polyphonic choral work, shorter than a mass, employing a sacred Latin text other than that of the mass. With the mass, the motet was one of the two main forms of sacred music during the Renaissance (late fourteenth to sixteenth centuries).

Mozart

Wolfgang Amadeus Mozart (1756-91) is often considered the greatest musical genius of all time. His output—especially in view of his short life—was enormous and included 16 operas, 41 symphonies, 27 piano and five violin concerti, 25 string quartets, 19 masses, and other works in every form popular in his time. Perhaps his greatest single achievement is in the characterization of his operatic figures.

Mozart was born on Jan. 27, 1756, in Salzburg, Austria. His father, Leopold Mozart, held the position of composer to the archbishop and was a well-known violinist and author of a celebrated theoretical treatise. When Wolfgang was only six years old, his father took him and his older sister, Maria Anna (called Nannerl) on tours throughout Europe during which they performed as harpsichordists and pianists, both separately and together. They gave public concerts, played at the various courts, and met the leading musicians of the day. In Paris in 1764, Mozart wrote his first published works, four violin sonatas. In London he came under the influence of Johann Christian Bach. In 1768 young Mozart became honorary concertmaster for the archbishop.

In 1772, however, a new archbishop came to power, and the cordial relationship Mozart enjoyed with the previous archbishop came to an end. By 1777 the situation became so strained that the young composer asked to be relieved of his duties, and the archbishop grudgingly agreed.

In 1777 Mozart traveled with his mother to Munich and Mannheim, Germany, and to Paris, where she died. On this trip alone, Mozart composed seven violin sonatas, seven piano sonatas, a ballet, and three symphonic works, including the *Paris Symphony*.

The final break between Mozart and the archbishop occurred in 1781, although prior to that time Mozart had unsuccessfully sought another position. Six years later, in 1787, Emperor Joseph II finally engaged him as chamber composer—at a salary considerably smaller than that of his predecessor. Mozart's financial situation worsened steadily, and he incurred significant debts that hounded him until his death.

Meanwhile, his opera *The Abduction from the Seraglio* enjoyed great success in 1782; in the same year he married Constanze Weber, the daughter of friends. He composed his great *Mass in C Minor* for her, and she was the soprano soloist at its premiere.

During the last ten years of his life, Mozart produced most of his great piano concerti; four horn concerti; the *Haffner, Prague, Linz*, and *Jupiter* symphonies; the six string quartets dedicated to Haydn; five string quintets; and the major operas, *The Marriage of Figaro, Don Giovanni, Così Fan Tutte, La Clemenza di Tito*, and *The Magic Flute*. Mozart was unable to complete his final work, a *Requiem*, because of illness. He died in Vienna on Dec. 5, 1791, and was buried in a multiple grave. Although the exact nature of his illness is unknown, there is no evidence that Mozart's death was deliberately caused (as the popular movie, *Amadeus*, implies).

Opera

We give special treatment to this form of music later in the chapter.

Oratorio

An oratorio is a large-scale composition using chorus, vocal soloists, and orchestra. Normally an oratorio sets a narrative text (usually biblical), but does not employ acting, scenery, or costumes. The oratorio was a major achievement of the baroque period of 1600 to 1750. This type of musical composition unfolds through a series of choruses, arias, duets, recitatives, and orchestral interludes. The chorus of an oratorio is especially important and can comment on or participate in the dramatic exposition. Another feature of the oratorio is the use of a narrator, whose recitatives (vocal lines imitating the rhythms and inflections of normal speech) tell the story and connect the various parts. Like operas, oratorios can last more than two hours. (Listen to Handel's "Hallelujah Chorus" from the oratorio *Messiah*, CD track 10.)

Sonata

An outgrowth of the baroque period (1600-1750), a sonata is an instrumental composition in several movements written for one to eight players. After the baroque period, the sonata changed to a form typically for one or two players. The trio sonata of the baroque period had three melodic lines (hence its name). It actually uses four players. (Listen to Mozart's "Piano Sonata No. 11 in A, K. 331"—Rondo: alla turca, CD track 12). This general type of musical composition should not be confused with "sonata form," which is a specific form for a single movement of a musical composition. Sonata form consists of three main sections: the exposition in which themes are presented; the development in which themes are treated in new ways; and the recapitulation, in which the themes return. A concluding section,

called a "coda," often follows the recapitulation. (Listen to Beethoven's *Symphony No. 5 in C minor*—First movement, CD track 13.)

Suite

A suite comprises a set of dance-inspired movements written in the same key but differing in tempo, meter, and character. An outgrowth of the baroque period (1600-1750), a suite can employ solo instruments, small ensembles, or an orchestra. The movements of a suite typically are in two parts, with each section repeated (AABB). The A section opens in the tonic key and modulates to the dominant (the fifth tone of the scale). The B section begins in the dominant and returns to the tonic. Both sections employ the same thematic material and exhibit little by way of contrast.

Symphony

An orchestral composition, usually in four movements, a symphony typically lasts between twenty and forty-five minutes. In this large work, the composer explores the full dynamic and tonal range of the orchestral ensemble. The symphony is a product of the classical period of the eighteenth century and evokes a wide range of carefully structured emotions through contrasts of tempo and mood. The sequence of movements usually begins with an active fast movement, changes to a lyrical slow movement, moves to a dancelike movement, and closes with a bold fast movement. The opening movement is almost always in sonata form (see Sonata). In most classical symphonies, each movement is self-contained with its own set of themes. Unity in a symphony occurs partly from the use of the same key in three of the movements and also from careful emotional and musical complement among the movements. (Listen to Berlioz's *Symphonie Fantastique*—Fourth movement, "March to the Scaffold", CD track 16; also Beethoven's *Symphony No. 5 in C minor*—First movement, CD track 13.)

How is it put together?

Understanding vocabulary and being able to identify its application in a musical work help us comprehend communication using the musical language, and thereby understand the creative communicative intent of the composer and the musicians who bring the composition to life. The ways in which musical artists shape the characteristics that follow bring us experiences that can challenge our intellects and excite our emotions. As in all communication, meaning depends on each of the parties involved; communicators and respondents must assume responsibility for facility in the language utilized.

Among the basic elements by which music is put together, we will identify and discuss seven: 1) Sound, 2) Rhythm, 3) Melody, 4) Harmony, 5) Tonality, 6) Texture, and 7) Form.

Sound

Music is composed by designing sound and silence. The latter is reasonably clear, but what of the former? What is sound? In the broadest sense, sound is anything that excites the auditory nerve: It can be sirens, speech, crying babies, jet engines, falling trees, and so on. We might even call such sources noise. Musical composition, although it can even employ "noise," usually depends on sound that can be controlled and shaped, sound that can be consistent in quality. We distinguish music from other sounds by recognizing four basic properties: 1) pitch, 2) dynamics, 3) tone color, and 4) duration.

Pitch

Pitch is a physical phenomenon measurable in vibrations per second. So when we describe differences in pitch we are describing recognizable and measurable differences in sound waves. A pitch has a steady, constant frequency. A faster frequency produces a higher pitch; a slower frequency, a lower pitch. If a sounding body—a vibrating string, for example—is shortened, it vibrates more rapidly. Musical instruments designed to produce high pitches, such as the piccolo, therefore tend to be small. Instruments designed to produce low pitches tend to be large—for instance, bass viols and tubas. In music, a sound that has a definite pitch is called a tone.

In Chapter 3 we discussed color. Color comprises a range of light waves within a visible spectrum. Sound also comprises a spectrum, one whose audible pitches range from 16 to 38,000 vibrations per second. We can perceive 11,000 different pitches! Obviously that is more than is practical for musical composition. Therefore, *by convention* the sound spectrum is divided into roughly ninety equally spaced frequencies comprising seven and a half *octaves*. The piano keyboard, consisting of eighty-eight keys (seven octaves plus two additional tones) representing the same number of equally spaced pitches, serves as an illustration (Fig. 4.1).

The thirteen equally spaced pitches in an octave, (C to C, for example) are called a *chromatic scale*. However, the scales that sound most familiar to us are the major and minor scales, which consist of an octave of eight pitches. The distance between any two pitches is an *interval*. Intervals between two adjacent pitches are *half steps*. Intervals of two half steps are *whole steps*. The major scale—*do re mi fa sol la ti do* (recall the song, "Doe, a deer . . ."from *The Sound of Music*)—has a specific arrangement of whole and half steps (Fig. 4.2). Lowering the third and sixth notes of the major scale gives us the diatonic (the most common) minor scale.

To reiterate, a scale, which is an arrangement of pitches or tones played in ascending or descending order, is a conventional organization of the frequencies of the sound spectrum. Not all music conforms to this convention. Music of Western civilization prior to approximately A.D. 1600 does not, nor does Eastern music, which makes great use of quarter tones. In addition, some contemporary Western music departs from

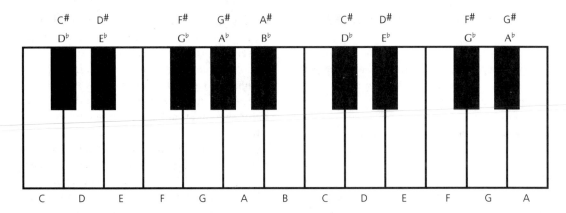

Figure 4.1 Part of the piano keyboard and its pitches.

the conventions of tonality of the major or minor scale. Listen to tracks 1–3 on the music CD. These examples are from cultures whose music does not conform to the western conventions of pitch and scale, or tonality. There are, however, other characteristics that make this music sound different from the music of Bach, for example (track 9). At the end of our discussion of musical elements, identify the additional ways in which these three selections differ from traditional western music.

Dynamics

Degrees of loudness or softness in music are called dynamics. Any tone can be loud, soft, or anywhere in between. Dynamics is the *decibel* level of tones, and depends on the physical phenomenon of *amplitude* of vibration. When greater force is employed in the production of a tone, the resulting sound waves are wider and cause greater stimulation of the auditory nerves. The *size* of the sound wave, not its number of vibrations per second, is changed.

Composers indicate *dynamic levels* with a series of specific notations:

pp	pianissimo	very soft
p	piano	soft
mp	mezzo piano	moderately soft
mf	mezzo forte	moderately loud
f	forte	loud
ff	fortissimo	very loud

The notations of dynamics that apply to an individual tone, such as *p*, *mp*, and *f*, also may apply to a section of music. Changes in dynam-

Figure 4.2 The major and minor scales.

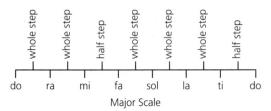

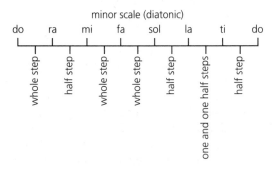

ics may be abrupt, gradual, wide, or small. A series of symbols also governs this aspect of music.

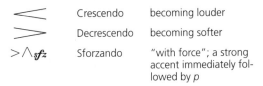

	Crescendo	becoming louder
	Decrescendo	becoming softer
	Sforzando	"with force"; a strong accent immediately followed by *p*

As we listen to and compare musical compositions we can consider the use and breadth of dynamics in the same sense that we consider the use and breadth of palette in painting.

Tone Color

Tone color, or *timbre* (pronounced TAM-ber), is the characteristic of tone that allows us to distinguish a pitch played on a violin, for example, from the same pitch played on a piano. In addition to identifying characteristic differences among sound-producing sources, tone color characterizes differences in quality of tones produced by the same source. Here the analogy of tone color is particularly appropriate. A tone that is produced with an excess of air—for example, by the human voice—is described as "white." Figure 4.3 illustrates some of the various sources that produce musical tone and account for its variety of tone colors. The following table lists some of the various sources that produce musical tone and account for its variety of timbres.

Voice			*Electronic*
Soprano			Synthesizer
Mezzo-sporano	}	Women's	
Contralto			
Tenor			
Baritone	}	Men's	
Bass			

Strings	*Woodwinds*	*Brasses*
Violin	Flute	Trumpet
Viola	Piccolo	Horn
Cello	Oboe	Trombone
(violoncello)		
Bass	English horn	Tuba
Harp	Clarinet	
	Bassoon	

Percussion

Snare drum	Piano	Harpsichord
Bass drum		
Timpani		
Triangle		
Cymbal		

The piano could be considered either a stringed or a percussion instrument because it produces its sound by vibrating strings *struck* by hammers. The harpsichord's strings are set in motion by plucking.

Electronically produced music, available since the development of the RCA synthesizer at the Columbia-Princeton Electronics Music Center, has become a standard source in assisting contemporary composers (Fig. 4.4). Originally electronic music fell into two categories: (1) the electronic altering of acoustically produced sounds, which came to be labeled as *musique concrète* (see Glossary) and (2) electronically generated sounds. However, advances in technology have blurred those differences over the years.

Duration

Another characteristic of sound is *duration*, the length of time in which vibration is maintained without interruption. Duration in musical composition is designed within a set of conventions called musical notation (Fig. 4.5). This system consists of a series of symbols (notes) by which the composer indicates the relative duration of each tone. The system is progressive—that is, each note is either double or half the duration of an adjacent note. Musical notation also includes a series of symbols that denote the duration of *silences* in a composition. These symbols are called *rests*, and have the same durational values as the symbols for duration of tone.

Rhythm

Rhythm comprises recurring pulses and accents that create identifiable patterns. Without

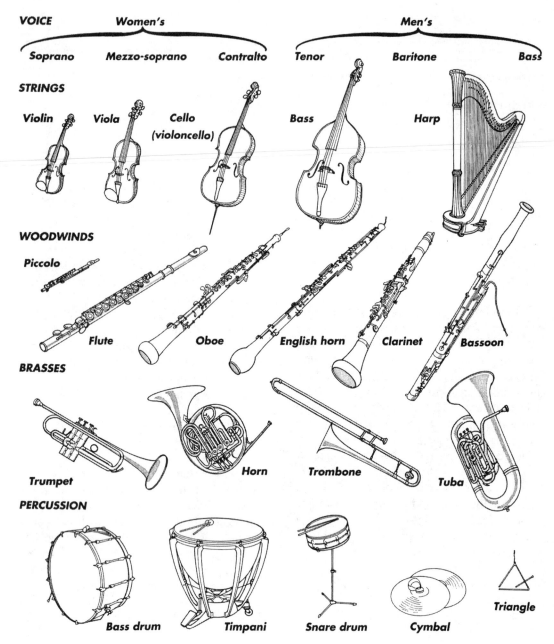

Figure 4.3 The key sources of musical tone in an orchestra (instruments not to scale). John Calmann & King, Ltd.

Figure 4.4 Musician at an electronic control panel. Randy Matusow/Monkmeyer Press.

rhythm we have only an aimless rising and falling of tones. Earlier we noted that each tone and silence has duration. Composing music means placing each tone into a time or rhythmical relationship with every other tone. As with the dots and dashes of the Morse code we can "play" the rhythm of a musical composition without reference to its tones. Each symbol (or note) of the musical notation system denotes a duration relative to every other symbol in the system. Rhythm consists of: 1) beat, 2) meter, and, 3) tempo.

Beat

The individual pulses we hear are called *beats*. Beats may be grouped into rhythmic patterns by placing accents every few beats. Beats are basic units of time and form the background against which the composer places notes of various lengths.

Figure 4.5 Musical notation.

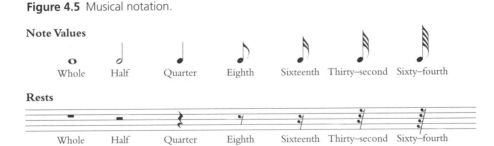

Note Values

| Whole | Half | Quarter | Eighth | Sixteenth | Thirty–second | Sixty–fourth |

Rests

| Whole | Half | Quarter | Eighth | Sixteenth | Thirty–second | Sixty–fourth |

Meter

Normal musical practice is to group clusters of beats into units called *measures*. When these groupings are regular and reasonably equal they comprise *simple* meters. When the number of beats in a measure equals three or two it constitutes *triple* or *duple* meter. As listeners, we can distinguish between duple and triple meters because of their different *accent* patterns. In triple meter we hear an accent every third beat—ONE two three, ONE two three—and in duple meter the accent is every other beat—ONE two, ONE two. If there are four beats in a measure, the second accent is weaker than the first—ONE two THREE four, ONE two THREE four. Listen to CD track 15, Chopin's Nocturne in E-Flat Major, Op. 9, No. 2 and note the triple meter. Compare that with Louis Armstrong's "Mack the Knife" (CD track 22), which illustrates the martial character of quadruple meter.

When accent occurs on normally unaccented beats, we have *syncopation*, as occurs in Duke Ellington's "It Don't Mean a Thing" (CD track 23). Here the basic meter is duple, but the orchestra provides counterpoint for the vocalist with strong off-beat accents.

Sometimes repetitive patterning or strict metrical development does not occur. Listen to CD tracks 4, 5, 8, and 19 in sequence. In track 4, an example of Gregorian chant, the rhythm is free flowing with undistinguishable meter. The same is true of track 5, also a composition from the Middle Ages by Hildegard of Bingen. In contrast, Robert Morley's "Now is the Month of Maying" (track 8) is written in a strict, lively quadruple meter. Its repetitive pattern of 1, 2, 3, 4 is very obvious. On the other hand, Debussy's "Prelude to the Afternoon of a Faun" (track 19) changes meter so frequently that patterns virtually disappear (a faun, pronounced fawn, is a mythological creature with the body of a man and the horns, ears, tail, and sometimes legs of a goat).

Tempo

Tempo is the rate of speed of the composition. A composer may notate tempo in two ways. The first is by a *metronome marking*, such as $\quarternote = 60$. This means the piece is to be played at the rate of sixty quarter notes (\quarternote) per minute. Such notation is precise. The other method is less precise and involves more descriptive terminology in Italian.

Largo (broad) Grave (grave, solemn)	Very slow
Lento (slow) Adagio (leisurely)	Slow
Andante (at a walking pace) Andantino (somewhat faster than andante) Moderato (moderate)	Moderate
Allegretto (briskly) Allegro (cheerful, faster than allegretto)	Fast
Vivace (vivacious) Presto (very quick) Prestissimo (as fast as possible)	Very fast

The tempo may be quickened or slowed, and the composer indicates this by the words *accelerando* (accelerate) and *ritardando* (retard, slow down). A performer who takes liberties with the tempo is said to use *rubato* (pronounced roo-BAH-toh).

Melody

Melody is a succession of sounds with rhythmic and tonal organization. We can visualize melody as linear and essentially horizontal. Thus any organization of musical tones occurring *one after another* constitutes a melody. Two other terms, *tune* and *theme*, relate to melody as parts to a whole. For example, the *tune* in Figure 4.6 is a melody—that is, a succession of tones. However, a melody is not always a tune. In general, the term *tune* implies singability, and there are many melodies that cannot be considered singable. A

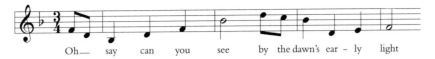

Figure 4.6 "The Star Spangled Banner" (excerpt).

theme is also a melody. However, in musical composition it specifically means a central musical idea, which may be restated and varied throughout a piece. Thus a melody is not necessarily a theme.

Related to theme and melody is the *motif*, or *motive*, a short melodic or rhythmic idea around which a composer may design a composition. For example, in Beethoven's Symphony No. 5 in C minor, (CD track 13) the first movement is developed around a motif of four notes.

In listening for how a composer develops melody, theme, and motive we can use two terms to describe what we hear: *conjunct* and *disjunct*. Conjunct melodies comprise notes close together, stepwise, on the musical scale. For example, the interval between the opening notes of the soprano line of J. S. Bach's chorale "Jesu Joy of Man's Desiring" from his Cantata 147 (Fig 4.7) is never more than a whole step. Such melodic development is highly conjunct. Disjunct melodies contain intervals of a third or more. However, no formula determines disjunct or conjunct characteristics; there is no line at which a melody ceases to be disjunct and becomes conjunct. These are relative and comparative terms that assist us in description. For example, we would say that the opening melody of "The Star Spangled Banner" (Fig. 4.6) is more disjunct than the opening melody of "Jesu Joy of Man's Desiring"—or that the latter is more conjunct than the former.

Harmony

When two or more tones sound at the same time, we have harmony. Harmony is essentially a vertical arrangement, in contrast with the horizontal arrangement of melody.

However, as we shall see, harmony also has a horizontal property—movement forward in time. In listening for harmony we are interested in how simultaneous tones *sound together*.

Two tones played simultaneously are an *interval*; three or more form a *chord*. When we hear an interval or a chord our first response is to its *consonance* or *dissonance*. Consonant harmonies sound stable in their arrangement. Dissonant harmonies are tense and unstable. Consonance and dissonance, however, are not absolute properties. Essentially they are conventional and, to a large extent, cultural. What is dissonant to our ears may not be so to someone else's. What is important in musical response is determining *how* the composer utilizes these two properties. Most of our music is primarily consonant. Dissonance,

Figure 4.7 "Jesu Joy of Man's Desiring" (excerpt).

on the other hand, can be used for contrast, to draw attention to itself, or as a normal part of *harmonic progression*.

As its name implies, harmonic progression involves the movement forward in time of harmonies. In discussing pitch we noted the convention of the major and minor scales—that is, the arrangement of the chromatic scale into a system of *tonality*. When we play or sing a major or minor scale we note a particular phenomenon: Our movement from *do* to *re* to *mi* to *fa* to *sol* to la is smooth and seems natural. But when we reach the seventh tone of the scale, *ti*, something strange happens. It seems as though we must continue back to *do*, the *tonic* of the scale. Try it! Sing a major scale and stop at *ti*. You feel uncomfortable. Your mind tells you to *resolve* that discomfort by returning to *do*. That same sense of tonality—that sense of the tonic—applies to harmony. Within any scale a series of chords may be developed on the basis of the individual tones of the scale. Each of the chords has a subtle relationship to each of the other chords and to the tonic—that is, the *do* of the scale. That relationship creates a sense of progression that leads back to the chord based on the tonic.

The harmonic movement toward, and either resolving or not resolving to, the tonic is called *cadence*. Three different cadences are shown in Figure 4.8. The use of cadence is one way of articulating sections of a composition or of surprising us by upsetting our expectations. A composer using a full cadence uses a harmonic progression that resolves just as our ear tells us it should. We have a sense of ending, of completeness. However, when a half cadence or a deceptive cadence is used, the expected progression is upset and the musical development moves in an unexpected direction.

As we listen to music of various historical periods we may note that in some compositions tonal centers are blurred because composers frequently *modulate*—that is, change from one key (see Glossary) to another. In the twentieth century many composers, some of them using purely mathematical formulas to utilize equally all tones of the chromatic scale, have removed tonality as an arranging factor and have developed *atonal* music, or music without tonality. A convention of harmonic progression is disturbed when tonality is removed. Nonetheless, we still have harmonic progression, and we still have harmony—dissonant or consonant.

Tonality

Utilization of tonality, or key, has taken composers in various directions over the centuries. Conventional tonality, employing the major and minor scales and keys we discussed previously relative to pitch, forms the basis for most sixteenth to twentieth-century music, as well as traditionally oriented music of the twentieth century. In the early twentieth century, traditional tonality was abandoned by some composers and a new *atonal* harmonic expression occurred. Atonal

Figure 4.8 Full, half, and deceptive cadences.

Full Half Deceptive

compositions seek the freedom to use any combination of tones without the necessity of having to resolve chordal progressions.

Texture

The aspect of musical relationships known as *texture* is treated differently by different sources. The term itself has various spatial connotations, and using a spatial term to describe a nonspatial phenomenon creates part of the divergence of treatment. Texture in painting and sculpture denotes surface quality—that is, roughness or smoothness. Texture in weaving denotes the interrelationship of the warp and the woof—that is, the horizontal and vertical threads in fabric. The organization in Figure 4.9 would be described as open or loose texture; that in Figure 4.10, closed or tight. There really is no single musical arrangement that corresponds to either of these spatial concepts. The characteristic called *sonority* by some comes the closest. Sonority describes the relationship of tones played at the same time. A chord with large intervals between its members would have a more open, or thinner, sonority (or texture) than a chord with small intervals between its tones; that chord would have a tight, thick, or close sonority or texture. *Sonority* is a term that does not have universal application;

some sources do not mention it at all. Composers can vary textures within their pieces to create contrast and interest. Let's examine the three basic musical textures: monophony, polyphony, and homophony.

Monophony

When we have a single musical line without accompaniment, the texture of the piece is monophonic. There may be many voices or instruments playing at the same time, as in the Gregorian chant illustrated on CD track 4, but as long as they are singing the same notes at the same time—that is, in unison—the texture remains monophonic. In Handel's "Hallelujah" Chorus (CD track 10), there occur instances in which men and women sing the same notes in different octaves. This still represents monophony.

Polyphony

Polyphony means "many-sounding," and it occurs when two or more melodic lines of relatively equal interest are performed at the same time. This combining technique also is called counterpoint. We can hear it in a very simple statement in Josquin Desprez's "Ave Maria . . . Virgo Serena" (CD track 6). Palestrina's

Figure 4.9 Open (loose) texture.

Figure 4.10 Closed (tight) texture.

"Kyrie" from the *Pope Marcellus Mass* (CD track 7) is more complex. When the counterpoint uses an immediate restatement of the musical idea, as in the Desprez, then the composer is utilizing *imitation*.

Homophony

When chords accompany one main melody, we have homophonic texture. Here the purpose of the composer is to focus attention on the melody by supporting it with subordinate sounds. The Bach chorale on CD track 9 illustrates this type of texture very well. In this example all four voices sing together in simultaneous rhythm. The main melody is in the soprano, or top, part. The lower parts sing melodies of their own, which are different from the main melody, but, rather than being independent as would be the case in polyphony, they support the soprano melody and move with it in a progression of chords related to the syllables of the text.

Changes of Texture

Of course, composers may change textures within a piece, as Handel does in the "Hallelujah" chorus (CD track 10). This creates an even richer fabric of sound for our response.

Musical Form

Tones and rhythms that proceed without purpose or stop arbitrarily make little sense to the listener. Therefore, just as the painter, sculptor, or any other artist must try to develop design that has focus and meaning, the musician must attempt to create a coherent composition of sounds and silences. The principal means by which artists create coherence is repetition. As we noted in Chapter 1, the Volkswagen (Fig. 1.10) achieved unity through strong geometric repetition that varied only in size. Music achieves coherence, or unity, through repetition in a similar fashion. However, because music deals with time as opposed to space, repetition in music usually involves recognizable themes.

Thus form can be seen as organization through repetition to create unity. Form may be divided into two categories: *closed form* and *open form*. These terms are somewhat similar to the same ones used in sculpture and to composition kept within or allowed to escape the frame in painting. Closed form directs the musical eye back into the composition by restating at the end of the thematic section that which formed the beginning of the piece. Open form allows the "eye" to escape the composition by utilizing repetition of thematic material only as a departure point for further development, and by ending without repetition of the opening section. A few of the more common examples of closed and open forms follow.

Closed Forms

Binary form, as the name implies, consists of two parts: the opening section of the composition and a second part that often acts as an answer to the first: AB. Each section is then repeated.

Ternary form is a three-part development in which the opening section is repeated after the development of a different second section: ABA.

Ritornello, which developed in the baroque period, and *rondo*, which developed in the classical period, employ a continuous development that returns to modified versions of the opening theme after separate treatments of additional themes. Ritornello alternates orchestral or *ripieno* passages with solo passages. Rondo alternates a main theme in the tonic key with subordinate themes in contrasting keys.

Sonata form, or *sonata-allegro form*, which we introduced earlier takes its name from the conventional treatment of the first movement of the sonata. It is also the form of development of the first movement of many symphonies. The pattern of development is ABA or AABA. The first A section is a statement of two or three main and

subordinate themes, known as the *exposition*. To cement the perception of section A, the composer may repeat it: AA. The B section, the *development*, takes the original themes and develops them with several fragmentations and modulations. The movement then returns to the A section; this final section is called the *recapitulation*. Usually, the recapitulation section is not an exact repetition of the opening section; in fact, it may be difficult to recognize in some pieces. In Mozart's Symphony No. 40 the opening movement (allegro) is in sonata-allegro form. However, the recapitulation section is identified only by a very brief restatement of the first theme, as it was heard in the exposition, not a repetition of the opening section. Then, after a lengthy *bridge*, the second theme from the exposition appears. Mozart closes the movement with a brief *coda*, or closing section, in the original key, based on the first phrase of the first theme.

Open Forms

The *fugue*, again which we introduced earlier, is a polyphonic development of one, two, or sometimes three short themes. Fugal form, which takes its name from the Latin *fuga* ("flight"), has a traditional, although not a necessary, scheme of development. Two characteristics are common to all fugues: (1) counterpoint and (2) a clear dominant-tonic relationship—that is, imitation of the theme at the fifth above or below the tonic. Each voice in a fugue (as many as five or more) develops the basic subject independent from the other voices, and passes through as many of the basic elements as the composer deems necessary. Unification is achieved not by return to an opening section, as in closed form, but by the varying recurrences of the subject throughout.

The *canon* is a contrapuntal form based on note-for-note imitation of one voice by another. The voices are separated by a brief time interval—for example (the use of letters here does *not* indicate sectional development):

Voice 1: a b c d e f g
Voice 2: a b c d e f g
Voice 3: a b c d e f g

The interval of separation is not always the same among the voices. The canon is different from the *round*, an example of which is "Row, row, row your boat." A round is also an exact melodic repeat, but, the canon develops new material indefinitely; the round repeats the same phrases over and over. The interval of separation in the round stays constant—a phrase apart.

Variation form is a compositional structure in which an initial theme is modified through melodic, rhythmic, and harmonic treatments, each more elaborate than the last. Each section usually ends with a strong cadence, and the piece ends, literally, when the composer decides he or she has done enough.

How does it stimulate the senses?

Our Primal Responses

We can find no better means of illustrating the sensual effect of music than to contrast two totally different musical pieces. The Chopin nocturne we noted earlier (CD track 15) provides us with an example of how musical elements can combine to give us a relaxing and soothing experience. Here, the tone color of the piano, added to the elements of a constant beat in triple meter, consonant harmonies, subtle dynamic contrasts, and extended duration of the tones combine in a richly subdued experience that engages us but lulls us at the same time. In contrast, listen to Stravinsky's "Auguries of Spring: Dances of the Youths and Maidens" from *The Rite of Spring* (CD track 20). Here the driving rhythms, strong syncopation, dissonant harmonies, wildly contrasting dynamics, and the broad tonal palette of the orchestra rivet us and ratchet up our excitement level. It is virtually impossible to

listen to this piece without experiencing a rise in pulse rate. In both cases, our senses have responded at an extremely basic rate over which we have, it would seem, little control.

Music contains a sensual attraction difficult to deny. At every turn music causes us to tap our toes, drum our fingers, or bounce in our seats in a purely physical response. This involuntary motor response is perhaps the most primitive of our sensual involvement—as primitive as the images in Stravinsky's *Rite of Spring*. If the rhythm is irregular and the beat divided or syncopated, as it is in *Rite of Spring*, we may find one part of our body doing one thing and another part doing something else. Having compared the Chopin and Stravinsky pieces, do we have any doubt that a composer's choices have the power to manipulate us sensually?

From time to time throughout this chapter, we have referred to certain historical conventions that permeate the world of music. Some of these have a potential effect on our sense response. Certain notational patterns, such as *appoggiaturas* (see Glossary), are a kind of musical shorthand, or perhaps mime, that conveys certain kinds of emotion to the listener. Of course,

they have little meaning for us unless we take the time and effort to study music history. Some of Mozart's string quartets indulge in exactly this kind of communication. This is another illustration of how expanded knowledge can increase the depth and value of the aesthetic experience.

The Musical Performance

A certain part of our sense response to music occurs as a result of the nature of the performance itself. As we suggested earlier in the chapter, the scale of a symphony orchestra gives a composer a tremendously variable canvas on which to paint. Let's pause, momentarily, to familiarize ourselves with this fundamental aspect of the musical equation. As we face the stage in an orchestral concert, we note perhaps as many as one hundred instrumentalists facing back at us. Their arrangement from one concert to another is fairly standard, as illustrated in Figure 4.11.

A large symphony orchestra can overwhelm us with diverse timbres and volumes; a string quartet cannot. Our expectations and our focus may change as we perceive the performance of

Figure 4.11 Typical seating plan for a large orchestra (about 100 instrumentalists), showing the placement of instrumental sections.

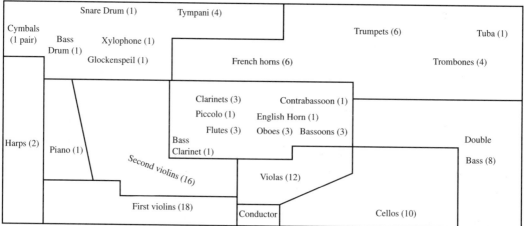

Impressionism in Music

In the late nineteenth century, a free use of chromatic tones and an anti-Romantic spirit produced a style of music called *impressionism*, which stressed tone color, atmosphere, and fluidity. During this time, some composers made free use of chromatic harmony and key shifts but stayed within the parameters of traditional major/minor tonality. Others rejected traditional tonality completely, and a new *atonal* harmonic expression came into being (Atonal means the avoidance of tonal centers or keys in a musical composition). This rejection of traditional tonality led to impressionism.

Impressionistic music can best be found in the work of its primary champion, the Frenchman Claude Debussy (day-byoo-SEE; 1862-1918), although he did not like to be called an "impressionist"—the label had been coined by an art critic to refer to painters of an analogous style in visual art and was meant to be derogatory. Debussy maintained that he was "an old Romantic who has thrown the worries of success out the window," and he sought no association with the painters. There are, however, similarities. His use of tone color has been described as "wedges of color," much like those the painters provided with individual brushstrokes. Oriental influences are also apparent, especially in Debussy's use of the Asian six-tone scale. He wished above all to return French music to fundamental sources in nature and move it away from the heaviness of the German tradition. He delighted in natural scenes, and he sought to capture the effects of shimmering light in music.

Unlike his predecessors, Debussy reduced melodic development to limited short motifs, and in perhaps his greatest break with tradition he moved away from traditional progressions of chordal harmonies. Debussy considered a chord strictly on the merits of its expressive capabilities, apart from any idea of tonal progression within a key. As a result, gliding chords, that is, the repetition of a chord up and down the scale, became a hallmark of musical impressionism. Dissonance and irregular rhythm and meter further distinguish Debussy's works. Here form and content are subordinate to expressive intent. His works suggest rather than state, leaving the listener only with an impression, perhaps even an ambiguous one.

Freedom, flexibility, and nontraditional timbres mark Debussy's compositions, the most famous of which is *Prélude a l'aprés-midi d'un faune (Prelude to the Afternoon of a Faun)*, based on a poem by Mallarmé (mahl-ar-MAY).) The piece uses a large orchestra, with emphasis on the woodwinds, most notably in the haunting theme running throughout (Listen to CD track 19). Two harps also play a prominent part in the texture, and antique cymbals are used to add an exotic touch near the end. Although freely ranging in an irregular $\frac{9}{8}$ meter and having virtually no tonal centers, the Prélude does have a traditional ABA structure.

one or the other. For example, because we know our perceptual experience with a string quartet will not involve the broad possibilities of an orchestra, we tune ourselves to seek the qualities that challenge the composer and performer within the particular medium. The difference between listening to an orchestra and listening to a quartet is similar to the difference between viewing a museum painting of monumental scale and viewing the exquisite technique of a miniature.

Textual suggestion can have much to do with sensual response to a musical work. For example, Debussy's *Prélude à l'après-midi d'un faune* (CD track 19) ellicits images of Pan frolicking through the woodlands and cavorting with the nymphs on a sunny afternoon. Of course, much of what we imagine has been stimulated by the title of the composition. Our perception is heightened further if we are familiar with the poem by Mallarmé on which the symphonic poem is based. Titles and especially text in musical compositions may be the strongest devices a composer has for communicating directly with us. Images are triggered by words, and a text or title can stimulate our imaginations and senses to wander freely and fully through the musical development. Johannes Brahms called a movement in his *German Requiem* "All Mortal Flesh Is as the Grass"; we certainly receive a philosophical and religious communication from that title. Moreover, when the chorus ceases to sing and the orchestra plays alone, the instrumental melodies and harmonies stimulate images of fields of grass blowing in the wind.

Harmony and tonality are both of considerable importance in stimulating our senses. Just as paintings and sculpture stimulate sensations of rest and comfort or action and discomfort, so harmonies create a feeling of repose and stability if they are consonant and a sensation of restlessness and instability if they are dissonant. Harmonic progression that leads to a full cadential resolution leaves us feeling fulfilled; unresolved cadences are puzzling and perhaps irritating. Major or minor tonalities have sig-

nificantly differing effects: Major sounds positive; minor, sad or mysterious. The former seems close to home, and the latter, exotic. Atonal music sets us adrift to find the unifying thread of the composition.

Melody, rhythm, and tempo are very similar to the use of line in painting, and the term *melodic contour* could be seen as a musical analogue to this element of painting. When the tones of a melody are conjunct and undulate slowly and smoothly, they trace a pattern having the same sensual effect as their linear visual counterpart—that is, soft, comfortable, and placid.

When melodic contours are disjunct and tempos rapid, the pattern and response change:

In conclusion, it remains for us as we respond to music to analyze how each of the elements available to the composer has in fact become a part of the channel of communication, and how the composer, consciously or unconsciously, has put together a work that elicits sensory responses from us.

OPERA

The composer Pietro Mascagni reportedly said, "In my operas do not look for melody or beauty . . . look only for blood." Mascagni represented a style of late nineteenth century opera called *verismo*, a word with the same root as verisimilitude, meaning true to life. Verismo opera treated themes, characters, and events from life in a down-to-earth fashion. In Mascagni's operas and operas of other composers of the verismo style, we find plenty of blood, but we also find fine drama and music. The combination of drama and music into a single artistic form constitutes opera.

Richard Danielpour
Contemporary Voice

Richard Danielpour (b. 1956) studied at the New England Conservatory and the Juilliard School and also trained as a pianist. Currently he is a member of the composition faculty at the Curtis Institute and the Manhattan School of Music. Speaking of his recent rise in the ranks of recognized composers, Danielpour reflected, "From the beginning, it was agonizing. It was like waiting for a Polaroid to develop, but the Polaroid took 10 years instead of 30 seconds." Indicative of his standing in the music world is his collaboration with Nobel Prize winning writer Toni Morrison on a piece titled "Sweet Talk," premiered by Jessye Norman at Carnegie Hall.

In the early 1980's Mr. Danielpour moved away from the complexities of modernism toward a more accessible style. As a result, his music's large and romantic gestures, brilliant orchestrations and vibrant rhythms appeal to a wide cross-section of the public. In this regard, some critics have compared him to Leonard Bernstein, Aaron Copland, Igor Stravinsky, Dmitri Shostakovich, and other twentieth-century masters.

"As I got older, I was aware of a number of different strands coming together in my music, rather than seeing myself on a mission with one particular ax to grind," he said. He calls himself an assimilator rather than an innovator. By utilizing familiar and unthreatening styles as a basis for his compositions, he has been able to win over even conservative audiences.

In the process of finding the means to express his message, Danielpour draws from many resources. "For me style is not the issue," he said. "It's how well a piece is written on a purely technical level. If other composers see themselves as superior just because their music may be more 'original,' that's O.K. That's not what I'm about." His "American-sounding rhythmic swagger," easy lyricism and keen understanding of instrumental color, create an appealing formula.

Although reluctant to discuss his music's spiritual component, he tends to label supposedly abstract instrumental works with intriguing, metaphysical titles. The movements of his Piano Quintet, for example, are "Annunciation," "Atonement," and "Apotheosis." Such titles, he admits, can be distracting. "Maybe it would be better not to have any at all," he said. When he does discuss spirituality in music, he doesn't hesitate to place himself in good company. "Some of my favorite composers," he said, "are also philosopher-composers who find themselves addressing questions about life and death in the very music they write: Mahler, Shostakovich, Bernstein."

He speaks of the creative process in spiritual and perhaps eccentric terms. "Where is the music received from?" he asks. "Where do your dreams come from? Composing is like being in a waking dream. To me the where is not important. It's intuition that has to lead the way and thinking that has to follow it. To speak of the mind first is worthless."

Perhaps typical of all professionals in today's music world, he has a sense of the business side of music. He knows about contracts and commissions and how to be in the right place at the right time. Nonetheless, Mr. Danielpour insists that he is no more active in self-promotion than his colleagues.*

*The New York Times, January 18, 1988, section 2, p. 41.

In basic terms, opera is drama sung to orchestral accompaniment. In opera music comprises the predominant element, but the addition of a story line, scenery, costumes, and staging make opera significantly different from other forms of music.

In one sense, we could describe opera as the purest integration of all the arts. It contains music, drama, poetry, and visual arts. It even includes architecture, because an opera house constitutes a particular architectural entity with very specific requirements for orchestra, audience, and stage space, as well as stage machinery. In its wide variety of applications, opera ranges from tragedies of spectacular proportions, involving several hundred people, to intimate music dramas and comedies with two or three characters (Figures 4.12, 4.13, 4.14).

Unlike theatre, an opera production reveals character and plot through song rather than speech. This convention removes opera from the life-likeness we might expect in the theatre and asks us to suspend our disbelief so we can enjoy magnificent music and the heightening of dramatic experience that music's contribution to mood, character, and dramatic action affords us. Central to an opera are performers who can sing and act simultaneously. These include major characters played by star performers as well as secondary solo singers and chorus members plus *supernumeraries*—"supers" or "extras"—who do not sing but merely flesh out crowd scenes.

Types of Opera

In Italian, the word opera means "work." In Florence, Italy, in the late sixteenth century, artists, writers, and architects eagerly revived the culture of ancient Greece and Rome. Opera was an attempt by a group known as the *camerata* (Italian for "fellowship" or "society") to re-create the

Figure 4.12 Giacomo Puccini, *Manon Lescaut.* Opera Company of Philadelphia. Photo by Trudy Cohen.

Figure 4.13 Georges Bizet, *Carmen*. Opera Company of Philadelphia. Composite photo by Trudy Cohen.

effect of ancient Greek drama, in which, scholars believed, words were chanted or sung as well as spoken. Through succeeding centuries, various applications of the fundamental concept of opera have arisen, and among these applications are four basic types of opera: 1) grand opera; 2) opéra comique; 3) opera buffa; and 4) operetta.

Grand Opera

Grand opera, used synonymously with "opera," refers to serious or tragic opera, usually in five acts. Another name for this type of opera is *opera seria* ("serious opera"), which usually treats heroic subjects—for example, the gods and heroes of ancient times—in a highly stylized manner.

Opéra Comique

Opéra comique is any opera, regardless of subject matter, that has *spoken dialogue*. This type of opera must not be confused with comic opera.

Opera Buffa

Opera buffa is comic opera (again, not to be confused with opéra comique), which usually does not have spoken dialogue. Opera buffa usually uses satire to treat a serious topic with humor—for example, Mozart's *Marriage of Figaro*.

Operetta

The fourth variety is *operetta*. Operetta also has spoken dialogue, but it has come to refer to a light style of opera characterized by popular themes, a romantic mood, and often a humorous tone. It is frequently considered more theatrical than musical, and its story line is usually frivolous and sentimental.

THE OPERA PRODUCTION

Like theatre, opera is a collaborative art, joining the efforts of a composer, a dramatist, a stage director, and a musical director. At its beginnings, an opera emerges when a composer sets to music a text, called a *libretto* (and written by a *librettist*). As we suggested earlier, the range of subjects and characters in opera may be extremely broad, from mythological to everyday. All characters come to life through performers who combine singing and acting. Opera includes the basic voice ranges we noted earlier (soprano, alto, tenor, bass), but divides them more precisely. Here are *some* of the categories:

Figure 4.14 Giuseppi Galli de Bibiena (1696–1757), *Scene design for an opera*, 1719. Contemporary engraving. The Metropolitan Museum of Art, New York. The Elisha Whittelsey Collection, The Elisha Whittelsey Fund, 1951.

Coloratura soprano	Very high range; capable of executing rapid scales and trills
Lyric soprano	Fairly light voice; cast in roles requiring grace and charm
Dramatic soprano	Full, powerful voice, capable of passionate intensity
Lyric tenor	Relatively light, bright voice
Dramatic tenor	Powerful voice, capable of heroic expression
Basso buffo	Cast in comic roles; can sing very rapidly
Basso profundo	Extremely low range, capable of power; cast in roles requiring great dignity.

Because the large majority of operas in the contemporary repertoire are not of American origin, the American respondent usually has to overcome the language barrier to understand the dialogue and thereby the plot. It is not a desire for snobbery or exclusivity that causes the lack of English-translation performances; much of it is pure practicality. Performing operas in their original language makes it possible for the best singers to be heard around the world. Think of the complications that would arise if Pavarotti, for example, had to learn a single opera in the language of every country in which he performed it. In addition, opera loses much of its musical character in translation. We spoke of tone color, or timbre, earlier in this chapter. There are timbre characteristics implicit in the Russian, German, and Italian languages that are lost when they are translated into English.

Experienced operagoers may study the score before attending a performance. However, every concert program contains a plot synopsis (even

when the production is in English), so that even the neophyte can follow what is happening. Opera plots, unlike mysteries, have few surprise endings, and knowing the plot ahead of time does not diminish the experience of responding to the opera. To assist the audience, opera companies often project the translated lyrics on a screen above the stage, much like subtitles in a foreign film.

The opening element in an opera is the *overture*. This orchestral introduction may have two characteristics. First, it may set the mood or tone of the opera. Here the composer works directly with our sense responses, putting us in the proper frame of mind for what is to follow. In his overture to *I Pagliacci,* for example, Ruggiero Leoncavallo creates a tonal story that tells us what we are about to experience. Using only the orchestra, he tells us we will see comedy, tragedy, action, and romance. If we listen to this overture, we will easily identify these elements, and in doing so understand how relatively unimportant the work's being in English is to comprehension. Add to the "musical language" the language of body and mime, and we can understand even complex ideas and character relationships—*without* words. In addition to this type of introduction, an overture may provide melodic introductions—passages introducing the arias and recitatives that will follow.

The plot unfolds musically through *recitative*, or sung dialogue. The composer uses recitative to move the plot along from one section to another; recitative has little emotional content to speak of, and the words are more important than the music. There are two kinds of recitative. The first is *recitativo secco*, for which the singer has very little musical accompaniment, or none at all. If there is accompaniment it is usually in the form of light chording under the voice. The second type is *recitativo stromento*, in which the singer is given full musical accompaniment.

The real emotion and poetry of an opera lie in its *arias*. Musically and poetically, an aria is the reflection of high dramatic feeling. The great

opera songs with which we are likely to be familiar are arias, such as "La Donna E Mobilé" from *Rigoletto* by Guiseppi Verdi (CD Track 17).

Every opera contains duets, trios, quartets, and other small ensemble pieces. There also are chorus sections in which everyone gets into the act. In addition, ballet or dance interludes are not uncommon. These may have nothing to do with the development of the plot, but are put in to add more life and interest to the dramatic production, and in some cases to provide a *segue* from one scene into another.

Bel canto, as its name implies, is a style of singing emphasizing the beauty of sound. Its most successful composer, Gioacchino Rossini, had a great sense of melody and sought to develop the *art song* to its highest level. In bel canto singing the melody is the focus.

Richard Wagner (Listen to a brief excerpt from his *Tristan and Isolde*—CD track 18.) gave opera and theatre a prototype that continues to influence theatrical production—*organic unity*. Every element of his productions was integral and shaped to create a work of total unity. Wagner was also famous for the use of *leitmotif*, a common element in contemporary film. A leitmotif is a musical theme associated with a particular person or idea. Each time that person appears or is thought of, or each time the idea surfaces, the leitmotif is played.

CHRONOLOGY OF SELECTED WORKS FOR ADDITIONAL STUDY

c. 600–c. 1600 A.D.

Medieval
 Gregorian Chant
 Hildegard of Bingen: *The Lauds of Saint Ursula*
Renaissance
 Dufay: *Salve Regina*
 des Prez: *Ave Maria*
 Palestrina: *Missa Salve Regina*

c. 1600–c. 1825

Baroque
J. S. Bach: *Mass in B Minor*
Handel: *Messiah*
Vivaldi: *The Four Seasons*
Classical
Hayden: Symphony No. 94 in G Major
Mozart: Symphony No. 40 in G Minor
Beethoven: Symphony No. 5 in C Minor

c. 1825–c.1900

Romanticism
Berlioz: *Symphonie Fantastique*
Brahms: German Requiem
Chopin: *Étude in C minor*

Liszt: Concerto No. 1 for Piano and Orchestra in E flat Major
Mendelssohn: *Elijah*
Tchaikovsky: *Overture 1812*
Wagner: *Ring Cycle*
Verdi: *Rigoletto*
Rossini: *The Barber of Seville*

c. 1900–c. 2000

Bartók: *Concerto for Orchestra*
Copland: *Appalachian Spring*
Debussy: *Prelude to the Afternoon of a Faun*
Ives: *The Unanswered Question*
Shoenberg: *Variations for Orchestra, Op. 31*
Danielpour: *Sweet Talk*

Theatre

Of all the arts, theatre comes the closest to personalizing the love, rejection, disappointment, betrayal, joy, elation, and suffering that we experience in our daily lives. It does so because theatre uses live people acting out situations that very often look and sound like real life. Theatre once functioned in society like television and movies do today. Many of the qualities of all three forms are identical. We'll find in this chapter the ways that theatre, which frequently relies on *drama* (a written script), takes lifelike circumstances and compresses them into organized episodes. The result, although looking like reality, goes far beyond reality in order to make us find in its characters pieces of ourselves.

The word *theatre* comes from the Greek *theatron*—the area of the Greek theatre building where the audience sat. Its literal meaning is "a place for seeing." The Greeks' choice of this word suggests how they may have perceived the essence of theatre, which is to a large extent a visual experience. In addition to the words of the script, provided by the playwright, and the treatment of those words by the actors, the theatre

artwork, the production, also involves visual messages. These include actor movement, costume, setting, lighting, and the physical relationship of the playing space to the audience.

Like the other performing arts, theatre is an interpretive discipline. Between the playwright and the audience stand the director, the designers, and the actors. Although each functions as an individual artist, each also serves to communicate the playwright's vision to the audience. Sometimes the play becomes subordinate to the expressive work of its interpreters, and sometimes the concept of director as master artist places the playwright in a subordinate position. Nonetheless, a theatrical production always requires the interpretation of a concept through spectacle and sound by theatre artists.

What is it?

Theatre represents an attempt to reveal a vision of human life through time, sound, and space. It gives us flesh-and-blood human beings involved

in human action (Plate 12)—we must occasionally remind ourselves that the dramatic experience is not reality: It is an imitation of reality, acting as a symbol to communicate something about the human condition. Theatre is make-believe: Through gesture and movement, language, character, thought, and spectacle, it imitates action. However, if this were all theatre consisted of, we would not find it as captivating as we do, and as we have for more than 2,500 years.

At the formal level, theatre comprises *genre*—or type of play—from which the production evolves. *Some* of the genres of theatre are *tragedy, comedy, tragicomedy,* and *melodrama.* Some are products of specific periods of history, and illustrate trends that no longer exist; others are still developing and as yet lack definite form. Our response to genre is a bit different from our formal response or identification in music, for example, because we seldom find generic identification in the threatre program. Some plays are well-known examples of a specific genre, for example, the tragedy *Oedipus the King* by Sophocles. In these cases, as with a symphony, we can see how the production develops the conventions of genre. Other plays, however, are not well known or may be open to interpretation. As a result, we can draw our conclusions only after the performance has finished.

Tragedy

We commonly describe tragedy as a play with an unhappy ending. The playwright Arthur Miller describes tragedy as "the consequences of a man's total compulsion to evaluate himself justly, his destruction in the attempt posits a wrong or an evil in his environment." In the centuries since its inception, tragedy has undergone many variations as a means by which the playwright makes a statement about human frailty and failing.

Typically, tragic heroes make free choices that bring about suffering, defeat, and sometimes, tri-umph as a result of defeat. The protagonist often undergoes a struggle that ends disastrously. In Greek classical tragedy of the fifth century B.C., the hero generally was a larger-than-life figure who gained a moral victory amid physical defeat. The classical hero usually suffers from a tragic flaw—some defect that causes the hero to participate in his or her own downfall. In the typical structure of classical tragedies, the climax of the play occurs as the hero or heroine recognizes his or her role, and accepts destiny. In the years from Ancient Greece to the present, however, writers of tragedy have employed many different approaches. Playwright Arthur Miller argues the case for tragic heroes of "common stuff," suggesting tragedy is a condition of life in which human personality flowers and realizes itself.

Comedy

In many respects, comedy is much more complex than tragedy, and even harder to define. Comedy embraces a wide range of theatrical approaches, ranging from the intellectual and dialogue-centered high comedy of the seventeenth century to the slapstick, action-centered low comedy found in a variety of plays from nearly every historical period. Low comedy may include *farce,* typically a wildly active and hilarious comedy of situation, usually involving a trivial theme. We might say that the difference between comedy and farce is more than a matter of degree and includes a different point of view. Comic characters are usually sympathetic (we like them). Characters in farce are often ridiculous and, occasionally, contemptible. It is the kind of comedy we associate with actions such as pies in the face, mistaken identities, and pratfalls. Whatever happens in a farce carries little serious consequence. It perhaps provides an opportunity for the viewer to express unconscious and socially unacceptable desires without having to take responsibility for them.

William Shakespeare

William Shakespeare (1564-1616) was one of the world's greatest literary geniuses. Most of his work was for the theatre, but he left a remarkable sequence of sonnets in which he pushed the resources of the English language to breathtaking extremes. In his works for the theatre, Shakespeare represents the Elizabethan love of drama, and the theatres of London were patronized by lords and commoners alike. They sought and found, usually in the same play, action, spectacle, comedy, character, and intellectual stimulation deeply reflective of the human condition. Thus it was with Shakespeare, the pre-eminent Elizabethan playwright. His appreciation of the Italian Renaissance—which he shared with his audience—can be seen in the settings of many of his plays. With true Renaissance breadth, Shakespeare went back into history, both British and classical, and far beyond, to the fantasy world of *The Tempest*. Like most playwrights of his age, Shakespeare wrote for a specific professional company of which he became a partial owner. The need for new plays to keep the company alive from season to season provided much of the impetus for his prolific output.

Although we know only a little of his life, the principal facts are well established. Playwrights were not highly esteemed in England in the sixteenth century, and there was virtually no reason to write about them. We do, however, know more about Shakespeare than we do most of his contemporaries. He was baptized in the parish church of Stratford-upon-Avon on April 26, 1564, and probably attended the local grammar school. We next learn of him in his marriage to Ann Hathaway in 1582, when a special action was necessary to allow the marriage without delay. The reason is clear—five months later, Ann gave birth to their first daughter, Susanna. The next public mention comes in 1592, when his reputation as a playwright was sufficient to warrant a malicious comment from another playwright, Robert Greene. From then on, there are many records of his activities as dramatist, actor, and businessman. In addition to his steady output of plays, he also published a narrative poem entitled *Venus and Adonis*, which was popular enough to have nine printings in the next few years. His standing as a lyric poet was established with the publication of 154 Sonnets in 1609.

In 1594 he was a founder of a theatrical company called the Lord Chamberlain's Company, in which he functioned as shareholder, actor, and playwright. In 1599, the company built its own theatre, the Globe, which came directly under the patronage of James I when he assumed the throne in 1603 (A complete reproduction of Shakespeare's Globe Theatre was completed in London in 1998). Shakespeare died in 1616 shortly after executing a detailed will. Shakespeare's will, still in existence, bequeathed most of his property to Susanna and her daughter. He left small mementoes to friends. He mentioned his wife only once, leaving her his "second best bed" with its furnishings.

Between the extremes just noted exist a variety of comic forms. One of these is the popular domestic comedy, in which family situations are the focus of attention, and in which members of a family and their neighbors find themselves in various complicated and amusing situations, for example Neil Simon's plays *Brighton Beach Memoirs* and *Broadway Bound*.

Defined in its broadest terms, comedy may not involve laughter. Many employ stinging *satire*, although we probably can say with some accuracy that humor forms the root of all comedy. In many circumstances comedy treats a serious theme, but remains basically lighthearted in spirit: Characters may be in jeopardy, but not *too* seriously so. Comedy deals with the world as we find it, focusing on everyday people through an examination of the incongruous aspects of behavior and relationships. The idea that comedy ends happily is probably due to our expectations that in happy endings everyone is left more or less to do what they please. However, happy endings often imply different sets of circumstances in different plays. Comedy appears to defy any such thumbnail definitions.

Tragicomedy

As the name suggests, tragicomedy is a mixed form of theatre, which, like the other types, has been defined in different terms in different periods. Until the nineteenth century, the ending determined the necessary criterion for this form. Traditionally, characters reflect diverse social standings—kings (like tragedy) and common folk (like comedy), and reversals went from bad to good and good to bad. It also included language appropriate to both tragedy and comedy. Tragicomedies were serious plays that ended, if not happily, then at least by avoiding catastrophe. In the last century and a half, the term has been used to describe plays in which the mood may shift from light to heavy, or plays in which endings are neither exclusively tragic or comic.

Melodrama

Melodrama is another mixed form. It takes its name from the terms *melo*, Greek for music, and "drama." Melodrama first appeared in the late eighteenth century, when dialogue took place against a musical background. In the nineteenth century, it was applied to describe serious plays without music. Melodrama uses stereotypical characters involved in serious situations in which suspense, pathos, terror, and occasionally hate are all aroused. Melodrama portrays the forces of good and evil battling in exaggerated circumstances. As a rule, the issues involved are either black or white—they are simplified and uncomplicated: Good is good and evil is evil; there are no ambiguities.

Geared largely for a popular audience, the form concerns itself primarily with situation and plot. Conventional in its morality, melodrama tends toward optimism—good always triumphs in the end. Typically, the hero or heroine is placed in life-threatening situations by the acts of an evil villain, and then rescued at the last instant. The forces against which the characters struggle are external ones—caused by an unfriendly world rather than by inner conflicts. Probably because melodrama took root in the nineteenth century, at a time when scenic spectacularism was the vogue, many melodramas depend on sensation scenes for much of their effect. This penchant can be seen in the popular nineteenth-century adaptation of Harriet Beecher Stowe's novel *Uncle Tom's Cabin*, as Eliza and the baby, Little Eva, escape from the plantation and are pursued across a raging ice-filled river. These effects taxed the technical capacities of contemporary theatres to their maximum, but gave the audience what it desired—spectacle. Not all melodramas use such extreme scenic devices, but such use was so frequent that it has become identified with the type. If we include motion pictures and television as dramatic structures, we could say that melodrama was the most popular dramatic form of the twentieth century.

Performance Art

The postmodern movement of the late twentieth century, which implies a turn away from the qualities that characterized "modern" art, produced a form of theatrical presentation called *Performance Art*. Performance Art pushes the traditional theatre envelope in a variety of directions, some of which deny traditional concepts of theatrical production itself. It is a type of performance that combines elements from fields in the humanities and arts, from urban anthropology to folklore, and dance to feminism. Performance art pieces called "Happenings" grew out of the pop-art movement of the 1960s and were designed as critiques of consumer culture. European performance artists were influenced by the early twentieth century movement of dadaism and tended to be more political than their American counterparts. The central focus of many of the "Happenings" was the idea that art and life should be connected (a central concept in postmodernism in general).

Because of its hybrid and diverse nature, there is no "typical" performance artist or work we can study as an illustration. We can, however, note three brief examples, which, if they do not typify, at least illumine this movement. The Hittite Empire, an all-male performance art group performs *The Undersiege Stories*, which focuses on non-verbal communication and dance and includes confrontational scenarios. Performance artist Kathy Rose blends dance and film animation in unique ways. In one performance in New York, she creatively combined exotic dances with a wide variety of styles that included German Expressionism and science fiction. The *New York Times* called her performance "a visual astonishment." Playwright Rezo Abdoh's *Quotations from a Ruined City*, an intense and kinetic piece, features ten actors who act out outrage in fascinating, energetic fashion. The complicated, overlapping scenes, tableaux, and dances are punctuated by loud but unintelligible prerecorded voices. The piece combines elements depict-ing brutality, sadism, and sexuality. In the 1990s, performance art saw some difficult times because many people viewed it as rebellious and controversial for its own sake.

How is it put together?

Theatre consists of a complex combination of elements that form a single entity called a performance, or a production. Understanding the theatre production as a work of art can be enhanced if we have some tools for approaching it, which come to us from the distant past.

Writing 2,500 years ago in the *Poetics*, Aristotle argued that tragedy consisted of plot, character, diction, music, thought, and spectacle. We can use and expand on Aristotle's terminology to describe the basic parts of a production, and to use them as a set of tools for understanding theatrical productions as these six parts—and their descriptive terminology—still cover the entire theatrical product.

In the paragraphs that follow, we reshape Aristotle's terms into language that is more familiar to us, explain what the terms mean, and learn how we can use them to know how a theatrical production is put together—things to look and listen for in a production. We examine first the script, and include in that discussion Aristotle's concept of diction, or *language*. Next, we examine plot, thought—themes and ideas—character, and spectacle, which we call the visual elements. That is followed by a brief discussion of what Aristotle called music but which, to avoid confusion, we call aural elements.

The Script

A playwright creates a written document called a *script*, which contains the dialogue used by the actors. Aristotle called the words written by the playwright *diction*; however, we refer to this part of a production as its *language*. The playwright's language tells us at least part of what we can

expect from the play. For example, if he has used everyday speech, we generally expect the action to resemble everyday truth, or reality. In the play *Fences*, playwright August Wilson uses everyday language to bring the characters to life in the context of the period, 1957:

> (*Act I, scene iii. Troy is talking to his son.*)
>
> Like you? I go out of here every morning . . . bust my butt . . . putting up with them crackers everyday . . . cause I like you? You about the biggest fool I ever saw.
>
> (Pause)
>
> It's my job. It's my responsibility! You understand that? A man got to take care of his family. You live in my house . . . sleep you behind on my bedclothes . . . fill you belly up with my food . . . cause you my son.

Poetic language, in contrast, usually indicates less realism and perhaps stronger symbolism. Compare the language of *Fences* with the poetry used by Jean Racine, seventeenth-century dramatist, in *Le Cid* to create a mythical hero who is larger than life:

> (*Act III, scene iv*)
>
> Rodrigue: I'll do your bidding, yet still do I desire
> To end my wretched life, at your dear hand.
> But this you must not ask, that I renounce

My worthy act in cowardly repentance.
The fatal outcome of too swift an anger
Disgraced my father, covered me with shame.

In both plays, we use language and its tone to help determine the implication of the words. Language helps to reveal the overall tone and style of the play. It also can reveal character, theme, and historical context.

Plot

Plot is the structure of the play, the skeleton that gives the play shape, and on which the other elements hang. The nature of the plot determines how a play works: how it moves from one moment to another, how conflicts are structured, and how ultimately the experience comes to an end. We can examine the workings of plot by seeing the play somewhat as a timeline, beginning as the script or production begins, and ending at the final curtain, or the end of the script. In many plays plot tends to operate like a climactic pyramid (Fig. 5.1). In order to keep our attention, the dynamics of the play will rise in intensity until they reach the ultimate crisis—the *climax*—after which they will relax through a resolution called the *denouement*, to the end of the play.

Depending on the playwright's purpose, plot may be shaped with or without some of the features described below. Sometimes plot may be so deemphasized that it virtually disappears. How-

Figure 5.1 Hypothetical dynamic and structural development of a three-act play.

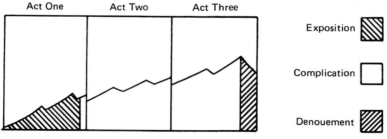

Absurdism in Theatre

Many artists of the 1940s, 50s and 60s lost faith in religion, science, and humanity itself. In their search for meaning, they found only chaos, complexity, grotesque laughter, and perhaps insanity. Certain European and American dramatists embraced Albert Camus's (pronounced cah-MOO; 1913-60) assessment, in his essay *Le Mythe de Sisyphe* (1942; *The Myth of Sisyphus*; pronounced SIS-ih-fuhs), that the human situation is essentially absurd and devoid of purpose. Camus was the first writer to apply the term "absurd" to the human condition. This he took to be a state somewhere between humanity's aspirations and the meaninglessness of the universe which is the condition of life. Determining which way to take a chaotic universe is the theme of Camus' plays, such as *Cross Purposes* (1944).

Absurdist playwrights ignored most of the logical structures of traditional theatre. Dramatic action is negligible and plot, as we have defined it, is de-emphasized to the point where it occasionally seems to disappear. Such action as occurs serves only to underscore the absence of meaning in the characters' existence.

The forerunner of later absurdism, however, was Luigi Pirandello (pronounced peer-ahn-DALE-oh; 1867-1936) who obsessively asks the question "What is real?" with brilliant variations. *Right You Are if You Think You Are* (1917) presents a wife, living with her husband in a top-floor apartment, who is not permitted to see her mother. After attempts to explain the situation by the husband and mother, finally, someone asks the wife, who is the only one who can clear up the mystery. She responds, as the curtain falls, with loud laughter!

From such antecedents came numerous dramas, the best known of which were written by the French existentialist philosopher, writer, and playwright Jean-Paul Sartre (pronounced sahrt; 1905-80). Sartre held that there were no absolute or universal moral values and that humankind was part of a world without purpose. Therefore, men and women were responsible only to themselves. Plays such as *No Exit* (1944) translated his views into dramatic form.

Following the work of these playwrights came a series of absurdists who differed quite radically from them. While early absurdists strove to bring order out of absurdity, the plays of Samuel Beckett, Eugene Ionesco (ee-oh-NEHS-ko), and Jean Genet (zhuh-NAY) all tend to point only to the absurdity of existence and to reflect the chaos in the universe. Their plays are chaotic, and ambiguous, and that makes direct analysis purely a matter of interpretation. *Waiting for Godot* (1958), the most popular work of Samuel Beckett (1906-1989) has been interpreted in so many ways to suggest so many different meanings that it has become an eclectic experience in itself. Beckett left it to the audience to draw whatever conclusions they wished about the work. The plays of Eugène Ionesco (1912-1994) are even more baffling, using nonsense syllables and clichés for dialogue, endless and meaningless repetition, and plots that have no development.

ever, as we try to evaluate a play critically, the elements of plot give us things to look for—if only to note that they do not exist in the play at hand.

Exposition

Exposition provides necessary background information: Through it the playwright introduces the characters, their personalities, relationships, backgrounds, and their present situation. Exposition is frequently a recognizable section at the beginning of a play. It can be presented through dialogue, narration, setting, lighting, costume— or any device the playwright or director chooses. The amount of exposition in a play depends on where the playwright takes up the story, called the *point of attack*. A play told chronologically may need little expositional material; others require a good bit of prior summary.

Complication

Drama is about conflict. Although not every play fits that definition, in order to interest an audience, conflict of some sort is a fundamental dramatic device. At some point in the play, the normally expected course of events is usually frustrated, giving the audience a reason to be interested in what transpires. At a specific moment, an action is taken or a decision is made that upsets the current state of affairs. This is sometimes called the *inciting incident* and it opens the middle part of the plot—the complication. The complication is the meat of the play, and it comprises a series of conflicts and decisions—called *crises* (from the Greek word *krisis*, meaning "to decide")—that rise in intensity until they reach a turning point—the *climax*—that constitutes the end of the complication section.

Denouement

The denouement is the final resolution of the plot. It is the period of time during which the audience is allowed to sense that the action is ending: a period of adjustment, downward in intensity, from the climax. Ideally, the denouement brings about a clear and ordered resolution.

Exposition, complication, and denouement comprise a time frame in which the remaining parts of the play operate. The neat structural picture of plot that exposition, complication, and denouement describe will not, however, always be so neat. The fact that a play does not conform to this kind of plot structure does not make it a poorly constructed play, or one of inferior quality. Nor does it mean that these concepts cannot be used as a means for describing and analyzing how a play is put together.

Foreshadowing

Preparation for subsequent action—foreshadowing—helps to keep the audience clear about where they are at all times. Foreshadowing provides credibility for future action, keeps action logical, and avoids confusion. It builds tension and suspense: The audience is allowed to sense that something is about to happen, but because we do not know exactly what or when, anticipation builds suspense and tension. In the movie *Jaws* a rhythmic musical theme foreshadows the presence of the shark. Just as the audience becomes comfortable with that device, the shark suddenly appears—without the music. As a result, uncertainty as to the next shark attack is heightened immensely. Foreshadowing also moves the play forward by pointing toward events that will occur later.

Discovery

Discovery is the revelation of information about characters, their personalities, relationships, and feelings. Hamlet discovers from his father's ghost that his father was murdered by Claudius, and is urged to revenge the killing, a discovery without which the play cannot proceed. The skill of the playwright in structuring the revelation of such information in large part

determines the overall impact of the play on the audience.

Reversal

Reversal is any turn of fortune; for example, Oedipus falls from power and prosperity to blindness and exile; King Lear goes from ruler to disaster. In comedy, reversal often changes the roles of social classes, as peasants jump to the upper class, and vice versa.

Character

Character is the psychological motivation of the persons in the play. In most plays, the audience will focus on why individuals do what they do, how they change, and how they interact with other individuals, as the plot unfolds.

Plays reveal a wide variety of characters—both persons and motivating psychological forces. In every play we will find characters that fulfill major functions and on which the playwright wishes us to focus. We will also find minor characters—those whose actions may interact with the major characters, and whose actions constitute subordinate plot lines. Much of the interest created by the drama lies in the exploration of how persons with specific character motivations react to circumstances. For example, when Rodrigue in *Le Cid* discovers his father has been humiliated, what is it in his character that makes him decide to avenge the insult, even though it means killing the father of the woman he loves, thereby jeopardizing that love? Such responses, driven by character, are the choices that drive plays forward.

The Protagonist

Inside the structural pattern of a play some kind of action must take place. We must ask ourselves: How does this play work? How do we get from the beginning to the end? Most of the time, we take that journey via the actions and decisions of the *protagonist,* or central personage. Deciding the protagonist of a play is not always easy, even for directors. However, it is important to understand whom the play is about if we are to understand it. In Terence Rattigan's *Cause Célèbre* we could have three different responses depending on who the director decided was the protagonist. The problem is this: There are two central feminine roles. A good case could be made for either as the central personage of the play. Or they both could be equal. What we understand the play to be about depends on whom the director chooses to focus as protagonist.

Thought

In order to describe the intellectual content of the play, Aristotle uses *thought,* a term we use to refer to the themes and ideas that the play communicates. In Lanford Wilson's *Burn This* (1987), for example, a young dancer, Anna, lives in a Manhattan loft with two gay roommates, Larry and Robby. As the play opens, we learn that Robby has been killed in a boating accident; Anna has just returned from the funeral and a set of bizarre encounters with Robby's family. Larry, a sardonic advertising executive, and Burton, Anna's boyfriend, maintain a constant animosity. Into the scene bursts Pale, Robby's brother and a threatening, violent figure. Anna is both afraid and irresistibly attracted to Pale; the conflict of their relationship drives the play forward to its climax.

This brief description summarizes the *plot* of a play. However, what the play is about—its thought—remains for us to discover and develop. Some might say the play is about loneliness, anger, and the way not belonging is manifested in human behavior. Others might focus on abusive relationships, and others would see a thought content dealing with hetero- and homosexual conflicts and issues. The process of coming to conclusions about meaning involves several layers of interpretation. One involves the playwright's interpretation of the ideas through the

characters, language, and plot. A second layer of interpretation lies in the director's decisions about what the playwright has in mind, which will be balanced by what the director wishes to communicate, because, or in spite, of the playwright. Finally, it is important that we interpret what we actually see and hear in the production, along with what we may perceive independently from the script.

Visual Elements

The director takes the playwright's language, plot, and characters and translates them into action by using, among other things, what Aristotle called *spectacle*, or what the French call *mise-en-scène*, but which we can simply call the *visual elements*. The visual elements of a production include, first of all, the physical relationship established between actors and audience. The actor/audience relationship can take any number of shapes. For example, the audience might sit surrounding or perhaps on only one side of the stage. The visual elements also include stage settings, lighting, costumes, and properties, as well as the actors and their movements. Whatever the audience can see contributes to this part of the theatrical production

Theatre Types

Part of our response to a production is shaped by the design of the space in which the play is produced. The earliest and most natural arrangement is the theatre-in-the-round, or *arena* theatre (Fig. 5.2), in which the audience surrounds the playing area on all sides. Whether the playing area is circular, square, or rectangular is irrelevant. Some argue that the closeness of the audience to the stage space in an arena theatre provides the most intimate kind of theatrical experience. A second possibility is the *thrust*, or three-quarter, theatre (Fig. 5.3), in which the audience surrounds the playing area on three sides. The most familiar illustration of this theatre is

what we understand to be the theatre of the Shakespearean period. The third actor/audience relationship, and the one most widely used in the twentieth century, is the *proscenium* theatre, in which the audience sits on only one side and views the action through a frame (Fig. 5.4).

There are also experimental arrangements of audience and stage space. On some occasions acting areas are placed in the middle of the audience, creating little island stages. In certain circumstances, these small stages create quite an interesting set of responses and relationships between actors and audience.

Common experience indicates that the physical relationship of the acting area to the audience has a causal effect on the depth of audience involvement. Experience has also indicated that some separation is necessary for certain kinds of emotional responses. We call this mental and physical separation *aesthetic distance*. The proper aesthetic distance allows us to become involved in what we know is fictitous and even unbelievable.

The visual elements may or may not have independent communication with the audience;

Figure 5.2 Ground plan of an arena theatre.

Figure 5.3 Ground plan of a thrust theatre.

Figure 5.4 Ground plan of a proscenium theatre.

this is one of the options of the director and designers. Before the nineteenth century, there was no coordination of the various elements of a theatre production. This, of course, had all kinds of curious, and in some cases catastrophic, consequences. However, for the last century, most theatre productions have adhered to what is called the *organic theory of play production*: That is, everything, visual and aural, is designed with a single purpose. Each production has a specific goal in terms of audience response, and all of the elements in the production attempt to achieve this.

Scene Design

Simply stated, the purpose of scene design in the theatre is to create an environment conducive to the production's ends. The scene designer uses the same tools of composition—line, form, mass, color, repetition, and unity—as the painter. In addition, because a stage design occupies three-dimensional space and must allow for the movement of the actors in, on, through, and around the elements of scenery, the scene

designer becomes a sculptor as well. Figures 5.5, 5.6, 5.7, and 5.8 illustrate how emphasis on given elements of design highlight different characteristics in the production. C. Ricketts's design for *The Eumenides* (Fig. 5.5) stresses formality, asymmetricality, and symbolism. Charles Kean's *Richard II* (color insert Plate 13) is formal, but light and spacious. His regular rhythms and repetition of arches create a completely different feeling from the one elicited by Ricketts's design. William Telbin's *Hamlet* (color insert Plate 14), with its strong central triangle and monumental scale, creates an overwhelming weight that, while utilizing diagonal activity in the sides of the triangles, cannot match the action of Robert Burroughs's zigzagging diagonals juxtaposed among verticals in his design for *Peer Gynt* (Fig. 5.6). Unlike the painter or sculptor, however, the scene designer is limited by the stage space, the concepts of the director, the amount of time and budget available for the execution of the design, and elements of practicality, for example, can the design withstand the wear and tear of the actors? A scene designer also is limited by the talent and

Figure 5.5 Scene design for Aeschylus's *The Eumenides* (c. 1922). Designer: C. Ricketts. Courtesy of the Victoria and Albert Museum, London.

abilities of the staff available to execute the design. A complex setting requiring sophisticated painting and delicate carpentry may be impossible to do if the only staff available are unskilled. These are the constraints, and also the challenges, of scene design.

Lighting Design

Lighting designers are perhaps the most crucial of all the theatre artists in modern productions. Without their art nothing done by the actors, costume designer, property master, director, or scene designer could be seen by the audience. Yet lighting designers work in an ephemeral medium. They must sculpt with light and create shadows that fall where they desire them to fall; they must "paint" over the colors provided by the other designers. In doing so, they use lighting instruments with imperfect optical qualities. Lighting designers do their work in their minds, unlike scene designers, who can paint a design and then calculate it in feet and inches. Lighting designers must imagine what their light will do to an actor, to a costume, to a set. They must enhance the color of a costume, accent the physique of an actor, and reinforce the plasticity of a setting. They also try to reinforce the dramatic structure and dynamics of the play. They work within the framework of light and shade. Without shadows

Figure 5.6 Scene design for Henrik Ibsen's *Peer Gynt,* the University of Arizona Theatre. Director: Peter R. Marroney. Scene designer: Robert C. Burroughs.

and highlights, the human face and body become imperceptible: A human face without shadows cannot be seen clearly more than a few feet away. In a theatre, such small movements as the raising of an eyebrow must be seen clearly as much as 100 feet away. It is the lighting designer who makes this possible.

Costume Design

One is tempted to think of the costumes of the theatre merely as clothing that has to be researched to reflect a particular historical period and constructed to fit a particular actor. But costuming goes beyond that. Costume designers work with the entire body of the actor. They design hair styles and clothing and sometimes makeup to suit a specific purpose or occasion, a character, a locale, and so forth (Figs. 5.7 and 5.8).

The function of stage costuming is three-fold. First, it *accents*—that is, it shows the audience which personages are the most important in a scene, and it shows the relationship between personages. Second, it *reflects*—a particular era, time of day, climate, season, location, or occasion. The designs in Figure 5.7 reflect a historical period. We recognize different historical periods primarily through silhouette, or outline. Costume designers may merely suggest full detail or may

Figure 5.7 Costume designs for Shakespeare's *Twelfth Night,* the Old Globe Theatre, San Diego, California. Director: Craig Noel. Costume designer: Peggy J. Kellner.

actually provide it, as has been done in Figure 5.7. We see here the designer's concern not only for period, but also for character in her choice of details, color, texture, jewelry, and also hairstyle. Notice the length to which the designer goes to indicate detail, providing not only front but also back views of the costume, and also a head study showing the hair without a covering. Third, stage costuming *reveals* the style of the performance, the characters of the personages, and the personages' social position, profession, cleanliness, age, physique, and health. In Figure 5.8 the concern of the designer is clearly less with historical

period than with production style and character. This costume design reveals the high emotional content of the particular scene, and we see at first glance the deteriorated health and condition of King Lear as he turns mad on the heath. The contrast provided by the king in such a state heightens the effect of the scene, and details such as the bare feet, the winter furs, and the storm-ravaged cape are precise indicators of the pathos we are expected to find and respond to. Costume designers work, as do scene and lighting designers, with the same general elements as painters and sculptors: the elements of composition. A

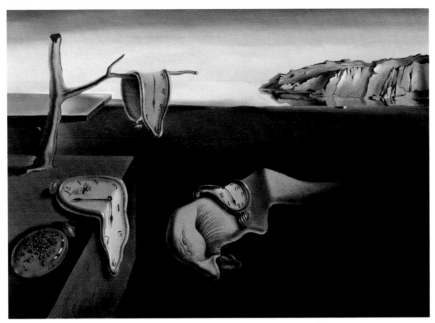

Plate 8 Salvadore Dali, *The Persistence of Memory* (1931). Oil on canvas, 9½″ × 13″. The Museum of Modern Art, New York. Given anonymously.

Plate 10 Giorgio de Chirico, *Nostalgia of the Infinite* (c. 1913–14, dated on painting 1911). Oil on canvas, 53¼″ × 25½″. The Museum of Modern Art, New York. Purchase.

Plate 9 Sir Peter Paul Rubens (Flemish, 1577–1640), *The Assumption of the Virgin* (c. 1626). Oil on panel, 49³⁄₈″ × 37¹⁄₈″; framed: 62 × 49¹⁄₂″ × 3¹⁄₄″. National Gallery of Art, Washington, D.C. Samuel H. Kress Collection.

Plate 11 Henry Moore, *Two Large Forms* (1969). The Serpentine, Hyde Park, London.

Plate 12 James Earl Jones and Dianne Wiest in a 1981 production of Shakespeare's *Othello* (c. 1990 Martha Swope). Time, Inc. Photo.

Plate 13 Shakespeare's *Richard II,* Act II, scene 2: Entrance into St. Stephen's Chapel. Producer: Charles Kean, London (1857). Courtesy of The Victoria and Albert Museum, London.

Plate 14 Scene design (probably an alternate design) for Charles Fechter's revival of Shakespeare's *Hamlet,* Lyceum Theatre, London (1864). Designer: William Telbin. Courtesy of The Victoria and Albert Museum, London.

Figure 5.8 Costume designs for Shakespeare's *King Lear,* the Old Globe Theatre, San Diego, California. Director: Edward Payson Call. Costume designer: Peggy J. Kellner.

stage costume is an actor's skin: It allows her to move as she must, and occasionally it restricts her from moving as she should not.

Properties

Properties fall into two general groups: *set props* and *hand props.* Set properties are part of the scene design: furniture, pictures, rugs, fireplace accessories, and so on. Along with the larg-

er elements of the set, they identify the mood of the play and the character of those who inhabit the world they portray. Hand properties used by the actors in stage business also help to portray characters: cigarettes, papers, glasses, and so forth. The use of properties can be significant to our understanding of a play. For example, if at the opening curtain all properties appear to be neat and in order, but as the play develops the actors disrupt the properties, so that at the end of

Expressionism in Theatre

In the late nineteenth and early twentieth centuries, an artistic theory and accompanying practice emerged called *expressionism*. In this style the subjective or subconscious thoughts and emotions of the artist, the struggle of abstract forces, or the inner realities of life are presented by a wide variety of nonnaturalistic techniques that include abstraction, distortion, exaggeration, primitivism, fantasy, and symbolism. The style occurred as a reaction against social conditions of the times, for example, materialism, bourgeois prosperity, rapid mechanization, and urbanization.

We may be more familiar with expressionism as a style in visual art than in theatre. In visual art, whose approaches came into theatrical expressionism via the art of the scenic designer, the artist aimed at eliciting in the viewer the same feelings the artist felt in creating the work—a sort of joint artist/viewer response to elements in the work of art. Any element—line, form, color—might be emphasized to elicit this response. The subject matter did not matter. What mattered was that the artist consciously tried to stimulate in the viewer a specific response similar to his or her own. The imagery, however, was often irrational and haunting, leaving the viewer with a sense of unease and anxiety. In film, this can be seen in such classics as Robert Wiene's *The Cabinet of Dr. Caligari* (1919).

The beginnings of expressionism in drama can be found in the work of a number of German dramatists who wrote between 1907 and the early 1920s. In many respects, expressionism, for playwrights, proved merely an extension of realism or naturalism, but it allowed them to express their reactions to the universe more fully. Others, however, developed a highly emotional and subjective form of expression. August Strindberg (1849-1912), for example, turned inward to the subconscious in expressionistic plays such as *Ghost Sonata*. In so doing, he created a "presentational" rather than "representational" style.

The plays of Ernst Toller (TAHW-luhr; 1893-1939) typify German expressionistic disillusionment after World War I. Toller's personal struggles, his communist idealism, and his opposition to violence are reflected in the heroine of *Man and the Masses* (1923). Sonia, a product of the upper class, leads a strike for peace. Her desire to avoid violence and bloodshed is opposed by the mob spirit (the "Nameless One"), who seeks just those results, and to destroy the peace the strike intends to achieve. For leading the disastrous strike, Sonia is imprisoned and sentenced to death.

Expressionism also found its way to America. Elmer Rice's *Adding Machine* (1923) introduces the viewer to Mr. Zero, a cog in the great industrial machinery of twentieth-century life, who stumbles through a pointless existence. Finding himself replaced by an adding machine, he goes berserk, kills his employer, and is executed. Adrift later in the hereafter, he is too narrow-minded to understand the happiness offered him there. He becomes an adding machine operator in heaven.

the play the entire scene is in disarray, that simple transition can help illustrate what may have happened in the play.

Aural Elements

What we hear also contributes to our understanding and enjoyment of the production. Aristotle's term for the aural elements of a production is *music*, which meant something quite different from today. The aural elements whether the actors' voices, the background music, or the clashing of swords, is an important part of the theatrical production. How a production sounds—and looks, and feels, and reads—represents a series of conscious choices on the part of all the artists involved: playwright, director, actors, and designers. Just as a composer of a musical piece creates harmonies, dynamics, rhythms, and melodies, the director, working with the actors and sound designer, makes the production develop in an aural sense so the audience is put into the proper mood, drawn in the proper emotional direction, and captured by the proper attention points.

Dynamics

Every production has its own dynamic patterns, which we can chart (for example, as in Figure 5.1). The structural pattern of a play, about which we just spoke, is made clear to us by the dynamic patterns the director establishes. These patterns also help to hold the interest of the audience. Scientific studies indicate that attention or interest is not a constant factor; human beings are able to concentrate on specific items only for very brief periods. Therefore, to hold audience attention over the two-hour span of a production, it is essential to employ devices whereby from time to time interest or attention is allowed to peak and then relax. However, the peaks must be carefully controlled. A production should build to a high point of dramatic interest—the

climax. However, each scene or act has its own peak of development—again, to maintain interest. So, the rise from the beginning of the play to the high point of dramatic interest is not a steady rise, but a series of peaks and valleys. Each successive peak is closer to the ultimate one. The director controls where and how high these peaks occur by controlling the dynamics of the actors—volume and intensity, both bodily and vocal.

The Actor

Although it not always easy to tell which functions in a production are the playwright's, which the director's, and which the actor's, the main channel of communication between the playwright and the audience is the actors. It is through their movements and speech that the audience perceives the play.

Our purpose is not to study acting; however, we can look for two elements in an actor's portrayal of a role that will enhance our response. The first is speech. Language is the playwright's words. Speech is the manner in which the actor delivers those words. Speech, like language, can range from high verisimilitude to high theatricality. If speech adheres to normal conversational rhythms, durations, and inflections, we respond in one way. If it utilizes extended vowel emphasis, long, sliding inflections, and dramatic pauses, we respond quite differently, even though the playwright's words are identical in both cases.

The second element of an actor's portrayal that aids our understanding is the physical reinforcement he or she gives to the character's basic motivation. Most actors try to identify a single basic motivation for their character. That motivation is called a *spine*, or *superobjective*. Everything that pertains to the decisions the person makes is kept consistent for the audience because those decisions and actions stem from this basic drive. Actors will translate that drive into something physical they can do throughout the play.

For example, Blanche, in Tennessee Williams's *A Streetcar Named Desire* is driven by the desire to clean what she encounters because of the way she regards herself and the world around her. Ideally, the actress playing Blanche will discover that element of Blanche's personality as she reads the play and develops the role. To make that spine clear to us in the audience, the actress will translate it into physical action. Therefore, we will see Blanche constantly smoothing her hair, rearranging and straightening her dress, cleaning the furniture, brushing imaginary dust from others' shoulders, and so forth. Nearly every physical move she makes will relate somehow to the act of cleaning. Of course, these movements will be subtle, but if we are attentive, we can find them, thereby understanding the nature of the character we are perceiving.

Verisimilitude

In describing the relationship of the visual elements to the play, we have noted the designers' use of compositional elements. The use of these elements relative to life can be placed on a continuum, one end of which is theatricality and the other, verisimilitude. Items high in verisimilitude are those with which we deal in everyday life: language, movements, furniture, trees, rocks, and so forth. As we progress on our continuum from verisimilitude to theatricality, the elements of the production express less and less relationship to everyday life. They become distorted, exaggerated, and perhaps even non-objective. Items far removed from verisimilitude are high in theatricality. Poetry, as we noted, is high in theatricality; everyday speech is high in verisimilitude. The position of the various elements of a production on this continuum suggests the style of the play, in the same sense that brushstroke, line, and palette indicate style in painting.

Figures 5.9 through 5.14 illustrate the range between verisimilitude and theatricality. Figure 5.9 is a proscenium setting high in verisimili-tude, including a full ceiling over the setting. Figure 5.10 is an arena setting high in verisimilitude; it reflects the basically lifelike overall style of the presentation. However, the requirement of the arena configuration that there be no walls can cause problems in some productions. Note that some theatricality—specifically, the empty picture frame—is present in the decoration of this set. This is not an inconsistency because the play develops as a flashback in the mind of its main personage. In Figure 5.11 the designer has attempted to heighten the theatrical nature of the production by using set props high in verisimilitude and a setting that is representational, but pushed toward theatricality by the use of open space where one might expect solid walls in this proscenium production. The setting in Figure 5.12 moves further toward theatricality, and indicates clearly through exaggerated detail and two-dimensionality the whimsical and fun nature of the production. The designs in color insert Plate 15 and Figure 5.13 create a purely formal and theatrical environment. No locale is specifically depicted, but the use of representational detail (various areas of the set served as locations and had realistic furniture) keeps the setting tied to the overall approach of the actors. Finally, in Figure 5.14, neither time nor place is indicated nor remotely suggested. Here the emphasis is on reinforcement of the high action of the production. The steep ramps throughout the set make it impossible for the actors to walk from one level to the next; the setting forces them to run.

In most arts the artist's style is unique, a recognizable mark on his or her artwork. Some artists change their style, but they do so by their own choice. Interpretive artists such as costume, scene, and lighting designers; and to a degree conductors as well, must submerge their personal style to that of the work with which they are involved. The playwright or the director sets the style, and the scene designer adapts to it and makes his or her design reflect that style.

Figure 5.9 A proscenium setting for Jean Kerr's *Mary Mary,* the University of Arizona Theatre. Director: H. Wynn Pearce. Scene and lighting designer: Dennis J. Sporre.

How does it stimulate the senses?

In each of the elements we have just discussed, our senses are stimulated in a particular manner. We respond to the play's structure and how it works; we respond to dynamics. We are stimulated by the theatricality or verisimilitude of the language of the playwright and the movements and speech of the actors. We find our response shaped by the relationship of the stage space to the audience, and by the sets, lights, properties, and costumes. All of these elements bombard us simultaneously with complex visual and aural stimuli. How we respond, and how much we are able to respond, will determine our ultimate reaction to a production.

The theatre is unique in its ability to stimulate our senses, because only in the theatre is there a direct appeal to our emotions through the live portrayal of other individuals involved directly in the human condition. Being in the presence of live actors gives us more of life in two hours than we could experience outside the theatre in that same time span. That phenomenon is difficult to equal. The term we use to describe our reaction to and involvement with what we experience in a theatrical production is *empathy*. Empathy causes us to cry when individuals we know are only actors become involved in tragic or emotional situations. Empathy makes us wince when an actor slaps the face of another actor or when two football players collide at full speed. Empathy is our mental and physical involvement in situations in which we are not direct participants.

Now let us examine a few of the more obvious ways a production can appeal to our senses. In plays that deal in conventions, language may act as virtually the entire stimulant of our senses.

Figure 5.10 An arena setting for Tennessee Williams's *The Glass Menagerie*, State University of New York at Plattsburgh. Director: H. Charles Kline. Scene and lighting designer: Dennis J. Sporre.

Figure 5.11 A proscenium setting for Oscar Wilde's *The Importance of Being Earnest*, the University of Arizona Theatre. Director: William Lang. Costume designer: Helen Workman Currie. Scene and lighting designer: Dennis J. Sporre.

Figure 5.12 Scene design for Jerry Devine and Bruce Montgomery's *The Amorous Flea* (musical), the University of Iowa Theatre. Director: David Knauf. Scene and lighting designer: Dennis J. Sporre.

Through language the playwright sets the time, place, atmosphere, and even small details of decoration. We become our own scene, lighting, and even costume designer, imagining what the playwright tells us ought to be there. In the opening scene of *Hamlet* we find Bernardo and Francisco, two guards. The hour is midnight; it is bitter cold; a ghost appears, in "warlike form." How do we know all of this? In a modern production we might see it all through the work of the costume and set designers. But this need not be the case, because the playwright gives us all of this information in the dialogue. Shakespeare wrote for a theatre that had no lighting save for the sun. His theatre (such as we know of it) probably used no scenery. The costumes were the street clothes of the day. The theatrical environment was the same whether the company was playing *Hamlet, Richard III*, or *The Tempest*. So what needed to be seen needed to be imagined. The language provided the stimuli for the audience.

We also respond to what we see. A sword fight performed with flashing action, swift movements, and great intensity sets us on the edge of our chair. Although we know the action is staged and the incident fictitious, we are caught in the excitement of the moment. We also can be gripped and manipulated by events of a quite different dynamic quality. In many plays we witness character assassination, as one life after another is laid bare before us. The intense but subtle movements of the actors— both bodily and vocal— can pull us here and push us there emotionally, and perhaps cause us to leave the theatre feeling emotionally and physically drained. Part of our response is caused by subject matter, part by language—but much of it is the result of careful manipulation of dynamics.

Mood is an important factor in theatrical communication and, hence, sense response. Before the curtain is up, our senses are tickled by stimuli designed to put us in the mood for what follows. The houselights in the theatre may be very low, or we may see a cool or warm light on the front curtain. Music fills the theatre. We may recognize the raucous tones of a 1930s jazz piece,

Figure 5.13 A proscenium setting for Stephen Sondheim's *Company* (musical), the University of Arizona Theatre. Director: Peter R. Marroney. Scene and lighting designer: Dennis J. Sporre.

or a melancholy ballad. Whatever the stimuli, they are all carefully designed to cause us to begin to react the way the director wishes us to react. Once the curtain is up, the assault on our senses continues. The palette utilized by the scene, lighting, and costume designers helps communicate the mood of the play and other messages about it. The rhythm and variation in the visual elements capture our interest and reinforce the rhythmic structure of the play. In Figure 5.6, the use of line and form as well as color provides a formal and infinite atmosphere reflecting the epic grandeur of Ibsen's *Peer Gynt*.

The degree of plasticity or three-dimensionality created by the lighting designer's illumination of the actors and the set causes us to respond in many ways. If the lighting designer has placed the primary lighting instruments directly in front of the stage, plasticity will be diminished and the actors will appear washed out or two-dimensional. We respond quite differently to that visual stimulant than to the maximum plasticity and shadow resulting from lighting coming nearly from the side.

We also react to the mass of a setting. Scenery that towers over the actors and appears massive

Figure 5.14 Scene design for Euripides's *The Bacchae*, University of Illinois at Chicago. Director: William Raffeld. Scene and lighting designer: Dennis J. Sporre.

in weight is different in effect from scenery that seems minuscule in scale relative to the human form. The settings in Figures 5.5 and 5.11 and Plates 13 and 14 are different from one another in scale, and each places the actors in a different relationship with their surroundings. In Figure 5.11, the personages are at the center of their environment; in Plate 14 they are clearly subservient to it.

Finally, focus and line act on our senses. Careful composition can create movement, outlines and shadows that are crisp and sharp. Or it can create images that are soft, fuzzy, or blurred. Each of these devices is a stimulant; each has the potential to elicit a relatively predictable response. Perhaps in no other art are such devices so available and full of potential for the artist. We, as respondents, benefit through nearly total involvement in the life situation that comes to us over the footlights.

CHRONOLOGY OF SELECTED WORKS FOR ADDITIONAL STUDY

c. 500 B.C–c. 1500

Greece
 Aeschylus: *The Oresteia*
 Sophocles: *Oedipus the King*
 Euripides: *Medea*
 Aristophanes: *Lysistrata*
Rome
 Plautus: *The Pot of Gold*
Medieval
 Everyman
 Maître Pierre Pathélin

c. 1500–c.1875

Renaissance
 Machiavelli: *The Mandrake*
 Shakespeare: *Hamlet*

Marlowe: *The Tragical History of Doctor Faustus*
Neoclassicism
 Corneille: *Le Cid*
 Racine: *Phèdre*
 Molière: *Tartuffe*
English Restoration and Jacobean
 Congreve: *The Way of the World*
 Sheridan: *The School for Scandal*

c. 1875–c. 2000

Ibsen: *A Doll House*
Shaw: *Major Barbara*
Chekhov: *The Sea Gull*
O'Neill: *Ah Wilderness!*

Miller: *After the Fall*
Williams: *The Glass Menagerie*
Brecht: *The Good Woman of Setzuan*
Pinter: *The Homecoming*
Shaffer: *The Royal Hunt of the Sun*
Beckett: *Waiting for Godot*
Albee: *Who's Afraid of Virginia Woolf?*
Coburn: *The Gin Game*
Pielmeier: *Agnes of God*
Simon: *Lost in Yonkers*
Albee: *Three Tall Women*
Mamet: *The Cryptogram*
Churchill: *The Striker*
Kushner: *Angels in America*
Wilson: *Fences*

Film

Like theatre, but without the spontaneity of "live" performers, film can confront us with life very nearly as we find it on our streets. On the other hand, through the magic of sophisticated *special effects*, film can take us to new worlds open to no other form of art.

Film, the most familiar and the most easily accessible art form, is usually accepted almost without conscious thought, at least in terms of the story line or the star image presented or the basic entertainment value of the product. Yet all these elements are carefully crafted out of editing techniques, camera usage, juxtaposition of image, and structural rhythms, among others. These details of cinematic construction can enhance our film viewing and can raise a film from mere entertainment into the realm of serious art. Bernard Shaw once observed that "details are important; they make comments." Our perception of the details of a film is not as easy as it might seem because at the same time we are searching them

out, the entertainment elements of the film are drawing our attention away from the search.

What is it?

Film is aesthetic communication through the design of time and three-dimensional space compressed into a two-dimensional image. Of all the arts discussed in this volume, film is the only one that also is an invention. Once the principles of photography had evolved and the mechanics of recording and projecting cinematic images were understood, society was ready for the production of pictures that could move, be presented in color, and eventually talk.

If we examine a strip of film, we will notice that it is only a series of pictures arranged in order. Each of these pictures, or *frames*, is about four-fifths of an inch wide and three-fifths of an inch high. If we study the frames in relation to

one another, we will see that even though each frame may seem to show exactly the same scene, the position of the objects in the separate frames is slightly different. When this film, which contains sixteen frames per foot of film, is run on a projecting device and passed before a light source at the rate of twenty-four frames per second (sixteen to eighteen frames per second for silent films), the frames printed on it are enlarged through the use of a magnifying lens, projected on a screen, and appear to show movement. However, the motion picture, as film is popularly called, does not really move but only seems to. This is due to an optical phenomenon called *persistence of vision*, which according to legend was discovered by the astronomer Ptolemy sometime around the second century A.D. The theory behind persistence of vision is that the eye takes a fraction of a second to record an impression of an image and send it to the brain. Once the impression is received, the eye retains it on the retina for about one-tenth of a second after the actual image has disappeared. The film projector has built into it a device that pulls the film between the light source and a lens in a stop-and-go fashion, the film pausing long enough at each frame to let the eye take in the picture. Then a shutter on the projector closes, the retina retains the image, and the projection mechanism pulls the film ahead to the next frame. Holes, or *perforations*, along the right-hand side of the filmstrip enable the teeth on the gear of the driving mechanism to grasp the film and not only move it along frame by frame but also hold it steady in the gate or slot between the light source and the magnifying lens. This stop-and-go motion gives the impression of continuous movement; if the film did not pause at each frame, the eye would receive only a blurred image.

The motion picture was originally invented as a device for recording and depicting motion. But once this goal was realized, it was quickly discovered this machine could also record and present stories—in particular, stories that made use of the unique qualities of the medium of film.

Our formal response to film recognizes three basic techniques of presentation. These are narrative film, documentary film, and absolute film.

Narrative Film

Narrative film tells a story; in many ways it uses the technique of theatre. Narrative film follows the rules of literary construction in that it usually begins with expository material, adds levels of complications, builds to a climax, and ends with a resolution of all the plot elements. As in theatre, the personages in the story are portrayed by professional actors under the guidance of a director; the action of the plot takes place within a setting designed and constructed primarily for the action of the story but that also allows the camera to move freely in photographing the action. Many narrative films are genre films, constructed out of familiar literary styles—the western, the detective story, and the horror story, among others. In these films the story elements are so familiar to the audience that it usually knows the outcome of the plot before it begins. The final showdown between the good guy and the bad guy, the destruction of a city by an unstoppable monster, and the identification of the murderer by the detective are all familiar plot elements that have become clichés or stereotypes within the genre; their use fulfills audience expectations. Film versions of popular novels and stories written especially for the medium of the screen are also part of the narrative-film form, but because film is a major part of the mass-entertainment industry, the narrative presented is usually material that will attract a large audience and thus ensure a profit.

Documentary Film

Documentary film is an attempt to record actuality using primarily either a sociological or journalistic approach. It is normally not reenacted by professional actors and often is shot as the event is occurring, at the time and place of its

occurrence. The film may use a narrative structure, and some of the events may be ordered or compressed for dramatic reasons, but its presentation gives the illusion of reality. The footage shown on the evening television news, television programming concerned with current events or problems, and full coverage either by television or film companies of a worldwide event, such as the Olympics, are all kinds of documentary film. All convey a sense of reality as well as a recording of time and place.

Absolute Film

Absolute film is simply film that exists for its own sake, for its record of movement or form. It does not tell a story, although documentary techniques can be used in some instances. Created neither in the camera nor on location, absolute film is built carefully, piece by piece, on the editing table or through special effects and multiple-printing techniques. It tells no story but exists solely as movement or form. Absolute film is rarely longer than twelve minutes (one reel) in length, and it usually is not created for commercial intent but is meant only as an artistic experience. Narrative or documentary films may contain sections that can be labeled absolute, and these sections can be studied either in or out of the context of the whole film.

How is it put together?

Editing

Film is rarely recorded in the order of its final presentation; it is filmed in bits and pieces and put together, after all the photography is finished, as one puts together a jigsaw puzzle or builds a house. The force or strength of the final product depends on the editing process used, the manner in which the camera and the lighting are handled, and the movement of the actors before the camera. Naturally, the success of a film depends

equally on the strength of the story presented and the ability of the writers, actors, directors, and technicians who have worked on the film. However, this level of success is based on the personal taste of the audience and the depth of perception of the individual, and therefore does not lie within the boundaries of this discussion.

Perhaps the greatest difference between film and the other arts discussed within this volume is the use of *plasticity*, the quality of film that enables it to be cut, spliced, and ordered according to the needs of the film and the desires of the filmmaker. If twenty people were presented with all the footage shot of a presidential inauguration and asked to make a film commemorating the event, we would probably see twenty completely different films; each filmmaker would order the event according to his or her own views and artistic ideas. The filmmaker must be able to synthesize a product out of many diverse elements. This concept of plasticity is, then, one of the major advantages of the use of the machine in consort with an art form.

The editing process, then, creates or builds the film, and within that process are many ways of meaningfully joining shots and scenes to make a whole. Let's examine some of these basic techniques. The *cut* is simply the joining together of shots during the editing process. A *jump cut* is a cut that breaks the continuity of time by jumping forward from one part of the action to another part that obviously is separated from the first by an interval of time, location, or camera position. It is often used for shock effect or to call attention to a detail, as in commercial advertising on television. The *form cut* cuts from an image in a shot to a different object that has a similar shape or contour; it is used primarily to make a smoother transition from one shot to another. For example, in D. W. Griffith's silent film *Intolerance*, attackers are using a battering ram to smash in the gates of Babylon. The camera shows the circular frontal area of the ram as it is advanced toward the gate. The scene cuts to a view of a circular shield, which in the framing of

PROFILE

D.W. Griffith

D.W. Griffith (1875-1948) was the first giant of the motion picture industry and a genius of film credited with making film an art form. As a director, D.W. Griffith never needed a script. He improvised new ways to use the camera and to cut the celluloid, which redefined the craft for the next generation of directors.

David Lewelyn Wark Griffith was born on Jan. 22, 1875, in Floydsfork, Kentucky, near Louisville. His aristocratic Southern family had been impoverished by the American Civil War, and much of his early education came in a one-room schoolhouse or at home. His father, a former Confederate colonel, told him battle stories that may have affected the tone of Griffith's early films.

When Griffith was 7, his father died and the family moved to Louisville. He quit school at 16 to work as a bookstore clerk. In the bookstore he met some actors from a Louisville theater. This acquaintanceship led to work with amateur theater groups and to tours with stock companies. He tried playwrighting, but his first play failed on opening night in Washington, D.C. He also attempted writing screenplays, but his first scenario for a motion picture also met with rejection. While acting for New York studios, however, he did sell some scripts for one-reel films, and when the Biograph Company had an opening for a director in 1908, Griffith was hired.

During the five years with Biograph, Griffith introduced or refined all the basic techniques of moviemaking. His innovations in cinematography included the close-up, the fade-in and fade-out, soft focus, high- and low-angle shots, and panning (moving the camera in panoramic long shots). In film editing, he invented the techniques of flashback and crosscutting—interweaving bits of scenes to give an impression of simultaneous action.

Griffith also expanded the horizon of film with social commentary. Of the nearly 500 films he directed or produced, his first full-length work was his most sensational. *The Birth of a Nation* (first shown as *The Clansman* in 1915; see Fig. 6.3) was hailed for its radical technique but condemned for its racism. As a response to censorship of *Birth of a Nation*, he produced *Intolerance* (1916), an epic integrating four separate themes.

After *Intolerance* Griffith may have turned away from the epic film because of the financial obstacles, but his gifted performers more than made up for this loss, for they were giants in their own right. Among the talented stars he introduced to the industry were Dorothy and Lillian Gish, Mack Sennett, and Lionel Barrymore.

In 1919 Griffith formed a motion picture distribution company called United Artists with Mary Pickford, Charlie Chaplin, and Douglas Fairbanks.

Griffith's stature within the Hollywood hierarchy was one of respect and integrity. He became one of the three lynchpins of the ambitious Triangle Studios, along with Thomas Ince and Mack Sennett.

He died in Hollywood, California, on July 23, 1948.

the shot is placed in exactly the same position as the front view of the ram.

Montage can be considered the most aesthetic use of the cut in film. It is handled in two basic ways: first, as an indication of compression or elongation of time, and, second, as a rapid succession of images to illustrate an association of ideas. A series of stills from Léger's *Ballet Mécanique* (Fig. 6.1) illustrates how images are juxtaposed to create comparisons. For example, a couple goes out to spend an evening on the town, dining and dancing. The film then presents a rapid series of cuts of the pair—in a restaurant, then dancing, then driving to another spot, then drinking, and then more dancing. In this way the audience sees the couple's activities in an abridged manner. Elongation of time can be achieved in the same way. The second use of montage allows the filmmaker to depict complex ideas or draw a metaphor visually. Sergei Eisenstein, the Russian film director, presented a shot in one of his early films of a Russian army officer walking out of the room, his back to the camera and his hands crossed behind him. Eisenstein cuts immediately to a peacock strutting away from the camera and spreading its tail. These two images are juxtaposed, and the audience is allowed to make the association that the officer is as proud as a peacock.

Camera Viewpoint

Camera position and viewpoint are as important to the structure of film as is the editing process. How the camera is placed and moved can be of great value to filmmakers as an aid in explaining and elaborating on their cinematic ideas. In the earliest days of the silent film the camera was merely set up in one basic position; the actors moved before it as if they were performing before an audience on a stage

Figure 6.1 *Ballet Mécanique* (1924). A film by Fernand Léger. ©1999 Artists Rights Society (ARS), New York/ADAGP, Paris.

in a theater. However, watching an action from one position became dull, and the early film-makers were forced to move the camera in order to add variety to the film.

The Shot

The *shot* is what the camera records over a particular period of time and is the basic unit of filmmaking. Several varieties are used. The *master shot* is a single shot of an entire piece of action, taken to facilitate the assembly of the component shots of which the scene will finally be composed. The *establishing shot* is a long shot introduced at the beginning of a scene to establish the interrelationship of details, a time, or a place, which will be elaborated on in subsequent shots. The *long shot* is a shot taken with the camera a considerable distance from the subject. The *medium shot* is taken nearer to the subject. The *close-up* is a shot taken with the camera quite near the subject. A *two-shot* is a close-up of two persons with the camera as near as possible while keeping both subjects within the frame. A *bridging shot* is a shot inserted in the editing of a scene to cover a brief break in the continuity of the scene.

Objectivity

An equally important variable of camera viewpoint is whether the scene is shot from an objective or subjective viewpoint. The *objective viewpoint* is that of an omnipotent viewer, roughly analogous to the technique of third-person narrative in literature. In this way filmmakers allow us to watch the action through the eyes of a universal spectator. However, filmmakers who wish to involve us more deeply in a scene may use the *subjective viewpoint:* The scene is presented as if we were actually participating in it, and the action is viewed from the filmmaker's perspective. This is analogous to the first-person narrative technique, and is usually found in the films of the more talented directors.

Cutting Within the Frame

Cutting within the frame is a method used to avoid the editing process. It can be created by actor movement, camera movement, or a combination of the two. It allows the scene to progress more smoothly and is used most often on television. In a scene in John Ford's classic, *Stage-coach*, the coach and its passengers have just passed through hostile Indian territory without being attacked; the driver and his passengers all express relief. Ford cuts to a long shot of the coach moving across the desert and *pans*, or follows, it as it moves from right to left on the screen. This movement of the camera suddenly reveals in the foreground, and in close-up, the face of a hostile warrior watching the passage of the coach. In other words, the filmmaker has moved from a long shot to a close-up without the need of the editing process. He has also established a spatial relationship. The movement of the camera and the film is smooth and does not need a cut to complete the sequence.

Cutting within the frame is a particularly effective means by which a film director can frustrate later attempts to tamper with his or her original product. When transitions occur using this method, it is impossible to cut out or add in material without destroying the rhythm of the scene. Utilization of this technique also means that the acting and action must be flawless and seamless, with no room for error from beginning to end. The effect, of course, creates a smooth structural rhythm in the film, in contrast to inserting closeups or utilizing jump cuts, for example. In the original production of *Jaws*, effective use of cutting within the frame allowed the director, in beach scenes, to move from distant objects off shore to faces in the foreground and, finally, including them both within the same frame. He could also pan across the beach, from foreground to background, seamlessly.

Dissolves

During the printing of the film negative, transitional devices can be worked into a scene. They are usually used to indicate the end of one scene and the beginning of another. The camera can cut or jump to the next scene, but the transition can be smoother if the scene fades out into black and the next scene fades in. This is called a *dissolve*. A *lap dissolve* occurs when the fade-out and the fade-in are done simultaneously and the scene momentarily overlaps. A *wipe* is a form of optical transition in which a line moves across the screen, eliminating one shot and revealing the next, much in the way a windshield wiper moves across the windshield of a car. In silent film the transition could also be created by closing or opening the aperture of the lens; this process is called an *iris-out* or an *iris-in*. Writer/Director George Lucas uses the iris-out as a transitional device dramatically in *Star Wars: Episode I, the Phantom Menace*. Although this episode contains fewer evidences of subtextual reference to old films than the original, *Episode IV*, Lucas employs the iris-in/iris-out in such an obvious way in the "prequel" that it is as if he wants us to remember the device, which was very prominent in early silent film.

Dissolves, then, whether lap dissolves, wipes, or iris-in/iris-out, give the film director and editor a means by which to create a smoother transition between scenes than can occur when they employ cuts. Our task, as participants in the film, is to develop an awareness of how the director articulates movement from one section to another and how that particular form of articulation contributes to the rhythm and style of the film, overall. We will find, eventually, that we will be able to notice details of film composition in passing, without letting them interfere with our enjoyment of the details of the story or mood. In fact, we will find our basic ability to process several layers of perception at the same time quite remarkable and enjoyable.

Movement

Camera movement also plays a part in film construction. The movement of the camera as well as its position can add variety or impact to a shot or a scene. Even the manner in which the lens is focused can add to the meaning of the scene. If the lens clearly shows both near and distant objects at the same time, the camera is using *depth of focus*. In the beach scenes in *Jaws*, foreground and background are equally in focus. In this way actors can move in the scene without necessitating a change of camera position. Many TV shows photographed before an audience usually use this kind of focus. If the main object of interest is photographed clearly while the remainder of the scene is blurred or out of focus, the camera is using *rack* or *differential focus*. With this technique the filmmaker can focus the audience's attention on one element within a shot.

There are many kinds of physical (as opposed to apparent) camera movement that can have a bearing on a scene. The *track* is a shot taken as the camera is moving in the same direction, at the same speed, and in the same place as the object being photographed. A *pan* is taken by rotating the camera horizontally while keeping it fixed vertically. The pan is usually used in enclosed areas, particularly TV studios. The *tilt* is a shot taken while moving the camera vertically or diagonally; it is used to add variety to a sequence. A *dolly shot* is taken by moving the camera toward or away from the subject. Modern sophisticated lenses can accomplish the same movement by changing the focal length. This negates the need for camera movement and is known as a *zoom shot*.

Lighting

Of course, the camera cannot photograph a scene without light, either natural or artificial. Most television productions photographed before a live audience require a flat, general illumination

Figure 6.2 *The Birth of a Nation* (1915). Director: D. W. Griffith.

pattern. For close-ups, stronger and more definitively focused lights are required to highlight the features, eliminate shadows, and add a feeling of depth to the shot. Cast shadows or atmospheric lighting (in art, *chiaroscuro*) is often used to create a mood, particularly in films made without the use of color (Fig. 6.2). Lighting at a particular angle can heighten the feeling of texture, just as an extremely close shot can. These techniques add more visual variety to a sequence.

If natural or outdoor lighting is used and the camera is hand-held, an unsteadiness in movement is found in the resulting film; this technique and effect is called *cinema veritée*. This kind of camera work, along with natural lighting, is found more often in documentary films or in sequences photographed for newsreels or television news programming. It is one of the conventions of current-events reporting and adds to the sense of reality necessary for this kind of film recording.

These techniques and many others are all used by filmmakers to ease some of the technical problems in making a film. They can be used to make the film smoother or more static, depending on the needs of the story line, or to add an element of commentary to the film. One school of cinematic thought believes that camera technique is best when it is not noticeable; another, more recent way of thinking believes the obviousness of all the technical aspects of film adds meaning to the concept of cinema. In any case, camera technique is present in every kind of film made and is used to add variety and commentary, meaning and method, to the shot, the scene, and the film.

Figure 6.3 Still photo from *The Birth of a Nation* (1915). Director D. W. Griffith. The Metropolitan Museum of Art/Film Stills Archive.

How does it stimulate the senses?

The basic aim of film, as with any art, is to involve us in its product, either emotionally or intellectually. Of course, there is nothing like a good plot with well-written dialogue delivered by trained actors to create interest. But there are other ways in which filmmakers may enhance their final product, techniques that manipulate us toward a deeper involvement or a heightened intellectual response. Figure 6.3 illustrates how angles and shadows within a frame help create a feeling of excitement and variety. An in-depth study of the films of Fellini, Hitchcock, or Bergman may indicate how directors can use some of the technical aspects of film to underline emotions or strengthen a mood or an idea in their films.

Perception is most important in the area of technical detail. We should begin to cultivate the habit of noticing even the tiniest details in a scene, for often these details may add a commentary that we may otherwise miss. For example, in Hitchcock's *Psycho,* when the caretaker of the motel (Tony Perkins) wishes to spy on the guests in cabin 1, he pushes aside a picture that hides a peephole. The picture is a reproduction of *The Rape of the Sabine Women.* Hitchcock's irony is obvious. Thus perception becomes the method through which viewers of film may find its deeper meanings as well as its basic styles.

Crosscutting

Filmmakers can use many techniques to heighten the feeling they desire their film to convey. The most familiar and most easily identified is that of *crosscutting*. Crosscutting is an alternation between two separate actions that are related by theme, mood, or plot but are usually occurring within the same period of time. Its most common function is to create suspense. Consider this familiar cliché: Pioneers going west in a wagon train are besieged by Indians. The settlers have been able to hold them off, but ammunition is running low. The hero has been able to find a cavalry troop, and they are riding to the rescue. The film alternates between views of the pioneers fighting for their lives and shots of the soldiers galloping to the rescue. The film continues to cut back and forth, the pace of cutting increasing until the sequence builds to a climax—the cavalry arriving in time to save the wagon train. The famous chase scene in *The French Connection*, the final sequences in *Wait Until Dark*, and the sequences of the girl entering the fruit cellar in *Psycho* are built for suspense through techniques of crosscutting.

A more subtle use of crosscutting, *parallel development*, occurs in *The Godfather, Part I*. At the close of that film Michael Corleone is acting as godfather for his sister's son; at the same time his men are destroying all his enemies. The film alternates between views of Michael at the religious service and sequences showing violent death. This parallel construction is used to draw an ironic comparison; actions are juxtaposed. By developing the two separate actions, the filmmaker allows us to draw our own inferences and thereby add a deeper meaning to the film.

Tension Buildup and Release

If the plot of a film is believable, the actors competent, and the director and film editor talented and knowledgeable, a feeling of tension will be built up. If this tension becomes too great, we will seek some sort of release, and an odd-sounding laugh, a sudden noise, or a loud comment from someone else may cause us to laugh, thus breaking the tension and in a sense destroying the atmosphere so carefully created. Wise filmmakers therefore build into their film a *tension release* that deliberately draws laughter from the audience, but at a place in the film where they wish them to laugh. This tension release can be a comical way of moving, a gurgle as a car sinks into a swamp, or merely a comic line. It does not have to be too obvious, but it should be present in some manner. After a suspenseful sequence the audience needs to be relaxed; once the tension release does its job, we can be drawn into another suspenseful or exciting situation.

Sometimes, to shock us or maintain our attention, a filmmaker may break a deliberately created pattern or a convention of film. In *Jaws*, as noted in Chapter five for example, each time the shark is about to appear, a four-note musical *motif* is played. We thereby grow to believe we will hear this warning before each appearance, and so we relax. However, toward the end of the film the shark suddenly appears without benefit of the motif, shocking us. From that point until the end of the film we can no longer relax, and our attention is fully engaged.

Direct Address

Another method used to draw attention is that of *direct address*. It is a convention in most films that the actors rarely look at or talk directly to the audience. However, in *Tom Jones*, while Tom and his landlady are arguing over money, Tom suddenly turns directly to the audience and says, "You saw her take the money." The audience's attention is focused on the screen more strongly than ever after that. This technique has been effectively adapted by television for use in commercial messages. For example, a congenial person looks at the camera (and us) with evident interest and asks

Neorealism, Symbolism, and the "New" in Film

As Italy recovered from World War II, a new concept in film set the stage for many years to come. In 1945, Roberto Rosellini's (rohs-sel-EE-nee) *Rome, Open City* showed the misery of Rome during the German occupation. It was shot on the streets of Rome using hidden cameras and mostly non-professional actors and actresses. Technically, the quality of the work was somewhat deficient, but its objective viewpoint and documentary style changed the course of cinema and inaugurated an important style called *neorealism*. The foreign film tradition continued to be dominated by this style into the 1960s, with works such as Fellini's (fel-LEE-nee) *La Strada* (*The Road*; 1954) and *La Dolce Vita* (*The Sweet Life*; 1960).

The stunning and symbolic artistry of Japanese director Akiro Kurasawa's (kyoo-rah-SAH-wah) *Rashomon* (1951) and *Seven Samurai* (1954) penetrated the human condition. In 1986 he directed the spectacular film *Ran*, based on Shakespeare's *King Lear*.

Heavy symbolism also marked the films of Sweden's Ingmar Berman. In works such as *The Seventh Seal* (1957), *Wild Strawberries* (1957), and *Virgin Spring* (1960), he delved into human character, suffering, and motivation. By the mid-1960s Bergman had assembled a team of actors who would appear in many of his subsequent films, among them Max Von Sydow and Liv Ulmann. Autobiographical comments mark *Fanny and Alexander* (1983) and *After the Rehearsal* (1984). The same may be said about *The Best Intentions* (1992), about his parents' marriage, which he wrote but did not direct.

The new wave of film directors emerges from the increasing number of films created for very specific and sophisticated audiences, and even movies made for commercial success have elements aimed at those in the know. Steven Spielberg's *Star Wars*, for example, consists of a carefully developed series of quotes from old movies and satires of them. Not recognizing these allusions does not hamper our enjoyment of the films, but knowing them certainly enhances the pleasure.

In the late 1990s, a new wave of film directors brought to the art flashy editing and sensibilities reflecting the changing tastes of audiences with a Hollywood scramble to find newer and more intense styles. Among the new wave are Bryan Singer (*The Usual Suspects*), Joel Schumacher (*Batman Forever*), Anthony Minghella (*The English Patient*), and others. Their styles have energy, directness, heightened intensity (fueled by MTV and Hong Kong action films), and a pursuit of the "language of the moment."

Among the many fine women film directors is Nancy Savoca. Nancy Savoca is one of the most distinctive voices in American independent cinema, known for her thoughtful and often humorous examinations of women's lives. Another significant director of the new wave, Beth B., as she is known, has created a body of work that defies the very act of classification. B herself says, "People are comfortable when they can label and define you . . . but I don't want to be limited by boundaries."

if we are feeling tired, run-down, and sluggish. He assumes we are and proceeds to suggest a remedy. In a sense, the aside of nineteenth-century melodrama and the soliloquy of Shakespeare were also ways of directly addressing an audience and drawing them into the performance.

Of course, silent films could not use this type of direct address to the audience; they had only the device of titles. However, some of the silent comedians felt they should have direct contact with their audience, and so they developed a *camera look* as a form of direct address. After an especially destructive moment in his films, Buster Keaton would look directly at the camera, his face immobile, and stare at the audience. When Charlie Chaplin achieved an adroit escape from catastrophe he might turn toward the camera and wink. Stan Laurel would look at the camera and gesture helplessly (Fig. 6.4), as if to say, "How did all this happen?" Oliver Hardy, after falling into an open manhole, would register disgust directly to the camera and the audience. These were all ways of commenting to the audience and letting them know the comedians knew they were there. Some sound comedies adapted this technique. In the road pictures of Bob Hope and Bing Crosby, both stars, as well as camels, bears, fish, and anyone else who happened to be around, would comment on the film or the action directly to the audience. However, this style may have been equally based on the audience's familiarity with radio programs, in which the performer usually spoke directly to the home audience.

Figure 6.4 *Your Darn Tootin'* (1928). A Hal Roach Production for Pathe Films. Director: Edgar Kennedy.

Magnitude and Convention

In considering the magnitude of a film, we must be aware of the means by which the film is to be communicated. In other words, was the film made for a television showing or for projection in a large screen theatre? Due to the size of the television receiver, large panoramas or full-scale action sequences are not entirely effective on the TV—they become too condensed. TV films, to be truly effective, should be built around the close-up and around concentrated action and movement, because the TV audience is closer to the image than are the viewers in a large theater. Scenes of multiple images with complex patterns of movement or scenes of great violence will become confusing because of the intimacy of television, and will seem more explicit than they really are. On the contrary, when close shots of intimate details are enlarged through projection in a theatre they may appear ridiculous. The nuance of a slightly raised eyebrow that is so effective in the living room will appear either silly or overly dramatic when magnified on a 60-foot screen. Today's moviemakers, when creating a film, must be aware of how it will appear if translated to the home screen or enlarged in a theater; their work ought to be designed to accommodate the size of either medium.

The film, as with theatre, has certain conventions or customs that we accept without hesitation. When an exciting chase scene takes place, no one asks where the orchestra is that is playing the music which enhances the sequence; we merely accept the background music as part of the totality of the film. A film photographed in black and white is accepted as a recording of reality, even though we know the real world has color although this particular reel world does not. When a performer sings and dances in the rain in the middle of a city street, no member of the audience worries if the orchestra is getting wet or wonders if the performer will be arrested for cre-

ating a public spectacle. The conventions of the musical film are equally acceptable to an audience conditioned to accept them.

This consideration of conventions is especially important to the acceptance of the silent film as a form of art. The silent film should not be thought of as a sound film without sound but as a separate entity with its own special conventions. These conventions revolve around the methods used to indicate sound and dialogue without actually using them. The exaggerated pantomime and acting styles, the use of titles, character stereotyping, and visual metaphors are all conventions that were accepted during the silent era but appear ludicrous today because of changes in style and taste and improvements in the devices used for recording and projecting film. The action in the silent film was recorded and presented at a speed of sixteen to eighteen frames per second; when that action is presented today on a projector that operates at twenty-four frames per second, the movement becomes too fast and appears to be jerky and disconnected. However, once we learn to accept these antiquated conventions, we may find the silent film is an equally effective form of cinematic art.

Structural Rhythm

Much of the effectiveness of a film relies on its success as a form as well as a style. Filmmakers create rhythms and patterns that are based on the way they choose to tell their stories or that indicate deeper meanings and relationships. The *structural rhythm* of a film is the manner in which the various shots are joined together and juxtaposed with other cinematic images, both visual and aural.

Symbolic images in film range from the very obvious to the extremely subtle, but they are all useful to filmmakers in directing our attention to the ideas inherent in the philosophical approach underlying the film. This use of symbolic elements can be found in such clichés as the

hero dressed in white and the villain dressed in black, in the more subtle use of water images in Fellini's *La Dolce Vita,* or even in the presence of an X whenever someone is about to be killed in *Scarface.*

Sometimes, symbolic references can be enhanced by form cutting—for example, cutting directly from the hero's gun to the villain's gun. Or the filmmaker may choose to repeat a familiar image in varying forms, using it as a composer would use a motif in music. Hitchcock's shower sequence in *Psycho* is built around circular images: the shower head, the circular drain in the tub, the mouth open and screaming, and the iris of the unseeing eye. In *Fort Apache* John Ford uses clouds of dust as a curtain to cover major events; the dust is also used to indicate the ultimate fate of the cavalry troop. Grass, cloud shapes, windblown trees, and patches of color have all been used symbolically and as motifs. Once they perceive such elements, serious students of film will find the deeper meanings of a film more evident and their appreciation of the film heightened.

Another part of structural rhythm is the repetition of certain visual patterns throughout a film. A circular image positioned against a rectangular one, a movement from right to left, an action repeated regularly throughout a sequence—all can become observable patterns or even thematic statements. The silent film made extreme use of thematic repetition. In *Intolerance* D. W. Griffith develops four similar stories simultaneously and continually crosscuts between them. This particular use of form enabled him to develop the idea of the similarity of intolerance throughout the ages. In their silent films Laurel and Hardy often built up a pattern of "you do this to me and I'll do that to you"; they called it "tit for tat." Their audience would be lulled into expecting this pattern, but at that point the film would present a variation on the familiar theme (a process quite similar to the use of *theme and variation* in musical composition). The unexpected breaking

of the pattern would surprise the audience into laughter.

Parallel development, discussed earlier, can also be used to create form and pattern throughout a film. For example, Edwin S. Porter's *The Kleptomaniac* alternates between two stories: a wealthy woman caught shoplifting a piece of jewelry, and a poor woman who steals a loaf of bread. Each sequence alternately shows crime, arrest, and punishment; the wealthy woman's husband bribes the judge to let her off; the poor woman is sent to jail. Porter's final shot shows the statue of justice holding her scales, one weighted down with a bag of gold. Her blindfold is raised over one eye, which is looking at the money. In this case, as in others, the form is the film.

Audio Techniques

When sound films became practicable, filmmakers found many ways of using the audio track, in addition to just recording dialogue. This track could be used as symbolism, as a motif that reinforced the emotional quality of a scene, or for stronger emphasis or structural rhythm.

Some filmmakers believe a more realistic feeling can be created if the film is cut rather than dissolved. They feel that cutting abruptly from scene to scene gives the film a staccato rhythm that in turn augments the reality they hope to achieve. A dissolve, they think, creates a slower pace and tends to make the film *legato* and thus more romantic. If the abrupt cutting style is done to the beat of the sound track, a pulsating rhythm is created for the film sequence; this in turn is communicated to us and adds a sense of urgency to the scene. In Fred Zinnemann's *High Noon* the sheriff is waiting for the noon train to arrive. The sequence is presented in *montage,* showing the townspeople, as well as the sheriff waiting. The shot is changed every eight beats of the musical track. As the time approaches noon, the shot is changed every four beats. Tension mounts. The feeling of rhythm is enhanced by shots of a

clock's pendulum swinging to the beat of the sound track. Tension continues to build. The train's whistle sounds. There is a series of rapid cuts of faces turning and looking, but there is only silence on the sound track, which serves as a tension release. This last moment of the sequence is also used as transition between the music and silence. In other films the track may shift from music to natural sounds and back to the music again. Or a pattern may be created of natural sound, silence, and a musical track. All depends on the mood and attitude the filmmaker is trying to create. In Hitchcock's films music often is used as a tension release or an afterthought, as Hitchcock usually relies on the force of his visual elements to create structural rhythm.

Earlier in this chapter we mentioned the use of motif in *Jaws*. Many films make use of an audio motif to introduce visual elements or convey meaning symbolically. Walt Disney, particularly in his pre-1940 cartoons, often uses his sound track in this manner. For example, Donald Duck is trying to catch a pesky fly, but the fly always manages to elude him. In desperation Donald sprays the fly with an insecticide. The fly coughs and falls to the ground. But on the sound track we hear an airplane motor coughing and sputtering and finally diving to the ground and crashing. In juxtaposing these different visual and audio elements, Disney is using his track symbolically.

John Ford often underlines sentimental moments in his films by accompanying the dialogue of a sequence with traditional melodies; as the sequence comes to a close the music swells and then fades away to match the fading out of the scene. In *The Grapes of Wrath*, when Tom Joad says good-bye to his mother, "Red River Valley" is played on a concertina; as Tom walks over the hill the music becomes louder, and when he disappears from view it fades out. Throughout this film, this familiar folk song serves as a thematic reference to the Joad's home in Oklahoma and also boosts feelings of nostalgia for some of us. In

She Wore a Yellow Ribbon the title of the film is underlined by the song of the same name, but through the use of different tempos and timbres the mood of the song is changed each time it is used. As the cavalry troop rides out of the fort the song is played in a strong 4/4 meter with a heavy emphasis on the brass; the sequence is also cut to the beat of the track. In the graveyard sequences the same tune is played by strings and reeds in 2/4 time and in a much slower tempo, which makes the song melancholy and sentimental. In the climactic fight sequence in *The Quiet Man* John Ford cuts to the beat of a sprightly Irish jig, which enriches the comic elements of the scene and plays down the violence.

Our discussion in these last few paragraphs touches only the surface of the techniques and uses of sound in film; of course, there are other ways of using sound and the other elements discussed thus far. But part of the challenge of the film as an art form is our discovery of the varying uses to which film technique can be put, and this in turn enhances further perceptions.

CHRONOLOGY OF SELECTED WORKS FOR ADDITIONAL STUDY

1899–1928

Méliès: *A Trip to the Moon*
Porter: *The Great Train Robbery*
Griffith: *The Birth of a Nation*
Chaplin: *Easy Street*
Weine: *The Cabinet of Dr. Caligari*
Von Stroheim: *Greed*
Eisenstein: *Potempkin*
Crosland: *The Jazz Singer*
Disney: *Steamboat Willie*

1929–1955

Hitchcock: *The Thirty-nine Steps*
Ford: *Stagecoach*
Selznick: *Gone with the Wind*

Welles: *Citizen Kane*
De Sica: *The Bicycle Thief*
Koster: *The Robe*

Spielberg: *Jaws*
Fosse: *All that Jazz*
Allen: *Manhattan*

1955–1990

Bergman: *The Seventh Seal*
Lean: *The Bridge on the River Kwai*
Godard: *Breathless*
Clayton: *Room at the Top*
Hitchcock: *Psycho*
Felini: *8*
Penn: *Bonnie and Clyde*
Kubrick: *2001*
Altman: *Mash*
Coppola: *The Godfather*

1990–2000

Scorsese: *Age of Innocence*
Blair: *Bad Behavior*
Leigh: *Naked*
Campion: *The Piano*
Amelio: *The Stolen Children*
Yimou: *The Story of Qiu Ju*
Saute: *Un Coeur en Hiver*
Mingella: *The English Patient*
Singer: *The Usual Suspects*

Dance

Every December, Tchaikovsky's "Nutcracker Ballet" rivals Handel's *Messiah* and television reruns of the Jimmy Stewart movie, *It's a Wonderful Life*, as a holiday tradition. Nevertheless, ballet and dance in general seem remote from most people. Ballet, in particular, evokes strong personal opinions of like or dislike. Why this is so and what those opinions are create spirited classroom discussion.

Dance is one of the most natural and universal of human activities. In virtually every culture, regardless of location or level of development, we find some form of dance. Dance appears to have sprung from human religious needs. For example, scholars are relatively sure the theatre of ancient Greece developed out of that society's religious, tribal dance rituals. Without doubt dance is part of human communication at its most fundamental level. We can see this expression even in little children, who, before they begin to paint, sing, or imitate, begin to dance.

What is it?

Dance focuses on the human form in time and space. In general it follows one of three traditions: ballet, modern dance, and folk dance. Other forms or traditions of dance exist including jazz dance, tap, and musical comedy. Their properties or qualities as concert dance are often debated. We note jazz dance in passing later in the chapter and focus our brief discussion on ballet, modern dance, and folk dance.

Ballet

Ballet comprises what can be called classical, or formal, dance; it is rich in tradition and rests heavily on a set of prescribed movements and actions, as we shall see. In general, ballet is a highly theatrical dance presentation consisting of solo dancers, duets, and choruses, or *corps de ballets*. According to Anatole Chujoy in the

Dance Encyclopedia, the basic principle in ballet is "the reduction of human gesture to bare essentials, heightened and developed into meaningful patterns." George Balanchine saw the single steps of a ballet as analogous to a single frame in a motion picture. Ballet, then, became a fluid succession of images, all existing within specialized codes of movement. As with all dance and all the arts, ballet expresses basic human experiences and desires.

Modern Dance

Modern dance is a label given to a broad variety of highly individualized dance works limited to the twentieth century, essentially American in derivation, and antiballetic in philosophy. It began as a revolt against the stylized and tradition-bound elements of the ballet. The basic principle of modern dance probably could be stated as an emphasis on natural and spontaneous or uninhibited movement, in strong contrast with the conventionalized and specified movement of the ballet. The earliest modern dancers found stylized ballet movement incompatible with their need to communicate in twentieth-century terms. As Martha Graham characterized it, "There are no general rules. Each work of art creates its own code." Nonetheless, in its attempt to be nonballetic, certain conventions and characteristics have accrued to modern dance. Although narrative elements do exist in many modern dances, there may be less emphasis on them than in traditional ballet. There also are differences in the use of the body, the use of the dance floor, and the interaction with the mise-en-scène.

Folk Dance

Folk dance, somewhat like folk music, is a body of group dances performed to traditional music. It is similar to folk music in that we do not know the artist who developed it; there is no choreographer of record for folk dances. The dances began as a necessary or informative part of certain cultures, and their characteristics are stylistically identifiable with a given culture. They developed over a period of years, without benefit of authorship, passing from one generation to another. They have their prescribed movements, rhythms, and music and costume. At one time or another they may have become formalized—that is, committed to some form of record. But they are part of a heritage, and usually not the creative result of an artist or a group of interpretative artists, as is the case with the other forms of dance. Likewise, they exist more to involve participants than to entertain an audience.

Folk dancing establishes an individual sense of participation in society, the tribe, or a mass movement. "The group becomes one in conscious strength and purpose, and each individual experiences a heightened power as part of it . . . [a] feeling of oneness with one's fellows which is established by collective dancing."*

How is it put together?

Dance is an art of time and space that utilizes many of the elements of the other arts. In the mise-en-scène and in the line and form of the human body it involves many of the compositional elements of pictures, sculpture, and theatre. Dance also relies heavily on the elements of music—whether or not music accompanies the dance presentation. However, the essential ingredient of dance is the human body and its varieties of expression.

* John Martin, *The Dance* (New York: Tudor, 1946), p. 26.

Modern Dance

The Romantic tradition in ballet began to find detractors in the late nineteenth century. The most significant of these was the remarkable and unrestrained Isadora Duncan (1878-1927). By 1905 Duncan had gained notoriety for her barefoot, deeply emotional dancing. She was considered controversial among balletomanes and reformers alike, but even figures in ballet itself found genius in her style.

Although an American, Isadora Duncan achieved her fame in Europe. Her dances were emotional interpretations of moods suggested to her by music or by nature. Her dance was personal. Her costume was inspired by Greek tunics and draperies, and, most significantly, she danced in bare feet. This break with convention continues to this day as a basic condition of the modern dance tradition she helped to form.

Despite the notoriety of this young feminist, it was her contemporary, Ruth St. Denis and her husband Ted Shawn (forming the Denishawn School), who laid more substantial cornerstones for modern dance. Much more serious than Duncan, Ruth St. Denis began her dancing as a strange combination of exotic, oriental interpretations and Delsartian poses. (Delsarte is a nineteenth-century system of gestures and postures that transmit feelings and ideas originated by François Delsarte.) Ruth St. Denis was a remarkable performer with a magnificently proportioned body. She manipulated it and various draperies and veils into presentations of line and form so graceful that the fabric appeared to become an extension of the body.

The Denishawn School took a totally eclectic approach to dance. All traditions were included, from formal ballet to oriental and American Indian dances. The touring company presented wildly varied fare, from Hindu dances to the latest ballroom crazes. Branches of the school were formed throughout the United States. By 1932, St. Denis and Shawn had separated, and the Denishawn Company ceased to exist. Nevertheless, it left its mark on its pupils, if not always a positive one.

Among the first to leave Denishawn was Martha Graham (See PROFILE in this chapter), probably the most influential figure in modern dance. Although the term "modern dance" defies accurate definition, it remains the most appropriate label for the nonballetic tradition that Martha Graham came to symbolize. Graham found Denishawn unsatisfactory as an artistic base. She did maintain the primacy of artistic individualism, however.

Yet principally because it tried so hard to be different from formal ballet, modern dance also developed its own conventions. Ballet movements were largely rounded and symmetrical. Therefore, modern dancers emphasized angularity and asymmetry. Ballet stressed leaps and based its line on toework, while modern dance hugged the floor and dancers went barefoot. As a result, the early works of Graham and others tended to be more fierce and earthy and less graceful. Beneath it all was the desire to express emotion. Martha Graham described her choreography as "a graph of the heart."

Formalized Movement

The most obvious repository of formalized movement in dance is ballet. All movement in ballet is based on five basic leg, foot, and arm positions. In the *first position* (Fig. 7.1) the dancer stands with weight equally distributed between the feet, heels together, and toes open and out to the side. In ballet all movements evolve from this basic *open* position; the feet are never parallel to each other with both pointing straight forward. The *second position* (Fig. 7.2) is achieved by opening the first position the length of one's foot, again with the weight placed evenly on both feet. In the *third position* (Fig. 7.3) the heel of the front foot touches the instep of the back foot; the legs and feet must be well turned out. In the *fourth*

position (Fig. 7.4) the heel of the front foot is opposite the toe of the back foot. The feet are parallel and separated by the length of the dancer's foot; again, the weight is placed evenly on both feet. The *fifth position* (Fig. 7.5) is the most frequently used of the basic ballet positions. The feet are close together with the front heel touching the toe of the back foot. The legs and the feet must be well turned out to achieve this position correctly, and the weight is placed evenly on both feet. As we can see in Figures 7.1 through 7.5, each position changes the attitude of the arms as well as that of the legs and feet. From these five basic positions a series of fundamental movements and poses is developed; these are the core of every movement of the human body in formal ballet.

Figure 7.1 First position. Linda Rich photo.

Figure 7.2 Second position. Linda Rich photo.

Martha Graham

Martha Graham (1893-1991), arguably, contributed more to the art of modern dance as an innovative choreographer and teacher than any other individual. Her techniques were rooted in the muscular and nerve-muscle responses of the body to inner and outer stimuli. She created the most demanding body-training method in the field of modern dancing.

Born in Pittsburgh on May 11, 1893, Graham spent her early years there and in Santa Barbara, Calif. As a teenager she began studying dance at Denishawn, a dance company founded by Ruth St. Denis and Ted Shawn. Martha's dance debut came in *Xochitl*, a ballet choreographed by St. Denis and based on an Aztec theme. It proved a great success both in vaudeville and concert performances.

Graham left Denishawn in 1923 to become a featured dancer in the Greenwich Village Follies. She also taught for a time at the Eastman School of Music in Rochester, N.Y. She debuted in New York City as an independent artist in 1926. One year later, her program included the dance piece, *Revolt*, probably the first dance of protest and social comment in the United States.

Social criticism as an artistic message came in with the Great Depression, and Graham began to pursue topical themes. Her interest in the shaping of America led to her renowned dance piece, *Appalachian Spring* (1944), set to the music of Aaron Copland. *Appalachian Spring* deals, among other things, with the triumph of love and common sense over the fire and brimstone of American Puritanism. Martha Graham, herself, danced the principal role of The Bride. Other roles included The Revivalist, The Husbandman, The Pioneering Woman, and The Followers. Perhaps the best known and best loved of Graham's works, and the one with the finest score, *Appalachian Spring* takes as its pretext a wedding on the American frontier. The dance is like no actual ceremony or party, however. The movement not only expresses individual character and emotion, but it has a clarity, spaciousness, and definition that relate to the open frontier, which must be fenced and tamed. During the dance, the characters emerge to make solo statements; the action of the dance suspends while they reveal what is in their hearts. The Bride's two solos suggest not only joy but trepidation for the future.

In a career spanning 70 years, Martha Graham created 180 dance works. Some of these were based on Greek legends: *Night Journey*, first performed in 1947, about Jocasta, the mother of Oedipus; *Clytemnestra* (1958); and *Cave of the Heart* (1946), about the tragedy of Medea. *Letter to the World* (1940) was based on the life of poet Emily Dickinson. *Seraphic Dialogue* (1955) dealt with Joan of Arc, and *Embattled Garden* (1962) took up the Garden of Eden legend. Among her other works were *Alcestis* (1960); *Acrobats of God* (1960); and *Maple Leaf Rag* (1990). Graham announced her retirement in 1970, but she continued to create new dances until her death from cardiac arrest in New York City on April 1, 1991.

Some of the fundamental ballet poses and movements can be recognized throughout a dance work, including modern dance; a few lend themselves to photographic illustration. Figure 7.6 shows a *demi-plié* in first position. This half-bend of the knees can be executed in any position. The *grand plié* shown in Figure 7.7, also in first position, carries the bend to its maximum degree. The *arabesque* is a pose executed on one foot with arms and foot extended. It can appear in a variety of positions; it is shown in Figure 7.8 in the *penché*, or leaning position. The *port de bras* (Fig. 7.9) is simply the technique of moving the arms correctly. As we might imagine, many variations can be made on the five basic positions. For example, the *grande seconde* (Fig. 7.10) is a variation on second position in which the leg is elevated to full height. The leg also is ele-

vated in the *demihauteur*, or "half height" (Fig. 7.11). Full height requires extension of the leg at a 90-degree angle to the ground; half height requires a 45-degree extension. Movements carry the same potential for variety. For example, in the *ronds de jambe à terre* (Fig. 7.12) the leg from the knee to and including the foot is rotated in a semi-circle. Other basic movements (defined in the Glossary) include the *assemblé, changement de pied, jeté, pirouette,* and *relevé*. As we develop expertise in perceiving dance it will become obvious to us in watching formal ballet (and to a lesser degree, modern dance) that we see a limited number of movements and poses, turns and leaps, done over and over again. In this sense these bodily compositions form a kind of theme and variation, and they are interesting in that right alone.

Figure 7.3 Third position. Linda Rich photo.

Figure 7.4 Fourth position. Linda Rich photo.

Figure 7.5 Fifth position. Linda Rich photo.

Figure 7.6 *Demi-plié* in first position. Linda Rich photo.

In addition, it is possible for us to find a great deal of excitement in the bodily movements of formal ballet if for no other reason than the physical skills required for their execution. The standards of quality applied to a ballet dancer are based on the ability of the dancer to execute these movements properly. Just as in gymnastics or figure skating, the strength and grace of the individual in large part determines his or her qualitative achievement. It goes without saying, however, that ballet is far more than just a series of gymnastic exercises.

Perhaps the most familiar element of ballet is the female dancer's toe work or dancing *on point* (Fig. 7.13). A special kind of shoe is required for toe work (Fig. 7.14). Dancing on point is a fundamental part of the female dancer's develop-

ment. It usually takes a minimum of two years of thorough training and development before a dancer can begin to do toe work. Certain kinds of turns are not possible without toe shoes and the technique for using them—for example, spinning on point or being spun by a partner.

We have focused on ballet in this discussion of formalized movement because it is the most familiar of the traditional, formalized dance forms. Ballet, however, is not alone in adhering to formalized patterns of movement. It is, in part, formalized movement that allows us to distinguish among folk and other dances, such as the *pavane*, the *galliard*, the *waltz*, or the *mambo*. All have formal or conventional patterns of movement. Perhaps only modern dance resists formal movement, and even then not completely.

Figure 7.7 *Grand plié* in first position. Linda Rich photo.

Figure 7.8 *Arabesque (penché).* Linda Rich photo.

Line, Form, and Repetition

The compositional elements of line, form, and repetition apply to the use of the human body in exactly the same sense that they apply to those elements in painting and sculpture— the latter especially. The body of the dancer can be analyzed as sculptural, three-dimensional form that reflects the use of line, even though the dancer is continually in motion. The body as a sculptural form moves from one pose to another, and if we were to take a stop-action movie of a dance, we could analyze, frame by frame or second by second, the compositional qualities of the human body. The human form in every illustration in this chapter, including those that show group-

ings of dancers, can be analyzed as a composition of line and shape. Dance, therefore, can be seen at two levels: first, as a type of pictorial communication employing symbols that occur only for a moment, and, second, as the design of transition with movement between these movements. Because the dancer moves through time, the concept of repetition becomes an important consideration in analyzing how a dance work is put together. The relationship of the movements to each other as the dance progresses from beginning to end shows us a repetitional pattern that again is very similar to theme and variation in music. So, *choreographers* concern themselves with the use of the individual dancer's body as well as combinations of dancers' bodies in duets,

Ballet in the Romantic Style

The ballet to which we have devoted much attention in this chapter comes to us chiefly from the Romantic tradition of the nineteenth century. It was a time when all the arts turned against what was perceived as the often cold formality of classicism and neoclassicism. A more subjective viewpoint and emotional feeling sought release.

Two sources provide assistance in understanding Romantic ballet: the writings of Théophile Gautier (goh-TEEYAY) and Carlo Blasis (blah-SEE). Gautier (1811-72) was a poet and critic, and his aesthetic principles held first of all that beauty was truth—a central Romantic conception. Gautier believed that dance was visual stimulation to show "beautiful forms in graceful attitudes." Dancing for Gautier was like a living painting or sculpture, "physical pleasure and feminine beauty." This exclusive focus on ballerinas placed sensual enjoyment and eroticism squarely at the center of his aesthetics. Gautier's influence was significant, and it accounted for the central role of the ballerina in Romantic ballet. Male dancers were relegated to the background, strength being the only grace permissible to them.

The second general premise for Romantic ballet came from *Code of Terpsichore* (terp-SIK-oh-ree) by Carlo Blasis (1803-78). Blasis was much more systematic and specific than Gautier—he was a former dancer—and his principles covered training, structure, and positioning. Everything in the ballet required a beginning, a middle, and an ending. The basic "attitude" in dance was to stand on one leg with the other brought up behind at a 90-degree angle with the knee bent. The dancer needed to display the human figure with taste and elegance. If the dancer trained each part of the body, the result would be grace without affectation. From Blasis came the turned out position still basic to ballet today (Fig. 7.1).

These broad principles provided the framework, and, to a great extent, a summary, of objectives for Romantic ballet: delicate ballerinas, lightly poised, costumed in soft tulle, and moving *en pointe* with elegant grace.

The first truly Romantic balled occurred as part of an opera, *Robert the Devil* (1831). It told the story of Duke Robert of Normandy, his love for a princess, and an encounter with the devil. The ballet sections contain ghosts, bacchanalian dancing, and a spectral figure. It opened with a less than auspicious start. In a totally unrehearsed move, a ballerina leaped from the tomb on which she posed and narrowly escaped a piece of falling scenery. Stage lights dropped onto the stage, and a tenor fell into an open trapdoor. The novelty of the accidents, however, was eclipsed by the startling novelty of the choreography.

Choreographers of Romantic ballet sought magic and escape in fantasies and legends. Nymphs were greatly popular, as were madness, sleepwalking, and opium dreams. Filippo Taglioni's *The Revolt in the Harem* is possibly the first ballet about the emancipation of women. The Romantic ballet repertoire still consists of the ballets *La Sylphide* (1832), *Giselle* (1841), *Swan Lake* (1877), and *The Nutcracker* (1892).

Figure 7.9 *Port de bras.* Linda Rich photo.

Mime and Pantomime

Within any dance form, modern dance included, there may be elements of bodily movement we call *mime* and *pantomime*. Bodily movement is *mimetic* whenever it suggests the kinds of movements we associate with people or animals. It is also mimetic if it employs any of the forms of conventional sign language, such as the Delsarte system. Of course, if there are narrative elements in the dance and the dancer actually portrays a character in the theatrical sense, there also may be pantomimetic action. Pantomime is the acting out of dramatic action without words. In the Romantic style of ballet, for example, pantomime helps to carry forward the story line. We sense the emotions, feelings, and character relationships in the dancers' steps,

Figure 7.10 *Grande seconde.* Linda Rich photo.

trios, or the entire corps de ballet (Figs. 7.15 and 7.16 and color insert, Plate 18).

Rhythm

As we watch a dance we can see the steps are related and coherent. Dance phrases are held together in their rhythm, in the same sense as occurs in musical rhythm. Sequences of long and short motions occur that are highlighted by accents. In a visual sense dance rhythms occur in spatial arrangements, up and down, back and forth, curved and linear, large and small. We also can perceive rhythmic relationships in the ebb and flow of dancers' energy levels. Energy, of course, calls to mind dynamics in the same sense that we discussed the term in music and theatre.

gestures, movements, and facial expressions. Only when the movement of the dance is purely an emotional expression of the dancer can we say it is free of mime or pantomime.

Idea Content

Our consideration of the presence or absence of mime leads us to a consideration of how dance communicates its idea content. There are three general possibilities. First, the dance may contain *narrative* elements; that is, it may tell a story. Second, the dance may communicate through *abstract* ideas. There is a specific theme to be communicated in this case, but no story line. The ideas are abstract and general and relate to some aspect of human emotion or the human condi-

tion. Modern dance, especially, tends to deal with human psychology and behavior. Social themes occur frequently, as do impressions or expressions from plays, poems, and novels. Religious themes as well as folk themes can be found in explorations of subject ideas in modern dance. Modern ballet (that is, twentieth-century ballet) has dealt increasingly with abstract ideas. The third possibility is the absence of narrative or abstract communication. The work may be a *divertissement*, or diversion.

A variation of abstract idea content in dance is *ethnic influence*. It is interesting to note how elements of dance reflect sociocultural background. Jazz dance, for example, may stimulate us to consider the African heritage in America. Jazz dance has emerged strongly in the twentieth

Figure 7.11 *Demi-hauteur.* Linda Rich photo.

Figure 7.12 *Ronds de jambe à terre.* Linda Rich photo.

Figure 7.13 On point. Linda Rich photo.

Figure 7.14 Toe shoes. Linda Rich photo.

century, and many would include it as a form equal to ballet, modern, and folk. Jazz dance has its own history, which is linked closely with the African experience in America, show business, and jazz as a musical idiom.

Music

We associate music with dance as a matter of course. Most of the time music serves as a basis for the bodily movement of the work we are perceiving, although it is not necessary for dance to be accompanied by music. However, it is impossible to have dance without one element of music—rhythm, as we noted previously. Every action of a dancer's body has some relationship in time to every other movement, and those relationships establish rhythmic patterns that are musical regardless of the presence or absence of auditory stimuli.

When we hear music accompanying a dance we can respond to the relationship of the dance to the musical score. The most obvious relationship we will see and hear is the one between the gestures and footfalls of the dancer and the beat of the music. In some cases the two are in strict accord; the *beat-for-beat* relationship is one to one. In other cases there may be virtually no perceivable beat-for-beat relationship between the dancer's movements and the accent or rhythmic patterns of the musical score.

Another relationship is that of the *dynamics* of the dance to those of the music. Of prime importance in this relationship is the intensity, or *force,* of the dance movement. Moments of great intensity in a dance can manifest them-

selves in rapid movement and forceful leaps. Or they may be reflected in other qualities. We must discern how the actual performance employs dynamics.

We can use the same kind of analysis in dance as we did in theatre in plotting dynamic levels and overall structure. For maximum interest there must be variety of intensity. If we chart the relationship of the peaks and valleys of dynamics, we are likely to conclude that the dynamic structure of a dance is similar to the dynamic structure of a play; it tends to be pyramidal: It builds to a high point and then relaxes to a conclusion. This applies whether or not narrative elements are present.

Mise-en-Scène

Because dance is essentially a visual and theatrical experience, part of our response must be to those theatrical elements of dance that are manifested in the environment of the presentation. In other words, we can respond to the *mise-en-scène* of the dance (Figs. 7.16 and Plate 18). We can note the elements of verisimilitude in the mise-en-scène and how those elements reflect or otherwise relate to the aural and visual elements of the dance. A principal consideration here is the interrelationship of the dance with properties, settings, and the floor of the theatrical environment. The dance may use *properties* in significant or insignificant ways. As for *settings*, some dances employ massive stage designs. Others have no setting at all; they are performed in a neutral environment. Again, part of our response is to the relationship of the elements of the setting to the rest of the dance.

A principal difference between formal ballet and modern dance lies in the use of the *dance floor*. In formal ballet the floor acts principally as an agent from which the dancer springs and to which the dancer returns. But in modern dance the floor assumes an integral role in the dance, and we are likely to see the dancers sitting on the floor, rolling on it—in short, *interacting with* the floor. So, consideration of the use of the floor in dance concerns not only whether or not it is employed as an integral part of a dance, but also how the use of the floor relates to the idea content of the dance.

In discussing the relationship of *costume* to dance, we would do well to return to the section on costume design in Chapter 5 to note the purposes of costume, because those purposes apply to the dance in the same manner that they apply to a theatre production. In some dances costume will be traditional, conventional, and neutral. There would be little representation of story line or character in the tights and *tutu* of the female dancer shown in Figure 7.17. However, in many dances we are likely to see costumes high in verisimilitude. Costumes may help portray character, locality, and other aspects of the dance (Figs. 7.15 and 7.16).

In addition, it is especially important that the costume allow the dancer to do whatever it is that the choreographer expects him or her to do. In fact, costume may become an integral part of the dance itself. An example of this is Martha Graham's *Lamentation*, in which a single dancer is costumed in what could be best described as a tube of fabric—no arms, no legs, just a large envelope of cloth. Every movement of the dancer stretches that cloth so the line and form of the dancer is not the line and form of a human body but rather the line and form of a human body enveloped in a moving fabric.

The final element of the dance costume to be considered, and one of great significance, is footgear. Dancers' footgear ranges from the simple, soft, and supple ballet slipper to the very specialized toe shoe of formal ballet, with street shoes, character oxfords, and a variety of representational or symbolic footwear in between. In addition, modern dance often is done in bare feet. Of course, the fundamental requirements of footgear are comfort and enough flexibility to allow the dancer to do whatever he or she must do. Footgear, whether it be toe shoe, ballet slipper, character oxford,

Figure 7.15 *Nameless Hour,* Jazz Dance Theatre at Penn State, Pennsylvania State University. Choreographer: Jean Sabatine. Photo by Roger Greenawalt.

or bare feet, must be appropriate to the surface of the stage floor. Great care must be taken to ensure the dance floor is not too hard, too soft, too rough, too slippery, or too sticky. The floor is so important that many touring companies take their own floor with them to ensure they will be able to execute their movements properly. There have been cases in which professional dance companies refused to perform in local auditoriums because the floor was dangerous for the dancers.

Lighting

Inasmuch as the entire perception of a dance relies on perception of the human body as a three-dimensional form, the work of the lighting designer is of critical importance in the art of dance. How we perceive the human form in space depends on how that body is lit. Certainly our emotional and sense response is highly shaped by the nature of the lighting that plays on the dancer and the dance floor.

Figure 7.16 *A Family Tree,* Jazz Dance Theatre at Penn State, The Pennsylvania State University. Choreographer: Jean Sabatine. Photo by Roger Greenawalt.

How does it stimulate the senses?

The complex properties of the dance make possible diverse and intense communicative stimuli. We noted earlier that opera is a synthesis of all of the arts. The dance, as well, integrates elements of all of the arts, and it does so in such a way as to communicate in a highly effective symbolic and nonverbal manner.

We noted previously that it is possible to respond at different levels to an artwork. To some extent we can respond even at a level of total ignorance. In many ways artworks are like onions. If they lack quality we can call them rotten. But more important, and more seriously, an artwork, like an onion, has a series of layers. As we peel away one that is obvious to us, we reveal another and another and another, until we have gotten to the core. There will be levels of understanding, levels of meaning, levels of potential response for the uninitiated as well as the thoroughly sophisticated viewer. The more sophisticated a *balletomane* one becomes, the fuller one's understanding and response.

Figure 7.17 Traditional tights and tutu. Linda Rich photo.

Moving Forms

Like every other artwork that exists in space, the dance appeals to our senses through the compositional qualities of line and form. These qualities exist not only in the human body but in the visual elements of the mise-en-scène. Essentially, horizontal line stimulates a sense of calm and repose. Vertical lines suggest grandeur and elegance. Diagonal lines stimulate a feeling of action and movement (Fig. 7.16), and curved lines, grace. As we respond to a dance work we respond to how the human body expresses line and form, not only when it is standing still but also when it moves through space. If we are alert and perceptive we will recognize not only how lines and forms are created, but also how they are repeated from dancer to dancer and from dancer to mise-en-scène.

Often, the kind of line created by the body or body characteristics of the dancer is a key to understanding the work of the choreographer. George Balanchine, for example, insisted that his dancers be almost skin and bone; you would not see a corpulent or overly developed physique in his company. So, bodies themselves appeal to our senses, and choreographers capitalize on that appeal in their dance conceptions.

Force

We noted in Chapter 4 that the beat of music is a fundamental appeal to our senses. Beat is the aspect of music that sets our toes tapping and our fingers drumming. Probably our basic response to a dance is to the dynamics expressed by the dancers and in the music. A dancer's use of vigorous and forceful action, high leaps, graceful turns, or extended pirouettes appeals directly to us, as does the tempo of the dance. Variety in dynamics—the louds and softs and the highs and lows of bodily intensity as well as musical sound—is the dancer's and choreographer's means of providing interest, just as it is the actor's, the director's, and the painter's.

Sign Language

The dancer, like the actor, can stimulate us directly because he or she is another human being and can employ many symbols of communication (Fig. 7.15). Most human communication requires us to learn a set of symbols, and therefore, we can respond to the dance at this level only when we have mastered this language. There are systems of sign language, such as the Delsarte, in which the positions of the arms, the hands, and the head have meanings. Likewise,

in our response to the hula dance, experts tell us, we ought not concentrate on the vigorous hip movements of the dancer but rather on the hand movements, each of which communicates an idea. But until we learn what each of these movements means, we cannot respond in any significant way. However, there is a set of universal body symbols to which all of us respond (so psychologists tell us), regardless of our level of familiarity or understanding. For example, the gesture of acceptance in which the arms are held outward with the palms up has the same meaning universally. The universal symbol of rejection is the hands held in front of the body with the palms out as if to push away. When dancers employ universal symbols we respond to their appeal to our senses just as we would to the nonverbals or body language in everyday conversation.

Color

Although the dancer uses facial and bodily expressions to communicate some aspect of the human condition, we do not receive as direct a message from them as we do from the words of the actor. So, to enhance the dancer's communication the costume, lighting, and set designers must strongly reinforce the mood of the dance through the mise-en-scène they create. The principle means of expression of mood is color. In dance, lighting designers are free to work in much more obvious ways with color because they do not have to create patterns of light and shadow as high in verisimilitude as those of their counterparts in the theatre. As a result, they may not have to worry if the face of a dancer is red or blue or green, an attribute that would be disastrous in a play. Thus we are apt to see much stronger, colorful, and more suggestive lighting in the dance than in theatre. Colors will be more saturated, and the qualities of the human body, as form, will be explored much more strongly by light from various directions. The same is true of

costumes and settings. Because dancers obviously do not portray a role in a highly verisimilar way, their costume can be very communicative in an abstract way. On the other hand, scene designers must be careful to utilize color in such a way that the dancer receives the focus in the stage environment. In any but the smallest of stage spaces it is very easy for the human body to be overpowered by the elements of the setting because it occupies much more space. So, scene designers, in contrast to lighting designers, must be careful to provide a background against which the dancer will stand out in contrast unless a synthesis of the dancer with the environment is intended, as in the case, for example, of some works by choreographer Merce Cunningham. Nevertheless, scene designers use color as forcefully as they can to help reinforce the overall mood of the dance.

The examples of how dance affects our senses that we have just noted are rudimentary ones. Perhaps more than any other art, dance causes us to ascend beyond our three cognitive questions—What is it? How is it put together? How does it affect the senses?—and dwell in that fourth level of response: What does it mean?

CHRONOLOGY OF SELECTED WORKS FOR ADDITIONAL STUDY

Dance Music

Stravinsky: *The Firebird; The Rite of Spring*
Copland: *Appalachian Spring*

Films

Ballet with Edward Villella (LCOA). Contains excerpts—*Pas de Deux, Giselle, Apollo,* and *Rubies*—choreographed by George Balanchine.
Dance: Anna Sokolow's "Rooms" (Indiana University)
Dance: Echoes of Jazz (Indiana University)

Dance: Four Pioneers (Indiana University)

Dance: New York City Ballet (Indiana University)

Dance: Robert Joffrey Ballet (Indiana University)

Seraphic Dialogue (Martha Graham) (Indiana University)

Martha Graham Dance Company (Parts 1, 2, and 3) (Indiana University)

Landscape Architecture

With the exception of architecture, we come into contact with landscape architecture more than any other art form. Arguably, perhaps, landscape architecture makes a minimal conscious impact on us while it makes a maximum contribution to our well-being. Cities without parks seem unlivable, and every drab apartment building cries out for a bed of flowers.

What is it?

Landscape architecture as an art and science is the design of three-dimensional outdoor space. Its purposes are to accommodate people's functions, improve their relationship with their artificial and natural environments, and enhance their pursuit of their activities. Typical landscape designs include streetscapes, malls, urban plazas, shopping centers, parks and playscapes, and residential, commercial, and industrial areas. The discipline, then, includes large and small spaces, rural, suburban, and urban spaces,

and public as well as private areas. As a science and an art the design and planning process that takes place in landscape architecture manifests reasoned judgments as well as intuitive and creative interpretation.

The purpose and design structure of contemporary landscape design trace their roots to early history. The concept of private gardens arranged in formal geometric patterns appeared in early Egyptian times and found its way into classical Greek and Roman civilization. Eventually the Moorish influences in Spain resulted in a transition from rigid, confined spaces to designs that included views beyond the garden walls (Fig. 8.1). The Renaissance gardens of France and Italy continued the formal geometric and symmetrical arrangements. We find the same concept of formality in Middleton Place, Charleston, South Carolina, America's oldest landscaped gardens. The gardens, laid out in 1741 by Henry Middleton, president of the First Continental Congress, are part of the restored plantation (color insert, Plate 19).

Figure 8.1 Moorish influence in Spain.

The antithesis of formal landscape design can be traced to the early Chinese and Japanese gardens. The veneration of nature in these two cultures promoted the development of a very informal, natural landscape with emphasis on the use of the natural elements of ground form, stone, sand, plants, and water. The influence of this informal, natural setting was evident in a style of landscape design that evolved in England during the eighteenth century (Fig. 8.2). The style was one that exemplified asymmetrical arrangements and informality. The English parks designed in this style formed the basis for the concept of Central Park in New York City, designed in the 1850s by the father of landscape ar-

chitecture in America, Frederick Law Olmsted, and his partner, Calvert Vaux.

The twentieth century revolted against the *eclecticism* of preconceived symmetrical forms and patterns of design. The concept of functionalism—signified by the maxim "form follows function"—left its mark on present-day landscape design. In fact, contemporary landscape architecture reflects to some degree all of these influences.

What has evolved from this history is an art form that embraces the organization and arrangement of land and the spaces above it, including the natural and artificial physical elements that give form and character to the spaces on the land. The result is a three-dimensional pattern

Frederick Law Olmsted

Frederick Law Olmsted (1822-1903) is widely recognized as the founder of the profession of landscape architecture in the United States and the nation's foremost parkmaker. Olmsted was born in Hartford, Connecticut, on April 26, 1822. At age 14 his eyesight was affected by sumac poisoning, which limited his formal education. Instead he studied on his own. During a trip to Europe he became fascinated by English landscape gardening. He also became interested in scientific farming and founded a successful nursery business in 1844. During the 1850s, on a commission from the New York Times, he traveled extensively through the South to report on its economy and slavery. A keen observer of social and economic conditions, he published his travel journals of the South as *Journeys and Explorations in the Cotton Kingdom 1861.*

When the New York Central Park project was announced in 1857, Olmsted entered the competition. In collaboration with the British architect Calvert Vaux he presented the winning design and became superintendent of the project. Thus, Olmsted and his partner directed Central Park's design and construction.

From 1861 to 1863 he was secretary of the United States Sanitary Commission. He spent the next two years in California helping to establish Yosemite National Park. After the American Civil War (1861-65) he became a sought-after planner of public parks, designing the grounds of the World's Columbian Exposition 1893 (Now Jackson Park, Chicago).

Olmsted borrowed much in his designs from the picturesque landscape design of England (Fig. 8.2).

Other parks designed by Olmsted were Riverside and Morningside parks in Manhattan, Prospect Park in Brooklyn, Fairmont Park in Philadelphia, Belle Isle Park in Detroit, the Capitol grounds in Washington, D.C., Mount Royal Park in Montreal, the grounds of Stanford University in California, and the Boston park system. The last great project that Olmsted was involved with was the laying out of George Vanderbilt's 120,000 acre Biltmore Estate near Asheville, North Carolina. Unlike many of the public entities that Olmsted had done work for, Vanderbilt had the resources to carry out all of Olmsted's plans. Vanderbilt wanted an English manner style estate. Olmsted argued that the land would be better suited to have a grand garden area close to the house, and have majestic views beyond it with 80,000 acres of the land being turned into a grand Forest, which became the basis for the Pisgah National Forest. Olmsted chose to fill the area with a variety of vegetation. It was a much celebrated design and won him praise from many horticulturists.

In late 1895 he suffered a mental breakdown and spent his remaining years resting in an Asylum in Waverly, Massachusetts. In August 1903 he died.

Not until 20 years later did people begin to realize the impact and grandness of Olmsted's work, and the vast wonders that he had left the world.

Figure 8.2 Informal design in eighteenth-century England.

of elements and spaces that have functional and visual *harmony* and create meaningful experiences for the people using them.

How is it put together?

Several factors link the landscape architecture of the past and present. These include *the function of the design, the people for whom the spaces are created*, and *the influences of the particular site and its surroundings*. In addition, the compositional elements of unity, scale, time, space and mass, light and shade, and texture and color persist in landscape architecture.

Space

The landscape designer assumes an intermediary role between the client and the eventual users of the space or spaces he or she creates. *Space*,

then, is a basic medium of landscape design. It can take its form from the arrangement of living walls of plants, from concave or convex land forms, from structural walls of brick or concrete, or from buildings. The floor of the space and the overhead plane of sky or tree canopy form the other units of spatial definition.

Intent

An important aspect of space is its character, or quality. *Character* refers to the *intent* of the designer to create a landscape whose elements are harmonious and unified and support intended functions and experiences. For example, the spatial character of an area designed to support quiet park activities might use natural colors and textures, flowing landforms, indigenous plants, curving forms, lines and spaces, and soothing sounds. In addition, the *scale*, or size, of the elements and spaces, if appropriate to humans, may create a

feeling of intimacy rather than of grandeur or monumentality.

Sequence

Another basic consideration in landscape design is *time and space*, or *sequence*. Sequence involves movement through space and movement from space to space. Designers can control a desired response by the way they organize this movement. Spaces can be connected in sequential movement up or down, from narrow to wide, from closed to open, from large to small, or in controlled random movement, depending on the function and experiences desired.

Within a given space, landscape designers can create light or dark spaces depending on the *density*, mass, texture, and color of the enclosing elements. In addition, they can induce sequential movement through space by contrasting dark with light, shade with sun, and so forth, in their design of spaces.

The Floor

In most landscape design the *floor* of the space becomes a basic organizational element. The floor contains the walks or roads that define movement, and the linear qualities of these arteries—free flowing or rigid and straight—form the backbone of spatial function and our experience of the designed spaces.

The Design Process

The Client

The process of designing outdoor spaces can be thought of as including three phases. Phase one is the analysis of the client's program of functions to determine their interrelatedness and how they should be organized in a logical sequence. The design of a shopping area, for example, would consider the main entry drive leading to the parking area near the stores, an area close to the stores for pickup of passengers, a walk from the parking area to the stores, and so forth. The designer must consider the logic of the sequence as well as ensuring that the change from driver to pedestrian is a safe yet pleasant experience.

The Site

Second, the site and its surroundings must be analyzed. This entails looking at the natural or deliberately constructed landscape and its existing character to determine whether it is strong enough to manifest itself in the design character to be established. In the case of a rugged, mountainous area with craggy, steep slopes, angular forms, and heavy natural forests, the designer can complement these qualities with the form, materials, textures, and colors he or she uses in the design. Or the designer can use delicate curving forms, smooth textures, and vivid colors as a contrast with the natural backdrop, creating a foil that enhances both what exists and what is designed (Fig. 8.3). Other aspects of the site that the landscape designer must consider include views into and from the site; the climatic influences of sun and wind exposure to determine orientation; and the topographic limitations or potentials of the site.

Synthesis

Having analyzed these factors, the landscape architect *synthesizes* the functions with the site and produces the final three-dimensional form.

How does it stimulate the senses?

The analysis of how a landscape design is synthesized does not consist merely of an explanation of the factors we have mentioned. Landscape architecture is a space-time experience that includes people as participants. Therefore, readers must project themselves into space and time and

Figure 8.3 Frank Lloyd Wright, Kaufmann House, "Falling Water," Bear Run, Pennsylvania, 1936-37.

become a participant in the spaces. The effects of landscape design on the senses can then become more meaningful and understandable.

Formality

Villa Lante, created in 1564 for a wealthy cardinal, is an excellent example of formal symmetrical design (Figs. 8.4-8.8). Set outside Rome, the villa served as a summering place where one could escape the heat of the city. It was sited on a hillside so it could capture welcome breezes.

The designer's inheritance of the time was *formal composition*, an arrangement that tends to express and emphasize human will by announcing clear order and the relationship of parts in achieving unity and balance. The relationship of the design to the hillside is crisply delineated vertically and horizontally by dividing the hillside into four specific levels that are separated twice by vertical walls and twice by clearly defined geometric shapes.

A single, dominant centerline forms the spine of the design, but almost without exception one

Baroque Style in Landscape Architecture

The term "baroque" (pronounced buh-ROHK) originally referred to a large, irregularly shaped pearl of the kind often used in the extremely fanciful jewelry of the post-Renaissance period, and the art of the baroque period of 1600 to 1750 was luscious, ornate, and emotionally appealing. It is a perfect example of an anti-classical style.

Baroque style appealed both to the emotions and to a desire for magnificence through opulent ornamentation. At this time, realism (life-likeness using selected details) replaced beauty as the objective for visual art. Color and grandeur were emphasized, as was dramatic use of light and shade (chiaroscuro). In much of baroque art, sophisticated organizational schemes carefully subordinate and merge one part into the next to create a complex but unified whole. Open composition symbolizes the notion of an expansive universe: The viewer's eye travels off the canvas to a wider reality. The human figure, as an object or focus in painting, could be monumental, but it could also now be a miniscule figure in a landscape, part of, but subordinate to a vast universe. Landscape architecture, a fundamental expression of the style, could take hundreds and thousands of acres and turn them into a visual composition of overwhelming proportion.

Like its cousin of the nineteenth century, Romanticism, the Baroque style exalted intuition, inspiration, and the genius of human creativity as reactions against the rationalistic classicism of Renaissance and High Renaissance styles.

Having said that, however, we must caution that Baroque art was also diverse and pluralistic. Its artistic expressions do not conform to a simple mold.

As we noted, the baroque style in landscape architecture, as in architecture itself, emphasized contrasts between light and shade with the same action, opulence, and ornamentation as the other arts of the period. Because of their scale, however, the effect was one of intense dramatic spectacle.

The grounds of baroque palaces—for example, Villa Lante (Figs. 8.4-8.8), the portion of Hampton Court Palace designed by Christopher Wren (Fig. 9.24), and Versailles (Figs. 9.26 and 9.31)—had grounds adorned with fountains and statues. At Versailles, the magnificent Fountain of Apollo by Tuby sits astride the east-west axis of the grounds and was originally covered with gold. This particular landscape application was an allegorical glorification of King Louis XIV, representing the break of day, as the sun-god rises in his chariot from the waters.

The formal landscape design of Hampton Court (Fig. 9.28) illustrates the monumental and yet intricate character of landscape design in the baroque style. Careful arrangement and shaping of plant material and trees, interlaced with walkways and open lawns, results in an immense composition of complex color, texture, and shape. Each individual part has its own design integrity, and each small segment can be responded to. Yet each contributes in a systematically rational way to the entire effect.

cannot walk along it. Consequently, one views the central focal points on a diagonal, which yields far less awareness of the overall symmetry. In most cases the strongest organizational factor of landscape design is the path or road system that guides people through space.

The first level of the villa (Fig. 8.4), near a village, is monumental in scale and is well juxtaposed with the adjoining buildings in the composition. The gate and broad expanse of the floor of the space are conventions used to create the relationship of *scale* between humans and the space. The gate also creates a transition from the village to the villa. The pool and fountain begin to set the theme of a summering place and to complement the red and green colors of the garden beds. The chromatic effects are subdued. The water becomes a definite link between the various levels of the design, and this repetition of an element also helps to create unity.

Looking in the other direction up the hill (Fig. 8.5), we find two twin structures tucked into the base of the slope. This architectural treatment creates a strong definition between the hillside and the level plane. In addition, it narrows the space to form an entry, which emphasizes movement up the hill. Sloping planes of lawn lead to the second level.

The second level (Fig. 8.6) has a fountain as a *focal point* along the centerline axis and introduces sound as a part of the experience. In addition, the design incorporates an overhead canopy of trees to create a more intimate scale and to introduce a change from the light, open space below. Moving into and through the space, one becomes more aware of and comes into closer contact with the textural qualities of the materials of the design.

The third level (Fig. 8.7) is reached by a set of stairways, and again the convention of

Figure 8.4 Formal symmetry in landscape design. Villa Lante, Rome, First level.

Figure 8.5 Villa Lante.

Figure 8.6 Villa Lante.
Second level.

Figure 8.7 Villa Lante. Third level.

a focal area in the center of the space is used. The long basin gives added depth to the illusion of perspective. Space encloses more, water continues, space modulates in size and feeling between levels, and our attention is drawn upward.

Above this level is a sloping cascade of water that directs our attention to yet another focal point, which in turn leads to a backdrop in the wooded hillside (Fig. 8.8). This progression of space also must be viewed and experienced as one moves in the opposite direction, down to the open terrace below. The water, which begins in

a natural grotto, eventually finds itself in the quiet basin below. The downward progression allows for looking down and across the town, and the spaces continually open up to reveal the countryside. This movement from beginning to end in landscape design is planned as such, it does not just happen.

Informality

Let's look now at a pleasure garden designed in the 1960s in Montreal, Canada (Figs. 8.9–8.12). The finished design was to be primarily a

Figure 8.8 Villa Lante.

sensory experience. The design expresses *informality*. Focal points are introduced on an informal axis, a walkway, but not on any centerline of vision. They are casually dispersed, but controlled. Water, plants, and natural elements dominate the design. The scale is decidedly intimate: The designer puts us in close contact with the textures, sounds, and colors of nature.

The view in the illustration (Fig. 8.9) is not seen as one enters the space of the design, but attention is drawn to this part of the garden by its sounds. The experience of this part of the garden sets the theme for what is to occur as one moves through the sequence. The plants introduce a play of shade and shadow, darks and lights, and all elements seem in harmony with one another.

Movement through the space changes gradually, and at times the walls seem alive (Fig. 8.10). The axis of the design is informal and moves us at a casual pace. The walkway through the garden is designed at points to reinforce the slow pace and informality so as to encourage close union with the elements. Plants are used as accents and masses throughout the composition. Openings focus attention or allow the eye to explore the effects that have been created (Fig. 8.11). Very little use of color is made; earth tones, grays, and greens dominate and unify the composition and our experience of it. The spatial qualities and the character of the design are easily perceived in its theme, and the cadence of movement supports the sensory experience.

Figure 8.9 Informality in landscape design. Garden, Place Bonaventure, Montreal, Canada. Architects: Sasaki, Dawson, DeMay Associates. Quebec Government House.

The final point of focus is contained in a larger space with a major backdrop of greenery and architecture (Fig. 8.12). One could easily compare this part of the garden to a painted landscape with foreground, middle ground, and background. Turning back in the sequence, one would find it hard to imagine this rooftop garden surrounded by hotel rooms and lobbies.

Composition

In both Villa Lante and the garden in Place Bonaventure, *focal points* are distributed along a sequence. Moreover, *spatial size* is varied in both designs, and there are similarities in the use of

materials. The opening and closing of space, the use of overhead planes, shade and shadows, and darks and lights, and emphasis on contact with sound and texture are realized in each design. However, the garden exhibits no obvious order or pattern and is continuously intimate in scale, whereas the villa contrasts monumentality with intimacy, for emphasis.

Function

The sculpture in Figure 8.13 identifies a playground space designed in Washington, D.C., in the 1960s (Figs. 8.14–8.17). The client was a government body. The site was near an urban

school. The goal was to provide for recreational needs of various age groups in a densely populated area where daily access to large attractive state parks miles away is impossible. A playground at this site would provide facilities where they were needed and be accessible on a daily basis. The potential users of the space spent most of their recreational energy on sidewalks, in streets, and on vacant lots. Fulfilling a social function, therefore, was the major consideration in this design.

The urban setting, with its familiar rectangular forms and concrete, brick, wood, and steel materials, represented an existing environmental character that would give substance and form to the final design (Fig. 8.14) To meet the requirements of providing activities for various age groups on a small site, different levels were

Figure 8.10 Garden, Place Bonaventure.

Figure 8.11 Garden, Place Bonaventure. Quebec Government House.

provided for different spaces; walks and steps serve as transitions between spaces (Fig. 8.15). The steps also function as places from which to observe the various activities. The older group can enjoy basketball, the younger group the play-apparatus area, and families or other groups picnics or seating under the shade of the roof. These uses are compatible with one another. Moreover, the spaces are close to one another so a variety of experiences can be enjoyed and are sequenced for easy movement from one to the next. The organization is decidedly informal: It reflects free movement and choice, in direct contrast with the walks and streets that govern most experiences in the city.

The use of *scale* in the design—that is, the use of spaces and objects appropriate to the size and age of the persons using them—creates *harmony*

between the playground and its users (Fig. 8.16). Children can easily orient themselves to space and objects. They are not awed by their size, but rather are invited to carry on their activities because the designer's use of scale adds to the experience of the space and enhances relationships among user, objects, and spaces.

We might characterize the design quality of the space in this playground as one of dynamic action (Fig. 8.17). The solid materials of stone, concrete, wood, and steel, the forms of varying height, the texture and colors, the play of horizontal, vertical, and angled lines and forms, the variety of enclosed and open space, the play of shade and shadows and of dark and light areas—all embody the designer's expression and composition, support human usage, and provide sensual pleasure.

SUMMARY

A landscape design comes from the analysis of the client's expressed needs, the users, the site, and its environment. Reason and intuition combine to create functional spaces and at the same time exhibit an artist's appreciation for the use of artistic elements to create not only unity and harmony among geometric forms but also functional and visual variety and interest. The result is a stimulation of a *predetermined response from the user.*

All the factors, then—space and time, people, functions and experiences, site and surroundings, plus the designer's sensitivity to creating appropriate design qualities—are interrelated. Landscape design is unique in that it can stimulate the senses only by the full participation of the "audience" in the use of its spaces. A person's reaction to the various stimuli in the landscape can encourage active or passive participation. The medium of space—the elements constituting its boundaries or existing within it—create the atmosphere for reaction. Large open spaces can produce fright unless a scale suitable to humans is used. Dark, poorly lit, narrow spaces can cause one to hurry ahead to the relief of an area open to the sky. Active forms and bright colors can stimulate playful participation. Horizontal forms and planes, curving

Figure 8.12 Garden, Place Bonaventure.

Figure 8.13 Sculpture at site of playground illustrated in Figures 8.14–8.17.

lines and spaces, the dappled shade of a tree, the warmth of the sun, and quiet natural colors can combine to create a feeling of relaxation. Dynamic forms, bold colors, elements in motion, looping paths, the sounds of voices, music, and water, intersecting planes, and large and small spaces, apparently unorganized—all can stimulate the senses and create the setting for yet another type of experience.

Landscape designers usually try to stimulate a predetermined response by their organizational pattern, definition of form and spaces, use of lines, textures, and scale, and choice of natural or synthetic materials. They are responsible for functional as well as sensual qualities. However, the true test of landscape design rests with the people who use and experience the space.

CHRONOLOGY OF SELECTED WORKS FOR ADDITIONAL STUDY

1000–1600

Alhambra and Generalife, Granada
Villa Medici, Rome
Villa D'Este, Tivoli

1600–1800

Vaux-le-Vicomte, Melun, France. Le Nôtre.
Versailles, France. Le Nôtre.
Hampton Court, London. Wren.
Villa Balbianello, Lake Como, Italy.

1800–1900

Birkenhead Park, Near London. John Paxton.
Central Park, New York City. Olmsted and Vaux.

1900–2000

Biltmore Estate, Asheville, North Carolina. Olmsted
Mellon Square, Pittsburgh. Simonds and Simonds.
Constitution Plaza, Hartford. Sasaki, Dawson, DeMay Associates
Copley Square, Boston. Sasaki, Dawson, DeMay Associates
Ghirardelli Square, San Francisco. Lawrence Halprin and Associates

Figure 8.14 Function in landscape design. Playground, Washington, D.C. Designer: M. Paul Friedberg.

Figure 8.15 Playground, Washington, D.C.

Figure 8.16 and **Figure 8.17** Playground, Washington, D.C.

Architecture

Every street in our towns represents a museum of ideas and engineering. The houses, churches, and commercial buildings we pass every day reflect appearances and techniques that may be as old as the human race itself. We go in and out of these buildings, often without notice, and yet they engage us and frequently dictate actions we can or cannot take.

In approaching architecture as an art, it is virtually impossible for us to separate aesthetic properties from practical or functional properties. In other words, architects first have a practical function to achieve in their buildings, which is their principal concern. The aesthetics of the building are important, but they must be tailored to overall practical considerations. For example, when architects set about to design a 110-story skyscraper, they are locked into an aesthetic form that will be vertical rather than horizontal in emphasis. They may attempt to counter verticality with strong horizontal elements, but the physical fact that the building will be taller than it is wide is the basis from which the architects must work.

Their structural design must take into account all the practical needs implicit in the building's use. Nonetheless, considerable room for aesthetics remains. Treatment of space, texture, line, and proportion can give us buildings of unique style and character or buildings of unimaginative sameness.

Architecture often is described as the art of sheltering. To consider it as such we must use the term *sheltering* very broadly. Obviously there are types of architecture within which people do not dwell and under which they cannot escape the rain. Architecture encompasses more than buildings. So, we can consider architecture as the art of sheltering people both physically and spiritually from the raw elements of the unaltered world.

What is it?

As we noted, architecture can be considered the art of sheltering. In another large sense, it is the design of three-dimensional space to create

practical enclosure. Its basic forms are residences, churches, and commercial buildings. Each of these forms can take innumerable shapes, from single-family residences to the ornate palaces of kings to high-rise condominiums and apartments. We also could expand our categorization of architectural forms to include bridges, walls, monuments, and so forth.

How is it put together?

In examining how a work of architecture is put together we limit ourselves to ten fundamental elements: structure, materials, line, repetition, balance, scale, proportion, context, space, and climate.

Structure

There are many systems of construction or systems of structural support. We deal with only a few of the more prominent. *Post-and-lintel*, *arch*, and *cantilever* systems can be viewed, essentially, as historical systems. Contemporary architecture, however, can better be described by two additional terms, which to some extent overlap the others. These contemporary systems are *bearing-wall* and *skeleton frame*.

Post-and-Lintel

Post-and-lintel structure (Figs. 9.1–9.4) consists of horizontal beams (lintels) laid across the open spaces between vertical supports (posts). In

Figure 9.1 Stonehenge, Salisbury Plain, England (c. 1800–1400 B.C.). British Information Services photo.

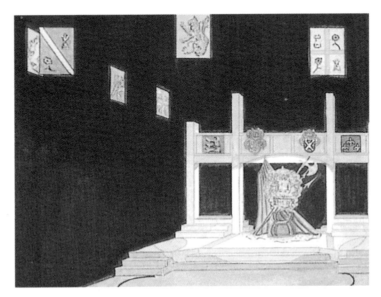

Plate 15 A thrust setting for Shakespeare's *King John*, University of Illinois at Chicago. Director: H. Don Dickenson. Scene and lighting designer: Dennis J. Sporre.

Plate 18 Dancers of the Joffrey Ballet rehearse with choreographer Gerald Arpino to achieve desired line and form. (© Migdoll).

Plate 19 Formal gardens of Middleton Place, Charleston, South Carolina, a restored plantation of the Old South. They were laid out in 1741 by Henry Middleton, president of the first Continental Congress, and are the oldest landscaped gardens in the United States. (Courtesy Middleton Place, S.C.)

Plate 20 Giovanni Paolo Panini (Roman, 1691–1765), *Interior of the Pantheon, Rome* (c. A.D. 1734). Oil on canvas, 50½″ × 39″; framed: 56¾″ × 45″. 1995 Board of Trustees, National Gallery of Art, Washington, D.C. Samuel H. Kress Collection. Photo by Richard Carafelli.

Plate 21 Renzo Piano and Richard Rogers, Pompidou Center, Paris, 1971–78. Spectators in plaza near Pompidou Center can view unique architectural feature of engineering support appearing on exterior of structure. (Charles Kennard/Stock Boston)

Plate 22 Renzo Piano and Richard Rogers, Pompidou Center, Paris, 1971–78. Escalator bearing passengers skyward in Pompidou Center. (David Simpson/Stock Boston)

Plate 23 Charles Moore, Piazza d'Italia, New Orleans, 1978–79. (R. Pasley/Stock Boston)

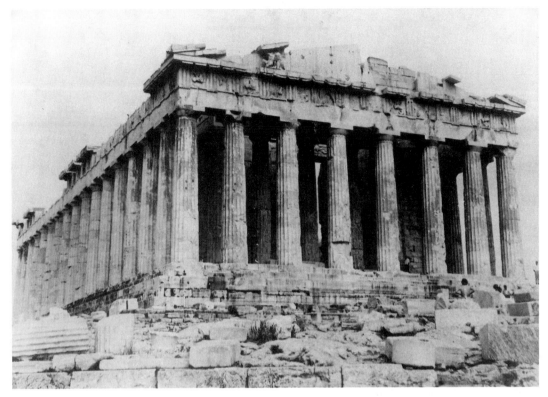

Figure 9.2 The Parthenon, Acropolis, Athens (448-432 B.C.). AC&R Relations photo.

this architectural system the traditional material is stone. Post-and-lintel structure is similar to *post-and-beam* structure, in which series of vertical posts are joined by horizontal members, traditionally of wood. The wooden members of post-and-beam structure are held together by nails, pegs, or lap joints.

Because of the lack of tensile strength in its fundamental material, stone, post-and-lintel structure is limited in its ability to define space. *Tensile strength* is the ability of a material to withstand bending. If we lay a slab of stone across an open space and support it only at each end, we can span only a narrow space before it cracks in the middle and falls to the ground. However, stone has great *compressive strength*—the ability to withstand compression or crushing.

A primitive example of post-and-lintel structure is Stonehenge, that ancient and mysterious religious configuration of giant stones in Great Britain (Fig. 9.1). The ancient Greeks refined this system to high elegance; the most familiar of their post-and-lintel creations is the Parthenon (Fig. 9.2). A more detailed view of this style and structure can be seen in Figures 9.3 and 9.4.

The Greek refinement of post-and-lintel structure is a *prototype* for buildings throughout the world and across the centuries. So it makes sense to pause to examine the Greek style in more detail. One of the more interesting aspects of the style is its treatment of columns and *capitals*. Figure 9.5 shows the three basic Greek orders: Ionic, Doric, and Corinthian. These, of

Architectural Classicism

The foundations of Western culture rest firmly on the bedrock of Classicism. These foundations were laid in Athens, Greece in the fifth century B.C. and then spread from India to the western edges of Europe and into Africa and the Middle East.

The term classicism generally denotes the ideals and styles of ancient Greece and Rome as embodied primarily in their arts. Almost universally, these ideals and styles have been translated into notions of simplicity, harmony, restraint, proportion, and reason.

Occasionally we describe arts history as a struggle between classical and anti-classical values and further describe that struggle as one between "form" on one hand and "feeling" on the other. A primary emphasis on "form"—that is, rationality, simplicity, and restraint—denotes classicism; appeals to emotion, complexity, and abandon—that is, "feeling"—denote anticlassicism. Classicism believes in the power of reason and searches for rational principles. Anti-classicism in its various styles promotes individualism and subjectivity.

Greek architecture of the fifth century B.C., specifically, Greek temples, (Figs. 9.2-9.5) offers a clear and consistent picture of the basic classical style, and the Parthenon (Fig. 9.2), in particular, provides a model we can find replicated in architecture as recently as today.

The Parthenon stands on the Acropolis at Athens, and it was the greatest temple built by the Greeks. Balance is achieved through geometric symmetry, and the clean simple lines represent a perfect balance of forces holding the composition together.

The Parthenon has short sides slightly less than half the length of the long sides. Its interior, or *naos*, which is divided into two parts, housed a 40-foot statue of the goddess Athena, the patron deity of Athens. The temple is *peripteral*—that is, surrounded by a single row of columns. The number of columns across the front and along the sides of the temple is determined by a specific convention. The internal harmony of the design rests in the regular repetition of virtually unvaried forms. All the columns appear alike and to be spaced equidistantly. But at the corners the spacing is adjusted to give a sense of grace and perfect balance, while preventing the monotony of unvaried repetition.

All the elements are carefully adjusted. A great deal has been written about the "refinements" of the Parthenon—those features that seem to be intentional departures from strict geometric regularity. According to some, the slight bulge of the horizontal elements compensates for the eye's tendency to see a downward sagging when all elements are straight and parallel. Each column swells toward the middle by about 7 inches (18 centimeters), to compensate for the tendency of parallel vertical lines to appear to curve inward. This swelling is known as *entasis*. The columns also tilt inward slightly at the top, in order to appear perpendicular.

Thus, in a single structure, the Parthenon exhibits the classical characteristics of convention, order, balance, simplicity, and grace.

Figure 9.3 The Nereid Monument, c. 400 B.C. The British Museum, London.

Figure 9.4 The Nereid Monument, c. 400 B.C. (roof detail). The British Museum, London.

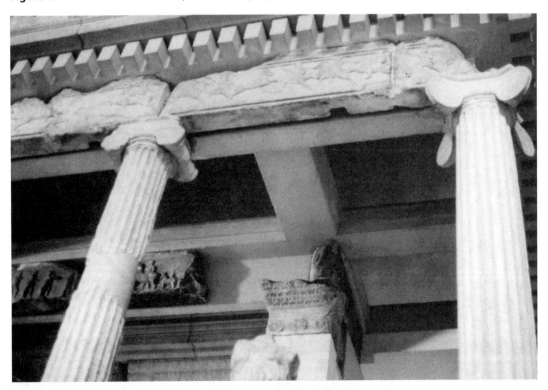

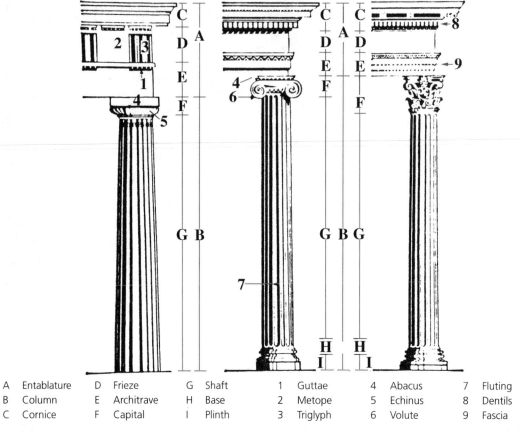

A	Entablature	D	Frieze	G	Shaft	1	Guttae	4	Abacus	7	Fluting
B	Column	E	Architrave	H	Base	2	Metope	5	Echinus	8	Dentils
C	Cornice	F	Capital	I	Plinth	3	Triglyph	6	Volute	9	Fascia

Figure 9.5 Greek columns and capitals: (left) Doric, (center) Ionic, (right) Corinthian. Calmann & King, Ltd.

Figure 9.6 Column capital, Central portal, Westminster Cathedral, London.

Figure 9.7 Column capital, Egypt (eighth century A.D.). The British Museum, London.

Columns also may express a variety of detail—for example, Figures 9.6 and 9.7. A final element, present in some columns, is *fluting*—vertical ridges cut into the column (Fig. 9.4).

Arch

A second type of architectural structure is the arch. As we indicated earlier, post-and-lintel structure is limited in the amount of unencumbered space it can achieve. The arch, in contrast, can define large spaces because its stresses are transferred outward from its center (the *keystone*) to its legs. So it does not depend on the tensile strength of its material.

There are many different styles of arches, some of which are illustrated in Figure 9.8. The characteristics of different arches may have structural as well as decorative functions.

The transfer of stress from the center of an arch outward to its legs dictates the need for a strong support to keep the legs from caving outward. Such a reinforcement is called a *buttress*

course, are not the only styles of post-and-lintel structure. Column capitals can be as varied as the imagination of the architect who designed them. Their primary purpose is to act as a transition for the eye as it moves from post to lintel.

Figure 9.8 The Arch. *A.* Round (Roman) arch. *B.* Horseshoe (Moorish) arch. *C.* Lancet (pointed, Gothic) arch. *D.* Ogee arch. *E.* Trefoil arch. *F.* Tudor arch.

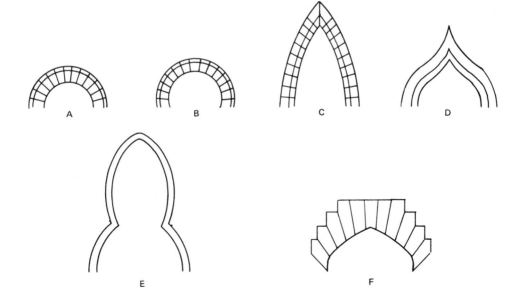

Figure 9.9 Buttress.

Figure 9.10 Flying buttresses.

(Fig. 9.9). The designers of Gothic cathedrals sought to achieve a sense of lightness. Because stone was their basic building material, they recognized some system had to be developed that would overcome the bulk of a stone buttress. Therefore, they developed a system of buttresses that accomplished structural ends but were light in appearance. These structures are called *flying buttresses* (Fig. 9.10).

Arches placed back to back to enclose space form a *tunnel vault* (Fig. 9.12). Several arches placed side by side form an *arcade* (Fig. 9.11).

Figure 9.11 Arcade.

Figure 9.12 Tunnel vault.

Figure 9.14 Ribbed vault.

When two tunnel vaults intercept at right angles, as they do in the floor plan of the traditional Christian cathedral, they form a *groin vault* (Fig. 9.13). The protruding masonry indicating diagonal juncture of arches in a tunnel vault or the juncture of a groin vault is *rib vaulting* (Fig. 9.14).

When arches are jointed at the top with their legs forming a circle, the result is a *dome* (Fig. 9.15). The dome, through its intersecting arches, allows for more expansive, freer space within the structure. However, if the structures supporting the dome form a circle, the result is a circular building such as the Pantheon (color insert, Plate 20). To permit squared space be-

neath a dome, the architect can transfer weight and stress through the use of *pendentives* (Fig. 9.16).

Cantilever

A *cantilever* is an overhanging beam or floor supported only at one end (Fig. 9.17). Although not a twentieth-century innovation—many nineteenth-century barns in the central and eastern parts of the United States employed it—the most dramatic uses of cantilever have emerged with the introduction of modern materials such as steel beams and prestressed concrete (Fig. 9.18).

Figure 9.15 Dome, St. Paul's Cathedral, London (1675–1710). British Tourist Authority.

Figure 9.13 Groin vault.

Figure 9.16 Dome with pendentives (P).

Bearing Wall

In the bearing-wall system, the wall supports itself, the floors, and the roof. Log cabins are examples of bearing-wall construction; so are solid masonry buildings, in which the walls are the structure. In variations of bearing-wall construction, such as Fig. 9.30, the wall material is continuous, that is, not jointed or pieced together. This variation is called *monolithic* construction.

Skeleton Frame

When a skeleton frame is used, a framework supports the building; the walls are attached to the frame, thus forming an exterior skin. When skeleton framing utilizes wood, as in house construction, the technique is called *balloon construction*. When metal forms the frame, as in skyscrapers, the technique is known as *steel cage construction*.

Building Materials

Historic and contemporary architectural practices and traditions often center on specific materials, and to understand architecture further, we need to note a few.

Stone

The use of stone as a material turns us back to post-and-lintel systems and Figures 9.1 through 9.4. When stone is used together with mortar, for example, in arch construction, that combination is called *masonry* construction. The most obvious example of masonry, however, is the brick wall, and masonry construction is based on that principle. Stones, bricks, or blocks are joined together with mortar, one on top of the other, to provide basic, structural, weight-bearing walls of a building, a bridge, and so forth (Fig. 9.19).

Figure 9.17 Cantilever.

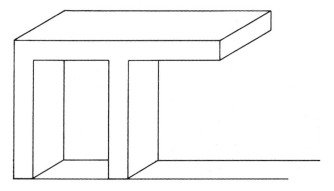

Figure 9.18 Grandstand, Zarzuela Race Track, Madrid (1935). Architect: Eduardo Torroja.

There is a limit to what can be accomplished with masonry because of the pressures that play on the joints between blocks and mortar and the foundation on which they rest. However, when one considers that office buildings such as Chicago's Monadnock Building (Fig 9.20) are skyscrapers and their walls are completely masonry

Figure 9.19 Masonry wall.

(that is, there are no hidden steel reinforcements in the walls), it becomes obvious that much is possible with this elemental combination of stone and mortar.

Concrete

The use of concrete is central to much contemporary architectural practice, but it was also significant as far back in the past as ancient Rome. The Pantheon (Plate 20) comprises a masterful structure of concrete with a massive concrete dome, 142 feet in diameter, resting on concrete walls 20 feet thick. In contemporary architecture, we find *precast* concrete, which is concrete cast in place using wooden forms around a steel framework. We also find *ferro-concrete* or *reinforced concrete*, which utilizes metal

Figure 9.20 Monadnock Building, Chicago, Illinois (1891). Architects: Burnam and Root.

reinforcing embedded in the concrete. Such a technique combines the tensile strength of the metal with the compressive strength of the concrete. *Prestressed* and *post-tensioned* concrete use metal rods and wires under stress or tension to cause structural forces to flow in predetermined directions. Both comprise extremely versatile building materials.

Wood

Whether in balloon framing or in laminated beaming, wood has played a pivotal role, especially in the United States. As new technologies emerge in making engineered beams from what

once was scrap wood, wood's continuation as a viable building product will probably remain—with less negative impact on the environment.

Steel

The use of steel comprises nearly endless variation and almost limitless possibilities for construction. Its introduction into the nineteenth-century industrial age forever changed style and scale in architecture. *Steel cage* construction and cantilever construction were noted earlier. *Suspension* construction in bridges, superdomes, aerial walkways, and so on, has carried architects to the limits of space spansion. The *geodesic dome* (Fig. 9.21) is a unique use of materials invented by an American architect, R. Buckminster Fuller. Consisting of a network of metal rods and hexagonal plates, the dome is a light, inexpensive, yet strong and easily assembled building. Although it has no apparent size limit (Fuller claims he could roof New York City, given the funds), its potential for variation and aesthetic expressiveness seems somewhat limited.

Line, Repetition, and Balance

Line and repetition perform the same compositional functions in architecture as in painting and sculpture. In his Marin County Courthouse (Fig. 9.22), Frank Lloyd Wright takes a single motif, the arc, varies only its size, and repeats it almost endlessly. The result, rather than being monotonous, is dynamic and fascinating.

Let's look at three other buildings. The main gate of Hampton Court Palace (Fig. 9.23), built in the English Tudor style around 1515 by Thomas Wolsey, at first appears haphazard to us because we seem to see virtually no repetition. Actually, this section of the palace is quite symmetrical, working its way left and right of the central gatehouse in mirror images. However, the myriad of chimneys, the imposition of the main palace, which is not centered on the main gate,

Frank Lloyd Wright

Frank Lloyd Wright (1867-1959) pioneered ideas in architecture far ahead of his time and became probably the most influential architect of the twentieth century. Born in Richland Center, Wisconsin, Wright grew up under strong influences of his clergyman father's love of Bach and Beethoven. He entered the University of Wisconsin at age 15, forced to study engineering because the school had no program in architecture.

In 1887 Wright took a job as a draughtsman in Chicago and, the next year, joined the firm of Adler and Sullivan. In short order Wright became Louis Sullivan's chief assistant. As Sullivan's assistant Wright handled most of the firm's designing of houses. Deep in debt, Wright moonlighted by designing for private clients on his own. When Sullivan objected, Wright left the firm to set up his own private practice.

As an independent architect, Wright led the way in a style of architecture called the Prairie school. Houses designed in this style have low-pitched roofs and strong horizontal lines reflecting the flat landscape of the American prairie. These houses also reflect Wright's philosophy that interior and exterior spaces blend together.

In 1904 Wright designed the strong, functional Larkin Building in Buffalo, New York, and in 1906 the Unity Temple in Oak Park, Illinois. Traveling to Japan and Europe, he returned in 1911 to build a house on his grandfather's farm, Taliesin, which is Welsh for "shining brow." In 1916 Wright designed the Imperial Hotel in Tokyo, floating the structure on an underlying sea of mud. As a consequence, when the catastrophic earthquake of 1923 occurred, the hotel suffered very little damage.

The Great Depression of the 1930s greatly curtailed new building projects, and Wright spent his time writing and lecturing. In 1932 he established the Taliesin Fellowship, a school in which students learned by working with building materials and problems of design and construction. In winter the school moved from Wisconsin to Taliesin West, a desert camp near Phoenix, Arizona.

The mid-1930s represented a period of intense creative output for Frank Lloyd Wright, and some of his most famous designs occurred during those years. Perhaps his most dramatic project, the Kaufmann House—Fallingwater—in Bear Run, Pennsylvania (Fig. 8.3) emerged in 1936-37 during this period. Another famous project was the S. C. Johnson and Son Administration Building in Racine, Wisconsin.

Two other significant buildings, among many, came later. The Solomon R. Guggenheim Museum (Fig. 9.33) began in 1942 with completion in 1957, and the Marin County Courthouse, California, followed over the period during 1957-63.

Wright's work was always controversial, and he lived a flamboyant life full of personal tragedy and financial difficulty. Married three times, he had seven children and died in Phoenix, Arizona on April 9, 1959.

Figure 9.21 Geodesic dome. Climatron, St. Louis, Missouri (1959). Architect: R. Buckminster Fuller. Wayne Andrews/Esto Photographics, Inc.

Figure 9.22 Marin County Courthouse, California (1957–1963). Architect: Frank Lloyd Wright. Ezra Stoller/Esto Photographics, Inc.

Figure 9.23 Hampton Court Palace, England. Tudor entry (c. 1515).

and our own vantage point cause an apparent clutter of line and form that prompts our initial reaction. Line and its resultant form give Hampton Court Palace the appearance of a substantial castle.

Although it seems impossible, Figure 9.24 is the same Hampton Court Palace. Figure 9.23 reflects the style and taste of England during the reign of Henry VIII (who appropriated the palace from its original owner, Cardinal Wolsey). Later monarchs found the cumbersome and primitive appearance unsuited to their tastes, and Christopher Wren was commissioned to plan a new palace. So, in 1689, in the reign of William and Mary, renovation of the palace proper began. The result was a new and classically oriented facade in the style of the English baroque.

As we can see in Figure 9.24, Wren has designed a sophisticated and overlapping system of repetition and balance. Note first that the facade is symmetrical. The outward wing at the far left of the photograph is duplicated at the right (but not shown in the photo). In the center of the building are four attached columns surrounding three windows. The middle window forms the exact center of the design, with mirror-image repetition on each side. Now note that above the main windows is a series of relief sculptures, pediments (triangular casings), and circular windows. Now return to the main row of windows at the left border of the photo and count toward the center. The outer wing contains four windows; then seven windows; then the central three; then seven; and finally the four of the unseen outer wing. Patterns of threes and sevens are very popular in architecture and carry religious and mythological symbolism. Wren has established a pattern of four in the outer wing three in the center, and then repeated it within each of the seven-window groups to create yet three

Figure 9.24 Hampton Court Palace, England. Wren façade (1689).

additional patterns of three! How is it possible to create four patterns of three with only seven windows? First, locate the center window of the seven. It has a pediment and a relief sculpture above it. On each side of this window are three windows (a total of six) without pediments. So, we have *two* groupings of three windows each. Above each of the outside four windows is a circular window. The window on each side of the center window does not have a circular window above it. Rather, it has a relief sculpture, the presence of which joins these two windows with the center window to give us our third grouping of three. Line, repetition, and balance in this facade form a marvelous perceptual exercise and experience.

Buckingham Palace (Fig. 9.25) and the Palace of Versailles (Fig. 9.26) illustrate different treatments of line and repetition. Buckingham Palace uses straight line exclusively, with repetition of rectilinear and triangular form. Like Hampton Court Palace, it exhibits *fenestration* groupings of threes and sevens, and the building itself is symmetrically balanced and divided by three pedimented, porticolike protrusions. Notice how the predominantly horizontal line of the building is broken by the three major pediments and given interest and contrast across its full length by the window pediments and the verticality of the attached columns.

Contrast Buckingham Palace with the Palace of Versailles, in which repetition occurs in groupings of threes and fives. Contrast is provided by juxtaposition and repetition of curvilinear line in the arched windows and baroque statuary. Notice how the horizontal line of the building,

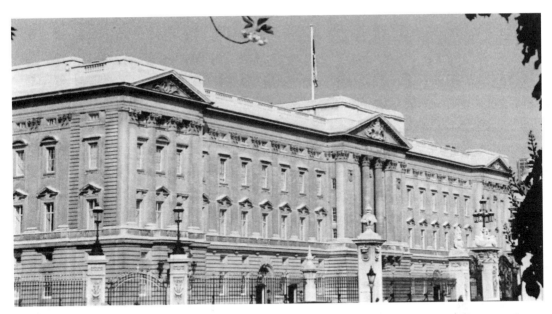

Figure 9.25 Buckingham Palace, London. British Tourist Authority.

Figure 9.26 Palace of Versailles, France (1669–1685). Architects: Louis LeVau and Jules Hardouin-Mansart. Pan American World Airlines, Inc.

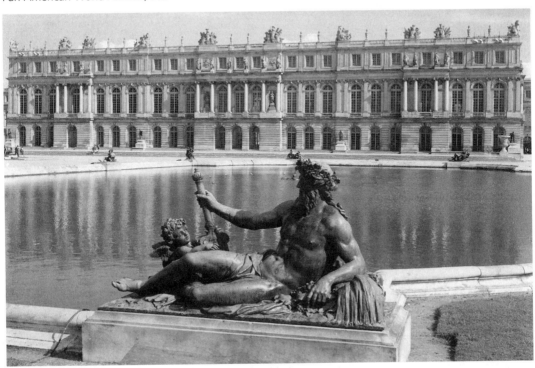

despite three porticoes, remains virtually un-disturbed, in contrast with Buckingham Palace.

Scale and Proportion

The mass, or *scale*, and proportion of a building and its component elements are very important compositional qualities. Scale refers to the build-ing's size and the relationship of the building and its decorative elements to the human form.

Proportion, or the relationship of individual elements in a composition to each other, also plays a role in the overall analysis and appear-ance of a design. Let's step outside architecture for a familiar example. The Concorde superson-ic airliner appears to be a rather large plane when we view it on the movie screen or on tele-vision. Yet if we were to see the plane in actual-ity, we would be surprised to find that it is not particularly large—in comparison with a DC-10, a Boeing 747, or even a Boeing 757. The proportion of the Concorde's window area to its overall size is misleading when we see the plane out of context with the human body. The Con-corde's windows are very small, much smaller than in other airliners. So when we see the Con-corde in a newsreel we immediately equate the window size with which we are familiar with the windows in the Concorde. We assume the rela-tionship or *proportion* of window size to overall fuselage is conventional, and that assumption gives us a larger-than-actual image of the size of the plane. In terms of architecture, proportion and scale are tools by which the architect can create relationships that may be straightforward or deceptive. We must decide how these ele-ments are used and to what effect. In addition, proportion in many buildings is mathematical: The relationships of one part to another often are based on ratios of three to two, one to two, one to three, and so on, as were the parts of the chest of drawers discussed in Chapter 1. Dis-covering such relationships in buildings is one of the fascinating ways in which we can respond to architecture.

Context

An architectural design must take into account its context, or environment. In many cases con-text is essential to the statement made by the de-sign. For example, Chartres Cathedral (Fig. 9.27) sits at the center of and on the highest point in the village of Chartres, France. Its placement at that particular location had a purpose for the me-dieval artisans and clerics responsible for its de-sign. The centrality of the cathedral to the community was an essential statement of the centrality of the church to the life of the me-dieval community. Context also has a psycho-logical bearing on scale. A skyscraper in the midst of skyscrapers has great mass but does not appear as massive in scale when overshadowed by another, taller skyscraper. A cathedral, when

Figure 9.27 Exterior, *Chartres Cathedral,* France (1145–1220). Photo Lauros/Giraudon, Art Resource, N.Y.

Postmodern Architecture

Discourses about postmodernism raise issues that resist easy conclusions. Advocates for postmodernism harshly criticize traditional culture, theory, and politics, and detractors from postmodernism—that is, the defenders of modernism—respond that postmodernism is a passing fad, a specious invention of self-seeking intellectuals, or an attempt to devalue the liberating theories and values of modernism.

In fact, there is no unified postmodern theory, or even a set of coherent positions. Rather, we find great diversity among theories often lumped together as postmodern and a great plurality—often contradictory—among postmodern positions. We certainly do not have the space here to trace the issues in depth, but we must, at least, acknowledge them up front.

Postmodern theorists claim that in contemporary high tech media society, emergent processes of change and transformation are producing a new "postmodern" society that constitutes a novel state of history and novel socio-cultural formation which requires new concepts and theories. "Postmodernism" would describe those diverse aesthetic forms and practices which come after and break with modernism. The debate centers on whether there is or is not a sharp conceptual distinction between modernism and postmodernism and the relative merits and limitations of these movements.

Therefore, postmodernism begins with a loss of faith in the dreams of modernism (the mindset that emerged during the Enlightenment of the eighteenth century, an optimistic faith in the idea that the methodology of science could lead to meaningful understanding of people). Postmodernism, however, does not suggest anything to replace modernism. Rather, it invents a new and evolving language with words such as "metaphorical structuring," "deconstruction," and "metanarrative."

Postmodern, or "revisionist," architecture takes past styles and does something new with them. Postmodern architects derive much of their architectural language from the past, taking—as Spanish architect Ricardo Bofill (BOH-feel) remarked—"without copying, different themes from the past, but in an eclectic manner, seizing certain moments in history and juxtaposing them, thereby prefiguring a new epoch."

Postmodern architecture focuses on meaning and symbolism, and it embraces the past. The postmodernist seeks to create buildings "in the fuller context of society and the environment." Function no longer dictates form, and ornamentation is acceptable. The goals of postmodern architecture are social identity, cultural continuity, and sense of place.

We can see a clear repudiation of the glass and steel box of the International Style and other popular forms in mainstream architecture, as represented by the Sears Tower (Fig. 9.34) in the design of the Pompidou Center in Paris (Plates 21 and 22), with its color-coded, externalized structure, and the highly colorful Piazza d'Italia (Plate 23).

compared with a skyscraper, is relatively small in scale. However, when standing at the center of a community of small houses, it appears quite the opposite.

Two additional aspects of context concern the design of line, form, and texture relative to the physical environment of the building. On one hand, the environment can be shaped according to the compositional qualities of the building. Perhaps the best illustration of that principle is Louis XIV's palace at Versailles, whose formal symmetry is reflected in the design of thousands of acres around it. On a more modest scale, the formal gardens of Hampton Court (Fig. 9.28) reflect the line and form of the palace.

In contrast, a building may be designed to reflect the natural characteristics of its environment. Frank Lloyd Wright's *Falling Water* (Fig. 8.3) illustrates this principle. Such an idea has been advanced by many architects and can be seen especially in residences in which large expanses of glass allow us to feel a part of the outside while we are inside. The interior decoration of such houses often takes as its theme the colors, textures, lines, and forms of the environment surrounding the home. Natural fibers, earth tones, delicate wooden furniture, pictures that reflect the surroundings, large open spaces—together they form the core of the design, selection, and placement of nearly every item in the home, from walls to furniture to silverware. Sometimes a building seems at odds with its context. Situated in the middle of historic Paris near the old marketplace, Les Halles, the Pompidou Centre (color inserts, Plates 21 and 22), an art museum whose brightly painted infrastructure appears on the outside of the building, seems out of place beside its more ancient neighbors.

Space

It seems almost absurdly logical to state that architecture must concern space—for what else, by definition, is architecture? However, the world is overwhelmed with examples of architectural design that have not met that need. Design of space essentially means the design and flow of contiguous *spaces* relative to function. Take, for example, a sports arena. Of primary concern is the space necessary for the sports intended to occupy the building. Will it play host to basketball, hockey, track, football, or baseball? Each of these sports places a design restriction on the architect, and there may be curious results when functions not intended by the design are forced into its parameters. When the Brooklyn Dodgers moved to Los Angeles, they played for a time in the Los Angeles Coliseum, a facility designed for the Olympic games and track and field and reasonably suited for the addition of football. However, the imposition of baseball created ridiculous effects; the left-field fence was only slightly over 200 feet from home plate!

In addition to the requirements of the game, a sports arena must also accommodate the requirements of the spectators. Pillars that obstruct the spectator's view do not create goodwill and the purchase of tickets. Likewise, attempting to put more seats in a confined space than ought to be there can create great discomfort. Determining where to draw the line between more seats and fan comfort is not easy. The old Montreal Forum, in which anyone over the height of 5 feet 2 inches was forced to sit with the knees under the chin, did not prove deleterious to ticket sales for the Montreal Canadiens hockey team. However, such a design of space might be disastrous for a franchise in a less hockey-oriented city.

Finally, the design of space must concern the relationship of various needs peripheral to the primary functions of the building. Again, in a sports arena the sport and its access to the spectator are primary. However, the relationship of access to spaces such as rest rooms and concession stands must also be considered. I once had season basketball tickets in an arena seating 14,000 people in which access to the *two* concession stands required standing in a line that,

Figure 9.28 Three views of formal landscaping. Hampton Court Palace, England.

because of spatial design, intersected the line to the rest rooms! If the effect was not chaotic, it certainly was confusing, especially at half time of an exciting game.

Climate

Climate always has been a factor in architectural design in zones of severe temperature, either hot or cold. As the world's energy supplies diminish, this factor will grow in importance. In the temperate climate of much of the United States, solar systems and designs that make use of the moderating influence of the earth are common. These are *passive* systems—that is, their design accommodates natural phenomena rather than adding technological devices such as solar collectors. For example, in the colder sections of the United States a building can be made energy efficient by being designed with no glass, or minimal glass, on its north-facing side. Windows facing south can be covered or uncovered to catch existing sunlight, which even in midwinter provides considerable warmth. Also, because temperatures at the shallow depth of 3 feet below the earth's surface rarely exceed or go below 50 degrees regardless of season, the earth presents a gold mine of potential for design. Houses built into the sides of hills or recessed below the earth's surface require much less heating or cooling than those standing fully exposed—regardless of climate extremes. Even in zones of uniform and moderate temperature, climate is a design factor. The "California lifestyle," as it often is known, is responsible for design that accommodates easy access to the out-of-doors, and large, open spaces with free-flowing traffic patterns.

How does it stimulate the senses?

As should be clear at this point, our sensual response to a form of aesthetic design is a composite experience. To be sure, the individual characteristics we have discussed previously are the stimuli for our response. Lately, color has become an important tool to the postmodern architect in stimulating our sense responses. The effects of color in the Plaza d'Italia (color insert, Plate 23) turn architecture into an exotic sensual experience.

Controlled Vision and Symbolism

The Gothic cathedral has been described as the perfect synthesis of intellect, spirituality, and engineering. The upward, striving line of the Gothic arch makes a simple yet powerful statement of medieval people's striving to understand their earthly relation to the spiritual unknown. Even today the simplicity and grace of that design have an effect on most who view a Gothic cathedral. Chartres Cathedral (Figs. 9.27 and 9.29), unlike the symmetry of other gothic churches, has an asymmetrical design, arising from the replacement of one of its steeples because of fire. The new steeple reflects a later and more complex Gothic style, and as a result impedes the eye as it progresses upward. Only after some pause does the eye reach the tip of the spire, the point of which symbolizes the individual's escape from the earthly known to the unknown.

Included in this grandeur of simple vertical line is an ethereal lightness that defies the material from which the cathedral is constructed. The medieval architect has created in stone not the heavy yet elegant composition of the early Greeks, which focused on treatment of stone, but rather a treatment of stone that focuses on space—the ultimate mystery. Inside the cathedral the design of stained glass kept high above the worshipers' heads so controls the light entering the cathedral that the overwhelming effect is, again, one of mystery. Line, form, scale, color, structure, balance, proportion, context, and space all combine to form a unified composition that has stood for seven hundred years as a prototype and symbol of the Christian experience.

Figure 9.29 Interior, Chartres Cathedral, France.

Style

The Christian experience is also the denominator of the design of the Holy Family Church (Fig. 9.30). However, despite the clarity of line and the upward striving power of its composition, this church suggests modern sophistication through its style, perhaps speaking more of our own conception of space, which to us is less unknowable and more conquerable, than seemed to our medieval predecessors. The juxtaposing of rectilinear and curvilinear line creates an active and dynamic response, one that prompts in us abruptness rather than mystery. The composition is cool, and its material calls attention to itself—to its starkness and to its lack of decoration.

Each part of the church is distinct and is not quite subordinate to the totality of the design.

This building perhaps represents a philosophy intermediate between the philosophy underlying the Chartres Cathedral, whose entire design can be reduced to a single motif—the Gothic arch—and the philosophy such as the baroque style, as seen in the Hall of Mirrors of the Palace of Versailles (Fig. 9.31). No single part of the design of this hall epitomizes the whole, yet each part is subordinate to the whole. Our response to the hall is shaped by its ornate complexity, which calls for detachment and investigation and intends to overwhelm us with its opulence. Here, as in most art, the expression and the stimuli reflect the patron. Chartres Cathedral reflects the medieval church, the Church of the Holy Family, the contemporary church, and Versailles, King Louis XIV. Versailles is complex, highly active, and yet warm. The richness of its textures, the warmth of its colors, and its curvilinear softness create a certain kind of comfort despite its scale and formality.

In the U.S. Capitol, a neoclassic house of government (Fig. 9.32), formality creates a foursquare, solid response. The symmetry of its design, the weight of its material, and its coldness give us a sense of impersonal power, which is heightened by the crushing weight of the dome. Rather than the upward-striving spiritual release of the Gothic arch, or even the powerful elegance of the Greek post-and-lintel, the Capitol building, based on a Roman prototype, elicits a sense of struggle. This is achieved through upward columnar thrust (heightened by the context provided by Capitol Hill) and downward thrust (of the dome) focused toward the interior of the building.

Apparent Function

The architect Louis Sullivan, of whom Frank Lloyd Wright was a pupil, is credited with the concept that form follows function. To a degree we have seen that concept in the previous examples, even though, with the exception of the Church of the Holy Family, they all precede Sullivan in time. A worthy question concerning the

Figure 9.30 The Church of the Holy Family, Parma, Ohio (1965). Architects: Conrad and Fleishman.

Guggenheim Museum (Fig. 9.33) might be how well Wright followed his teacher's philosophy. There is a story that Wright hated New York City because of unpleasant experiences he had had with the city fathers during previous projects. As a result, the Guggenheim, done late in his life, became his final gesture of derision to the city. This center of contemporary culture and art, with its single, circular ramp from street level to roof, was built (so the story goes) from the plans for a parking garage! Be that as it may, the line and form of this building create a simple, smoothly flowing, leisurely, upward movement juxtaposed against a stark and dynamic rectilinear form. The building's line and color and the feeling they produce are contemporary statements appropriate to the contemporary art the museum houses. The modern design of the Guggenheim is quite in contrast with the classical proportions of the Metropolitan Museum of Art, just down the street, which houses great works of ancient and modern art. The interior design is outwardly expressed in the ramp, and one can speculate that the slowly curving, unbroken line of the ramp is highly appropriate to the leisurely pace that one should follow when going through a museum.

Dynamics

Leisurely progress through the Guggenheim is diametrically opposite the sensation stimulated by the cantilevered roof of the grandstand at

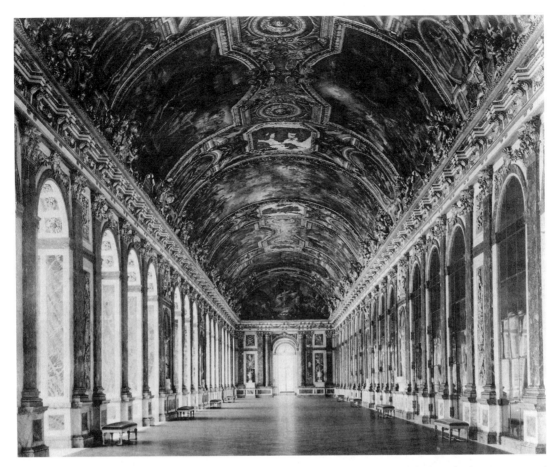

Figure 9.31 Hall of Mirrors, Palace of Versailles, France (1680). Architects: Jules Hardouin-Mansart and Charles LeBrun. French Government Tourist Office.

Zarzuela Race Track in Spain (Fig. 9.18). Speed, power, and flight are its preeminent concerns. The sense of dynamic instability inherent in the structural form—that is, cantilever, and this particular application of that form—mirror the dynamic instability and forward power of the race horse at full speed. However, despite the form and the strong diagonals of this design, it is not out of control; the architect has unified the design through repetition of the track-level arcade in the arched line of the cantilevered roof. The design is dynamic and yet humanized in the softness of its curves and the control of its scale.

Scale

Nothing suggests the technological achievement of modern humans more than the overwhelming scale of the skyscraper. Also, nothing symbolizes the subordination of humans to their technology more than the scale of this, once the

Figure 9.32 United States Capitol Building (1792-1856). Washington, D.C. Convention and Visitors Association Photo.

Figure 9.33 Guggenheim Museum, New York City (1942–1959). Architect: Frank Lloyd Wright. David Heald/ The Solomon R. Guggenheim Museum Photo.

world's tallest building (Fig. 9.34). Designed of rectangular components placed side by side, the Sears Tower is a glass and steel monolith overwhelming in its scale and proportion and cold in its materials. As a point of departure, its appeal to our senses raises the question of what comes next, the conquest of space or a return to respect for its natural mysteries?

Figure 9.34 Sears Tower, Chicago, Illinois (1971). Architects: Skidmore, Owings, and Merrill. Sears Roebuck & Co. Photo.

CHRONOLOGY OF SELECTED WORKS FOR ADDITIONAL STUDY

c. 4000 B.C.–c. 300 A.D.

Ancient Egyptian pyramids
Ancient Greece
 Ictinos and Callicrates: The Parthenon
 Temple of Athena
Rome
 Colosseum
 Pantheon
 Aqueduct, Segovia, Spain

c. 300–c. 1570

Byzantium
 Hagia Sophia
Romanesque Europe
 St. Trophime, Arles
 St. Sernin, Toulouse
Gothic style
 Chartres Cathedral, France
 Notre Dame de Paris
 Amiens Cathedral, France
 Exeter Cathedral, England
Renaissance Italy
 Brunelleschi: Pazzi Chapel, Florence
 Alberti: Palazzo Rucellai, Florence
High Renaissance Italy
 Bramante: Tempietto, Rome
 Michelangelo: apse, St. Peter's, Rome
Mannerism
 Lescot Wing of the Louvre, Paris

c. 1570–c. 1800

Baroque
 Le Vau, Hardouin-Mansart: Versailles
 Palace
 della Porta: Il Gesù, Rome
Neoclassicism
 Jefferson: Monticello
Rococo
 Pöppelmann: Zwinger Palace, Dresden
 Zimmermann: Church at Die Weis,
 Bavaria

c. 1800–2000

Romanticism
 Berry: Houses of Parliament, London
 Gilbert: Woolworth Building, New York
Art Nouveau
 Gaudí: Casa Battló, Barcelona
Modern
 Sidmore, Owings, and Merrill: Lever
 House, New York City
 Sullivan: Prudential Building, Buffalo,
 New York

Le Corbusier, Savoye House, Poissy-
 sur-Seine, France
Prairie Style
 Wright: Robie House, Chicago
Postmodern
 Piano and Rogers: Pompidou Centre,
 Paris
 Graves: Portland Public Office Building,
 Portland, Oregon

Literature

Read any good books lately? Ever tried to write poetry? From the earliest of times, cultures have been defined by their literature. Even before the invention of writing, myths and legends in prose and poetry told people who they were and where they came from. Today, before there can be a movie or a soap opera, there must be a story and, usually, a script. Such things comprise literature, our last subject for discussion.

What is it?

In the same sense that all artworks communicate through a particular medium someone's perception of reality or truth, so literature communicates using the forms we examine momentarily. There is a difference between literature that some call utilitarian and literature that may be called creative. Creative literature has a different approach than utilitarian literature. The approach determines the category in the same sense that a picture composed of line, form, and color is termed art, whereas another picture, composed of those same characteristics but whose purpose is merely to provide a visual copy, is termed "illustration."

The formal divisions of literature are fiction, poetry, biography, essay, and drama.

Fiction

Fiction is a work created from the author's imagination rather than from fact. Normally it takes one of two approaches to its subject matter: *realistic*, that is, the appearance of observable, true-to-life details; or *nonrealistic*, that is, fantasy. Other literary forms such as narrative poetry and drama can also be fiction, and fictional elements can be introduced into forms such as biography

Toni Morrison

Toni Morrison (b. 1931) was born in Lorain, Ohio as Chloe Anthony Wofford. She was the second of four children of George Wofford, a shipyard welder, and Ramah Willis Wofford. Her parents moved from the South to escape racism and to find better opportunities in the North. At home, Chloe heard many songs and tales of Southern black folklore. The Woffords were proud of their heritage. Lorain was a small industrial town populated with immigrant Europeans, Mexicans and Southern blacks who lived next to each other. Chloe attended an integrated school. In her first grade, she was the only black student in her class and the only one who could read. She was friends with many of her white schoolmates and did not encounter discrimination until she started dating. While attending Howard University in Washington, D.C., she majored in English, and because many people couldn't pronounce her first name correctly, she changed it to Toni, a shortened version of her middle name.

Later she taught at Howard where she joined a small writer's group as refuge from an unhappy marriage to a Jamaican architect, Harold Morrison. Today Ms. Morrison is one of America's most celebrated authors. Her six major novels, *The Bluest Eye* (1969), *Sula* (1973), *Song of Solomon* (1977), *Tar Baby* (1981), *Beloved* (1987), and *Jazz* (1992), have received extensive national acclaim. She received the National Book Critics Award in 1977 for *Song of Solomon* and the 1988 Pulitzer Prize for *Beloved*. In 1993 Ms. Morrison was awarded the Nobel prize for literature. She is an editor at Random House and a visiting lecturer at Yale University.

She is noted for her spare but poetic language, emotional intensity, and sensitive observation of African-American life. Her novel, *Jazz*, is meant to follow *Beloved* as the second volume of a projected trilogy, although *Jazz* doesn't extend the story told in *Beloved* in a conventional way. The characters are new, and so is the location. Even the narrative approach is different. In terms of chronology, however, *Jazz* begins roughly where *Beloved* ended and continues the greater story Morrison wishes to tell of her people passing through their American experience, from the days of slavery to the present. The individuals struggle to establish and sustain a personal identity without abandoning their own history, while individual and community interests clash. *Jazz* reads like a blues ballad from the musical age it suggests.

and epic poetry. Fiction traditionally is divided into novels and short stories.

Novels

The *novel* is a prose narrative of considerable length which has a plot that unfolds from the actions, speech, and thoughts of the characters. Normally the novel treats events within the range of ordinary experience and draws on original subject matter rather than traditional or mythic subjects. Novels typically have numerous characters and employ normal, daily speech. The subject matter of novels can be divided into two general categories, *sociological-panoramic*, covering a wide-ranging story of many years and various settings, and *dramatic-intimate*, which is restricted in time and setting.

Often, novels are formally classified by their subject matter. A few of these categories are as follows:

- picaresque: the adventures of a rogue
- manners: problems of personal relations
- sentimental: the development of emotionality, especially a sentimental appreciation of simplicity
- gothic: the trials of a pure, sensitive, and noble heroine who undergoes terrifying experiences, emerging undamaged. Usually this type of novel is stilted, melodramatic, and exploitive of the darker side of emotional psychology
- historical: intertwines historical events and fictional characters
- realistic: focuses on familiar situations and ordinary people
- lyrical: a short work with a metaphoric structure and a limited number of characters

Short Stories

As the name implies, short stories are short prose fictional works focusing on unity of characterization, theme, and effect.

Poetry

Poetry is a type of work designed to convey a vivid and imaginative sense of experience. Poetry uses condensed language selected for its sound, suggestive power, and meaning, and employs specific technical devices such as meter, rhyme, and metaphor. Poetry can be divided into three major types: narrative, dramatic, and lyric.

Narrative

Narrative poetry tells a story. *Epic* poetry is narrative poetry of substantial length and elevated style. It uses strong symbolism and has a central figure of heroic proportions. A *ballad* is a sung or recited narrative. A *metrical romance* is a long narrative, romantic tale in verse.

Dramatic

Dramatic poetry utilizes dramatic form or dramatic technique. Its major form is the dramatic monologue.

Lyric

Lyric poetry was originally intended to be sung and accompanied by a lyre. It is a brief, subjective work employing strong imagination, melody, and feeling to create a single, unified, and intense impression of the personal emotion of the poet.

Biography

Over the centuries, biography has taken many forms and witnessed many techniques and intentions, including literary narratives, catalogues of achievement, and psychological portraits. Biography is a written account of a person's life. Accounts of the lives of the saints and other religious figures are called *hagiographies*.

Essays

The essay traditionally is a short literary composition on a single subject, usually presenting the personal views of the author. The word comes from the French, meaning "to try" and the vulgar Latin, meaning "to weigh." Essays include many subforms and a variety of styles, but they uniformly present a personal point of view with a conscious attempt to achieve grace of expression. Essays characteristically are marked by clarity, grace, good humor, wit, urbanity, and tolerance.

An essay is a work of nonfiction reflecting the author's attitudes toward a specific subject. In so doing, it may reveal the author's personality or speculations. For the most part, essays are brief, but occasionally much longer works such as John Locke's treatise *Essay Concerning Human Understanding* (1690) have appeared. Traditionally, essays fall into two categories: formal or informal.

Informal

Informal essays tend to be brief and very personal. They are conversational in tone and loose in structure. This type of essay can be further divided into categories called *familiar* or *personal* and *character*. The personal essay presents an aspect of the author's personality as he or she reacts to an event. Character essays describe persons, isolating their dominant traits, for example.

Formal

Formal essays are longer and more tightly structured than informal essays. Formal essays tend to focus on impersonal subjects and place less emphasis on the personality of the author.

Drama

Drama is the written script, or play, on which a theatre performance may be based. We examined this genre in Chapter 5.

How is it put together?

Fiction

Point of View

Fiction is a story told by someone at a particular time and place to a particular audience. So it has a definite perspective, and, therefore, certain limitations of objectivity. It raises questions about the right way of seeing things. For the story to achieve credibility as fiction, the author must appear to distance himself or herself from the representative truth of the story and the reader. The "point of view" is a device to objectify the circumstances. Four types of narrative point of view are (1) *first person;* (2) *epistolary*, that is, told through the use of letters written by the characters; (3) *omniscient narration* or "third person"; and (4) *stream of consciousness* or "interior monologue" wherein a flow of thoughts, feelings, and memories come from a specific character's psyche. These arbitrary definitions regarding point of view may vary or be combined by authors to suit their own purposes. Point of view, as we have discussed it here, means merely that one of the means by which fiction is put together is usable by an author in several ways, at several levels, to communicate meaning.

Appearance and Reality

Fiction claims to be true to actuality, but it is built on invented sequences of events. It refers back on itself, layering the fictional and the factual.

Tone

Tone may also be called the atmosphere of the story. In essence, it is the author's attitude toward the story's literal facts. Reading is much like listening to conversation. That is, the words

carry meaning, but the way in which they are said—their tone—shapes meaning much more effectively. In addition, the atmosphere of the story sometimes includes the setting or the physical environment. In many stories, atmosphere is psychological as well as physical, and when all of these characteristics of tone are taken together, they provide subtle and powerful suggestions leading to our fuller understanding of the work.

Character

Literature appeals through its people, but not just people alone. Literature draws our interest because we see a human character involved in some kind of conflict—that is, a struggle with some important human problem. Authors write to that potential interest and usually strive to focus our attention, and to achieve unity, by drawing a central character with whose actions, decisions, growth, and development we can identify, and in whom we can find an indication of some broader aspect of the human condition. As we noted in the chapter on theatre, the term *character* goes beyond the mere identification of a "person." Character means the psychological spine of the individual, the driving force which makes that individual respond the way he or she does when faced with a given set of circumstances. Character is what we are interested in: Given a set of troubling or challenging circumstances, what does the character of the individual lead him or her to do?

In developing character, an author has numerous choices, depending, again, on his or her purposes. Character may be fully three-dimensional and highly individualistic—that is, as complex as the restrictions of the medium allow. Novels, because of their length and the fact that the reader can go back to double-check a fact or description, allow much more complex character development or individuality than do plays, whose important points must be found by the audience the moment they are presented. However, the author's purpose may be served by presenting character, not as a fully developed individual, but as a type. Whatever the author's choice, the nature of character development tells us much about the meaning we are to find in the work.

Plot

Plot is the structure of the work. It is more than the story line or the facts of the piece. In literature, as in the theatre, we find our interest depends on action. We are here to witness character in action. Plot is the structure of that action. It creates unity in the work and thereby helps us find meaning. Plot is the skeleton that determines the ultimate shape of the piece, once the elements of flesh have been added to it. The action of a literary work is designed to dramatize a fully realized theme, situation, or character.

Plot may be the major or subordinate focus in a work, and it can be open or closed. Closed plots rely on the Aristotelian model of pyramidal action with exposition, complication, and resolution or denouement. An open plot has little or no resolution. We merely leave the characters at a convenient point and imagine them continuing on as their characters will dictate.

Theme

Most good stories have an overriding idea or theme by which the other elements are shaped. Quality in works of art may rest on the artist's ability to utilize the tools of his or her medium and on whether the artist has something worthwhile to say. Some critics argue that the quality of a theme is less important than what the author does with it. Yet the conclusion is inescapable: The best artworks are those in which the author has taken a meaningful theme and developed it exceptionally. So the theme or idea of a work is what the author has to say. The other devices of the piece will help us understand the ultimate

Realism in Literature

The term realism, like classicism, can be used in a number of ways. One way of using the term is philosophical. For example, in Medieval philosophy realists opposed nominalists. Realists held that classes of things ("universals") have reality whereas individuals do not, or at least have less reality than universals. That is to say that individual humans take their reality from the classification "human," whereas nominalists argue that only individual humans have reality and that the classification "human" is only a formulation of the imagination.

In another philosophical sense, realism, since the Middle Ages, has become an opposite to idealism. In this case realism means that reality exists apart from ideas about it in the mind, whereas idealism holds that we can know nothing that is not in our minds.

In literature, realism is a nineteenth-century conception meaning, in general, the use of the imagination to represent things as common sense supposes them to be. In other words, realism (in art as well as literature) proposes fidelity to nature or to real life through accurate representation of details without idealization. Realism rejects the kind of idealizing found in Romanticism, for example, in favor of a close observation of outward appearances. The word also has been used critically to denote excessive minuteness of detail or preoccupation with trivial, sordid, or squalid subjects in art and literature.

Realism occurred as the result of several developments in the first half of the nineteenth century, including the anti-Romantic movement in Germany, with its emphasis on commonplace artistic subjects. In modern literature realism opposes sentimentalism. For example, the poetry of Langston Hughes, as illustrated in this chapter, could be described as "realistic."

The eighteenth-century novelist Daniel Defoe is considered one of the earliest realists in literature because of his factual description and narration. Other examples include Henry Fielding and Tobias Smollett.

Realism surfaced as a major trend in French literature between 1850 and 1880. The French realists rejected both classicism and Romanticism as artificial and argued that in order to be effective, a work must be contemporaneous. In pursuit of the principles we just summarized, the French realists portrayed the mores, problems, appearances, and customs of middle and lower class individuals in great detail.

The major proponent of French realism was the novelist Honoré de Balzac (1799-1850), who attempted to present a detailed, all-encompassing picture of the entire range of French society in *La Comédie humaine* (*The Human Comedy*).

Realism in literature, then, places an emphasis on detachment, objectivity, and accurate observation and makes clear but restrained criticism of social environment and mores as well as human understanding. It is closely related to another literary movement called *naturalism*.

idea. Theme may mean a definite intellectual concept, or it may indicate a highly complex situation. Clues to understanding the idea can come as early as our exposure to the title. Beyond that, the theme is usually revealed in small pieces as we move from beginning to conclusion.

Symbolism

Every work of literature is symbolic to one degree or another. It stands for something greater than its literal reality. Words are symbols, as is language. So any story is symbolic inasmuch as it reveals human experience. Often the symbols that occur in a story are cultural in derivation. That is why we often have difficulty understanding the levels of meaning in works from other cultures. We also find it difficult to grasp the symbols in works from our own tradition. The more we know about our culture and its various points of view through history, the more we are able to grasp the symbolism, and thereby the meaning, of the great thinkers, writers, and artists whose insights into the human condition can help us cope with the significant questions of our time and our personal condition.

Sometimes symbols are treated as if they are private or esoteric. In other words, sometimes writers will purposely try to hide some levels of meaning from all but the thoroughly initiated or truly sophisticated. Sometimes authors will try to create new symbol systems. Whatever the case, symbolism gives the story its richness and much of its appeal. When we realize a character, for example, is a symbol, regardless of how much of an individual he or she may be, the story takes on new meaning for us. We often discover that every character in the story symbolizes us—that is, some aspect of *our* complex and often contradictory characters. Symbols can be hidden, profound, or simple. When we discover them and unlock their revelations, we have made a significant stride toward understanding meaning.

Poetry

Language

Rhythm in poetry consists of the flow of sound through accents and syllables. For example, in Robert Frost's *Stopping by Woods on a Snowy Evening* (see the end of the chapter) each line contains eight syllables with an accent on every other syllable. Rhythms, like Frost's, that depend on a fixed number of syllables in each line, are called *accentual-syllabic*. Contrast that with the freely flowing rhythm of Shakespeare's "The Seven Ages of Man" in which rhythmic flow uses naturally occurring stresses in the words. This use of stress to create rhythm is called *accentual*.

Imagery comprises a verbal representation of a sensory experience. It can be literal or figurative. In the former, there is no change or extension in meaning; for example, "green eyes" are simply eyes that are a green color. In the latter, there is a change in literal meaning; for example, green eyes might become "green orbs."

Figures, like images, take words beyond their literal meaning. Much of poetic meaning comes in comparing objects in ways that go beyond the literal. For example, in Robert Frost's "Stopping by Woods on a Snowy Evening," snowflakes are described as *downy*, which endows them with the figurative quality of soft, fluffy feathers on a young bird. In the same sense, Frost uses "sweep" and "easy" to describe the wind.

Metaphors are figures of speech by which new implications are given to words. For example, the expression "the twilight of life" takes the word *twilight* and applies it to the concept of life to create an entirely new image and meaning.

Symbols also are often associated with figures of speech, but not all figures are symbols, and not all symbols are figures. Symbolism is critical to poetry, which uses compressed language to express, and carry us into, its meanings. In poetry "the whole poem helps to determine the meaning of its parts, and in turn, each part helps to determine the meaning of the whole poem" (K. L. Knickerbocker and W. Willard Reninger, *Interpreting Literature*, p. 218).

Structure

Form or structure in poetry derives from fitting together lines of similar structure and length tied to other lines by end rhyme. For example, the sonnet has fourteen lines of iambic pentameter rhymed 1–3, 2–4, 5–7, 6–8, 9–11, 10–12, 13–14.

Stanzas, which are any recurring groupings of two or more lines in terms of length, meter, and rhyme, are part of structure. A stanza usually presents a unit of poetic experience, and if the poem has more than one stanza, the pattern is usually repeated.

Sound Structures

Rhyme is the most common sound structure. Rhyme is, of course, the coupling of words that sound alike. Its function in poetry is to tie the sense together with the sound. Rhyme can be masculine, feminine, or triple. Masculine rhyme is based on single-syllable vowels such as "hate" and "mate." Feminine rhyme is based on sounds between accented and unaccented syllables, for example, "hating" and "mating." Triple rhyme comprises a correspondence among three syllables such as "despondent" and "respondent."

Alliteration is a second type of sound structure in which an initial sound is repeated for effect—for example *fancy free*.

Assonance is a similarity among vowels but not consonants.

Meter

Meter comprises the type and number of rhythmic units in a line. Rhythmic units are called *feet*. Four common kinds of feet are *iambic, trochaic, anapestic,* and *dactyllic*. Iambic meter alternates one unstressed and one stressed syllable; trochaic meter alternates one stressed and one unstressed syllable; anapestic alternates two unstressed and one stressed syllables; and dactyllic meter alternates one stressed and two unstressed syllables.

Line, also called verse, determines the basic rhythmic pattern of the poem. Lines are named by the number of feet they contain. One foot is monometer; two, dimeter; three, trimeter; four, tetrameter; five, pentameter; six, hexameter; seven, heptameter; and eight, octameter.

Biography

Facts

Facts are the verifiable details around which a biography is shaped. However, facts, other than matters such as birth, death, marriage, and other date-related occurrences, often have a way of becoming elusive. "Facts" often turn out to be observations filtered through the personality of the observer. Incontrovertible facts may comprise a chronological or skeletal framework for a biography, but often they do not create much interest. Often they do not provide much of a skeleton either. Many individuals about whose lives we would like to learn more have few facts recorded about them. In contrast, the lives of other important individuals have been chronicled in such great detail that too many facts exist. Artistry entails selection and composition, and in the latter case, interest may require leaving many facts out of the narrative. Of course,

another issue related to facts and biography is the question of what the author should do with the facts. If the facts are injurious, should they be used? In what context should they be used? Whatever the situation, facts alone do not comprise a sufficient quality for an artistic or interesting biography.

Anecdotes

Anecdotes are stories or observations about moments in a biography. Anecdotes take the basic facts and expand them for illustrative purposes, thereby creating interest. Anecdotes may be true or untrue. Their purpose, often, is to create a memorable generalization. They may also generate debate or controversy.

Quotations form part of anecdotal experience. Their purpose is to create interest by changing the presentational format to that of dialogue. In one sense, dialogue brings us closer to subjects of the biography by helping to create the impression that we are part of the scene, as opposed to being third parties listening to someone else describe a situation.

How does it stimulate the senses?

The following selections serve as illustrations of literature. Literature appeals to our senses by the way in which the writer uses the tools of the medium. We have applied the formal and technical elements of the arts enough times now that to do so again would be to restate the obvious. Read the following examples and decide for yourself how your response is manipulated by the author's use of the devices we have discussed. Discuss each example with a friend to see if your reactions were similar or different. Where differences arise, try to determine why.

FICTION

THE SOFT-HEARTED SIOUX

Zitkala-Sa [Gertrude Bonnin]

I

Beside the open fire I sat within our tepee. With my red blanket wrapped tightly about my crossed legs, I was thinking of the coming season, my sixteenth winter. On either side of the wigwam were my parents. My father was whistling a tune between his teeth while polishing with his bare hand a red stone pipe he had recently carved. Almost in front of me, beyond the centre fire, my old grandmother sat near the entranceway.

She turned her face toward her right and addressed most of her words to my mother. Now and then she spoke to me, but never did she allow her eyes to rest upon her daughter's husband, my father. It was only upon rare occasions that my grandmother said anything to him. Thus his ears were open and ready to catch the smallest wish she might express. Sometimes when my grandmother had been saying things which pleased him, my father used to comment upon them. At other times, when he could not

Source: Zitkala-sa (Gertrude Bonnin), "The Soft-Hearted Sioux." Reprinted from *The Singing Spirit,* edited by Bernd C. Peyer. Copyright 1989 The Arizona Board of Regents.

approve of what was spoken, he used to work or smoke silently.

On this night my old grandmother began her talk about me. Filling the bowl of her red stone pipe with dry willow bark, she looked across at me.

"My grandchild, you are tall and are no longer a little boy." Narrowing her old eyes, she asked, "My grandchild, when are you going to bring here a handsome young woman?" I stared into the fire rather than meet her gaze. Waiting for my answer, she stooped forward and through the long stem drew a flame into the red stone pipe.

I smiled while my eyes were still fixed upon the bright fire, but I said nothing in reply. Turning to my mother, she offered her the pipe. I glanced at my grandmother. The loose buckskin sleeve fell off at her elbow and showed a wrist covered with silver bracelets. Holding up the fingers of her left hand, she named off the desirable young women of our village.

"Which one, my grandchild, which one?" she questioned.

"Hoh!" I said, pulling at my blanket in confusion. "Not yet!" Here my mother passed the pipe over the fire to my father. Then she too began speaking of what I should do.

"My son, be always active. Do not dislike a long hunt. Learn to provide much buffalo meat and many buckskins before you bring home a wife." Presently my father gave the pipe to my grandmother, and he took his turn in the exhortations.

"Ho, my son, I have been counting in my heart the bravest warriors of our people. There is not one of them who won his title in his sixteenth winter. My son, it is a great thing for some brave of sixteen winters to do."

Not a word had I to give in answer. I knew well the fame of my warrior father. He had earned the right of speaking such words, though even he himself was a brave only at my age. Refusing to smoke my grandmother's pipe because my heart was too much stirred by their words, and sorely troubled with a fear lest I should disappoint them, I arose to go. Drawing my blanket over my shoulders, I said, as I stepped toward the entranceway: "I go to hobble my pony. It is now late in the night."

II

Nine winters' snows had buried deep that night when my old grandmother, together with my father and mother, designed my future with the glow of a camp fire upon it.

Yet I did not grow up the warrior, huntsman, and husband I was to have been. At the mission school I learned it was wrong to kill. Nine winters I hunted for the soft heart of Christ, and prayed for the huntsmen who chased the buffalo on the plains.

In the autumn of the tenth year I was sent back to my tribe to preach Christianity to them. With the white man's Bible in my hand, and the white man's tender heart in my breast, I returned to my own people.

Wearing a foreigner's dress, I walked, a stranger, into my father's village.

Asking my way, for I had not forgotten my native tongue, an old man led me toward the tepee where my father lay. From my old companion I learned that my father had been sick many moons. As we drew near the tepee, I heard the chanting of a medicine-man within it. At once I wished to enter in and drive from my home the sorcerer of the plains, but the old warrior checked me. "Ho, wait outside until the medicine-man leaves your father" he said. While talking he scanned me from head to feet. Then he retraced his steps toward the heart of the camping-ground.

My father's dwelling was on the outer limits of the round-faced village. With every heartthrob I grew more impatient to enter the wigwam.

While I turned the leaves of my Bible with nervous fingers, the medicine-man came forth from the dwelling and walked hurriedly away. He head and face were closely covered with the loose robe which draped his entire figure.

He was tall and large. His long strides I have never forgot. They seemed to me then as the uncanny gait of eternal death. Quickly pocketing my Bible, I went into the tepee.

Upon a mat lay my father, with furrowed face and gray hair. His eyes and cheeks were sunken far into his head. His sallow skin lay thin upon his pinched nose and high cheek-bones. Stooping over him, I took his fevered hand. "How, Ate?" I greeted him. A light flashed from his listless eyes and his dried lips parted. "My son!" he murmured, in a feeble voice. Then again the wave of joy and recognition receded. He closed his eyes, and his hand dropped from my open palm to the ground.

Looking about, I saw an old woman sitting with bowed head. Shaking hands with her, I recognized my mother. I sat down between my father and mother as I used to do, but I did not feel at home. The place where my old grandmother used to sit was now unoccupied. With my mother I bowed my head. Alike our throats were choked and tears were streaming from our eyes; but far apart in spirit our ideas and faiths separated us. My grief was for the soul unsaved; and I thought my mother wept to see a brave man's body broken by sickness.

Useless was my attempt to change the faith in the medicine-man to that abstract power named God. Then one day I became righteously mad with anger that the medicine-man should thus ensnare my father's soul. And when he came to chant his sacred songs I pointed toward the door and bade him go! The man's eyes glared upon me for an instant. Slowly gathering his robe about him, he turned his back upon the sick man and stepped out of our wigwam. "Hā, hā, hā! my son, I cannot live without the medicine-man!" I heard my father cry when the sacred man was gone.

III

On a bright day, when the winged seeds of the prairie-grass were flying hither and thither, I walked solemnly toward the centre of the camping-ground. My heart beat hard and irregularly at my side. Tighter I grasped the sacred book I carried under my arm. Now was the beginning of life's work.

Though I knew it would be hard, I did not once feel that failure was to be my reward. As I stepped unevenly on the rolling ground, I thought of the warriors soon to wash off their war-paints and follow me.

At length I reached the place where the people had assembled to hear me preach. In a large circle men and women sat upon the dry red grass. Within the ring I stood, with the white man's Bible in my hand. I tried to tell them of the soft heart of Christ.

In silence the vast circle of bareheaded warriors sat under an afternoon sun. At last, wiping the wet from my brow, I took my place in the ring. The hush of the assembly filled me with great hope.

I was turning my thoughts upward to the sky in gratitude, when a stir called me to earth again.

A tall, strong man arose. His loose robe hung in folds over his right shoulder. A pair of snapping black eyes fastened themselves like the poisonous fangs of a serpent upon me. He was the medicine-man. A tremor played about my heart and a chill cooled the fire in my veins.

Scornfully he pointed a long forefinger in my direction and asked,

"What loyal son is he who, returning to his father's people, wears a foreigner's dress?" He paused a moment, and then continued: "The dress of that foreigner of whom a story says he bound a native of our land, and heaping dry sticks around him, kindled a fire at his feet!" Waving his hand toward me, he exclaimed, "Here is the traitor to his people!"

I was helpless. Before the eyes of the crowd the cunning magician turned my honest heart into a vile nest of treachery. Alas! the people frowned as they looked upon me.

"Listen!" he went on. "Which one of you who have eyed the young man can see through his bosom and warn the people of the nest of young snakes hatching there? Whose ear was so acute that he caught the hissing of snakes whenever the young man opened his mouth? This one has not only proven false to you, but even to the Great Spirit who made him. He is a fool! Why do you sit here giving ear to a foolish man who could not defend his people because he fears to kill, who could not bring venison to renew the life of his sick father? With his prayers, let him drive away the enemy! With his soft heart, let him keep off starvation! We shall go elsewhere to dwell upon an untainted ground."

With this he disbanded the people. When the sun lowered in the west and the winds were quiet, the village of cone-shaped tepees was gone. The medicine-man had won the hearts of the people.

Only my father's dwelling was left to mark the fighting-ground.

IV

From a long night at my father's bedside I came out to look upon the morning. The yellow sun hung equally between the snow-covered land the cloudless blue sky. The light of the new day was cold. The strong breath of winter crusted the snow and fitted crystal shells over the rivers and lakes. As I stood in front of the tepee, thinking of the vast prairies which separated us from our tribe, and wondering if the high sky likewise separated the soft-hearted Son of God from us, the icy blast from the north blew through my hair and skull. My neglected hair had grown long and fell upon my neck.

My father had not risen from his bed since the day the medicine-man led the people away. Though I read from the Bible and prayed beside him upon my knees, my father would not listen. Yet I believed my prayers were not unheeded in heaven.

"Hā, hā, hā! my son," my father groaned upon the first snowfall. "My son, our food is gone. There is no one to bring me meat! My son, your soft heart has unfitted you for everything!" Then covering his face with the buffalo-robe, he said no more. Now while I stood out in that cold winter morning, I was starving. For two days I had not seen any food. But my own cold and hunger did not harass my soul as did the whining cry of the sick old man.

Stepping again into the tepee, I untied my snow-shoes, which were fastened to the tent-poles.

My poor mother, watching by the sick one, and faithfully heaping wood upon the centre fire, spoke to me:

"My son, do not fail again to bring your father meat, or he will starve to death."

"How, Ina," I answered, sorrowfully. From the tepee I started forth again to hunt food for my aged parents. All day I tracked the white level lands in vain. Nowhere, nowhere were there any other footprints but my own! In the evening of this third fast-day I came back without meat. Only a bundle of sticks for the fire I brought on my back. Dropping the wood outside, I lifted the door-flap and set one foot within the tepee.

There I grew dizzy and numb. My eyes swam in tears. Before me lay my old grayhaired father sobbing like a child. In his horny hands he clutched the buffalo-robe, and with his teeth he was gnawing off the edges. Chewing the dry stiff hair and buffalo-skin, my father's eyes sought my hands. Upon seeing them empty, he cried out:

"My son, your soft heart will let me starve before you bring me meat! Two hills eastward stand a herd of cattle. Yet you will see me die before you bring me food!"

Leaving my mother lying with covered head upon her mat, I rushed out into the night.

With a strange warmth in my heart and swiftness in my feet, I climbed over the first hill, and soon the second one. The moonlight upon the white country showed me a clear path to the white man's cattle. With my hand upon the knife in my belt, I leaned heavily against the fence while counting the herd.

Twenty in all I numbered. From among them I chose the best-fattened creature. Leaping over the fence, I plunged my knife intoit.

My long knife was sharp, and my hands, no more fearful and slow, slashed off choice chunks of warm flesh. Bending under the meat I had taken for my starving father, I hurried across the prairie.

Toward home I fairly ran with the life-giving food I carried upon my back. Hardly had I climbed the second hill when I heard sounds coming after me. Faster and faster I ran with my load for my father, but the sounds were gaining upon me. I heard the clicking of snowshoes and the squeaking of the leather straps at my heels; yet I did not turn to see what pursued me, for I was intent upon reaching my father. Suddenly like thunder an angry voice shouted curses and threats into my ear! A rough hand wrenched my shoulder and took the meat from me! I stopped struggling to run. A deafening whir filled my head. The moon and stars began to move. Now the white prairie was sky, and the stars lay under my feet. Now again they were turning. At last the starry blue rose up into place. The noise in my ears was still. A great quiet filled the air. In my hand I found my long knife dripping with blood. At my feet a man's figure lay prone in blood-red snow. The horrible scene about me seemed a trick of my senses, for I could not understand it was real. Looking long upon the blood-stained snow, the load of meat for my starving father reached my recognition at last. Quickly I tossed it over my shoulder and started again homeward.

Tired and haunted I reached the door of the wigwam. Carrying the food before me, I entered with it into the tepee.

"Father, here is food!" I cried, as I dropped the meat near my mother. No answer came. Turning about, I beheld my gray-haired father dead! I saw by the unsteady firelight an old gray-haired skeleton lying rigid and stiff.

Out into the open I started, but the snow at my feet became bloody.

V

One the day after my father's death, having led my mother to the camp of the medicine-man, I gave myself up to those who were searching for the murderer of the paleface.

They bound me hand and foot. Here in this cell I was placed four days ago.

The shrieking winter winds have followed me hither. Rattling the bars, they howl unceasingly: "Your soft heart! your soft heart will see me die before you bring me food!" Hark! something is clanking the chain on the door. It is being opened. From the dark night without a black figure crosses the threshold. . . . It is the guard. He comes to warn me of my fate. He tells me that tomorrow I must die. In his stern face I laugh aloud. I do not fear death.

Yet I wonder who shall come to welcome me in the realm of strange sight. Will the loving Jesus grant me pardon and give my soul a soothing sleep? or will my warrior father greet me and receive me as his son? Will my spirit fly upward to a happy heaven? or shall I sink into the bottomless pit, an outcast from a God of infinite love?

Soon, soon I shall know, for now I see the east is growing red. My heart is strong. My face is calm. My eyes are dry and eager for new scenes. My hands hang quietly at my side. Serene and brave, my soul awaits the men to perch me on the gallows for another flight. I go.

POETRY

THE SEVEN AGES OF MAN

William Shakespeare 1564–1616

All the world's a stage,
And all the men and women merely players.
They have their exits and their entrances,
And one man in his time plays many parts,
His acts being seven ages. At first the infant, 5
Mewling[1] and puking in the nurse's arms.
Then the whining schoolboy, with his satchel
And shining morning face, creeping like snail
Unwillingly to school. And then the lover,
Sighing like furnace, with a woeful ballad[2] 10
Made to his mistress' eyebrow. Then a soldier,
Full of strange oaths and bearded like the pard,[3]
Jealous in honor,[4] sudden and quick in quarrel,
Seeking the bubble reputation[5]
Even in the cannon's mouth. And then
 the justice, 15
In fair round belly with good capon lined,[6]
With eyes severe and beard of formal cut,
Full of wise saws[7] and modern instances;[8]
And so he plays his part. The sixth age shifts
Into the lean and slippered Pantaloon,[9] 20
With spectacles on hose and pouch on side;
His youthful hose, well saved, a world too wide
For his shrunk shank, and his big manly voice,
Turning again toward childish treble, pipe
And whistles in his sound. Last scene of all, 25
That ends this strange eventful history,
Is second childishness and mere oblivion,
Sans[10] teeth, sans eyes, sans taste, sans everything.

—*As You Like It*, II. vii. 139–166

[1] Whimpering. [2] Poem. [3] Leopard. [4] Sensitive about honor. [5] As quickly burst as a bubble. [6] Magistrate bribed with a chicken. [7] Sayings. [8] Commonplace illustrations. [9] The foolish old man of Italian comedy. [10] Without.

STOPPING BY WOODS ON A SNOWY EVENING

Robert Frost 1874–1963

Whose woods these are I think I know.
His house is in the village though;
He will not see me stopping here
To watch his woods fill up with snow.

My little horse must think it queer 5
To stop without a farmhouse near
Between the woods and frozen lake
The darkest evening of the year.

He gives his harness bells a shake
To ask if there is some mistake. 10
The only other sound's the sweep
Of easy wind and downy flake.

The woods are lovely, dark and deep.
But I have promises to keep,
And miles to go before I sleep, 15
And miles to go before I sleep.

THEME FOR ENGLISH B

Langston Hughes 1902–67

The instructor said,

 Go home and write
 a page tonight.
 And let that page come out of you—
 Then it will be true.
I wonder if it's that simple?

I am twenty-two, colored, born in Winston-Salem.
I went to school there, then Durham, then here
to this college on the hill above Harlem.
I am the only colored student in my class.

The steps from the hill lead down into Harlem
through a park, then I cross St. Nicholas.
Eighth Avenue. Seventh, and I come to the Y,
the Harlem Branch Y, where I take the elevator
up to my room, sit down, and write this page:
It's not easy to know what is true for you or me
at twenty-two, my age. But I guess I'm what
I feel and see and hear, Harlem, I hear you:
hear you, here me-we two-you, me, talk on this page.
(I hear New York, too) Me—who?

Well, I like to eat, sleep, drink, and be in love.
I like to work, read, learn, and understand life.
I like a pipe for a Christmas present,
or records—Bessie, bop, or Back.
I guess being colored doesn't make me not like
the same things other folks like who are other races.
So will my page be colored that I write?
Being me, it will not be white.
But it will be
a part of you, instructor.
You are white—
Yet a part of me, as I am a part of you.
that's American.
Sometimes perhaps you don't want to be a part of
 me.
Nor do I often want to be apart of you.
But we are, that's true!

As I learn from you
I guess you learn from me—
although you're older—and white—
and somewhat more free.

This is my page for English B.

Source: Langston Hughes, "Theme for English B" from *Collected Poems*. Copyright © 1994 by the estate of Langston Hughes. Reprinted by permission of Alfred A. Knopf, Inc.

HARLEM

Langston Hughes 1902–67

What happens to a dream deferred?
Does it dry up
like a raisin in the sun?
Or fester like a sore—
And then run?
Does it stink like rotten meat?
Or crust and sugar over—
like a syrupy sweet?
Maybe it just sags
like a heavy load.
Or does it explode?

Source: Langston Hughes, "Harlem" Copyright © 1951 Langston Hughes. Reprinted from *The Panther and the Lash* by permission of Alfred A. Knopf, Inc.

BIOGRAPHY

GOD BROUGHT ME SAFE

John Wesley 1703–1791
[Oct. 1743.]

Thur. 20—After preaching to a small, attentive congregation, I rode to Wednesbury. At twelve I preached in a ground near the middle of the town to a far larger congregation than was expected, on "Jesus Christ, the same yesterday, and to-day, and for ever." I believe every one present felt the power of God; and no creature offered to molest us, either going or coming; but the Lord fought for us, and we held our peace.

I was writing at Francis Ward's in the afternoon when the cry arose that the mob had beset the house. We prayed that God would disperse them, and it was so. One went this way, and another that; so that, in half an hour, not a man was left. I told our brethren, "Now is the time for us to go"; but they pressed me exceedingly to stay; so, that I might not offend them, I sat down, though I foresaw what would follow. Before five

the mob surrounded the house again in greater numbers than ever. The cry of one and all was, "Bring out the minister; we will have the minister." I desired one to take their captain by the hand and bring him into the house. After a few sentences interchanged between us the lion became a lamb. I desired him to go and bring one or two more of the most angry of his companions. He brought in two, who were ready to swallow the ground with rage; but in two minutes they were as calm as he. I then bade them make way, that I might go out among the people. As soon as I was in the midst of them I called for a chair, and, standing up, asked, "What do any of you want with me?" Some said, "We want you to go with us to the Justice." I replied, "That I will, with all my heart." I then spoke a few words, which God applied; so that they cried out with might and main, "The gentlemen is an honest gentleman, and we will spill our blood in his defence." I asked, "Shall, we go to the Justice tonight, or in the morning?" Most of them cried, "To-night, to-night"; on which I went before, and two or three hundred followed, the rest returned whence they came.

The night came on before we had walked a mile, together with heavy rain. However, on we went to Bentley Hall, two miles from Wednesbury. One or two ran before to tell Mr. Lane they had brought Mr. Wesley before his Worship. Mr. Lane replied, "What have I to do with Mr. Wesley? Go and carry him back again." By this time the main body came up, and began knocking at the door. A servant told them Mr. Lane was in bed. His son followed, and asked what was the matter. One replied, "Why an't please you, they sing psalms all day; nay, and make folks rise at five in the morning. And what would your Worship advise us to do?" "To go home," said Mr. Lane, "and be quiet."

Here they were at a full stop, till one advised to go to Justice Persehouse at Walsall. All agreed to this; so we hastened on, and about seven came to his house. But Mr. P. likewise sent word that

he was in bed. Now they were at a stand again: but at last they all thought it the wisest course to make the best of their way home. About fifty of them undertook to convoy me. But we had not gone a hundred yards when the mob of Walsall came, pouring in like a flood, and bore down all before them. The Darlaston mob made what defense they could; but they were weary, as well as outnumbered; so that in a short time, many being knocked down, the rest ran away, and left me in their hands.

To attempt speaking was vain, for the noise on every side was like the roaring of the sea. So they dragged me along till we came to the town, where, seeing the door of a large house open, I attempted to go in; but a man, catching me by the hair, pulled me back into the middle of the mob. They made no more stop till they had carried me through the main street, from one end of the town to the other. I continued speaking all the time to those within hearing, feeling no pain or weariness. At the west end of the town, seeing a door half open, I made toward it, and would have gone in, but a gentleman in the shop would not suffer me, saying they would pull the house down to the ground. However, I stood at the door and asked, "Are you willing to hear me speak?" Many cried out, "No, no! knock his brains out; down with him; kill him at once." Others said, "Nay, but we will hear him first." I began asking, "What evil have I done? Which of you all have I wronged in word or deed?" and continued speaking for above a quarter of an hour, till my voice suddenly failed. Then the floods began to lift up their voice again, many crying out, "Bring him away! Bring him away!"

In the meantime my strength and my voice returned, and I broke out aloud into prayer. And now the man who had just before headed the mob turned and said, "Sir, I will spend my life for you: follow me, and not one soul here shall touch a hair of your head." Two or three of his fellows confirmed his words, and got close to me immediately. At the same time, the gentleman in the

shop cried out, "For shame, for shame! Let him go." An honest butcher, who was a little farther off, said it was a shame they should do thus; and pulled back four or five, one after another, who were running on the most fiercely. The people then, as if it had been by common consent, fell to the right and left; while those three or four men took me between them, and carried me through them all. But on the bridge the mob rallied again: we therefore went on one side over the milldam, and thence through the meadows, till, a little before ten, God brought me safe to Wednesbury, having lost only one flap of my waistcoat and a little skin from one of my hands.

ESSAY

THE BENEFITS OF LUXURY, IN MAKING A PEOPLE MORE WISE AND HAPPY

Oliver Goldsmith 1730?–1774

From such a picture of nature in primeval simplicity, tell me, my much respected friend, are you in love with fatigue and solitude? Do you sigh for the severe frugality of the wandering Tartar, or regret being born amidst the luxury and dissimulation of the polite? Rather tell me, has not every kind of life vices peculiarly its own? Is it not a truth, that refined countries have more vices, but those not so terrible; barbarous nations few, and they of the most hideous complexion? Perfidy and fraud are the vices of civilized nations, credulity and violence those of the inhabitants of the desert. Does the luxury of the one produce half the evils of the inhumanity of the other? Certainly those philosophers who declaim against luxury have but little understood its benefits; they seem insensible, that to luxury we owe not only the greatest part of our knowledge, but even of our virtues.

It may sound fine in the mouth of a declaimer, when he talks of subduing our appetites, of teaching every sense to be content with a bare sufficiency, and of supplying only the wants of nature; but is there not more satisfaction in indulging those appetites, if with innocence and safety, than in restraining them? Am not I better pleased in enjoyment than in the sullen satisfaction of thinking that I can live without enjoyment? The more various our artificial necessities, the wider is our circle of pleasure; for all pleasure consists in obviating necessities as they rise: luxury, therefore as it increases our wants, increases our capacity for happiness.

Examine the history of any country remarkable for opulence and wisdom, you will find they would never have been wise had they not been first luxurious; you will find poets, philosophers, and even patriots, marching in luxury's train. The reason is obvious: we then only are curious after knowledge, when we find it connected with sensual happiness. The senses ever point out the way, and reflection comments upon the discovery. Inform a native of the desert of Kobi, of the exact measure of the parallax of the moon, he finds no satisfaction at all in the information; he wonders how any could take such pains, and lay out such treasures, in order to solve so useless a difficulty: but connect it with his happiness, by showing that it improves navigation, that by such an investigation he may have a warmer coat, a better gun, or a finer knife, and he is instantly in raptures at so great an improvement. In short, we only desire to know what we desire to possess; and whatever we may talk against it, luxury adds the spur to curiosity, and gives us a desire to becoming more wise.

But not our knowledge only, but our virtues are improved by luxury. Observe the brown savage of Thibet, to whom the fruits of the

spreading pomegranate supply food, and its branches are habitation. Such a character has few vices, I grant, but those he has are of the most hideous nature: rapine and cruelty are scarcely crimes in his eye; neither pity nor tenderness, which ennoble every virtue, have any place in his heart; he hates his enemies, and kills those he subdues. On the other hand, the polite Chinese and civilized European seem even to love their enemies. I have just now seen an instance where the English have succoured those enemies, whom their own countrymen actually refused to relieve.

The greater the luxuries of every country, the more closely, politically speaking, is that country united. Luxury is the child of society alone; the luxurious man stands in need of a thousand different artists to furnish out his happiness; it is more likely, therefore, that he should be a good citizen who is connected by motives of self-interest with so many, than the abstemious man who is united to none.

In whatsoever light, therefore, we consider luxury, whether as employing a number of hands naturally too feeble for more laborious employment; as finding a variety of occupation for others who might be totally idle; or as furnishing our new inlets to happiness, without encroaching on mutual property; in whatever light we regard it, we shall have reason to stand up in its defence, and the sentiment of Confucius still remains unshaken: *that we should enjoy as many of the luxuries of life as are consistent with our own safety, and the prosperity of others; and that he who finds out a new pleasure is one of the most useful members of society.*

CHRONOLOGY OF SELECTED WORKS FOR ADDITIONAL STUDY

Prehistory–c. 1800 A.D.

Mesopotamia
 Gilgamesh Epic
 The Bible
Ancient Greece
 Homer: *The Iliad*
 Plato: *The Republic*
 Aristotle: *Poetics*
Rome
 Virgil: *The Aeneid*
The Middle Ages
 Beowulf
 Nibelungenlied
 Dante: *The Divine Comedy*
 Chaucer: *Canterbury Tales*
Renaissance
 Boccaccio: *Decameron*
Baroque
 Cervantes: *Don Quixote*

c. 1800–c. 1900

The Enlightenment
 Votaire: *Candide*
Romanticism
 Goethe: *Faust*
 Wordsworth: *Tintern Abbey*
 Byron: *Don Juan*
 Dostoevski: War and Peace

c. 1900–2000

Eliot: *The Wasteland*
Faulkner: *A Rose for Emily*
O'Conner: *Revelation*
Jones: *Corregidora*
Walker: *The Color Purple*
Morrison: *Jazz*
Kawabata: *Snow Country*
Solzhenitsyn: *One Day in the Life of Ivan Denisovich*

Afterword

Little needs to be said by way of summary to this text, except to draw attention to what has *not* been included. We have not dealt much with philosophy of art or literature; only in passing have we noted art and literary history. Above all, we have not even covered completely the technical information that was our focus. We have covered only the basic skeleton. Although we have attempted to remain as neutral as possible in presenting information about each of the disciplines, there is no denying that subjectivity is present. The method of treatment was arbitrary, as was the choice of information presented. You may find such a technical approach sterile and disturbing. As indicated earlier, however, these pages should be viewed only as an introduction. The real life, the enthusiasm, the enjoyment, and the meaning of the arts and literature depend on what happens next. If, through the information presented in these pages, you have found a new appreciation for a form that was previously an enigma, or have found a means by which your previous knowledge has been enlarged, then this book has achieved its goal.

Finally, it should be obvious, and it will become obvious, that not every definition of every term is uniformly agreed on by artists themselves. Words serve only as a convenience for us as we try in some way to cope with what we see and what we hear, how and why we react as we do to those experiences, and how and why we try to share them with others. It may not be possible to understand the *whats* and the *whys* of some works, such as totally abstract paintings or dance presentations. Sometimes the significance or the meaning must wait until we have passed the time barrier and become historians rather than journalists in our perception.

Glossary

ABA: in music, a three-part structure that consists of an opening section, a second section, and a return to the first section.

absolute music: music that is free from any reference to nonmusical ideas, such as a text or a program—for example, Mozart's Symphony No. 40 in G minor.

abstraction: a thing apart, that is, removed from real life.

accelerando: in music, a gradual increase in tempo.

accent: in music, a stress that occurs at regular intervals of time. In the visual arts, any device used to highlight or draw attention to a particular area, such as an accent color. See also *focal point*.

adagio: musical term meaning "slow and graceful."

additive: in sculpture, those works that are built. In color, the term refers to the mixing of hues of light.

aerial perspective: indication of distance in painting through use of light and atmosphere.

aesthetic distance: combination of mental and physical factors that provides the proper separation between a viewer and an artwork; it enables the viewer to achieve a desired response. See *detachment*.

affective: relating to feelings or emotions, as opposed to facts. See *cognitive*.

aleatory: deliberate incorporation of chance in the composition, whether using chance methods to determine one or more elements or allowing performers to utilize chance variations in performing the work.

allegretto: musical term denoting a lively tempo, but one slower than allegro.

allegro: musical term meaning brisk or lively.

alliteration: sound structure in which an initial sound is repeated for effect.

alto: in music, the lowest female voice.

andante: musical term meaning a medium, leisurely, walking tempo.

andantino: musical term meaning a tempo a little faster than andante.

appoggiatura: in music, an ornamental note or series of notes above and below a tone of a chord.

aquatint: intaglio printmaking process in which the plate is treated with a resin substance to create textured tonal areas.

arabesque: classical ballet pose in which the body is supported on one leg, and the other leg is extended behind with the knee straight.

arcade: series of arches placed side by side.

arch: in architecture, a structural system in which space is spanned by a curved member supported by two legs.

aria: in opera or oratorio, a highly dramatic melody for a single voice.

articulation: connection of the parts of an artwork.

art song: vocal musical composition in which the text is the principal focus. See *song cycle.*

assemblé: in ballet, a leap with one foot brushing the floor at the moment of the leap and both feet coming together in fifth position at the finish.

assonance: sound structure employing a similarity among vowels but not consonants.

atonality: avoidance or tendency to avoid tonal centers in musical composition.

balletomane: term used by ballet enthusiasts to refer to themselves. A combination of *ballet* and *mania.*

balloon construction: construction of wood using a skeletal framework. See *skeleton frame.*

baroque: seventeenth- and eighteenth-century style of art, architecture, and music that is highly ornamental.

barre: wooden railing used by dancers to maintain balance while practicing.

barrel vault (tunnel vault): series of arches placed back to back to enclose space.

battement jeté: ballet movement using a small brush kick with the toe sliding on the floor until the foot is fully extended about 2 inches off the floor.

bearing wall: construction in which the wall supports itself, the roof, and floors. See *monolithic construction.*

beats: in music, the equal parts into which a measure is divided.

binary form: musical form consisting of two sections.

biography: written account of a person's life.

biomorphic: representing life-forms, as opposed to geometric forms.

bridge: in music, transitional material between themes or sections of a composition.

cadence: in music, the specific harmonic arrangement that indicates the closing of a phrase.

camera pan: turning of the camera from one side to the other to follow the movement of a subject.

canon: musical composition in which each voice imitates the theme in counterpoint.

cantilever: architectural structural system in which an overhanging beam is supported only at one end.

capital: transition between the top of a column and the lintel.

chaîné: series of spinning turns in ballet utilizing a half turn of the body on each step.

chamber music: vocal or instrumental music suitable for performance in small rooms.

changement de pied: in ballet, a small jump in which the positions of the feet are reversed.

character oxfords: shoes worn by dancers that look like ordinary street shoes, but are actually specially constructed for dance.

chiaroscuro: light and shade. In painting, the use of highlight and shadow to give the appearance of three-dimensionality to two-dimensional forms. In theatre, the use of light to enhance the plasticity of the human body or the elements of scenery.

chord: three or more musical tones played at the same time.

choreography: composition of a dance work; the arrangement of patterns of movement in dance.

chromatic scale: musical scale consisting of half steps.

cinematic motif: in film, a visual image that is repeated either in identical form or in variation.

cinema verité: candid camera; a televisionlike technique of recording life and people as they are.

The hand-held camera, natural sound, and minimal editing are characteristic.

classic: specifically referring to Greek art of the fifth century B.C.

classical: adhering to traditional standards. May refer to Greek and Roman art or any art in which simplicity, clarity of structure, and appeal to the intellect are fundamental.

coda: passage added to the end of a musical composition to produce a satisfactory close.

cognitive: facts and objectivity as opposed to emotions and subjectivity. See *affective*.

collography: printmaking process utilizing assorted objects glued to a board or plate.

composition: arrangement of line, form, mass, and color in a work of art.

conjunct melody: in music, a melody comprising notes close together in the scale.

consonance: the feeling of a comfortable relationship between elements of a composition, in pictures, sculpture, music, theatre, dance, or architecture. Consonance may be both physical and cultural in its ramifications.

conventions: customs or accepted underlying principles of an art, such as the willing suspension of disbelief in the theatre.

Corinthian: specific order of Greek architecture employing an elaborate leaf motif in the capitals.

corps de ballet: chorus of a ballet ensemble.

counterpoint: in music, two or more independent melodies played in opposition to each other at the same time.

crescendo: an increase in loudness.

crosscutting: in film, alternation between two independent actions that are related thematically or by plot to give the impression of simultaneous occurrence.

curvilinear: formed or characterized by curved line.

cutting: the trimming and joining that occurs during the process of editing film.

cutting within the frame: changing the viewpoint of the camera within a shot by moving from a long or medium shot to a close-up, without cutting the film.

decrescendo: decrease in loudness.

demi-hauteur: ballet pose with the leg positioned at a 45-degree angle to the ground.

demi-plié: in ballet, a half bend of the knees in any of the five positions.

denouement: section of a play's structure in which events are brought to a conclusion.

detachment: intellectual as opposed to emotional involvement. The opposite of *empathy*.

diatonic minor: standard musical minor scale achieved by lowering by one half step the third and sixth of the diatonic or standard major scale.

disjunct melody: in music, melody characterized by skips or jumps in the scale. The opposite of *conjunct melody*.

dissonance: occurrence of inharmonious elements in music or the other arts. The opposite of *consonance*.

divertissement: dance, or a portion thereof, intended as a diversion from the idea content of the work.

documentary: in photography or film, the recording of actual events and relationships using real-life subjects as opposed to professional actors.

dome: architectural form based on the principles of the arch in which space is defined by a hemisphere used as a ceiling.

Doric: Greek order of architecture having no base for its columns and only a simple slab as a capital.

drypoint: intaglio process in which the metal plate is scratched with a sharp needlelike tool.

dynamics: range and relationship of elements such as volume, intensity, force, and action in an artwork.

eclecticism: style of design that combines examples of several differing styles in a single composition.

editing: composition of a film from various shots and sound tracks.

elevation: in dance, the height to which a dancer leaps.

empathy: emotional-physical involvement in events to which one is a witness but not a participant.

engraving: intaglio process in which sharp, definitive lines are cut into a metal plate.

en pointe: see *on point*.

entablature: upper section of a building; it is usually supported by columns, and includes a lintel.

entrechat: in ballet, a jump beginning from fifth position in which the dancer reverses the legs front and back one or more times before landing in fifth position. Similar to the *changement de pied*.

ephemeral: transitory, not lasting.

esprit d'escalier: French, meaning "spirit of the stairs." Remarks, thought of after the fact, that could have been *bon mots* had they been thought of at the right moment; witty remarks.

essay: short literary composition on a single subject, usually presenting the personal views of the author. Essays can be formal or informal.

etching: intaglio process in which lines are cut in the metal plate by an acid bath.

étude: a study; a lesson. A musical composition, usually instrumental, intended mainly for the practice of some point of technique.

farce: theatrical genre characterized by broad slapstick humor and implausible plots.

fenestration: exterior openings, such as windows and archways, in an architectural facade.

ferroconcrete: reinforced concrete that utilizes metal reinforcing embedded in the concrete.

fiction: literary work created from the author's imagination rather than from fact.

fluting: vertical ridges in a column.

focal point (focal area): major or minor area of visual attraction in picture, sculpture, dance, play, film, landscape design, or building.

foreground: area of a picture, usually at the bottom, that appears to be closest to the respondent.

form: shape, structure, configuration, or essence of something.

form cutting: in film, the framing in a successive shot of an object that has a shape similar to an image in the preceding shot.

forte: musical term meaning loud.

found object: object taken from life that is presented as an artwork.

fresco: method of painting in which pigment is mixed with wet plaster and applied as part of the wall surface.

fugue: originated from a Latin word meaning "flight." A conventional musical composition in which a theme is developed by counterpoint.

full round: sculptural works that explore full three-dimensionality and are meant to be viewed from any angle.

galliard: court dance done spiritedly in triple meter.

genre: category of artistic composition characterized by a particular style, form, or content.

geometric: based on patterns such as triangles, rectangles, circles, ellipses, and so on. The opposite of *biomorphic*.

Gestalt: a whole. The total of all elements in an entity.

glyptic: sculptural works emphasizing the qualities of the material from which they are created.

Gothic: style of architecture based on a pointed-arch structure and characterized by simplicity, verticality, elegance, and lightness.

gouache: watercolor medium in which gum is added to ground opaque colors mixed with water.

grande seconde: ballet pose with the leg in second position in the air.

grand jeté: in ballet, a leap from one foot to the other, usually with a running start.

grand plié: in ballet, a full bend of the knees with the heels raised and the knees opened wide toward the toes. May be done in any of the five positions.

grave: in music, a tempo marking meaning "slow."

groin vault: ceiling formation created by the intersection of two tunnel or barrel vaults.

harmony: relationship of like elements, such as musical notes, colors, and repetitional patterns. See *consonance* and *dissonance*.

homophony: musical texture characterized by chordal development of one melody. See *monophony* and *polyphony*.

hue: spectrum notation of color; a specific pure color with a measurable wavelength. There are primary hues, secondary hues, and tertiary hues.

icon: artwork whose subject matter includes idolatry, veneration, or some other religious content.

identification: see *empathy*

impasto: the painting technique of applying pigment so as to create a three-dimensional surface.

intaglio: printmaking process in which ink is transferred from the grooves of a metal plate to paper by extreme pressure.

intensity: the degree of purity of a hue. In music, theatre, and dance, that quality of dynamics denoting the amount of force used to create a sound or movement.

interval: difference in pitch between two tones.

Ionic: a Greek order of architecture that employs a scroll-like capital with a circular column base.

iris: in film and photography, the adjustable circular control of the aperture of a lens.

isolation shot: in film, the isolation of the subject of interest in the center of the frame.

jeté: in ballet, a small jump from one foot to the other, beginning and ending with one foot raised.

jump cut: in film, the instantaneous cut from one scene to another or from one shot to another; often used for shock effect.

key: system of tones in music based on and named after a given tone—the tonic.

kouros: archaic Greek statue of a standing nude youth.

labanotation: system for writing down dance movements.

largo: in music, a tempo notation meaning large, broad, very slow, and stately movement.

legato: in music, a term indicating that passages are to be played with smoothness and without break between the tones.

lento: musical term indicating a slow tempo.

libretto: words, or text, of an opera or musical.

linear perspective: creation of the illusion of distance in a two-dimensional artwork through the convention of line and foreshortening—that is, the illusion that parallel lines come together in the distance.

linear sculpture: sculptural works emphasizing two-dimensional materials.

lintel: horizontal member of a post-and-lintel structure in architecture.

lithography: printmaking technique, based on the principle that oil and water do not mix, in which ink is applied to a piece of paper from a specially prepared stone.

magnitude: scope or universality of the theme in a play or film.

manipulation: sculptural technique in which materials such as clay are shaped by skilled use of the hands.

melodrama: theatrical genere characterized by stereotyped characters, implausible plots, and emphasis on spectacle.

melody: in music, a succession of single tones.

metaphor: figure of speech by which new implications are given to words.

mime: in dance or theatre, actions that imitate human or animal movements.

mise-en-scène: complete visual environment in the theatre, dance, and film, including setting, lighting, costumes, properties, and physical structure of the theatre.

modern dance: form of concert dancing relying on emotional use of the body, as opposed to formalized or conventional movement, and stressing human emotion and the human condition.

modulation: change of key or tonality in music.

monolithic construction: variation of *bearing-wall* construction in which the wall material is not jointed or pieced together.

monophony: musical texture employing a single melody line without harmonic support.

montage: in the visual arts, the process of making a single composition by combining parts of other pictures so the parts form a whole and yet remain distinct. In film, a rapid sequence of shots that bring together associated ideas or images.

motive (motif): in music, a short, recurrent melodic or rhythmic pattern. In the other arts, a recurrent element.

musique concrète: twentieth-century musical approach in which conventional and recorded sounds are altered electronically or otherwise and recorded on tape to produce new sounds.

neoclassicism: various artistic styles that borrow the devices or objectives of classic or classical art.

novel: prose narrative of considerable length which has a plot that unfolds by the actions, speech, and thoughts of the characters.

objective camera: camera position based on a third-person viewpoint.

objet d'art: French term meaning "object of art."

octave: in music, the distance between a specific pitch vibration and its double; for example, concert A equals 440 vibrations per second, one octave above that pitch equals 880, and one octave below equals 220.

on point: in ballet, a specific technique utilizing special shoes in which the dancer dances on the points of the toes.

opera bouffa: comic opera.

opus: single work of art.

overtones (overtone series): sounds produced by the division of a vibrating body into equal parts. See *sympathetic vibration*.

palette: in the visual arts, the composite use of color, including range and tonality.

pas: in ballet, a combination of steps forming one dance.

pas de deux: dance for two dancers, usually performed by a ballerina and her male partner.

pavane: stately court dance in 2/4 time; usually follows a galliard.

pediment: typically triangular roof piece characteristic of the Greek and Roman style.

pendentives: curved triangular segments leading from the corners of a rectangular structure to the base of a dome.

perspective: representation of distance and three-dimensionality on a two-dimensional surface. See also *aerial perspective* and *linear perspective*.

photojournalism: photography of actual events that have sociological significance.

piano: musical term meaning "soft."

pirouette: in ballet, a full turn on the toe or ball of one foot.

plasticity: the capability of being molded or altered. In film, the ability to be cut and shaped. In painting, dance, and theatre, the accentuation of three-dimensionality of form through chiaroscuro.

platemark: ridged or embossed effect created by the pressure used in transferring ink to paper from a metal plate in the intaglio process.

poetry: literary work designed to convey a vivid and imaginative sense experience through the use of condensed language selected for its sound and suggestive power and meaning, and employing specific technical devices such as meter, rhyme, and metaphor. There are three major types of poetry: narrative, dramatic, and lyric.

polyphony: see *counterpoint*.

port de bras: technique of moving the arms correctly in dance.

post-and-lintel: architectural structure in which horizontal pieces (lintels) are held up by vertical columns (posts); similar to post-and-beam structure, which usually utilizes wooden posts and beams held together by nails or pegs.

post-tensioned concrete: concrete using metal rods and wires under stress or tension to cause structural forces to flow in predetermined directions.

precast concrete: concrete cast in place using wooden forms around a steel framework.

presto: musical term signifying a rapid tempo.

prestressed concrete: see *post-tensioned concrete*.

program music: music that refers to nonmusical ideas through a descriptive title or text. The opposite of *absolute music*.

prototype: model on which something is based.

pyramidal structure: in theatre, film, and dance, the rising of action to a peak, which then tapers to a conclusion.

quadrille: (1) an American square dance; (2) a European ballroom dance of the eighteenth and nineteenth centuries.

realism: artistic selection and use of elements from life; contrasts with naturalism, in which no artistic selection is utilized.

recitative: sung dialogue in opera, cantata, and oratorio.

rectilinear: in the visual arts, the formed use of straight lines and angles.

reinforced concrete: see *ferroconcrete*.

relevé: in ballet, the raising of the body to full height or half height during the execution of a step or movement.

relief printing: process in printmaking by which the ink is transferred to the paper from raised areas on a printing block.

representational: objects that are recognizable from the real life.

requiem: mass for the dead.

rhyme: sound structure coupling words that sound alike.

rhythm: relationship, either of time or space, between recurring elements of a composition.

ribbed vault: structure in which arches are connected by diagonal as well as horizontal members.

ritardando: in music, a decrease in tempo.

rondo: form of musical composition employing a return to an initial theme after the presentation of each new theme.

ronds de jambe à terre: in ballet, a rapid semicircular movement of the foot in which the toe remains on the floor and the heel brushes the floor in first position as it completes the semicircle.

rubato: a style of musical performance in which liberty is taken by the performer with the rhythm of the piece.

saturation: in color, the purity of a hue in terms of whiteness; the whiter the hue, the less saturated it is.

scale: in music, a graduated series of ascending or descending musical tones. In architecture, the mass of a building in relation to the human body.

serigraphy: printmaking process in which ink is forced through a piece of stretched fabric, part of which has been blocked out—for example, silk-screening and stenciling.

short story: short fictional works of prose focusing on unity of characterization, theme, and effect.

skeleton frame: construction in which a skeletal framework supports the building. See *balloon construction* and *steel cage construction*.

song cycle: group of art songs combined around a similar text or theme.

sonority: in music, the characteristic of texture resulting from chordal spacing.

staccato: in music, the technique of playing so that individual notes are detached and separated from each other.

static: devoid of movement or other dynamic qualities.

steel cage construction: construction using a metal framework. See *skeleton frame*.

stereotype: standardized concept or image.

style: individual characteristics of a work of art that identify it with a particular artist, nationality, historical period, or school of artists.

stylization: reliance on conventions, distortions, or theatricality; the exaggeration of characteristics that are fundamentally verisimilar.

subjective camera: camera position that gives the audience the impression they are actual participants in the scene.

substitution: sculptural technique utilizing materials transformed from a plastic, molten, or fluid into a solid state.

subtractive: in sculpture, referring to works that are carved. In color, referring to the mixing of pigments as opposed to the mixing of colored light.

symbolism: suggestion through imagery of something that is invisible or intangible.

symmetry: balancing of elements in design by placing physically equal objects on either side of a center-line.

sympathetic vibration: physical phenomenon of one vibrating body being set in motion by a second vibrating body. See also *overtones*.

symphony: large musical ensemble; a symphony orchestra. Also, a musical composition for orchestra usually consisting of three or four movements.

syncopation: in a musical composition, the displacement of accent from the normally accented beat to the offbeat.

synthesizer (also called *Moog synthesizer*): electronic instrument that produces and combines musical sounds.

tempera: opaque watercolor medium, referring to ground pigments and their color binders such as gum, glue, or egg.

tempo: rate of speed at which a musical composition is performed. In theatre, film, or dance, the rate of speed of the overall performance.

terra-cotta: earth-brown clay used in ceramics and sculpture.

tessitura: general musical range of the voice in a particular musical composition.

texture: in art, the two-dimensional or three-dimensional quality of the surface of a work. In music, the melodic and harmonic characteristics of a composition.

theatricality: exaggeration and artificiality; the opposite of *verisimilitude*.

theme: general subject of an artwork, whether melodic or philosophical.

timbre (tone color): quality of sound that distinguishes one instrument or voice from another.

toccata: composition usually for keyboard instrument intended to display technique.

tonality: in music, the specific key in which a composition is written. In the visual arts, the characteristics of value.

tondo: a circular painting.

tone color: see *timbre*.

tonic: in music, the root tone (*do*) of a key.

triad: a musical chord consisting of three tones.

tunnel vault: see *barrel vault*.

tutu: many-layered bell-shaped crinoline skirt worn by a ballerina.

value (value scale): in the visual arts, the range of tonalities from white to black.

variation: repetition of a theme with minor or major changes.

verisimilitude: appearance of reality in any element of the arts.

virtuoso: referring to the display of impressive technique or skill by an artist.

vivace: musical term denoting a vivacious or lively tempo.

waltz: dance in 3/4 time.

woodcut: relief printing executed from a design cut in the plank of the grain.

wood engraving: relief printing made from a design cut in the butt of the grain.

Further Reading

Abcarian, Richard, and Klotz, Marvin, eds. *Literature and the Human Experience*. New York: St. Martinís Press, 1998.

Acton, Mary. *Learning to Look at Paintings*. London: Routeledge, 1997.

Arnheim, Rudolph. *Art and Visual Perception: A Psychology of the Creative Eye*. Berkeley: University of California Press, 1989.

_____. *Film as Art*. Berkeley: University of California Press, 1972.

Bacon, Endmund N. *Design of Cities*. New York: Viking Press, 1976.

Benbow-Pfalzgraf, Taryn. *International Dictionary of Modern Dance*. New York: St James Press, 1998.

Bobker, Lee R. *Elements of Film*. New York: Harcourt Brace Jovanovich, 1979.

Bordwell, David, and Kristin Thompson. *Film Art: An Introduction*. Reading, MA: Addison-Wesley, 1996.

Brockett, Oscar Gross. *The Essential Theatre* (5th ed.). New York: Holt Rinehart & Winston, 1992.

Cameron, Kenneth M., Patti P. Gillespie, and Kenneth M. Camerson. *The Enjoyment of the Theatre* (4th ed.). Boston, MA: Allyn & Bacon, 1996.

Canaday, John. *What is Art?* New York: Knopf, 1990.

Cass, Joan. *Dancing Through History*. Upper Saddle River, NJ: Prentice Hall, 1993.

Ching, Frank D. K. and Francis D. K. Ching. *Architecture: Form, Space, and Order* (2nd ed). New York: John Wiley & Sons, 1996.

Cook, David A. *A History of Narrative Film*. New York: Norton, 1996.

Corner, James S. *Taking Measures Across the American Landscape*. New Haven, CT: Yale University Press, 1996.

Davis, Phil. *Photography*. Dubuque, IA: William C. Brown, 1996.

Dean, Alexander, and Lawrence Carra. *Fundamentals of Play Directing*. New York: Holt, Rinehart and Winston, 1990.

Finn, David. *How to Look at Sculpture*. New York: Harry N. Abrams, 1989.

Frampton, Kenneth. *Modern Architecture: A Critical History* (3rd ed.). London: Thames and Hudson, 1992.

Giannetti, Louis. *Understanding Movies*. Upper Saddle River, NJ: Prentice Hall, 1996.

Giedion, Sigfried. *Space, Time and Architecture: the Growth of a New Tradition* (5th ed.). Cambridge, MA: Harvard University Press, 1967.

Hartnoll, Phyllis and Peter Found, eds. *The Concise Oxford Companion to the Theatre* (2nd ed.). New York: Oxford University Press, 1992.

Heyer, Paul. *Architects on Architecture: New Directions in America*. New York: Walker and Company, 1978.

Highwater, Jamake. *Dance: Rituals of Experience* (3rd ed.). New York: Oxford University Press, 1996.

Hyman, Isabelle, and Marvin Trachtenberg. *Architecture: From Prehistory to Post-Modernism/The Western Tradition*. New York: Harry N. Abrams, 1986.

Kramer, Jonathan D. *Listen to the Music: A Self-Guided Tour Through the Orchestral Repertoire*. New York: Schirmer Books, 1992.

Le Corbusier, Charles-Édouard Jeaneret. *Towards a New Architecture*. New York: Dover, 1986.

Nesbitt, Kate, ed. *Theorizing a New Agenda for Architecture: An Anthology of Architectural Theory 1965-1995*. New Haven, CT: Princeton Architectural Press, 1996.

Newton, Norman, T. *Design on the Land: The Development of Landscape Architecture*. Cambridge, MA: Harvard University Press, 1971.

Rasmussen, Steen Eiler. *Experiencing Architecture*. Cambridge, MA: MIT Press, 1984.

Ryman, Rhonda. *Dictionary of Classical Ballet Terminology*. Princeton, NJ: Princeton Book Company, 1998.

Simonds, John Ormsbee. *Landscape Architecture: A Manual of Site Planning and Design* (3rd ed.). New York: McGraw Hill, 1997.

Sporre, Dennis J. *The Art of Theatre*. Upper Saddle River, NJ: Prentice Hall, 1993.

_____. *Reality Through the Arts* (3rd ed.). Upper Saddle River, NJ: Prentice Hall, 1997.

_____. *The Creative Impulse* (5th ed.). Upper Saddle River, NJ: Prentice Hall, 2000.

Sporre, Dennis J. and Robert C. Burroughs. *Scene Design in the Theatre*. Upper Saddle River, NJ: Prentice Hall, 1990.

Stanley, John. *An Introduction to Classical Music Through the Great Compsers & Their Masterworks*. New York: Readers Digest, 1997.

Steinberg, Michael. *The Symphony: A Listener's Guide*. New York: Oxford University Press, 1995.

Summerson, John Newenham. *Classical Language of Architecture*. Cambridge, MA: MIT Press, 1984.

Thompson, Kristin, and David Bordwell. *Film History: An Introduction*. New York: McGraw Hill, 1994.

Vacche, Angela Dalle. *Cinema and Painting: How Art Is Used in Film*. Austen, TX: University of Texas Press, 1996.

Yenawine, Philip. *How To Look at Modern Art*. New York: Harry N. Abrams, 1991.

Zorn, Jay D. *Listen to Music*. Upper Saddle River, NJ: Prentice Hall, 1994.

Index